MILLENNIAL MASCULINITY

MILLENNIAL MASCULINITY

Men in Contemporary
American Cinema

Edited by Timothy Shary

Wayne State University Press Detroit

17 16 15 14 13 5 4 3 2 1

Library of Congress Cataloging-in-Publication Data

Millennial masculinity : men in contemporary American cinema / edited by Timothy Shary.
 p. cm. — (Contemporary approaches to film and media series)
 Includes bibliographical references and index.
 ISBN 978-0-8143-3435-5 (pbk. : alk. paper) — ISBN 978-0-8143-3844-5 (ebook)
 1. Men in motion pictures. 2. Motion pictures—United States.
I. Shary, Timothy, 1967–
 PN1995.9.M46M55 2013
 791.43′652041—dc23
2012023757

∞

Song lyrics from "When I Was a Boy" by Dar Williams (1995) reprinted with permission of MCT Management.

Maria San Filippo's essay "More than Buddies: *Wedding Crashers* and the Bromance as Comedy of (Re)Marriage Equality" originally appeared in her book *The B Word: Bisexuality in Contemporary Film and Television* (Indiana University Press, 2012). Reprinted with permission of Indiana University Press.

An earlier version of Claire Sisco King's essay "Legendary Troubles: Trauma, Masculinity, and Race in *I Am Legend*" originally appeared in her book *Washed in Blood: Male Sacrifice, Trauma, and the Cinema* (Rutgers University Press, 2011). Reprinted with permission of Rutgers University Press.

Typeset by Alpha Design & Composition
Composed in Warnock Pro and Meta

Contents

Preface

As Joe Jackson so eloquently sang in his 1982 song *Real Men*, "What's a man now, what's a man mean? / Is he rough or is he rugged, is he cultural and clean?" The goal of this book is to answer both of those questions, specifically through the lens of cinema.

And those are certainly not easy questions to answer, considering the complexities of masculinity and how gender has changed in recent years. As a primary example, which Maria San Filippo studies more thoroughly in her chapter, consider the rise of the "bromance" in recent years. These films have become ubiquitous, featuring men who find a deep emotional connection with other men, usually in small groups or as a couple, and almost always as a result of initially displacing female love interests. The route to that connection is often through comedic mishaps, usually as a result of the hyper-hetero nature of one or more characters, as with the dudes in most movies featuring Will Farrell (*Old School*, 2003; *Anchorman: The Legend of Ron Burgundy*, 2004; *Talledega Nights: The Ballad of Ricky Bobby*, 2006; *Blades of Glory*, 2007; *Step Brothers*, 2008; *The Other Guys*, 2010, and *Casa de mi Padre*, 2012) and now more prominently with films made by Judd Apatow's production company, which include some of the Farrell films as well as *The 40-Year-Old Virgin* (2005), *Superbad* (2007), *Pineapple Express* (2008), *Funny People* (2009), and *Get Him to the Greek* (2010). To this mix we could also add *Wedding Crashers* (2005), *I Now Pronounce You Chuck & Larry* (2007), *Humpday* (2009), *I Love You, Man* (2009), *The Hangover* (2009) and *The Hangover Part II* (2011), and the three *Harold and Kumar* films (2004–11), not to mention the increasing number of bromantic television shows in recent years.

To be sure, men have been forging emotional bonds with each other in movies going back to at least the Great Depression, when the colder and stoic nature of past masculine repression gave way to a certain communal bonding among men, as we saw in war stories, crime sagas, and

sports dramas. And of course there have been established male duos in so-called buddy movies like Laurel and Hardy ('20s–'30s), Abbott and Costello ('40s–'50s), and Martin and Lewis ('50s), who usually found themselves in quizzical adventures leading to harmless outcomes. After WWII, the western began to feature more sensitive versions of the rough male cowboy type, as was the case with the proliferation of action films during the post–Vietnam War era—and yet with few exceptions, these characters did not have open discussions about their emotions *for each other* such as we began to see in the bromance films of the past generation.

Where the protagonist of the *Rambo* trilogy (1982–88) could cry about his solitary torment after returning from the Vietnam War, these men were just beginning to struggle with their relationships to other men. Bromance movies have come to assume that male characters already have some recognition of their affection for each other, and their struggle is to express that affection and not to simply accept the relationship with safe ambiguity. This is indicative of the changing attitudes about the previously perceived crisis in masculinity, because in so many ways characters in bromance films enjoy themselves and face much lesser conflicts than those otherwise emotional men of previous genres and generations. I argue this is a positive, if perhaps still slight, advance in American men's appreciation of gender malleability, since we witness in these films minimal transference of male-to-male affection into anti-homosexual denials and see more acceptance of sincere male bonding that had become so conflicted in previous generations.

Now is indeed the time to evaluate what a man is now, and what a man means. Finding where that evaluation takes us will be genuinely worthwhile.

My own beacon has been moved under moon and star since I began this project in 2006, so first and foremost my thanks must go to my excellent contributors, all of whom have weathered a long process of editing, revision, and a change in publisher. On this last point, I give enormous thanks to our excellent acquisitions editor at Wayne State University Press, Annie Martin, who took on and encouraged this work after its initial gestation elsewhere, having sincere determination along the way to its publication. The incomparable Barry Keith Grant, as series editor, gave the project a great boost of confidence while guiding us to its ultimate completion. Our understanding production editor, Carrie Downes Teefey, very dedicated copyeditor, Yvonne Ramsey, and creative design director, Maya Whelan, also brought their expertise to developing the text and images that form this book, especially through later crises. Contributor Claire Sisco King additionally and generously volunteered to polish off further proofreading in the final stages of production. And our ambitious marketing team, Emily

Nowak, Sarah Murphy, and Jamie Jones, have done impressive work to carry the book to the public.

I thank my editor at the University of Texas Press, Jim Burr, who introduced me to Annie with an enthusiastic endorsement. The list of contributors was aided by the energetic input of my friend Murray Pomerance at Ryerson University, film studies author extraordinaire. Angela Bazydlo at Clark University promoted my work so effectively in the early days of this project that it survived the arduous transition from concept to fruition. Unsung librarians also aided in this production, especially at the University of Central Oklahoma (Nicole Willard in Archives at Chambers), Salisbury University (Stephen Ford in Research/Instructional & Information Literacy at Blackwell), and Worcester-Wicomico Community College (Cheryl Michael in the Media Center).

With sweet surprise, I was honored by New England folk music legend Dar Williams, who granted immediate approval to excerpt "When I Was a Boy" (and Beth, you made it matter). I am also very grateful to Delmarva photography legend Kevin Fleming, who took the time to make my face presentable for publicity.

I presented portions of my research that were foundational to this anthology at national conferences of the Popular Culture / American Culture Association and their regional meetings in the Northeast, South, and Far West, the University Film and Video Association, and the Society for Cinema and Media Studies, where I met most of the contributors in this collection. Special thanks go to Mick Broderick and Antonio Traverso at Murdoch and Curtin Universities in Western Australia, who arranged for me to speak at their "Interrogating Trauma" conference in 2008. The Geena Davis Institute on Gender in Media also cordially invited me as a delegate to its rousing inaugural conference in 2009.

Generous financial support for this project was provided by two grants at Clark University from the Higgins School of Humanities and the Harrison Fund in Communication and Culture, and some research/travel funding was provided by the College of Arts and Sciences at the University of Oklahoma.

As for the uncountable acknowledgments of friends I must make . . . what is a man, what has he got, if not himself, then he has naught; to say the things he truly feels:

Richard Moore, my kind cousin, made me an altruistic offer to keep the book, and myself, alive. My parents and brother have also been a personal rock of support.

Adam Aries, a wondrous influence on my understanding of masculinity, died much too young. He empowered me to say that I've always been a little gay. The world needs more men like him.

And many other people have saved me and this project from the nothing we could have become: Christopher Goodwin, steadfast source of help and resolve; Christine LeBel, so thoughtful and devoted; Richard Brown, seriously funny yet startling serious; Devin Griffiths, loyal and uplifting all the way; Jon Kitzen, sympathetic agent provocateur; Claudia Robertson, who has always listened; Ilana Nash, whose feminism is so provocative; Gary Marcus, a paradigm shift of inspiration; Ethan Lewis, realistic in his positivity; Tom Scully, with his calm advice. And kiss the rest for me, I may find myself delayed: Anna Secor, Beth Gale, Bob Miklitsch, Chris Boucher, Christine Holmlund, Darci Cramer-Benjamin, Darcie Cote-Rumsey, Ian Peters, Jesse Rossa, Jillian Starr, John Savage, Jon Lupo, Julie Joy, Katrina Boyd, Louisa Stein, Mark Richardson, Marty Norden, Sara Hunicke Warren, Tamar Jeffers McDonald, and Zach Woods. They and so many others gave me vital levels of sanctuary throughout these past few years.

Nicole, you just hoped to make me feel better, and you did so in wonderful ways. The sparkle in your eyes kept me alive. Thank you.

To the angels who reach through windows to hold my hand at the exact moment the river becomes the sea, I will always carry you with me.

There are no expressions for the love and gratitude I have for Olivia Xendolyn, because I have seen the crescent, yet you will see the whole of the moon.

<div align="right">

Timothy Shary
May 2012
Millsboro, DE

</div>

Timothy Shary

Introduction

And so I tell the man I'm with about the other life I lived
And I say, "Now you're top gun, I have lost and you have won"
And he says, "Oh no, no, can't you see
When I was a girl, my mom and I we always talked
And I picked flowers everywhere that I walked
And I could always cry, now even when I'm alone I seldom do
And I have lost some kindness
But I was a girl too
And you were just like me, and I was just like you"

<div align="right">Dar Williams, "When I Was a Boy" (1993)</div>

Male characters have been dominant in films and media in every national culture of the world and certainly in American culture. Masculine issues and pursuits are far more common in movies than those of women, and men are certainly not an underrepresented minority group, nor are they politically marginalized or disempowered as a whole. However, this book makes clear that there is nonetheless a great intricacy and sensitivity to the depictions of men in American cinema, and many of their portraits challenge perceived norms about sexuality and sexual preference, social identities and expectations, power and strength, and the very essence of what "being a man" means, as Dar Williams captures so well in her song excerpted above. These challenges have been especially manifest in feature films since the 1990s, despite a lack of corresponding changes in the nature of film production or exhibition.

A great number of demographic shifts and historical events over recent decades have brought into question—if not revision—American notions of masculinity. For instance, marriage has rapidly become a less common condition of the population since 1990, falling by a rate of 45 percent up to 2008, with more adult Americans living unmarried than ever before; meanwhile, the divorce rate has nearly quadrupled since 1960. Both conditions have resulted in more women living single and fewer men providing financial and familial security for them. If there has been a weakening security in marriage, the security of education has become ever more important, and more so for women than men: women's college graduation rates increased by 360 percent from 1970 to 2009, compared to a 223 percent increase for men. As a consequence, 29 percent of American women and 30 percent of American men now complete college degrees, giving women more professional opportunities than ever before.[1] Men are also not as plentiful in positions of political power as they once were. In 1960, only 2 of the 100 U.S. senators were women, and 17 of the 437 members of the U.S. House of Representatives were women; in 2010, those numbers rose to 17 women in the Senate and 71 in the House. These are relatively modest but significant increases of roughly 17 percent in the Senate and 16 percent in the House, indicating some positive balanced growth in national political power (or at least visibility). Perhaps the most customary marker of authority—wealth, or the ability to earn it—has also changed dramatically for American men over the past generation, with the impact of economic recessions, increasing unemployment, and rising expectations of material possession further impacting the ability of men to achieve the same perceived potency as their forebears.

In terms of events that may have led to recent shifts in the perceptions of American men, consider just the following. After the relatively brief Persian Gulf War in early 1991, many soldiers were physically and mentally disabled by the ordeal but received strikingly little care, and the personal damage that many of them endured was systemically denied by the culture at large. In late 1991, the U.S. Supreme Court confirmation hearings of Clarence Thomas exposed a great deal of misconception about sexual harassment, supporting an interrogation of appropriate behavior between men and women. Social predicaments during the presidency of Bill Clinton from 1993 to 2001 produced numerous questions about gender roles, especially related to whether homosexuals could serve in the military, whether masturbation was a healthy practice, and to what extent men in power (such as the president himself) can exploit their positions to attract women. And the double-murder trial of former football star O. J. Simpson

from 1994 to 1995 opened profound clashes in the culture around race, justice, and domestic violence.

Men's anger was prominently displayed in at least three later 1990s' events. In 1995, an extremist ex-soldier detonated a massive bomb at a federal building in Oklahoma City, killing 168 people in a cowardly protest against the government. Further hatred was again exemplified in 1998 when two men fatally beat to death gay college student Matthew Shepard in Wyoming, drawing attention to long-repressed homophobia among men yet galvanizing many people to support gay rights. Then, following numerous other school shootings in the 1990s, in 1999 two traumatized teenage boys brutally murdered thirteen people at their high school in Colorado; investigators later deduced that the boys were the targets of ridicule by students and harbored unchecked pathological delusions.

The new millennium soon witnessed the terrorist attacks of September 11, 2001, that were carried out by a small group of men who murdered thousands and led to fervently disputed wars in Afghanistan and Iraq that caused far more deaths than the original attacks. In 2004, Massachusetts became the first state to allow same-sex marriage. Other states began to follow, encouraging further acceptance of homosexual lifestyles in American culture. And in 2009, Barack Obama became the first African American president, indicating a momentous step beyond the nation's past racism. In virtually every aspect of culture—health, marriage, family, morals, politics, sex, race, and economics—American men in the past generation have arguably faced more radical questions about themselves than at any other time in history.

MOVIE MASCULINITY

Many of these questions demonstrate how gender became an ever more germane issue for men throughout the 1990s and 2000s, as reflected in many films of both decades. Social transitions in sexual preference and racial diversity were concomitant gauges of change. The increasing visibility of nonheterosexual men was undeniable as the stigma of AIDS in the 1990s gave way to more tolerant and mature opinions about sex, while the nonwhite population of the United States continued to rise substantially, fueling apprehensions within some of the white population yet promoting a broader cultural appreciation for difference.[2]

At the movies, African American actors such as Will Smith, Denzel Washington, Morgan Freeman, Jamie Foxx, and Samuel L. Jackson all emerged as bankable A-list stars (each earned Oscar nominations and/ or awards), while films featuring them—for example, *Independence Day*

(1996), *American Gangster* (2007), *Million Dollar Baby* (2004), *Any Given Sunday* (1999), *Star Wars Episode I* (1999), *Star Wars Episode II* (2002), and *Star Wars Episode III* (2005)—became major box office hits. These films covered a remarkable range of stories far beyond typical discussions of racial distinctions, featuring nuanced characters in conflicts around authority, survival, family, competition, and morality. And despite how very few actors identified themselves as openly gay, movie depictions of queer male characters certainly became increasingly common in recent decades, with Oscar-nominated examples including *Longtime Companion* (1990), *JFK* (1991), *Philadelphia* (1993), *As Good as It Gets* (1997), *The Hours* (2002), *Brokeback Mountain* (2005), *Milk* (2008), and *A Single Man* (2009). The gay men in these films also progressed beyond past emphases on sexual identity to tackle issues of politics, health, and law.

Given the escalating developments within the gendered milieu of men in U.S. culture as well as the ongoing evolution of male roles (domestic, professional, performative) and the concerns that these vicissitudes presented to the patriarchal norm, a logical opportunity to reexamine masculinity at the turn of the millennium arises, especially since the positive advances in women's authority and men's humility over the past few decades have not created true gender equality. The comprehensive themes of cinema and its dependence on audience appeal to achieve success make movies the ideal medium through which we can better understand how men in contemporary culture have been changing and how our perceptions of men continue to change as well.

Furthermore, as in society, a great disparity remains in American cinema between women's roles and men's roles. According to the advocacy group Women in Film, in 2009 the percentage of women serving as directors, producers, writers, cinematographers, and/or editors on the top 250 highest-grossing U.S. films was 16 percent, which was actually a decline from 19 percent in 2001. While women did account for 7 percent of American directors in 2009, that was the same percentage as in 1987, indicating a further lack of progress in achieving gender equity in key positions of cinematic authority. Perhaps more telling, a full 22 percent of U.S. films in 2008 employed no women in these authoritative positions.[3]

In terms of the more observable positions of performance, of the one hundred highest-grossing American films of 2010, only eighteen focused on female characters, thus giving men and their stories much more visibility than women. In fact, only one of the top twenty highest-grossing films in 2010 focused on a somewhat realistic female character, the teen vampire drama *The Twilight Saga: Eclipse* (slightly more common were fairy-tale females in films such as *Alice in Wonderland* and *Tangled*), and none of the

Timothy Shary

Bruce Davison earned an Oscar nomination for portraying an openly gay character after his powerful performance in *Longtime Companion*.

Oscar-nominated films about women that year, such as *Black Swan, The Kids Are All Right, Winter's Bone,* and *Blue Valentine,* were among the top twenty. The combined gross of the top four highest-grossing films about women that year—*Alice in Wonderland, Eclipse, Tangled,* and *Salt*—was an average of $237 million; by contrast, the combined gross of the top four films about men averaged $329 million. Not only are far more films made about men than women, but audiences attend such films in much higher numbers, minimizing the impact of the many significant films featuring women.[4]

Curiously, however, unlike feminist film theory and criticism, which motivated prolific research starting in the early 1970s regarding the (mis)representation of women on-screen, studies of masculinity in film were rather scant until the 1990s. This was arguably due to the ostensible preponderance of existing film research related to films about men, even if that research rarely spoke directly to issues of masculinity itself. The earliest book-length study of men in American cinema appeared in 1977, just as feminist film research was establishing its prominence in the field, and was written with a feminist sensibility. Joan Mellen's *Big Bad Wolves: Masculinity in the American Film* (1977), a rather thorough history of male characters in American cinema from the silent days through the 1970s, made the case that Hollywood's men had been unrealistic

fabrications of masculine extremes.[5] Mellen argues that after the trauma of World War I and with the onset of the Great Depression in the 1930s, American movie men had become brutal, spontaneous, selfish, and recklessly adventurous; of course, they had always been very heterosexual as well. Other early studies that examined masculinity in movies tended to be rather sweeping and did not yield much consequential interest in the subject, as was the case with Donald Spoto's *Camerado: Hollywood and the American Man* (1978) and Michael Malone's *Heroes of Eros: Male Sexuality in the Movies* (1979), neither of which was as perceptive or influential as Mellen's seminal volume.[6]

Despite the myriad masculine tensions of the Reagan era and the rise of post–Vietnam War jingoistic action films featuring thick-bodied men in the 1980s, few film scholars continued the lead provided by the late 1970s' studies. But as the 1980s gave way to the 1990s, intense interest in movie masculinity emerged, focusing on classic male character types in earlier cinema (especially gangsters, soldiers, and cowboys) and/or highlighting movie stars who embodied those roles, as in James Neibaur's *Tough Guy: The American Movie Macho* (1989); Robert Sklar's *City Boys: Cagney, Bogart, Garfield* (1992); and Dennis Bingham's *Acting Male: Masculinities in the Films of James Stewart, Jack Nicholson, and Clint Eastwood* (1994).[7] Alongside these historical evaluations that necessarily problematized popular male movie images rather than merely embracing them, a series of more theoretical critiques of masculine representation appeared, often infused with cultural and political concerns akin to much of the feminist film criticism of the previous generation. Peter Lehman's highly renowned study of male physicality on film, *Running Scared: Masculinity and the Representation of the Male Body* (1993), inaugurated further complex theses on male figures in such works as Gaylyn Studlar's *This Mad Masquerade: Stardom and Masculinity in the Jazz Age* (1996) and Steven Cohan's *Masked Men: Masculinity and the Movies in the Fifties* (1997).[8] Thus, the academic establishment of masculine studies in cinema, although lagging behind feminist work on the cinema, was certainly clear by the end of the century, a development confirmed by the publication of several important anthologies such as *Screening the Male: Exploring Masculinities in Hollywood Cinema* (1993), edited by Steven Cohan and Ina Rae Hark, and the companion collections *You Tarzan: Masculinity, Movies, and Men* (1993) and *Me Jane: Masculinity, Movies, and Women* (1995), edited by Pat Kirkham and Janet Thumim.[9]

Since the turn of the current century, however, the field has been primarily interested in historical representations of movie masculinity, focusing on older films: Ashton Trice and Samuel Holland's *Heroes, Antiheroes,*

Timothy Shary

and Dolts: Portrayals of Masculinity in American Popular Films, 1921–1999 (2001), Mick LaSalle's Dangerous Men: Pre-Code Hollywood and the Birth of the Modern Man (2002), Stella Bruzzi's Bringing Up Daddy: Fatherhood and Masculinity in Post-War Hollywood (2005), and David Gerstner's Manly Arts: Masculinity and Nation in Early American Cinema (2006).[10] Alternately, two more diverse collections appeared: The Trouble with Men: Masculinities in European and Hollywood Cinema, edited by Phil Powrie, Ann Davies, and Bruce Babington (2004), spanning movie history and different national cinemas, and the ambitious anthology Pimps, Wimps, Studs, Thugs and Gentlemen: Essays on Media Images of Masculinity, edited by Elwood Watson (2009), which indicated the difficulty of codifying contemporary men in its title alone.[11] These approaches all have their merits, yet they have lacked an understanding of the American movie male that significantly engages with recent events and politics. The present volume is intended to fill this gap in the relatively new field of masculine film studies by focusing on contemporary movie masculinity.

Given the certain foundation of masculine film studies by now and yet the dearth of volumes that address the field in terms of the present generation, this collection has been designed to consider the latest representations of men in movies by building on and moving beyond these past analyses. In editing this anthology I have been quite deliberate in making progress past the predominant themes of other masculine movie studies: the crisis in masculinity that men in American culture are experiencing as their previously assumed gender supremacy has been threatened; men's movies across changing genres, especially more commonly masculine genres such as science fiction, crime films, and war movies; and depictions of the male body in contemporary media, particularly in relation to size and muscularity.

The crisis theme has been quite popular since at least the 1990s, perhaps due to the softer presidency of Bill Clinton and the increasing feminization of men in the American home, evidence of which is detailed in Brenton Malin's American Masculinity under Clinton: Popular Media and the Nineties "Crisis of Masculinity" (2005) and chronicled across more years in David Greven's Manhood in Hollywood from Bush to Bush (2009).[12] Such analyses arguably originated in the work of feminist film scholars such as Kaja Silverman and those in Male Trouble (1993), a collection edited by Constance Penley and Sharon Willis.[13] Subsequent books in this vein included Susan Jeffords's Hard Bodies: Hollywood Masculinity in the Reagan Era (1994) and David Grossvogel's Vishnu in Hollywood: The Changing Image of the American Male by (2000).[14] Many of the authors in Peter Lehman's valuable anthology Masculinity: Bodies, Movies, Culture (2001) also engage in

debates about the increasing complexity of male anxieties, and that deliberation remains evident in more recent studies such as Raya Morag's *Defeated Masculinity* (2009) and Donna Peberdy's *Masculinity and Film Performance: Male Angst in Contemporary American Cinema* (2011).[15] A strikingly comprehensive study that assertively debates the crisis theme is Barry Keith Grant's *Shadows of Doubt: Negotiations of Masculinity in American Genre Films* (2011), in which Grant utilizes examples from the silent era to the present in arguing that male images have been part of an ongoing cultural dialogue about the changing nature of masculinity rather than merely indulging in generic conflicts.[16] Of course, the ongoing dominance of men in American media may still cast doubt on just how pervasive such a masculine crisis may be.

Genre and gender have often been studied together, since so often genres depend on gender stereotypes or promote extreme versions of gender performance, such as the hardened cowboy in Westerns, the dedicated athlete in sports films, or the dangerous dames (femmes fatales) in film noir.[17] Relevant genre-gender studies include Yvonne Tasker's *Spectacular Bodies: Gender, Genre, and the Action Cinema* (1993), Kathleen Klein's *The Woman Detective: Gender and Genre* (1995), and Mark Rubinfeld's *Bound to Bond: Gender, Genre, and the Hollywood Romantic Comedy* (2001).[18] Indicative of the increasing attention to male images across genres, more recent books have included Philippa Gates's *Detecting Men: Masculinity and the Hollywood Detective Film* (2006), Mark Gallagher's *Action Figures: Men, Action Films, and Contemporary Adventure Narratives* (2006), Brian Baker's *Masculinity in Fiction and Film: Representing Men in Popular Genres, 1945–2000* (2006), and Mike Chopra-Gant's *Hollywood Genres and Postwar America: Masculinity, Family and Nation in Popular Movies and Film Noir* (2006).[19]

Studies of the male body in media have been essential in casting a new critical light on masculine representation, especially after Lehman's groundbreaking works. Yet in wanting to move this collection away from traditional takes on the male form, I sought essays that could continue to investigate masculine sex and power but more broadly consider the body over time in terms of other factors vital to corporeal imagery, such as dress, weight, and race. In fact, the initial call for papers that began this collection sought out studies that would not only shift the discourse on movie masculinity toward more contemporary concerns but also could collectively bring focus to novel or refreshed categories of male representation altogether. This goal inevitably posed a considerable taxonomic challenge and at the same time evolved throughout the editing process, yielding an

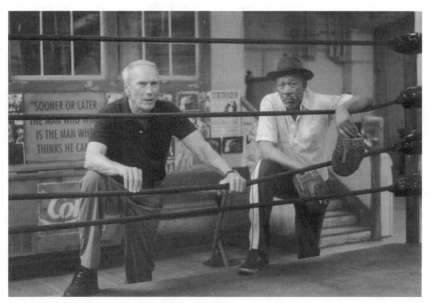

Movies such as *Million Dollar Baby*, featuring Clint Eastwood and Morgan Freeman, have undertaken a remarkable range of concerns about contemporary masculinity, including age, race, health, career, family, sports, and even religion.

array of approaches that could be both independently articulate and often effectively interrelated.

That initial call for papers resulted in more than seventy proposals from scholars around the world, and four distinct arenas of inquiry emerged as I considered the formation of the book. Perhaps the most unexpected theme was performance: not merely how men act or play at being men but how actors and their actions come to represent the various tropes and styles of masculinity. And while the crisis theme has perhaps run its course, there remained a certain coherence around issues of patriarchy, especially in relation to fatherhood and family, and psychological power in general. Male sexual practice also remained a prevalent topic, with a curious emphasis emerging around alternative beliefs about men and sex at the turn of the century as practice and preference have become ever more malleable. And for all of the studies devoted to racial and ethnic issues in cinema over the past few decades, an insufficient number have specifically addressed the crucial intersection between race and masculine identity, at least not beyond criminal activity. These four subjects became the working structure for the collection as I selected essays from the preliminary submissions and solicited essays directly from established scholars.

The first section, which covers performance, begins with a study of one of the most prominent male actors of the past generation, Adam Sandler, whose popular reception has provoked diatribes about why audiences find the bipolar angry-happy man-child so endearing in films such as *Billy Madison* (1995), *The Waterboy* (1998), and *Anger Management* (2003). In Aaron Taylor's essay on Sandler, the performative range of masculinity in recent movies is reconfigured, distrusting the often sanguine appearance of American masculinity and critiquing how the adolescent yet often pernicious nature of most Sandler characters has flourished, at least until recently. Taylor does not find Sandler's men to be liberated juveniles on the stage of masculine parody and instead places his characters within a political framework that draws out their perturbingly reactionary nature.

Donna Peberdy then ponders male performance through an examination of Sean Penn's Oscar-winning role in *Milk*, contemplating his cinematic presentation and his true-life reception. Penn is a character as an offscreen activist and as an on-screen virtuoso, and this duality is especially compelling in terms of portraying the homosexual icon Harvey Milk, who was murdered more than thirty years before the release of the film. The legacy of the real Milk, suggests Peberdy, is embodied in the political Penn and within the context of 2000s' culture, as broader acceptance of homosexuality became a welcome reality.

Concluding this section is a content analysis by Neal King on the heady genre of police movies, revealing many cogent points about male power and vicious behavior by utilizing a method rarely employed in cinema studies. Through considering the climactic scenes in more than three hundred examples as assorted as *Point Break* (1992), *L.A. Confidential* (1997), and *Untraceable* (2008), King is able to simultaneously demonstrate the demanding nature of gender analysis at the narrative level and contest many implicit equations of heroic masculinity with virtuous violence.

The four essays in the next section, on patriarchal issues, indicate that filmmakers and movie studios continue to traffic heavily in rather conservative codes of male conduct, while at the same time men in many films are seriously conflicted about their family relationships, personal potency, and mental health. Mike Chopra-Gant grapples with the dogmatism of fatherhood by evaluating debates about one of the most hypermasculine films of the past generation, *Fight Club* (1999). In reevaluating this widely dissected text through an explicit focus on the absent yet indelible father figure motif, Chopra-Gant explores pivotal themes of maturation, socialization, and unification among men. The film is at once an undeniable fantasy of byzantine

male aggression beyond the reach of conventional authority and a palimpsest upon which we can project latent longings for patriarchy itself.

Chris Robé continues this exploration of paternal problems through a survey of films by emergent auteur Wes Anderson, including *Rushmore* (1998), *The Royal Tenenbaums* (2001), and *The Life Aquatic with Steve Zissou* (2004). Appreciating Anderson's commentary on film families demands a historical perspective over the course of his oeuvre, as Robé illustrates through his analysis of the male elders in these plots, all of whom writhe in a certain discomfort within their domestic dominions. And via their exposition of families, Anderson's works also engage in strategic discourses around wealth, intelligence, and fame as well as gender, opening up further reservations about the sense of entitlement that patriarchs can no longer presume.

R. Barton Palmer, through a study of the overlooked 1999 Martin Scorsese film *Bringing Out the Dead,* commences with a discussion of class and spirituality as factors in masculine roles of late, topics that have been strikingly marginalized. In earlier Scorsese films such as *Mean Streets* (1973) and *Taxi Driver* (1976), the director foregrounded the ambitions of men to transcend their lowly states through some misguided effort at saving others, a movement toward deliverance from their inner demons that finds electrifying realization in the fin-de-siècle *Bringing Out the Dead.* Beyond making this connection, however, Palmer offers an absorbing reflection on the very nature of transcendence beyond gender roles.

The residue of the Travis Bickle character from *Taxi Driver* lingers throughout further depictions of agitated men, as David Greven's essay reveals through the ways that patriarchal pathology has developed in the supposedly psychotic men of recent American cinema and television. The depravity of psycho characters in the twenty-first century is quite unlike that of the past, because after years of celebrating such antiheroes, the movie industry and the American audience have been brought to confront the ersatz morality of these villains in decisive ways. Even comic depictions of the psycho in lighter fare such as *Observe and Report* (2009) have exposed a certain perversity in the cultural desire for order through chaos or justice through evil.

The third section assesses male sexuality, which is more often cast by Hollywood within a heteronormative context than female sexuality, in terms of contrasting portrayals against that context. Christopher Sharrett thereby considers the disruptive attributes of *Brokeback Mountain,* the so-called gay Western that broke so many bounds of genre and gender mythology. The story goes well beyond a romance between two otherwise stoic cowboys to offer a disparaging critique of sexual repression on a comprehensive social

level. Sharrett's analysis of the film is particularly affective in his assertion that not only does such expansive repression doom the romance of the protagonists, it also obliterates the men who cannot overcome its power and contaminates the mythology that it supposedly sustains.

The burgeoning bromance genre of recent years is the subject of Maria San Filippo's appraisal of the buddy comedy *Wedding Crashers* (2005), a film like many others of the 2000s that seems to support, if not encourage, a surprisingly reassuring level of bisexuality for its male characters. Rather than denying the overt affections between male protagonists for the ultimate restoration of heterosexual balance, these bromances posit a sophisticated conception of male relationships that is more positively queer than American movie men have shared before. At the same time, this genre also provides an operative sanctuary in which specific homosexual attractions between men can be suspended so that a more diversified realm of male attachments can be enjoyed, thereby allowing a refreshing awareness for the variety of men's sexualities.

The mutability of male sexuality is also at issue in Caeitlin Benson-Allott's stimulating study of actor Philip Seymour Hoffman in terms of his so-called fat characters and his parallel embodiment of queer identity through his physical form. His roles ranging from *Twister* (1996) to *Boogie Nights* (1997) to *Mission: Impossible III* (2006) present male bodies in excess, and yet Benson-Allott argues that Hoffman is able to subtly subvert the typically denigrated symbolism of these bodies. In the process, Hoffman's performances upset certain standards of sexual distinction that have worked to ostracize overweight and queer characters.

Race and masculinity, two conditions that exert much influence on each other in terms of representational politics, are nonetheless rarely analyzed within the same study. I made a dedicated effort to bring forth such analyses in this collection in the book's final section, beginning with the work of Melvin Donalson, one of the few film scholars to elucidate the intersections of race and masculinity at length.[20] His essay researches the directorial output of Spike Lee and John Singleton in terms of their male characters, highlighting the meaningful aspects of Lee's *Mo' Better Blues* (1990) and Singleton's *Rosewood* (1997) and taking them to task for their more conventional approaches in other films, such as, respectively, *She Hate Me* (2004) and *Baby Boy* (2001). Donalson traces the variances of these auteurs' works through the recent history of racial conditions in America and changes in the film industry that have engendered discordant expectations about the images of African American men on the whole.

Next, Claire Sisco King goes on to detail the elided but never absent issues of racial identity connected to the Will Smith character of *I Am Legend*

(2007), bringing further understanding to masculinity in past science fiction films such as *The World, the Flesh, and the Devil* (1959) and contemporary examples such as *2012* (2009). In a polemic that is both sensitive to post-9/11 trauma and its political framing, King reads the postapocalyptic Smith film as a fantasy of postracial culture for a solitary man whose civilization is all but extinct. Yet the story ultimately relies on the obsolete hegemony of male nobility and white purity, thereby corrupting the imperative possibility that its heroic black protagonist will actually save humanity, or his race.

Mark Gallagher then considers a multiracial ensemble film, the 2001 remake of *Ocean's Eleven,* and how its neoretro approach is relevant to masculine style. Moving beyond ambiguous markers of style such as attitude and speech so common to post–World War II morality tales featuring organized theft, as employed in the original 1960 *Ocean's Eleven,* Gallagher articulates the ways that newer depictions of chic thieves revel in the capacity of bankable stars to showcase designer clothes, to cohere a diffuse group of men spanning many ages and races, and to pull off improbable feats through their specialized ingenuity and confidence. These qualities are brought to a heightened fruition in the *Ocean's* trilogy that spanned the 2000s because the racial divisions of the characters are made deliberately conspicuous through their various senses of style, and yet the films offer a nearly utopian camaraderie among these principled lawbreakers.

The collection of essays concludes with Gina Marchetti's examination of the *Rush Hour* trilogy (1998–2007) in which she illuminates the complex tensions between the films' African American and Asian heroes. Jackie Chan's status as an international celebrity is a substantial factor in the making and marketing of these films, as is Chris Tucker's association with black comedy, making them anomalous paradigms of disseminated American entertainment during a time of evident scrutiny at the geopolitical level. The construction of male capacity in terms of customs, economics, and affiliations within the unreliable environments of these films—both on and off the screen—calls into question their effects on racial and gender representation far beyond the reach of the men responsible for those representations.

Of course, no single book can be fully comprehensive in addressing all aspects of movie masculinity, and given the ongoing development of this field of critical inquiry, I anticipate that many further studies will come forth to expand upon what we have been able to offer here. This project is intended to join the evolution of knowledge and dialogue about the nature of masculinity at large, and we can only hope that it may also contribute to the further dismantling of the previously perceived obligations, limitations, and mystifications of men.

NOTES

1. These statistics are from the *Statistical Abstract of the United States 2011,* prepared by the Chief of the Bureau of Statistics, Treasury Department (Washington, DC: U.S. Government Printing Office, 2012).

2. The makeup of racial populations in the United States has itself become a controversial topic in recent decades, since many people consider themselves multiracial or of indistinct racial background, and many respondents in population surveys, such as the U.S. census, determine their own race and/or ethnicity. In any cursory reading of the extant literature from 1990 to 2010, there is nonetheless ample evidence to argue that the population of the United States no longer self-identified as white has increased considerably during that time, from roughly 20 percent to 35 percent. Reliable statistics on the population of self-identified nonheterosexual men are perhaps even more difficult to assess, given the variability of human sexuality. However, since 1977 the Gallup Poll service has found a distinct increase in the percentage of Americans claiming to find gay/lesbian relations morally acceptable; in 2010 that percentage reached 52 percent, the highest ever. See two reports by Lydia Saad, both at Gallup.com: "Tolerance for Gay Rights at High-Water Mark," May 29, 2007, http://www.gallup.com/poll/27694/Tolerance-Gay-Rights-HighWater-Mark.aspx, and "Four Moral Issues Sharply Divide Americans," May 26, 2010, http://www.gallup.com/poll/137357/Four-Moral-Issues-Sharply-Divide-Americans.aspx.

3. Martha M. Lauzen, "The Celluloid Ceiling: Behind-the-scenes Employment of Women on the Top 250 Films of 2010," Women in Film, 2011, http://www.wif.org/images/repository/pdf/other/2011-celluloid-ceiling-exec-summ.pdf.

4. Box office figures are taken and calculated from boxofficemojo.com.

5. Joan Mellen, *Big Bad Wolves: Masculinity in the American Film* (New York: Pantheon, 1977).

6. Donald Spoto, *Camerado: Hollywood and the American Man* (New York: New American Library, 1978); Michael Malone, *Heroes of Eros: Male Sexuality in the Movies* (New York: Dutton, 1979).

7. James Neibaur, *Tough Guy: The American Movie Macho* (Jefferson, NC: McFarland, 1989); Robert Sklar, *City Boys: Cagney, Bogart, Garfield* (Princeton, NJ: Princeton University Press, 1992); Dennis Bingham, *Acting Male: Masculinities in the Films of James Stewart, Jack Nicholson, and Clint Eastwood* (New Brunswick, NJ: Rutgers University Press, 1994).

8. Peter Lehman, *Running Scared: Masculinity and the Representation of the Male Body* (Philadelphia: Temple University Press, 1993); Gaylyn Studlar, *This Mad Masquerade: Stardom and Masculinity in the Jazz Age* (New York: Columbia University Press, 1996); Steven Cohan, *Masked Men: Masculinity and the Movies in the Fifties* (Bloomington: Indiana University Press, 1997).

9. Steven Cohan and Ina Rae Hark, eds., *Screening the Male: Exploring Masculinities in Hollywood Cinema* (New York: Routledge, 1993); Pat Kirkham

and Janet Thumim, eds., *You Tarzan: Masculinity, Movies, and Men* (New York: St. Martin's, 1993); Pat Kirkham and Janet Thumim, eds., *Me Jane: Masculinity, Movies, and Women* (New York: St. Martin's, 1995).

10. Ashton Trice and Samuel Holland, *Heroes, Antiheroes, and Dolts: Portrayals of Masculinity in American Popular Films, 1921–1999* (Jefferson, NC: McFarland, 2001); Mick LaSalle, *Dangerous Men: Pre-Code Hollywood and the Birth of the Modern Man* (New York: St. Martin's, 2002); Stella Bruzzi, *Bringing Up Daddy: Fatherhood and Masculinity in Post-War Hollywood* (London: British Film Institute, 2005); David Gerstner, *Manly Arts: Masculinity and Nation in Early American Cinema* (Durham, NC: Duke University Press, 2006).

11. Phil Powrie, Ann Davies, and Bruce Babington, *The Trouble with Men: Masculinities in European and Hollywood Cinema* (London: Wallflower, 2004); Elwood Watson, ed., *Pimps, Wimps, Studs, Thugs and Gentlemen: Essays on Media Images of Masculinity* (Jefferson, NC: McFarland, 2009). For another recent perspective on masculinity in European cinema, see Ewa Mazierska, *Masculinities in Polish, Czech and Slovak Cinema: Black Peters and Men of Marble* (New York: Berghan, 2008).

12. Brenton Malin, *American Masculinity under Clinton: Popular Media and the Nineties "Crisis of Masculinity"* (New York: Peter Lang, 2005); David Greven, *Manhood in Hollywood from Bush to Bush* (Austin: University of Texas Press, 2009).

13. Kaja Silverman, *Male Subjectivity at the Margins* (New York: Routledge, 1992); Constance Penley and Sharon Willis, eds., *Male Trouble* (Minneapolis: University of Minnesota Press, 1993).

14. Susan Jeffords, *Hard Bodies: Hollywood Masculinity in the Reagan Era* (New Brunswick, NJ: Rutgers University Press, 1994); David Grossvogel, *Vishnu in Hollywood: The Changing Image of the American Male* (Lanham, MD: Scarecrow, 2000).

15. Peter Lehman, ed., *Masculinity: Bodies, Movies, Culture* (New York: Routledge, 2001); Raya Morag, *Defeated Masculinity: Post-Traumatic Cinema in the Aftermath of War* (New York: Peter Lang, 2009); Donna Peberdy, *Masculinity and Film Performance: Male Angst in Contemporary American Cinema* (New York: Palgrave Macmillan 2011).

16. Barry Keith Grant, *Shadows of Doubt: Negotiations of Masculinity in American Genre Films* (Detroit: Wayne State University Press, 2011).

17. For cowboys, see Ralph Lamar Turner and Robert J. Higgs, *The Cowboy Way: The Western Leader in Film, 1945–1995* (Westport, CT: Greenwood, 1999); Stanley Corkin, *Cowboys as Cold Warriors: The Western and U.S. History* (Philadelphia: Temple University Press, 2004); Mark Cronlund Anderson, *Cowboy Imperialism and the Hollywood Film* (New York: Peter Lang, 2007). For athletes, see Deborah Tudor, *Hollywood's Vision of Team Sports: Heroes, Race, and Gender* (New York: Garland, 1997); Aaron Baker, *Contesting Identities: Sports in American Film* (Urbana: University of Illinois Press, 2003); Randy Williams, *Sports Cinema: 100 Movies; The Best of Hollywood's Athletic Heroes, Losers,*

Myths, and Misfits (Pompton Plains, NJ: Limelight, 2006). For femmes fatales, see E. Ann Kaplan, *Women in Film Noir* (London: British Film Institute, 1998); Jans Wager, *Dames in the Driver's Seat: Rereading Film Noir* (Austin: University of Texas Press, 2005); Julie Grossman, *Rethinking the Femme Fatale in Film Noir: Ready for Her Close-Up* (New York: Palgrave Macmillan, 2009).

18. Yvonne Tasker, *Spectacular Bodies: Gender, Genre, and the Action Cinema* (New York: Routledge, 1993); Kathleen Klein, *The Woman Detective: Gender and Genre* (Urbana: University of Illinois Press, 1995); Mark Rubinfeld, *Bound to Bond: Gender, Genre, and the Hollywood Romantic Comedy* (Westport, CT: Praeger, 2001).

19. Philippa Gates, *Detecting Men: Masculinity and the Hollywood Detective Film* (Albany: SUNY Press, 2006); Mark Gallagher, *Action Figures: Men, Action Films, and Contemporary Adventure Narratives* (New York: Palgrave Macmillan, 2006); Brian Baker, *Masculinity in Fiction and Film: Representing Men in Popular Genres, 1945–2000* (London and New York: Continuum, 2006); Mike Chopra-Gant, *Hollywood Genres and Postwar America: Masculinity, Family and Nation in Popular Movies and Film Noir* (New York: Palgrave Macmillan, 2006).

20. Donalson has written three books dealing with these intersections: *Black Directors in Hollywood* (Austin: University of Texas Press, 2003), *Masculinity in the Interracial Buddy Film* (Jefferson, NC: McFarland, 2006), and *Hip Hop in American Cinema* (New York: Peter Lang, 2007). Another book addressing male roles in terms of race is Nicola Rehling, *Extra-ordinary Men: White Heterosexual Masculinity in Contemporary Popular Cinema* (Lanham, MD: Lexington, 2009).

Timothy Shary

I

PERFORMING MASCULINITY

Aaron Taylor

Adam Sandler, an Apologia

Anger, Arrested Adolescence, Amour Fou

In Adam Sandler's first star vehicle, *Billy Madison* (1995), he plays an idiotic twenty-something wastrel who decides to repeat grades one to twelve in order to prove himself worthy of inheriting his millionaire father's hotel business. While Billy's young classmates in the first grade respond politely to roll call, he answers with a colossal raspberry. He brays hysterically as the kids, the teacher, and (we presume) the audience collectively crack up.

Undoubtedly, Sandler's brand of humor has mass appeal. In terms of sheer box office allure, he is easily the most popular male comic personality of the last decade. In *Forbes* magazine's 2011 "Celebrity 100" list, Sandler was cited as the fifth highest-paid working performer in Hollywood, earning $20 million apiece for his roles in *Grown Ups* (2010) and *Just Go With It* (2011).[1] In the same list, he was also ranked as the tenth most-followed celebrity via various social media networks and thus the most popular actor with Facebook fans and Twitter followers. His comedies are among the most commercially successful movies released by the major studios. *Just Go With It* was the twenty-seventh highest-grossing film of 2011, with a gross box office figure of $214.9 million internationally and DVD sales of more than $15 million so far.[2]

However, not everyone is amused. For some, the pleasures of humor generally can be explained ethologically, as comic behavior can "result in social bonding in humans ... and reined-in behaviors that [otherwise] result in social fragmentation."[3] Unfortunately, comedy can also be quite divisive, as not all forms of humor are universally shared. Even the most cursory review of the critical literature on Sandler's comedies reveals a near-universal condemnation of the bulk of his comic output. Michael

Atkinson of the *Village Voice* sums up the critical consensus with considerable vitriol: "Since it's a given that Adam Sandler movies are the skivvie skid marks of modern American cinema, and that reviewing them is akin to quantifying the fractal measurements of windshield gull crap, let's cut to the consumer-advice bottom line: Stay home."[4]

The decidedly mixed responses to Sandler's fractious persona can be better understood by referring to broader tensions surrounding popular attitudes toward the type of masculinity he embodies. In investigating Sandler both as an exemplar of a particular masculine type and as a serio-comic performer in general, I have chosen to focus on certain leitmotifs that inform his star persona: performative and thematic recurrences with broader connotative significance. However, these elements are not merely semantic indicators of a specific dramatic or cultural type. We should avoid the temptation to lexically reify these elements as performance signs within a star text. Too often, such semiotic strategies result in reductive analyses of an actor in which he or she becomes a mere bundle of traits to which the analyst attends only superficially, simply noting patterns of recurrence and deviation. Moreover, strict symptomatic interpretations of these elements are undesirable as well. Describing them purely as reflective indexes to particular cultural pathologies reduces an actor's instrumentality to that of a mere social barometer. Stars can be signs of certain phenomena, but that is not all they are.

In considering the evaluative attitudes toward Sandler—both appreciative and pejorative—I have selected elements that collectively form the nucleus that organizes various discursive clusters surrounding his work. For convenience's sake, we can refer to these core principles as performative indices. Rather than thinking of these elements in strictly lexical or symptomatic terms, we can conceive of a star's evolving attitudes, behaviorisms, career choices, expressions, gestures, ideological beliefs, modes of dress, physicalities, social roles, typifications, and vocalizations as creative mobilizations of certain core principles. These principles are put into play as an actor performs a role and are in turn rooted in broader aesthetic and cultural conditions. It is not that we simply identify these structuring constituents but rather that we appreciate the particularities of how a performer enacts these performative indices creatively. Moreover, as we will see, the more skilled performers are not only conscious of these indices but will also use them to make particular assertions about both their own star persona and the larger beliefs, conditions, desires, ethical tenets, ideologies, problems, and tensions that their persona dramatizes.[5]

Three of Sandler's most prominent performative indices comprise the title of this apologia and will form the basis of each meditation: anger,

arrested adolescence, and *amour fou*. Each of these indices can refer to various flashpoints in the so-called crisis in masculinity, a predicament that began to attract cultural currency in the early 1990s. Indeed, this crisis has proven to be an intellectually and economically fecund calamity for journalists, sociologists, cultural critics, and Hollywood publicists alike. The popular sympathy and critical antipathy that Sandler's work provokes can be traced to his specific mobilizations of timely and resonant beliefs about maleness as a social condition. Thus, watching Sandler's mobilized emblematic principles allows a receptive viewer to engage with the star's own variety of masculinity in various complex ways.

I will be paying close attention to select details from a few performances that are representative of Sandler's essential indices. To overlook these details based on preconceived assumptions about his work is not simply to ignore his considerable talent as an actor; it is to disregard the assertions Sandler makes via his performance: about men, work, love, loss, alienation, power, and his own stardom. Again, these postulations are manifested by way of the performance itself; they are not imposed a posteriori after observing his work, nor are they interpretive readings of his expressive actions. The matter has been put most succinctly by Stanley Cavell: "we must let the films themselves teach us how to look at them and how to think about them."[6] Therefore, my close analysis of a few defining moments in Sandler's oeuvre is undertaken optimistically: I might learn something surprising or penetrating from a performer known for his hyperbolic displays of comic infantility. Whether these considerations represent a personal exorcism, misguided bravado, or the acknowledgment of discomfiting facets of my own masculinity is left to the gentle discretion of the reader.

To begin, then, a précis of a lucrative form of male idiocy.

Adam Sandler

Following his departure from *Saturday Night Live* in 1995, Sandler has generally gravitated toward comic roles in comedian comedies, a comic tradition that revolves around a "dialectic between eccentric behavior and social conformity."[7] Here, a clownish protagonist experiences difficulties in either integrating or extricating him or herself within the social order with hilariously disruptive results. Most of Sandler's comedian comedies are ideologically conservative in form, featuring a social misfit who gradually comes to recognize the necessity of adopting the hegemonic cultural norms that he initially spurned. His first two star vehicles, *Billy Madison* and *Happy Gilmore* (1996), serve as paradigmatic examples. The ironically named Happy is a violent would-be hockey player who takes up professional golf

(thanks to his incredible driving skills) in order to prevent the repossession of his beloved grandmother's house. He learns to rein in his raging temper and eventually wins respect for the genteel sport, the PGA championship, and the love of a beautiful public relations rep.

Although much of his comedy revolves around the exhibition of inappropriate behavior in socially restrictive situations, Sandler's clowns invariably move toward bourgeois integration. This conformist tendency places him within a tradition of such socially oriented male comics as Harold Lloyd, Bob Hope, Jerry Lewis, Jack Lemmon, Roberto Begnini, and Ben Stiller. Recall these agonizing efforts toward orthodoxy: the perennially boyish and bespectacled Lloyd, "who never dreamed of being out of the ordinary," dancing a jig to attain collegial approval in *The Freshman* (1925); Hope's boastful cowardice as a baby photographer who aspires to hard-boiled private dickery in *My Favorite Brunette* (1941); Lewis's "robot degenerate overprogrammed by the conflicting gods of Americana" in his collaborations with Frank Tashlin (1956–64); Lemmon's obsessive-compulsive neat freak in *The Odd Couple* (1968); Begnini's unaspiring but hypercaffeinated losers who come to be accidentally confused with violent public enemies in *Johnny Stecchino* (1991) and *Il Mostro* (1994); and Stiller's aspirations for patriarchal authority continually deflated in the *Fockers* series (2000, 2004, and 2010) by having Robert De Niro for a father-in-law.[8]

Similarly, Sandler's clowns are typically underachieving and infantile neurotics, almost always prone to displays of inarticulate rage and outright violence. Their sweet-natured clowning belies an untrammeled fury that erupts during moments of frustration. Sandler's own performance style can be characterized by turn-on-a-dime alternations between passive taciturnity and eruptions of pedomorphic aggression. After being ditched by his first girlfriend in *Happy Gilmore,* he screams helplessly at her retreating figure through his apartment intercom, "BEAT IT! I *HATE* YOU," only to propel himself back into the frame a beat later, wooing her in baby talk: "I'm sorry, baby, I just yell sometimes 'cuz I get scared." Caught in a desperate funk after being left at the altar in *The Wedding Singer* (1998), he tries out a bipolar rock ballad for Julia (Drew Barrymore) in which he moves from a halting, cutesy falsetto during the chugging verses to a shrieking, feedback-laden chorus of "SOMEBODY KILL ME PLEEEASE!" Thus, Sandler's prototypical comedic action is a curious admixture of puppyish ingratiation, reactionary bullying, and rabid masochism.

These qualities are manifested both physically and performatively in the recurring patterns, motifs, tendencies, and mannerisms exhibited within Sandler's performances. An actor who rarely looks completely

Aaron Taylor

comfortable on-screen, he consistently exudes a repressed nervous energy. When grateful, pleading, embarrassed, or shy, his clowns simply squeak garrulously. His Cajun mama's boy in *The Waterboy* (1998), weakling hell spawn in *Little Nicky* (2000), and elderly runt Whitey in *Eight Crazy Nights* (2002) are limit tests in squirrelly vocal obstreperousness. If he is nervous, confused, or faced with imminent rejection, his speech takes on the halting, inexpressive tones of an elementary school student who is about to forget the words of his public speaking assignment. Indeed, in *Bedtime Stories* (2008) he becomes tongue-tied before a crucial business presentation (due to a bee sting to the mouth) and babyishly gurgles his way through the film's climactic moment, in turn making hay of Disney's tradition of gooshy inspirational speeches. Often matched by sidelong hesitant glances, he mumbles his way through frequently intimidating social, romantic, or erotic interactions. Such gimpy sheepishness is evident in much of his dealings with the bumptiously urbane tabloid reporter Babe Bennett (Winona Ryder) in *Mr. Deeds* (2002). His sweet-natured meekness is at its most elementary here, despite the film's mawkish inability to measure up to Longfellow Deed's maxim of transcendence through simplicity.

Sandler's other physical qualities complement this anxious lowliness: his watery eyes; his tendency to tuck his bottom lip under his top teeth; his penchant for boxy button-down T-shirts, jerseys, and ill-fitting plaids; and the consistently clipper-cut Brillo Pad hair on his dramatically egg-shaped head.[9] All of these give the impression of an oversized boy, anxious to please but half-expecting failure or disapproval. Since his debut, Sandler has also developed pronounced pouches under his eyes and permanent worry lines between his eyebrows, and his unrepentant affection for oversized shirts sometimes suggests an ill-concealed paunch. All of these signs of aging are well suited for suggesting the physical toll of barely repressed anxiety. Playing beleaguered family men in *Spanglish* (2004) and *Click* (2006), he exudes the workaday pathos of a prom king gone to seed.

As his anxieties give way to full-fledged panic at the slightest provocation, Sandler expresses his sudden eruptions of comically inarticulate rage with gravely, glottal bellows. His mouth lurches sideways when screaming, giving him the appearance of a lantern-jawed simian. Alternatively, his bullying tendencies are most often accompanied by a garish lunatic bray of laughter, always in excess to the situation's comedic demands. Whether in paroxysms of rage or sadistic mirth, his eyes bulge ludicrously, and he adopts combatively angular positions: stiff-backed, arms often thrust forward, and backside thrust out, a parody of a defensive tackle squaring up for a drill. *Big Daddy* (1999) provides a prototypical example, as Sonny

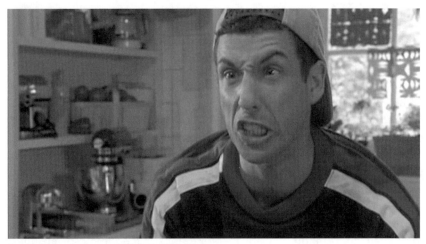
Sandler's devolutionary hostility in *Billy Madison*.

(Sandler) and his five-year-old pal crack up watching Central Park roller-bladers careen over sticks thrown in their path. Likewise, in *Billy Madison*, Sandler gibbers and capers manically while bowling over third graders during a game of dodge ball.

In short, Sandler's physiognomy and comic performativity evoke an anxious masculinity that is not merely juvenile but instead is positively prepubescent. His frequent helplessness, compulsive vulgarities, jejune naïveté, regressive hostility, and romantic ineptitudes are indicative of a seemingly devolutionary masculinity taken to histrionic extremes. The apparent problem of this charismatic yet untenable boyishness is endemic to any profitable discussion of our present so-called crisis in masculinity. Murray Pomerance has provided us with a precedent in his discussion of the wonder-struck men who populate the fantasies of Steven Spielberg. Rejecting the bifurcation of males into "boys" and "men," Pomerance posits the category of "man-boy" as a new kind of social ideal represented by the Spielbergian fantasist: "he is both a man who has grown and a boy who looks forward to growth."[10] And yet, such creative possibilities are largely inapplicable to Sandler's seemingly retrograde boyishness. Exploring and enriching this axial problematic in his dramatic and seriocomic roles, Sandler frequently suggests that his impossible boyhood is only a form of paralysis, only another aspect of dread. As he continually plays out anxious dramas of enculturation, he simultaneously offers various positions or the means to reflect upon the contradictory status of a great number of man-boys for whom childhood is more prison than regenerating Never-Never Land.

Aaron Taylor

John Clasky, we are told in a sterling restaurant review, is the best chef in the United States. Why, then, is *Spanglish*'s restaurateur and family man so passively disconsolate? So privately angry? Prior to reading the review, Clasky (Sandler) idealizes "three and a quarter stars" as the perfect review. "You're right there below the radar, where you get to mind your own business," he mutters to himself. "That's a good, solid life." There are echoes of Sandler's earlier deliberate underachievers here, but the desperateness behind his efforts to shirk success is much more intricate: his professional accomplishments drive his hyperambitious but out-of-work wife, Deb (Téa Leoni), toward overcompensational mania; he fears losing time with his beloved children; and ethnically speaking, his desire to keep the business modest and local is suggestive of an ambivalence toward the goyish accreditation of Jewish material achievement. While it is unfortunately beyond the scope of this essay to fully address the way Sandler's masculinity is informed by his prominent Jewish nationalism, it is worth mentioning that his own celebratory attitudes toward his ethnicity are submerged here within director James L. Brooks's much more hesitant representation of Jewish upper-middle-class success. Suffice it to say that Sandler frequently tends to draw on but also redress the centuries-old figure of the schlemiel—the perhaps-defensive figure of the habitual dolt in Jewish comic traditions—in his work.[11] He does so most hyperbolically with his superheroic and sexually majestic Israeli counterterrorist-turned-hairdresser in *You Don't Mess with the Zohan* (2007).[12] In *Spanglish*, however, this supreme masculine confidence is notably lacking, and his alternations between moments of quietly seething self-abnegation and tearful apoplexy are much more complex than the singular masochism of his earlier comedies.

To what extent can we attribute Sandler's anger to the aforementioned crisis in masculinity? Given the catchall nature of this apparent crisis, is his anger straightforwardly applicable? Tim Edwards has cited a number of general levels on which this crisis rests: the general devaluation of masculinity as a set of values and practices, the implosion of masculinity into femininity via an undermining of gender-role distinctions, and/or the conception of the male sex role as inherently crisis-inducing.[13] In more general terms, the dissipation of traditional male certainties is said to evoke a "deep sense of being lost" among a sizable proportion of the male population in the West, particularly among older undereducated and/or working-class men.[14] Do we number Sandler's aging child-men among the lost, their helpless bluster a signifier of a pervasive male anxiety? Is his enacted anger compensation for a perceived threat to men's self-respect, whereby the

male subject "fears that his claims towards masculinity may be a bad joke, and reacts often in rage and self-aggrandizement—hypermasculinity?"[15] I would suggest that Sandler's hyperbolic anger is not symptomatic of an all-pervasive anomie among men in general but instead is the expression of the "demographically and geographically specific 'crisis tendencies' for some men."[16] Because apparent causes and supposed symptoms of this limited condition are wide-ranging, it may be instructive to note some intersections with Sandler's articulation of male panic.

First, the crisis in masculinity is felt in the cultural transformation of nineteenth-century "manly" virtues (courage, stoicism) into contemporary masculine vices (aggression, inarticulacy), especially following America's various military misadventures from Vietnam to Iraq.[17] Male aggression is recoded as a pathological quality rather than an inherent or even potentially constructive trait. To a certain extent, it is possible to consider Sandler's violence as an ostentatious reflection of this perceived change. His hostility is often without a concrete target; it is simply a condition of his being. Like some kind of demented wind-up toy, he hisses, curses, and flails at everything and anything: a clown-faced obstacle at a miniature golf course in *Happy Gilmore*, downtown Dukesberry's Christmas and Hanukkah displays in *Eight Crazy Nights*, a glass patio door and bathroom stall in *Punch-Drunk Love* (2002), a dentist's office in *Reign Over Me* (2007), and whatever moves in *The Waterboy*.

Because Sandler's pugnacity is so alarmingly unfocused, his illegitimate and disruptive aggression is often channeled diegetically into circumstances that institutionally support ritualized forms of male violence. But if it is true that the cultural connotations of this violence have been profoundly transformed, then it is little wonder that his relationship to the games he plays in his sports films is often problematic. Sports are almost never a form of sociality for Sandler or a traditional opportunity for male camaraderie; they are usually just another source of frustration. Happy Gilmore is a violent disgrace of a hockey player and a physically combative golfer. For a bullied Bobby Boucher, becoming a linebacker is merely an opportunity for revenge in *The Waterboy*. Dave Stone associates basketball with his parents' deaths in *Eight Crazy Nights*. Even *The Longest Yard* (2005)—a prison drama about a football team of misfit inmates brought together by Sandler's ex-NFL quarterback-cum-reprobate—manifests decidedly schizoid tendencies. Perhaps due to the presence of Sandler's inherently disruptive persona, *The Longest Yard* continually undercuts the gridiron machismo of the prisoners with sight gags that underscore the comic excessiveness of their aggression. In fact, it is not until very recently that Sandler's sportiness has devolved into traditional and normative forms

Aaron Taylor

as the actor approaches middle age: in *Grown Ups* his prowess at basketball is now uncomplicated, and he even purposefully flubs a courtside showdown with his old high school nemeses so that these comparatively underprivileged schlubs can enjoy their moment in the sun.

Second, there are intermingled confusions and opportunities arising from an increasingly wider variety of masculine scripts available for adoption.[18] We might make note of two factors that influence these new departures from popular definitions of masculinity proffered in earlier generations: accelerated consumerism and the collapse of the traditional family. For some, the hypermaterialism of early twenty-first-century Western culture has led to the diversification of traditional masculine scripts. Certainly this has brought a greater level of acceptability to fashion-conscious neodandyism of the *GQ* variety, but cultural commentators are divided on what this ultimately means. For Susan Faludi, late capitalism's "ornamental culture" of display has created and perpetuates masculinity's present crisis. Men have become "feminized" consumers instead of "masculine" producers, and the superficial trappings of masculinity itself have become reified and commodified fetish objects. In a much-cited passage, Faludi asserts that "the internal qualities once said to embody manhood—surefooted inner strength, confidence of purpose—are merchandised back to [men] to enhance their manliness."[19]

All notions of "internal qualities" aside, Faludi is perhaps right to express concern over the degree to which marketing manhood has become a near-frenzied business imperative. And yet, she is not willing to recognize that male consumers do not invariably buy into these commercialized myths wholesale (or without irony in some situations). Mass-produced manliness is certainly not always something to get angry about. While Sandler occasionally competes against dapper antagonists (*Happy Gilmore*) or he-men rivals (*Wedding Singer*), these varying ideals of hunkishness are rarely sources of menace or resentment. Just as his oversexed Israeli hairdresser in *You Don't Mess with the Zohan* is a direct riposte to the normalizing of WASPish sex idols (Warren Beatty in *Shampoo* [1975] is an obvious target), Sandler's emerging popularity in the mid-1990s coincided with the declining commercial fortunes of such muscle-headed 1980s' stars as Sylvester Stallone, Arnold Schwarzenegger, Jean-Claude Van Damme, and Steven Segal.[20] Indeed, Sandler exudes a comfortable imperviousness from the twin pressures of health culture and high fashion. Unlike nearly all of his contemporary buffed-out peers, he almost never appears bare-chested onscreen (a comparison with the perpetually shirtless and gleaming Matthew McConaughey is instructive here), and his characters universally share an appreciation for the joys of cholesterol, snack foods, and beer. Eight years

after making *People*'s infamous "Worst Dressed" list in 1999, his wardrobe choices—both on and off the screen—still imply that he's rushing to make it to the tailgate party on time.[21] So assertive is his slobbery that it is a near-aesthetic shock to see him wear an equally assertive electric blue suit in *Punch-Drunk Love*. "I thought it'd be nice to get dressed for work, and I'm not exactly sure why," he mumbles to a bewildered employee. Notably, *Punch-Drunk Love* is the only film in which Sandler's "manly" indifference to style is interrogated, and concomitantly it is the only occasion in which he intuitively attempts to feel his way through competing models of self-presentation.

Third, it is most often claimed that masculinity's crisis emerges from an altered economic landscape of job role changes, downsizing and occupational insecurity, declining family capitalism, globalization, de-industrialization, and entry-level job hopping among young graduates. A number of contemporary comics make this destabilization of the old ties between men and work explicit. We might note Ben Stiller's defensive male nurse in *Meet the Parents* (2000) and shiftless security guard in *Night at the Museum* (2006) or Will Ferrell's steady succession of has-beens and wannabes from *Anchorman* (2004) to *Semi-Pro* (2008). Sandler's clowns are similarly invariably unable to achieve job satisfaction in any chosen profession. The contemporary problems of men at work are most clearly addressed in *Anger Management,* in which Sandler plays a businessman who is ordered to undertake counseling for an ironically nonexistent hostility problem. Perpetually overlooked for promotion by a boss who takes credit for his work, Dave Buznik's (Sandler) chronic passivity veils his festering resentment and self-loathing. For contemporary men, the economy of professional performance is in perpetual depression, and frustration is the only constant.

Men's consequent loss of the traditional breadwinner role and a perceived sense of redundancy within the family unit are related to these changes in mid-twentieth-century careerism. For Sandler, the family invariably figures as a predicament that must be negotiated. The demands of fatherhood are a particular source of vexation for Sandler's family men, who are often barely in control of their own personal lives and are resentful of the additional (and often contradictory) responsibilities of domesticity. His lackluster efforts as a foster father draw the attention of social services in *Big Daddy*. A manic effort and tragic inability to forget his dead wife and children drives him to near insanity in *Reign Over Me*. In *Click,* his workaholic architect Michael Newman resents the intrusions of his family into his manic job schedule and decides to "fast-forward" cumbersome homely entanglements via a magical remote control. Typically,

however, Sandler's clowns are given a domestic makeover. Newman can ogle the breasts of a female jogger or clout his overbearing boss with the expectation that he will eventually come to recognize the "self-centeredness" of his behavior. Thus, the film moves toward bathetic synecdoches of epiphanic maturation: Newman isolated within the frame, often gazing tearfully at tableaux of domestic happiness from which he is excluded. But if *Click* seems to give credence to these purported symptoms and causes of our present crisis—with its representations of helpless aggression, rival models of masculine success, and problematized relation to work and family—must we also support the film's smug assertion that the exigencies of contemporary masculinity can easily be met head-on and overcome? Can we assume that all a guy needs to do, after all, is spend more time with the wife and kids?

It is to Sandler's credit as a performer that he does not always smooth over the tensions inherent to his persona in such a summary fashion. Whether or not one takes stock in a crisis of masculinity, however represented, Sandler's anger is a performative index that bespeaks a categorical dilemma: masculinity *as* crisis. His turn as *Spanglish*'s quietly imploding family man is instrumental in this respect. While striving to maintain a general decency throughout his familial entanglements, John Clasky still has the grace to recognize that he's floundering. As he puts it, "Nothing we do can bring us satisfaction or release, but I'm still having a great time."

Nowhere is the admixture of wistfulness and frustration more evident than during John Clasky's final moments in *Spanglish*. His marriage to Deb is in shambles, and his affair with Flor (Paz Vega) has come to an abrupt end. Despite the desire that his "strange" domestic intuitiveness awakens, Flor recognizes that the class, ethnic, and cultural distances between them cannot be traversed. Leaving the Clasky household with her daughter, she quickly whispers over her shoulder to John, "*Mi amore.*" It is both confession and refusal: a goodbye as cataclysmic as the winking out of a star. Within a ten-second reaction shot, John is left to flounder through the hell of imagined possibilities lost and the dawning of terrible new realities.

As John registers bewildered shock, he has never seemed so tired and utterly defeated as he does here, as if he had suddenly aged ten years in an instant. As he turns to watch Flor disappear, we are presented with the disquieting nakedness of his face (we are so used to Sandler's guarded mugging): the ghost of a smile, the deadening of his eyes, and the first unprecedented overtures of regret (startling because the condition is so fundamentally alien to the Sandler persona). Within an instant, the openness of his face—its awful admixture of yearning and resignation—closes in on itself, and the hint of a familiar anger returns, signaled by suddenly

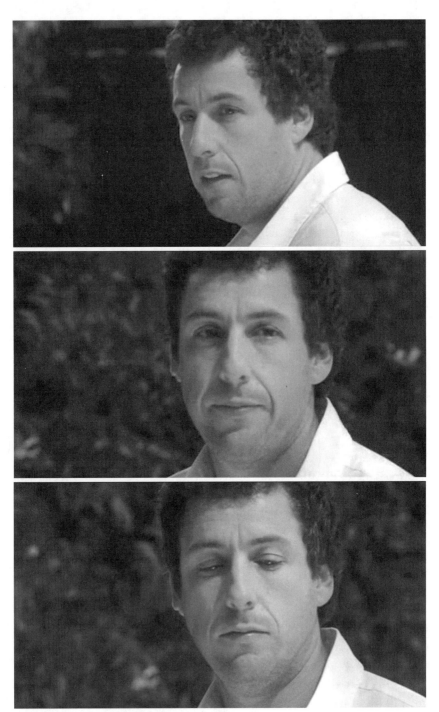

Sandler's internalized hostility in *Spanglish*.

downcast eyes and a hardened jaw. Abruptly he lurches out of view and shambles home.

This sudden flash of bitterness is more potent than any number of Sandler's previous or subsequent tantrums. There is a focus to and an awareness behind his anger that is utterly absent from the reactionary aimlessness of the actor's typically existential distemper. Perhaps it is an unspoken acknowledgment of the frustrations inherent in living out the competing expectations and desires endemic to bourgeois masculinity. Perhaps it is only another nod to the little quotidian resentments that are the by-products of the ongoing conflict between desire and obligation. Perhaps it is nothing more than an inspired moment in the maturing career of a comic actor. Yet no matter how we choose to see this face, we do not experience Sandler's emblematic irascibility in quite the same way afterward. His performance in *Spanglish* enriches this facet of his persona and invites us to consider his indelible anger afresh.

ARRESTED ADOLESCENCE

Alan Johnson (Don Cheadle) is brushing his teeth the morning after his father's wake when he is confronted by one of his preteen daughters, Cherie (Camille LaChe Smith). "Daddy, your friend is here," she scowls. "The one who acts like he's younger than Jo-Jo." Cherie's assessment of Charlie Fineman (Sandler) is corroborated soon after Alan invites his old college roommate in for breakfast. Charlie is perched atop the kitchen counter, enormous headphones enveloping both ears. Holding a bowl of cereal, he rocks back and forth singing along to Springsteen over a mouthful of cereal, oblivious to the mild consternation of Alan's family.

There is a small degree of reflexivity in the Johnsons' irritation with Charlie in *Reign Over Me.* As indicated earlier, studied juvenility is one of Sandler's core performative indices, and this is a facet of his persona for which a large critical faction has very little sympathy, patience, or tolerance. But despite the consistent ire of his critics, I would maintain that this recalcitrant childishness is Sandler's most interesting quality, both performatively and culturally. In the current Hollywood comic pantheon—glutted with dudes, slackers, aging and would-be Lotharios, underachievers, and other boy-men—he is unique in his unremitting infantility. As Hollywood continues its present obsession with comic leading men who just don't want to grow up, Sandler takes such regression well beyond the terrified paralysis of his comic peers. While his contemporary cronies are reluctant to leave the frat house, Sandler has yet to discover the world outside of kindergarten. In this preadolescent modality Sandler is perhaps without peer,

and his only major predecessors are arguably Harry Langdon and Pee-Wee Herman.

This is not to disparage the obsessive immaturity that fuels Sandler's performative indices. On the contrary, the prepubescent vulgarity that is so crucial to his work is indicative of a fascinating social contradiction. If it can be agreed that Sandler is essentially an overgrown child, then the intensity of the critical responses that he generates (one either loves or hates him) is symptomatic of the discursive intensities surrounding early twenty-first-century bourgeois constructions of childhood. As an object of reverence, the child continues to signify a number of privileged values: receptivity, curiosity, purity, sincerity, futurity. Simultaneously, however, the child is also associatively encoded with qualities that are reviled by middle-class imperatives and politesse: antisociality, vulgarity, emotionality, amorality, anarchy. It is the incongruity of Sandler as a performer—his reconciliation of juvenility and virility—that inspires these intensely ambivalent social attitudes toward childishness.

Richard Dyer has comprehensively delineated the ideological valence of stars and the political work accomplished by their performances. A star is able to reconcile contradictory values within the singularity of her or his persona. More specifically, "through their typicality and individuation, as well as the obvious fact of people's identification with them," stars inherently "dramatize . . . general social situations."[22] In this sense, Sandler's overgrown babies make transparent our opposing expectations of children: our yearning for and fear of their irresponsibility, their effortless freedom. He displaces and appropriates the child's unstudied solecism and disregard for propriety and in so doing awakens all our latent prejudices toward children. The comic incongruity of a grown man speaking baby talk can be deeply irritating because it exposes the impossible dilemma that we impose upon the child, the mixed signals that we invariably send: Oh, grow up already. Promise me you'll stay just the way you are.

Obviously there is no shortage of sophomoric crudeness in contemporary American comedy. It may prove tempting to link much of Sandler's output to the exhibitionism of men behaving badly in the 1990s' work of his fellow *Saturday Night Live* alumni, David Spade and Chris Farley (e.g., *Tommy Boy* [1995] and *Black Sheep* [1996]) as well as such subsequent examples as *Swingers* (1996), *Old School* (2003), and *Wedding Crashers* (2005). Such animal comedies emphasize the anarchic features of the genre rather than its conformist ones. These films are typically categorized by their emphasis on slapstick, hyperbawdiness, caustic humor, and homosocial relationships and their exclusionary and antiauthoritarian attitude.[23] Contemporary animal comedies—most broadly described as bromances

—produce frantic meditations on such androcentric themes as the emasculating effects of prolonged adolescence, virility as masquerade, and the inadequacies of serial monogamy. The majority of Frat Pack comedies—featuring such beleaguered stars as Jack Black, Steve Carell, Will Ferrell, Jonah Hill, John C. Reilly, Ben Stiller, Seth Rogen, Paul Rudd, Jason Segel, Vince Vaughan, and Owen Wilson—and nearly all of the films either produced, directed, or written by Judd Apatow revolve around these concerns. In addition to the films cited above, witness *High Fidelity* (2000); *Shallow Hal* (2001); *Saving Silverman* (2001); *The 40-Year-Old Virgin* (2005); *The Break-Up* (2006); *Talladega Nights: The Ballad of Ricky Bobby* (2006); *You, Me and Dupree* (2006); *Knocked Up* (2007); *Superbad* (2007); *Forgetting Sarah Marshall* (2008); *Pineapple Express* (2008); *Step Brothers* (2008); *I Love You, Man* (2009); *The Hangover* (2009); and *The Hangover II* (2011). This apparent collapse of unself-conscious machismo even deflates ordinarily confident models of classical masculinity, exemplified by Brad Pitt's underachiever in *The Mexican* (2001) and Matthew McConaughey's mama's boy in *Failure to Launch* (2006).

What is remarkable is how melancholy this comic cycle has become; nearly each and every case plays out as a goodbye to the wild days of youth. While the domestication of wild masculinity is an old standby of classical comedy, the crucial difference is that both the wildness and the process of taming are currently inflected by an unprecedented desperate, hysteric exaggeration. David Denby summarizes the dilemma facing *Knocked Up's* commune of animals: "The way Ben lives with his friends is tremendous fun; it's also as close to paralysis as you can get and continue breathing. Apatow, of course, has it both ways. He squeezes the pink-eyed doofuses for every laugh he can get out of them, but at the same time he suggests that the very thing he's celebrating is sick, crazy, and dysfunctional. The situation has to end. Boys have to grow up or life ceases."[24] On the one hand, contemporary animal comedies are much more richly self-conscious than their predecessors in recognizing the impossibilities of a persistent boyhood. On the other hand, their hyperbolic insistence on the animals' maturation is somewhat troubling, especially if these comedies dramatize the tensions between two competing models of manhood. Old masculinity, with its investment in work, responsibility, marriage, and family, consistently trumps new masculinity's preference for play, self-interest, serial monogamy, and fraternity. Denby does not recognize the puritanical impulses at work here. *Wedding Crashers* is a case in point: one of its swingers (Owen Wilson) is driven to alcoholism and attempted suicide when his exuberant hedonism ruins his chances for a long-term relationship. Grow up, or life ceases indeed.

To a certain extent, Sandler's sophomoric comedies share some affiliations with the animal comedy. At the industrial level, they also satisfy a certain commercial logic. Marketing campaigns tend to foreground the more physical and outrageous aspects of Sandler's brand of body humor, directing the product toward an adolescent male target market. At the same time, nearly all of the narratives of these films follow a similar pattern, tracing the Sandler character's maturation toward responsible adulthood and concomitant development as a respectable romantic partner. This formula of clownish callowness to mature love object is cannily aimed at satisfying stereotypical expectations believed to be held by gendered audiences.

But although Sandler's films ostensibly share many of the same qualities with the films cited above, the physicality and vulgarity of his humor have an ambivalent relationship to the resistant adolescence of the animal comedy. In fact, his childish fixations render the Frat Pack's deliberate rejection of paternalist privilege ridiculous by virtue of their excesses. Sandler is the little brother who consistently outgrosses them all, and not just in the anality of his humor. His sexual obsessions are consistently cartoonish, those of a ten-year-old gawking at the bra section of a Sears catalogue. Consequently, women in his comedies are nearly always caricatures of airbrushed sexual availability: *I Now Pronounce You Chuck and Larry* (2007) finds him engaged in a *ménage à sept* with five giggling Hooters waitresses *and* his doctor, no less. Even his recurring porn subscriptions are excessive in quantity and in their ridiculous titles (e.g., on Nudie Magazine Day a giddy Billy Madison drools over "Women over 80" and "Drunk Chicks").

Although Sandler shares the actual teenaged animals' disregard for work, he has never been a dude: those liminal figures on the cusp of mature adulthood who are often engaged in quasi-epic quests to enter the phallic order but on their own terms.[25] Sandler has always been too old to be a dude, and regardless, his relation to the so-called phallic order has always been an indifferent one. His characters always-already exist within a domain of material wealth and/or sexual gratification or are utterly uninterested in the pursuit of money and power for its own sake. Thus, his overgrown boys are almost always free to play and consequently are invariably brought to heel (as responsible, functional adults) by film's end. If nothing else, he is certainly more responsive to patriarchal authority than the Frat Packers or dudes of the animal comedy. Mentor figures appear recurrently to facilitate his socialization, especially since actual fathers in his films are nearly always distant, absent, or dead. Again, as Sandler approaches middle age, his films come closer to straightforwardly embracing normative (and often conservative) models of fatherhood: indeed, the

credits of *Grown Ups* features Sandler performing a song ("Stan the Man") written for his own father.

Sandler's clowns usually eschew the company of buddies as well. If the promotion (and contemporary interrogation) of homosocial camaraderie is one of the animal comedy's crucial syntactical elements, then it is notable how immaterial male friendship is in Sandler's films. Justin Wyatt has described how men often prefer group camaraderie to singular intimacy and argues that such adolescent banding is perpetuated into adulthood by self-empowering informal kinships.[26] By contrast, Sandler avoids the stereotypically dysfunctional support groups that currently pass as male kinships, or they are complete misfits, bullied and denied access to the empowering banding enjoyed by other men. Close friends are few and far between, which is ironic given the number of yes-men and college cronies with whom the actor surrounds himself in his actual professional life.[27] As a character, however, Sandler tends to go it alone: the animals' embarrassing younger brother who cannot be tolerated publicly because he mirrors, exaggerates, and thus exposes the constructedness of his older sibling's efforts at coolness.

If fraternity is one of the nineteenth-century masculine virtues that has lost its value and if homosociality is now reread as an enabler of patriarchy (or a forum for clueless, pathetic macho posturing at best), then should the tangentiality of male friendship in Sandler's films be interpreted as a progressive tendency? Celestino Deleyto has described how men's partnership is often construed as the enemy of idealized heterosexual relationships in contemporary romantic comedies. *You, Me and Dupree*'s scenario of the best man who overstays his welcome as the newlyweds' houseguest is a good recent example. However, it does not follow that we must give credence to films that reinforce the incompatibility between intimate male friendships and romantic heterosexual relationships. Why should the "growth" of romantic love be "impossible" when situated within this homosociality? Must we insist that a man's decision to "choose" romance over intimate male friendship is "proof" of his "maturity?"[28]

While *Reign Over Me* is obviously neither an animal comedy nor a romantic comedy, it may prove instructive to consider how the film appropriates the comic problem of regressive childishness and the disruptive potential of male friendships. The film is particularly interested in the conflicting attitudes that Charlie's emotional instability elicits in his sole friend, Alan. While Alan clearly recognizes that Charlie's juvenility is pathological (here we have a truly sick and very nearly crazy man-boy), Alan is unwilling to acknowledge his envy of his friend's retreat into utterly asocial irresponsibility (Alan feels stifled by a familial life of Friday night jigsaw puzzles and

ten o'clock bedtimes). And yet despite the domestic tensions provoked by Alan's decision to stick by Charlie, their friendship ultimately helps both men address their own considerable family problems. There are no sacrifices here, no ultimatums, and male intimacy is reconfigured as potentially redemptive instead of an embarrassment or an escape.

Six years after his beloved wife and three daughters are killed during the September 11 attacks on the World Trade Center, Charlie has almost completely withdrawn from any social interaction and denies that he ever had a family. When Alan accidentally runs into his former roommate, he nearly doesn't recognize him. It is indeed a shock to see Sandler's usually fresh-faced imp devolved into this shaggy, gray-haired, sunken-eyed, shambling apparition. In fact, *Reign Over Me*'s emotional force is largely derived from this uncanny treatment of the Sandler persona: the way it renders strange his familiar performative indices. Charlie's apartment-cum-hermitage, for example, is a nightmare version of Billy Madison's pleasure palace. With its thousands of LPs, numerous game stations, Elias Big Boy and Colonel Sanders statuettes, the apartment is a dumping bin for the wreckage of Charlie's life.

New dimension is also given to Sandler's invariable love for 1970s' and 1980s' rock. This music previously figured as an indulgent authorial nostalgia for the soundtrack of Sandler's adolescence; it now offers his character vital avenues of escape. The film's title is derived from the closing track of the Who's epic *Quadrophenia,* and it is a poignant reminder of love's potentially terrible dominion as a force that cannot be escaped. Charlie's reliance on his iPod emphasizes the device's inherent antisociality (he uses it to tune out undesired conversations), but it is also a mechanism for survival when used to obliterate unbearable memories through pure sound. Similarly, the adolescent connotations of his obsession with video games are given an intertextually poetic reworking. Charlie has an enslaving addiction to the PS2 game *Shadow of the Colossus,* in which the player's avatar attempts to defeat monstrous beings in order to resurrect a dead girl and is confronted by giants that collapse over and over again. The parallels to public and private tragedies should be clear, and they are poignantly indicative of a broader American eagerness for juvenile distraction as a refuge from national trauma.

It is extraordinary for Sandler to so unguardedly disclose the desperation that drives his trademark asocial juvenility. He brings a level of sophistication to his modulation of this performative index that is commensurable with his work in *Spanglish.* Concomitantly, the film is also remarkable as a Sandler vehicle for its atypical representation of male friendship, for its depiction of the lifelines that men extend toward one another in the guise of casual receptivity.

Aaron Taylor

One such notable scene occurs as the two unlikely friends take in a casual Chinese dinner (see following five images). Swathed in the red ochre glow of the restaurant's light, Alan delicately works his way toward a secret that Charlie will not even address with his therapist. As Alan abruptly puts down his fork to engage in petty bitchery about his "smothering" wife and pampered clientele while Charlie nods noncommittally, the pair are framed in a two-shot that emphasizes the distance between them, both physically and experientially. And yet, this distance is eventually traversed via the virtual links forged between the men in the shot-reverse-shot patterns that follow. The camera moves closer as Charlie becomes more responsive to Alan's workaday blues, making furtive eye contact and smiling a little. Finally, as a cautious Alan broaches the subject of Charlie's obsessive kitchen remodeling, their faces are held in unflinching close-ups: Charlie haltingly recounting the argument that would prove to be his last conversation with his wife, Alan gently advising him to let it go, asking earnestly if he'll be "all right." It is a moving exchange, elegantly played, with Cheadle looking on with sudden tender concern and Sandler struggling upward out of despair to make a feeble joke: "I'm more worried about you, Johnson." The camera pulls back respectfully, leaving these men to the privacy of their awkward, fragile intimacy, silently contending with competing impulses. Grow up? Or, just stay the same?

Amour Fou

Sandler's tendency toward irrational, passionate intensity in his affairs of the heart is the last of his performative indices under consideration. Although comedian comedy is Sandler's métier, his gravitation toward romantic comedy has resulted in surprising modulations in his persona. Even more surprising is how adeptly the subgenre makes syntactical adjustments in order to incorporate his jejunity and violent impulses. If masculinity is indeed in crisis, it is remarkable just how enticing these new male agonies have proven for the women (and men) who fall for conflicted man-boys: truly, madly, deeply.

Certain abrasive qualities cultivated in Sandler's comedian comedies are retained in his romantic comedies. What is startling about his popular success as a romantic male lead is the decidedly unromantic—or even antiromantic—nature of his comic persona. The hostile juvenility of Sandler's near-impotent child-men is undoubtedly a radical departure from the debonair, wealthy, and/or sensitive leading men of previous decades: Clark Gable, Cary Grant, Gregory Peck, Rock Hudson, Robert Redford, Burt Reynolds, Ryan O'Neal, Richard Gere, and Tom Hanks, to name

Casual receptivity in *Reign Over Me* (five images).

but a few. Sandler's comic boorishness seems "casually inimical to romantic love" and calls to mind the vulgar neuroses of these earlier stars' sidekicks: loutish buddies who were associated with "an archaic phase of perception and behavior."[29] If "the sidekick [has] become the hero" in contemporary comedies, what does it mean, then, for a puerile and outwardly assailing type such as Sandler to be constructed as a romantic ideal?[30]

We might approach the apparent problem thematically. While the mutual exclusivity of the comedian comedy and the romantic comedy is increasingly dwindling (largely due to commercial pressures), an important general distinction between the two based on their narrative syntax can still be made. Unlike the social dialectic found in comedian comedies (in which romance is usually a secondary concern), the romantic comedy's syntax is predicated on an individualistic paradox. According to Frank Krutnik's perceptive formulation, romances are intensely personal experientially (they are lived out as private affairs) and yet highly conventional in their expression (their articulation is dependent on clichés). Correspondingly, romantic comedies tend to oscillate between a view of romance as a form of defiance and a depiction of marriage as potentially asphyxiating.[31] Classical screwball comedies such as *Bringing Up Baby* (1938) solve this romantic paradox by featuring unconventional partners deviating from social norms through shared play.[32] By contrast, later "nervous romances" such as *Annie Hall* (1977) are torn between a desire for the stability that conventional romance promises to provide and a loss of faith in the idealization of the couple.[33]

At a thematic level, then, it is noteworthy that the romantic comedy has proven so accommodating to a disruptively childish figure such as Sandler. At the heart of his bifurcated romantic appeal is the seemingly contradictory irascibility and nascent sensitivity inherent to his star image. The

ingenious way that the genre accommodates Sandler's presence is to co-opt his defiant childishness. His anarchic boyishness is employed in the service of revitalizing the platitudinous conventionality of contemporary romance. In turn, his wildness is not so much domesticated as it is grounded: given a more mature basis for playful indulgences.

Sandler's two most popular romantic comedies offer dynamic exemplifications of the polarity between institutionalized partnerships and individualistic romances. In *The Wedding Singer,* the underachieving Robbie's zeal for matrimony undergoes a maturation after he is left at the altar by a fickle bride. The film depicts his evolving romanticism as he moves from viewing marriage institutionally as a symbolic sign of social accreditation and security to appreciating it personally as an expression of perfect mutuality between two lovers. The film *50 First Dates* approaches the paradox from the opposing direction. Henry, a womanizing tour guide in Hawaii, ironically finds that authentic love and ultimately marriage are ideally realized through constant repetition: his love interest, Lucy (Drew Barrymore), is afflicted with a form of amnesia that resets her memory every twenty-four hours and thus forces him to win her over on a daily basis. The metaphorical function of this fantasy is strangely touching. Henry's response to Lucy's amnesia is a fanciful return to the spirit of renewal that Cavell finds so crucial in the classical screwball comedies of remarriage. In these diurnal comedies, the task is always to avoid dullness, tameness, and domesticity to discover "the comic itself as the redemption of dailiness."[34] Thus, in *50 First Dates,* marriage is conceived as a series of routines and conventions that remain oddly open to rediscovery, renewal, and wonderment for those blessed with imagination, patience, and tenacious inventiveness.

In a number of ways, then, Sandler is not such an unlikely candidate for romantic comedy after all. Given the centrality of masculinity's present crisis to his performative indices, we can also note that his work in romantic comedy gives us yet another vantage point on the various shifts in men's perception of their maleness as such. At this point, we might consider the impact of second-generation egalitarian feminism and the mainstreaming of queer culture on traditional ideas of manhood: how instrumental these movements are to the apparent paradigm shift in patriarchal self-perception. Concurrently, we can note how Sandler's performances in his romantic comedies register these influences, both explicitly and implicitly.

The appropriation of gay culture by straight media outlets has also contributed to the cultural expansion of traditional masculine scripts. Of particular interest here is the co-opting and accommodating of gay male friendship within hetero comedies. Buddy pictures are no longer so quick to disavow the potential of queer bonding between heterosexual males,

especially when a pair of male friends gravitates toward a more intimate relationship within a larger homosocial group. Thus, "homosociality un-constrained by social conventions can foster a homosexual relationship," or relationships that can be read queerly, such as the dandyish pals in *Swingers*.[35] The cop-convict pairing between Sandler and Damon Wayans in *Bulletproof* (1996) has similar explicitly queer overtones, albeit crudely homophobic ones (Wayans's attempts to stop Sandler's small-time crook from fleeing by jamming a gun up his ass). Until *I Now Pronounce You Chuck and Larry*, however, Sandler's eschewal of buddy comedies placed limitations on the applicability of these ideas involving queer bonding to his work.

Considering its core demographic, *I Now Pronounce You Chuck and Larry*—a buddy comedy about two New York fireman who marry each other and pose as gay in order to perpetrate a life insurance scam—has unrealized potential as a radically progressive film. On the one hand, the film is an incoherent admixture of mealymouthed liberal humanism ("Our sexuality has nothing to do with who we are as people!") and familiar retro-grade gay stereotypes (its mincing drag queens are played almost entirely for laughs). On the other, the film provides some deft mockery of certain entrenched straight perceptions of gay life (Chuck's efforts to "gay up" their house in order to satisfy a fraud inspector involves buying Barry Manilow CDs and a glossy photo of Wham!). However confused the film is in its pol-itics, it does take a number of brave steps: its recognition of fireman—the übermasculine heroes of straight American culture—as gay fetish objects (the gang at the firehouse eventually poses in a queer pinup calendar); its celebration of the intimacy that emerges from Chuck and Larry's profes-sional and personal fraternity (the two friends publicly and unreservedly declare their love for one another); its support for the gay bonding that can potentially emerge in homosocial situations (we end in a utopian moment in which a firefighter and the uncloseted former Backstreet Boy sing George Michaels's "Freedom" together as two men exchange wedding vows).

If Sandler's gregarious childishness is only partially influenced by his dalliances with gay masculinity, his persona is more directly shaped by the impact of second-generation feminism on modern gender-scripting. The shift in men's perception of their own engendered identities as males is in-stigated not just by the feminization of the workplace in the public sphere but also by changing expectations of interpersonal and romantic relation-ships within the private sphere. Men must reconcile an old-style machismo with new demands for emotional expressivity and intimacy. The ambiva-lence that surrounds the stereotypical male attitude toward sensitivity—its dreaded associations with feminization—is indicative of a larger problem

Adam Sandler, an Apologia 41

for men. Their underlying difficulty is "with the reconciliation of the private and the public, the intimate and the impersonal, the emotional and the rational."[36] These dualities are felt to be antithetical aspects of a man's identity.

For Sandler, however, the situation is notably different. His romantic problems issue not so much from problems of reconciliation as from an inability to direct his sensitivity effectively. Most cogently, his accomplished screwball turn in *Punch-Drunk Love* provides us with insights into the conflicted anima that drives the men of romantic comedy to distraction. The film's leading lonely heart, Barry Egan (Sandler), is a joyless self-hating novelty toy distributor who oscillates between depression and inexplicable fits of rage. "I don't like myself very much," he confesses to his brother-in-law. "Can you help me?" Walter's deadpan reply—"But Barry, I'm a dentist."—is perfectly timed, and yet the film short-circuits the usual humor to be had from Sandler's angry infantility: his sudden, irrational outbursts are played as emotionally genuine rather than comically excessive. "Sometimes I cry a lot for no reason," Barry continues and abruptly covers his face with his hands, whimpering and sobbing as an embarrassed Walter looks on. Barry's stunted sensitivity—his potential responsiveness to the world—causes him considerable turmoil because it is not acknowledged or accredited in the film's tawdry microcosm of exploitative phone-sex operators, small-time pimps, bullying sisters, and glassy-eyed coworkers.

Happily for Barry, he discovers romance with the winsome Lena Leonard, who is mysteriously receptive to his nascent sensitivity and coaxes it into being. Despite her fetchingly prim ordinariness, her attraction to Barry's downtrodden boyishness marks her as a fellow adventurous spirit open to the promise of possibility. She is a rare incarnation of earlier screwball heroines: a lover who is drawn to a male partner because of, not in spite of, his boyishness. Rather than insisting that he leave behind childish things, grow up, and make a commitment, she actively cultivates this confused boyishness, giving it new direction, new opportunities for delight. On their first date, Barry excuses himself from the table and suffers an operatically violent case of first-date jitters in the washroom, destroying a cubicle in the process. And yet, his ejection from the restaurant is not a source of embarrassment for Lena. Instead, she leads him in an enchanting walk down the street outside: a long take punctuated by their small, furtive smiles and bolstered by the sudden swelling of the soundtrack's romantic theme.

In considering the pairing of the unlikely couple, Tom Wartenberg argues that the transgressive union of individuals from traditionally antagonistic social backgrounds inherently challenges "hierarchic social norm[s] regulating the composition of romantic couples."[37] Barry and Lena's oddball

pairing overturns the present hegemonic mandate that insists that boys must grow into men before they can be suitable, mature romantic partners. Likewise, it gives lie to romantic comedy's insistence that women only yearn for sobriety, stability, and responsibility from their men. But *Punch-Drunk Love* is even more radical than this by suggesting that *all* couples can be considered unlikely in our present age, in which romance itself is under such internal pressure and treated with considerable suspicion, an antiquated form of ritualized social exchange left over from the era of courtly love. Perhaps this is why Barry is so lost within the film's bewildering world of sudden interruptions, inexplicable disasters, questions without answers, tension without sources, tawdry violence, deadpan stares, awkward silences, and stunted timing. Romance has become so dizzyingly transformed—such a whirlwind of outmoded clichés—that it becomes difficult to endorse with a straight face. Hence, all lovers are now screwballs of a sort in their pursuit of regenerative whimsy.

Consequently, *Punch-Drunk Love* is full of random, awkwardly screwy action. More concretely, many of Sandler's familiar traits and performative gestures are rendered strange through various alienating techniques. For one, the motivations for a good deal of his comic action are deliberately mystified. When fleeing from the idiotic blond brothers who try to extort money from him, Sandler gibbers like Billy Madison, hurls himself over a fence into the street, and continues running long after his tormentors have disappeared. He also incorporates his clowns' violent impulses into strange, precoital exchanges. "I'm looking at your face," he whispers to his lover between kisses, "and I just want to fucking smash it with a sledgehammer and squeeze it, you're so pretty." Finally, comic timing is continually undermined, as are the slapstick mechanics of setup and payoff: characters fall out of chairs, trip over unseen objects, and walk into glass walls at random, all with minimal reaction. Wes Gehring claims that *Punch-Drunk Love* is not a screwball comedy just because it contains such "zany components" or "because [its] manic clown has a girlfriend."[38] And yet, these techniques *are* compatible with this comic cycle, for they are an impressionistic evocation of the mindless delirium of blossoming romance, a relationship that makes screwballs of us all. It is a representation of love itself as madness.

Who better, then, to celebrate the liberating mindlessness, the transportive idiocy of contemporary romance, than Adam Sandler? There are few better representations of this condition than the dance that Barry suddenly executes in the middle of a grocery store that is designed like an Andreas Gursky photograph. Sandler has always been a song-and-dance man at heart: engaging in a Broadway-style number in *Billy Madison,* composing and performing all of the songs in *Eight Crazy Nights,* and singing a cutesy

self-penned ballad to win Julia's heart in *The Wedding Singer*. Such innate musicality is further evidence of his riotous childishness, the sheer lack of self-consciousness required to burst into song or dance. Correspondingly, his brief dance in *Punch-Drunk Love* is completely without diegetic motivation other than to express his delight in accumulating thousands of free air miles by buying vast quantities of pudding.

There is an inherent absurdity in the scenario itself whereby pudding and a promotional error are conducive to the development of romance (Barry will try to use his air miles to meet Lena in Hawaii). Consequently, his unexpected dance manifests some of these qualities: a brief soft-shoe to indicate delight in the bureaucratic blunders that can ironically lead to greater freedom, self-congratulatory hand claps to acknowledge his cleverness, and a bowlegged shuffle to imply his eager readiness to pursue love for the first time. This is Sandler's fanciful boyishness at its most elementally pure.

While this boyishness may often be recalcitrant, it also provides opportunity for the flights of fancy that ensure the survival of beleaguered romance. Unlike his male contemporaries, romantic relationships are never a source of frustration or anger for him; rather, romance provides him with a forum in which his childish exuberance and imagination has restorative potential both for himself and his partner. When his romantic desires are realized, anger becomes impossible for Sandler. Mad love is a guarantor of sanity.

Again, Sandler's accomplishment here is to redefine our expectations of his persona and bring newfound layers of complexity to his recurring performative indices. In turn, his reflexive performance prompts us to reconsider our assumptions about certain tendencies in contemporary masculinity, including men's efforts to pursue hitherto unexplored avenues of intimacy in their interpersonal relationships. More specifically, the figuration of Sandler's choleric schlemiel as amorous ideal is a symptom of certain exigencies in the popular conception of romance. A seriocomic film such as *Punch-Drunk Love* dramatizes the desperation inherent with current affairs of the heart. When foregrounding the more abrasive elements of his persona and playing them straight, Sandler offers an interrogative performance that subversively queries not only his own star image but also the changing romantic roles and responsibilities of contemporary sweethearts. In this regard, his splenetic and impotent childishness is not a degraded form of what passes for passion today. Rather, it strikes a vibrant chord with many of those afflicted by the intertwining dis-eases of manliness and modern love.

Aaron Taylor

Sandler's fanciful boyishness in *Punch-Drunk Love.*

These benign afflictions have taken a decisive turn toward the malignant—perhaps even terminality—in Sandler's work of late. *Click*'s maudlin traditionalism has proven prophetic as this aging boy-man settles into middle age. Most of the actor's work since *Click* exhibits an explicit conservatism as he and his usual coterie produce films that unproblematically celebrate family, material success, and middle-class complacency. Correspondingly, homosocial camaraderie and a reliance on buddies have become increasingly central to these works. In turn, Sandler's performative indices have become quite static, with little connotative variance or modulation, and the formerly anarchic clown now often plays the straight man to the zanier antics of his current second banana of choice, Nick Swardson. *Bedtime Stories, Grown Ups,* and *Just Go With It* are particularly retrogressive examples of these tendencies. While Sandler has never been a critics' favorite, his post-2006 reviews have been among the worst of his career (e.g., his average "freshness" rating on *Rotten Tomatoes* has plummeted from 40.8 percent to 26.5 percent), but this time reviewers, amateur bloggers, and casual commentators alike complain about the star's apparent laziness and self-satisfaction rather than his lowbrow tendencies.[39] Sandler's retreat into conservatism and the ensuing critical drubbing is also compounded by the box office exhaustion of the bromance cycle, indie deflations of the melancholic and exclusionary excesses of this production trend (*Old Joy* [2006], *Humpday* [2009], and *Greenberg* [2010] are all noteworthy examples), and popular feminist backlashes against the cycle's misogynistic tendencies (*Bridesmaids* [2011] can be considered an explicit rejoinder to *The Hangover*'s hateful "What Happens in Vegas" boys' club mentality). The star himself seems conscious of the widespread perception of an atrophic tendency in his work and is even occasionally driven to assert defensive public statements about his films.[40]

Reign Over Me is one exception to this perceived stagnation; *Funny People* (2009) is another. By privileging Sandler's seriocomic roles in this essay, I have been implicitly suggesting that the star's more interesting performances—roles in which he imaginatively extends our understanding of his unique performative indices—tend to occur in films that are *not* made by his usual gang of yes-men (i.e., directors Frank Coraci, Dennis Dugan, and Peter Segal and screenwriters Tim Herlihy, Steve Koren, and Robert Smigel). That is, these elaborations are at their most prominent in his collaborations with a number of auteurs—Paul Thomas Anderson, Mike Binder, James L. Brooks, and Judd Apatow—who seem to have encouraged the more ambitious explorations of his recurrent tropes. *Funny People* is

perhaps the most intimate of these ingenious expansions, which may owe something to the long-standing friendship between the director and the star. The film also serves as a reflexive overview of Sandler's persona to date as he plays a successful comic and movie star, George Simmons, whose brush with mortality prompts an extended period of self-reevaluation. Remarkably, though, *Funny People* is a stark departure from other late-Sandler vehicles in which his characters pursue or indulge in familial relationships as a mere reflex gesture. In this film, his yearnings toward an authentic amorous renewal are utterly defeated, and his introspectiveness is exposed as an act of bad faith, indeed just another extension of his own narcissism.

Two last actorly moments, then, provide us with occasions to reflect on the performer's achievements and to engage with him in the act of thinking through his own meaningfulness. Apatow employs an ingenious strategy to open *Funny People*, inserting actual home video footage that he shot of a twenty-five-year-old Sandler while they shared an apartment together in 1991. In a barely furnished bedroom, Sandler emerges tortoise-like from the blankets in order to make a few crank calls. Adopting the personae of various addled and gastronomically challenged elderly women, Sandler warbles into the phone about stolen credit cards and regurgitated roast beef, barely able to keep from cracking up, as Apatow and a young Janeane Garofalo and Ben Stiller egg him on. The nostalgic gesture here is significantly denser than the slothful insularity of *Grown Ups*, with its inside-jokiness and atmosphere of a *Saturday Night Live* reunion. Instead, here the young comic's delight in irreverent scatology— his giddy exuberance at his own naughtiness—is presented as a marked contrast to the joyless celebrity he has become. A sound bridge of his infectious braying carries us into the present as a puffy, sullen George Simmons lurches out of his luxuriant bed, alone and clearly miserable. The collocation is *Funny People*'s key structural motif: the youthful, hungry spontaneity and immediacy of stand-up is offset by the atrophic routine of robotized stardom. This juxtaposition recurs again shortly after George is diagnosed with acute myeloid leukemia, and the despondent star is seated before multiple flat-screen monitors watching various images of himself at different points in his career. Sandler's own filmography is skewered quite mercilessly, as George's work is clearly to be understood as accentuated versions of Sandler's more moronic fare. Indeed, the scene begins with an excerpt from "Re-Do," a fictional George Simmons vehicle that harshly critiques Sandler's penchant for infantilism by featuring a scenario in which George has been transformed into a baby. The camera tilts down to reveal more found footage on another screen below: a teenaged Sandler performing a stand-up routine about his bar mitzvah.

Sandler as aging man-boy in *Funny People*.

In a reaction shot, George leans forward and exhibits a pained cringe, that suddenly and poignantly dissolves into a smile, a shadow trace of the uncontainable mirth formerly exhibited by a young man who can't resist laughing at his own deliberate idiocy.

In this moment Sandler movingly traverses the range of several performative indices, and in so doing he demonstrates that there is a fluid interconnectivity between the frustration and youthful self-indulgence of contemporary manhood. Correspondingly, *Funny People*'s achievement is its demonstration of comedy as a joyless profession and handy escape mechanism from the obligations of intimacy. Through his self-scrutinizing performance, Sandler allows us to consider the possibility

Aaron Taylor

that the conflictions of maleness as crisis in action—manifested as raging adolescence indefinitely postponed—may also be causes for profound self-loathing. It is perhaps his most sober consideration of the costs of a willful pursuit of jejunity, but just as noteworthy is his performative revelation that maturation is not achieved easily, nor is it a cure-all for the millennial fever of contemporary masculinity.

NOTES

For my brother, Ryan Taylor, and my fellow Sandlerphiles, Andrew "Crazy Protractor Beard" Damen and Marcel "So Sorry to Interruuuupt" Houillier.

1. Dorothy Pomerantz and Dan Bigman, eds., "The World's Most Powerful Celebrities," *Forbes.com*, May 18, 2011, http://www.forbes.com/wealth/celebrities/list.

2. Box office figures are derived from "2010 Worldwide Grosses," *Box Office Mojo*, September 4, 2011, http://www.boxofficemojo.com/yearly/chart/?yr=2011&p=.htm. DVD sales are derived from "Top Selling DVDs of 2011," *Numbers*, September 4, 2011, http://www.the-numbers.com/dvd/charts/annual/2011.php.

3. Dirk Eitzen, "The Emotional Basis of Film Comedy," in *Passionate Views: Film, Cognition, and Emotion*, edited by Carl Plantinga and Greg M. Smith (Baltimore: Johns Hopkins University Press, 1999), 96.

4. Michael Atkinson, "The Way We Laughed," *Village Voice*, July 3–9, 2002, http://www.villagevoice.com/film/0227,atkinson,36156,20.html.

5. I have written more extensively on the notion of performative indices in "Thinking through Acting: Performative Indices and Philosophical Assertions," in *Acting and Performance in Moving Image Culture: Bodies, Screens, Renderings*, Vol. 9, edited by Joerg Sternagel, Deborah Levitt, and Dieter Mersch, 17–35 (Bielefeld: Transcript Verlag, 2012).

6. Stanley Cavell, *Pursuits of Happiness: The Hollywood Comedy of Remarriage* (Cambridge, MA: Harvard University Press, 1981), 25.

7. Steve Seidman, *Comedian Comedy: A Tradition in Hollywood Film* (Ann Arbor: UMI Research Press, 1979), 6.

8. The quoted descriptions of Lloyd and Lewis are from David Thomson, *A Biographical Dictionary of Film*, 5th ed. (New York: Knopf, 2010), 587, 581.

9. This latter feature is occasionally mocked by other characters. In *Billy Madison*, a kindergarten classmate remarks, "You've got a misshaped head," and one of Lucy's many painted dream-portraits of Henry in *50 First Dates* replaces her perpetually forgotten lover's head with a giant egg.

10. Murray Pomerance, "The Man-Boys of Steven Spielberg," in *Where the Boys Are: Cinemas of Masculinity and Youth*, edited by Murray Pomerance and Frances Gateward (Detroit: Wayne State University Press, 2005), 153.

11. For more on the figure of the schlemiel, see Irving Howe, "The Nature of

Jewish Laughter," in *Jewish Wry: Essays on Jewish Humor,* edited by Sarah Blacher Cohen (Detroit: Wayne State University Press, 1987), 23–24. For a noteworthy consideration of Sandler's relation to Jewish comic traditions, see Don Perglut, "Jewish Comedy, Adam Sandler Style," *Don Perglut's Blog,* March 29, 2009, http://donperlgut.wordpress.com/personalities/jewish-comedy-adam-sandler-style/.

12. While most of Sandler's characters are explicitly Jewish, his ethnicity is celebrated most extensively in *You Don't Mess with the Zohan* and in the works that redress the alienating WASPishness of the Christmas season: *Eight Crazy Nights* and "The Chanukah Song," a novelty tune that he has performed steadily since its *Saturday Night Live* debut in 1994 and includes a roll-call of Jewish celebrities.

13. Tim Edwards, *Cultures of Masculinity* (London: Routledge, 2006), 17.

14. John Benyon, *Masculinities and Culture* (Buckingham: Open University Press, 2002), 95.

15. Henry Jenkins, "'The Laughingstock of the City': Performance Anxiety, Male Dread and *Unfaithfully Yours,*" in *Classical Hollywood Comedy,* edited by Kristine Brunovska Karnick and Henry Jenkins (New York: Routledge, 1995), 244.

16. Edwards, *Cultures of Masculinity,* 24.

17. For further details, see John MacInnes, *The End of Masculinity: The Confusion of Sexual Genesis and Sexual Difference in Modern Society* (Buckingham: Open University Press, 1998), 47.

18. Beynon, *Masculinities and Culture,* 95.

19. Susan Faludi, *Stiffed: The Betrayal of the American Man* (London: Vintage, 2000), 35.

20. The year of *Happy Gilmore*'s release, 1996, seems to mark the turning point in the box office draw of each of these stars. The four actors experienced an average 33 percent decline in the revenues of their films for this year compared to the gross revenues of their 1995 releases. This figure was established by averaging the combined differences between the box office grosses of their 1995–96 films as cited on their respective IMDb.com listings.

21. "Best and Worst Dressed '99," *People* 52, no. 11 (1999): 128.

22. Richard Dyer, *Stars,* 2nd ed. (London: British Film Institute, 1998), 104.

23. William Paul, "The Impossibility of Romance: Hollywood Comedy, 1978–1999," in *Genre and Contemporary Hollywood,* edited by Steve Neale (London: British Film Institute, 2002), 119.

24. David Denby, "A Fine Romance," *New Yorker,* July 23, 2007, 4, http://www.newyorker.com/reporting/2007/07/23/070723fa_fact_denby?currentPage=1.

25. John Troyer and Chani Marchiselli, "Slack, Slacker, Slackest: Homosocial Bonding Practices in Contemporary Dude Cinema," in Pomerance and Gateward, *Where the Boys Are,* 266.

26. Justin Wyatt, "Identity, Queerness and Homosocial Bonding: The Case of *Swingers,*" in *Masculinity: Bodies, Movie, Culture,* edited by Peter Lehman (New York: Routledge, 2001), 54.

27. His more boorish comedies are usually produced by his own Happy Madison production company. Moreover, they are written, directed, and produced and feature performances by a core circle of friends with whom he has worked since his *Saturday Night Live* days.

28. All of these quotations are taken from Celestino Deleyto, "Between Friends: Love and Friendship in Contemporary Hollywood Romantic Comedy," *Screen* 44, no. 2 (2003): 174.

29. Bruce Babington and Peter William Evans, *Affairs to Remember: The Hollywood Comedy of the Sexes* (Manchester, UK: Manchester University Press, 1989), 272.

30. Steve Neale, "The Big Romance or Something Wild? Romantic Comedy Today," *Screen* 33, no. 3 (1992): 292.

31. Frank Krutnik, "The Faint Aroma of Performing Seals: The 'Nervous' Romance and the Comedy of the Sexes," *Velvet Light Trap* 26 (Fall 1990): 57.

32. Ibid., 58.

33. Frank Krutnik, "Conforming Passions? Contemporary Romantic Comedy," in *Genre and Contemporary Hollywood,* edited by Steve Neale (London: British Film Institute, 2002), 139.

34. Cavell, *Pursuits of Happiness,* 242.

35. Wyatt, "Identity, Queerness and Homosocial Bonding," 55.

36. Anthony Clare, *On Men: Masculinity in Crisis* (London: Chatto and Windus, 2000), 212.

37. Thomas E. Wartenberg, *Unlikely Couples: Movie Romance as Social Criticism* (Boulder, CO: Westview, 1998), 7.

38. Wes Gehring, "Screwball Comedy," in *Schirmer Encyclopedia of Film,* Vol. 4, edited by Barry Keith Grant (Detroit: Thomson Gale, 2007), 46.

39. The statistics were generated by tabulating Sandler's ratings in his entry on Rotten Tomatoes, http://www.rottentomatoes.com/celebrity/adam_sandler/.

40. See "Sandler Angry at Critics," IMDb.com, August 12, 2008, http://www.imdb.com/news/ni0549765/.

DONNA PEBERDY

"Politics Is Theater"

Performance, Sexuality, and Milk

> To perceive Camp in objects and persons is to understand Being-as-Playing-a-Role. It is the farthest extension, in sensibility, of the metaphor of life as theater.
>
> Susan Sontag, "Notes on 'Camp'"

> Harvey: Politics is theater. It doesn't matter if you win. You make a statement. You say, "I'm here, pay attention to me."
> Scott: Harvey, you do that every time you cross the street.
>
> Harvey Milk (Sean Penn) and Scott Smith (James Franco) in *Milk*

At the start of his Oscar acceptance speech for Best Actor in a Leading Role for Gus Van Sant's film *Milk* (2008), Sean Penn expressed his gratitude to the Academy of Motion Picture Arts and Sciences and the audience: "Thank you. Thank you. You commie, homo-loving sons of guns." His statement was met with a mixture of nervous laughter and gradual applause as the actor went on to thank those involved in the project. Penn then turned his attention to the antigay protesters outside the Kodak theater and supporters of Proposition 8, the constitutional amendment passed less than three weeks earlier that overturned a prior ruling that same-sex couples have a legal right to marry: "I think that it is a good time for those who voted for the ban against gay marriage to sit and reflect and anticipate their great shame and the shame in their grandchildren's eyes if they continue that way of support," Penn announced, adding to thunderous applause that "We've got to have equal rights for everyone." It is interesting to consider Penn's speech alongside another made just before the Hollywood actor

took to the stage. For the 2009 Oscars, the Best Actor, Best Actress, and Best Supporting Actor awards were presented by five former winners in each category who introduced each of the nominees. Robert De Niro's introduction of Penn is worth quoting in its entirety:

> How did he do it? How for so many years did Sean Penn get all those jobs playing straight men? Being a movie star can get in the way of acting, but not for Sean. Sean Penn the actor loses himself in every role so we can discover men named Sam, *Mystic River*'s Jimmy Markham, the superdude Spiccoli, a dead man walking, and Harvey Milk. Sean brings the same commitment to his offscreen life. You see it when he campaigns for human rights, respectfully advises world leaders, and gently, gently reasons with the paparazzi. Tonight it's important to be a great actor; in life it's more important to be a great human.

Penn's was the only introduction made that evening that acknowledged an actor's offscreen persona. *Milk,* the film for which Penn had been nominated, was only fleetingly mentioned, alongside other films in which Penn "loses himself" in the role. More emphasis is given to Penn as a political figure, one who campaigns and advises world leaders. The focus moves away from the introduction to an award for a performance in a film toward an introduction to a "great human" award for contribution to real world affairs. The implication is that Penn cannot be considered merely as an actor; his offscreen persona is inseparable from and even overwhelms his on-screen performances.

The two speeches raise a number of issues that this chapter will examine in more detail: Hollywood's recent relationship to the presentation of homosexuality on-screen, the performance of homosexuality and the authenticity in playing gay, the performance of politics and politics of performance, and the centrality of the public persona in reading performance. First, the film invites a consideration of the performance of homosexuality. Harvey Milk, the first openly gay man to be elected to public office in California, is played by Penn, a heterosexual, calling attention to the differing codes and conventions of performing homosexuality. Second, *Milk* presents performance as political. Penn does not just play Harvey Milk, a politician with his own performance codes; he *becomes* the character, losing himself in the role as De Niro notes. The performance then becomes political in Penn's engagement with contemporary discourses around same-sex marriage and equal rights. Finally, *Milk* raises issues surrounding the politics of performance in the confusion between Penn's on-screen and offscreen

persona and the implication that his offscreen persona outweighs, overwhelms, or, at the very least, affects how we read his film performance. Ultimately, the speeches foreground the critical relationship between performance and sexuality, inviting the question: What does it mean to play gay? This chapter seeks to answer this question by examining not only the performance of homosexuality in *Milk* but also the politics of that performance that is inseparable from the identity of the performer.

By now it is well established that gender, sexuality, and identity are performances, constructed and acted out in everyday life. As Judith Butler states in "Performative Acts and Gender Constitution," "gender is in no way a stable identity or locus of agency from which various acts proceed; rather, it is an identity tenuously constructed in time—an identity instituted through a *stylized repetition of acts.*"[1] In *Bodies That Matter,* Butler warns against confusing performance and performativity, noting that "performativity is neither free play nor theatrical self-presentation; nor can it simply be equated with performance."[2] For Butler, performance is a "bounded 'act,'" whereas performativity is informed and determined by the culture; it "cannot be taken as the fabrication of the performer's 'will' or 'choice'" since it is informed by "a reiteration of norms which precede, constrain, and exceed the performer."[3] Phillip Brian Harper, for example, suggests that the distinction is between theatrical production (performance) and discursive production (performativity).[4] In other words, performance is subject to the control and manipulation of the performer, whereas performativity begins and ends outside the performer. Gender is thus a social construct, a series of reiterative acts that are performed and reperformed until they become perceived as natural. As I have argued elsewhere, however, the performance of social roles on-screen complicates an easy distinction between performance and performativity; film performance involves the presentation of actions, made up of specific gestures and mannerisms, but also involves the presentation of identity and social roles themselves informed by cultural expectations.[5] Theoretical distinctions between the terms notwithstanding, it is clear that the performance of sexuality on-screen involves more than actions and signs.

The performance of heterosexuality is, to a large extent, hidden by the culture,[6] yet performance for gay men and women, Richard Dyer notes, "is an everyday issue" whereby the individual must constantly decide between displaying his or her sexuality or hiding it.[7] The performance of homosexuality has a community function—to signal a form of identification to other gays and lesbians—but also provides a function "in playing with or contesting straight normativity."[8] Thus, the performance of homosexuality also reveals the performativity of heterosexuality. Despite the inherent performative

nature of sexuality, Jude Davies and Carol Smith have argued that "it remains impossible to read an individual's sexuality directly from their appearance."[9] This is certainly not the case with Hollywood, which has a long history of using stereotypes and two-dimensional caricatures of homosexual characters, defined explicitly by appearance and mannerisms.[10] However, Davies and Smith's statement suggests that it is not just appearance that signifies sexuality but rather what is done with that appearance. In other words, sexuality can be performed and enacted with the codes and conventions of enactment differentially activated from performer to performer.

In his 1981 publication *The Celluloid Closet,* Vito Russo wrote that "Hollywood is where gay directors make anti-homosexual films so that he can continue to work with the big boys. Hollywood is where gay screenwriters churn out offensive teenage sex comedies and do it well because there isn't anything they don't know about pretending to be straight."[11] A small number of mainstream films released since the publication of *The Celluloid Closet* not only foreground gay subject matter but have also suggested that homosexuality can be both a critically and an economically viable subject matter on Hollywood screens, such as Oscar winners *Philadelphia* (1993), *Boys Don't Cry* (1999), *Monster* (2003), and *Brokeback Mountain* (2005), four films that also carried a great deal of critical and popular discursive weight. These films were praised by numerous critics who saw their popularity as evidence of the progressiveness of American audiences and Hollywood as an industry, along with the Academy Awards for honoring them (although the Academy was criticized in many quarters for awarding *Crash* [2004] Best Film over *Brokeback Mountain*). Yet the same films were also criticized for their casting of heterosexual actors as homosexual characters, inviting criticism that Hollywood plays it safe by hiring straight actors for such roles and giving minor roles to gay and lesbian actors.

The lead performances in *Philadelphia* and *Brokeback Mountain* garnered much acclaim, although they have been criticized for their lack of verisimilitude regarding the performance of homosexuality; for critic Scott Thompson, "Hanks did not read gay remotely" in *Philadelphia,* while the *Advocate* noted of *Brokeback Mountain* that "critics of the film have grumbled that the apolitical Ennis (Heath Ledger) and Jack (Jake Gyllenhaal) aren't 'gay enough.'"[12] The straight actor's ability to convincingly play gay raises the issue of authenticity, which has been central to critical discussions of performance. As Dyer notes, "we no longer ask if someone performs well or according to certain moral precepts but whether what they perform is truthful."[13] Regarding the performances found in everyday life, anthropologist Erving Goffman terms the authenticity of performance "expressive coherence," which refers to "not only a coherence of manner but also a fit

between setting, costume and behaviour."[14] However, as Dyer points out in *The Culture of Queers,* the performance of sexuality "is something we do but only with the terms, the discourses, available to us."[15] Actors, then, have preestablished restrictions imposed on them that limit their social codes of enactment. The performance takes place, in Butler's terms, in a "culturally restricted corporeal space and enacts interpretations within the confines of already existing directives."[16] If we apply this to the performance of homosexuality, we might say that it is performed according to established cultural codes for playing gay based on the social knowledge of sexuality made available. Historically, this has meant reducing homosexuality to stereotypical iconography and gestures. Yet this is an active, not passive, employment of cultural codes, chosen and enacted with the knowledge that such codes are socially and culturally constructed. Arguably, with examples such as *Philadelphia, Brokeback Mountain,* and *Milk,* the corporeal space of representation has expanded in recent years as Hollywood has increasingly moved, however slight, away from solely reducing homosexuality to stereotype and caricature.

A consideration of industrial factors affecting film production and the circulation of images presents the idea of Hollywood playing it safe in a different light. *Milk* and *Brokeback Mountain* were both produced off-Hollywood by Universal subsidary Focus Features and, according to Harry Benshoff, were "marketed as prestigious critic-and-award-buzz pictures rather than films about lesbian, gay, or queer content *per se.*"[17] On its release, director Gus Van Sant also received criticism for his casting of straight Sean Penn as the eponymous Milk. Van Sant commented that there is a dearth of openly gay A-list actors in Hollywood who can "open a film." If an unknown was used, which the director said he would not have a problem with, it would be harder to secure financial backing for the film.[18] The weight of the star image thus becomes a major contributory factor in the presentation of homosexuality on-screen. It is not that Hollywood plays it safe by hiring straight actors to play gay; rather, Hollywood hires straight stars in order to get the film made. It could be argued that the performances of homosexuality in *Philadelphia, Brokeback Mountain,* and *Milk* and indeed more recently with *A Single Man* (2009) can never be authentic, since homosexuality is performed by straight actors; knowledge of their heterosexuality already undermines the presentation of homosexuality, and acting is always visible as acting. Yet such films go to great lengths to offer what Dyer refers to as "markers of authenticity" in their narratives, and it is also on closer examination of such authentic markers that *Milk* visibly departs from its counterparts, specifically in how it responds to sexuality and identity as performance.[19]

Donna Peberdy

Playing it safe? Colin Firth as George Falconer in *A Single Man*.

While *Philadelphia* and *Brokeback Mountain* have been accused of playing it safe by de-gaying their performances (indeed, the same criticism has more recently been leveled against the marketing of *A Single Man*), the performance of homosexuality in *Milk* is explicit to the point that some critics proclaimed that Penn played Harvey Milk too gay. A *Washington Times* critic, for example, suggested that his "over-the-top flamboyance [was] better suited to a 'Saturday Night Live' skit,"[20] while a critic for *Huffington Post* suggests that Penn only "just avoids overacting."[21] The explicitness of Penn's performance of Milk is narratively important, since Milk was the first openly gay elected official in major office in the United States. A visible homosexual identity is central to Milk's career as a politician; indeed, *Milk* not only foregrounds homosexuality as a performance and the politics of performance but also is equally concerned with the self-conscious performance of politics.

The visibility of Milk's sexuality and Penn's representation can be thought about in terms of camp, a concept that also complicates an easy distinction between performance and performativity. As with performativity, theoretical definitions of camp are often ambiguous and contradictory. Indeed, contradiction characterizes camp, as suggested in Susan Sontag's claim that camp is "love of the unnatural: of artifice and exaggeration." But it is also "esoteric—something of a private code."[22] When we talk of a camp performance, are we referring to a style or an identity, doing or being, an aesthetic or a sensibility? In seeing camp as a response to the typing and polarization of sexuality and gender in society, Jack Babuscio's definition of camp, for example, involves both. Drawing from Sontag, Babuscio notes:

To appreciate camp in things or persons is to perceive the notion of life-as-theatre, being versus role-playing, reality and appearance. If "role" is defined as the appropriate behavior associated with a given position in society, then gays do not conform to socially expected ways of behaving as men and women. Camp, by focusing on the outward appearances of role, implies that roles, and, in particular, sex roles, are superficial—a matter of style. Indeed, life itself is role and theatre, appearance and impersonation.[23]

Camp, then, becomes an exterior display of actions and acts that call attention to the constructedness of sex roles and identity. It is, as Moe Meyer has argued, "the total body of performative practices and strategies used to enact a queer identity, with the enactment defined as the production of social visibility."[24]

Milk presents a number of scenes in which Milk's identity as a gay man is presented as visible performance and is directly linked to his identity as a political figure. The politician changed his tact depending on his audience: "if I was speaking to a slightly hostile or mostly straight audience, I'd try to break the tension with a joke. . . . I know, I know. I'm not what you're expecting but I left my high heels at home" (he says in one example). Later Milk remarks, "Politics is theater. It doesn't matter if you win. You make a statement. You say, 'I'm here, pay attention to me.'" Milk's identity as a political figure corresponds with his personal identity so that the personal literally and explicitly becomes political. This duality is echoed in his introductory slogan—"My name is Harvey Milk and I want to recruit you"— that speaks to both Milk's political recruitment to his equal rights stance and acts as a parodic play on the fear that gays and lesbians would recruit America's children because they could not have their own, as gay rights opponent Anita Bryant proclaims in documentary footage inserts. According to Eric Patterson, "Milk had a sharp wit and frequently made funny, campy cracks, but his gay sense of irony was the opposite of being an expression of some sort of 'feminized' despair or futility—like many gay men, he used it as a weapon, stirring up his supporters and intimidating his rivals."[25] Milk's performance of homosexuality is self-conscious and active, a tool for generating support, intimidating the opposition and inciting a response.

Such dialogue and sequences contrast private, more intimate, moments of Milk alone, away from the political stage. These moments depict the "real" Milk behind the public persona via "markers of authenticity" that reveal the "immediate (= not controlled), spontaneous (= unpremeditated), and essential (= private) self."[26] In particular, the scenes showing Milk recording his "last testament" showcase the private, authentic self.

Donna Peberdy

It was screenwriter Dustin Lance Black's intention for the scenes of Milk speaking into the recorder to "feel intimate, as if Harvey is telling us things no one else knows."[27] Penn's voice is quieter and his mannerisms are more subdued, but such authentic moments are few and far between in *Milk*, which for the most part is interested in Harvey's public performances. In his relationship with Scott Smith, however, the conflict between public and private is given space, and it is the effect of this conflict on Harvey that causes Scott to leave. Harvey is unable to negotiate the two identities as the public self increasingly consumes the private so that an authentic private self is replaced by an authentic public identity: controlled, premeditated, and constructed. In fact, Harvey's popularity and success as a gay rights activist and then as city supervisor depend on the personal becoming the political and the public becoming the authentic image. At one crucial point in the campaign, Harvey encourages his closeted supporters to also make their personal public by coming out.

Milk makes another key departure from its contemporaries as a bi-opic. *Philadelphia* was based on real events, and still the story is fictionalized and does not present itself as fact. Not only is *Milk* a retelling of actual events, but this is done via an iconic political figure whose story had already garnered critical recognition by the Academy with the award-winning documentary *The Times of Harvey Milk* (1984). *Milk* includes virtually shot-for-shot re-creations of the footage used in the documentary to underscore the film's pursuit of authenticity. The re-creation is most explicitly presented at the close of the film, which juxtaposes images of the actors with their real-life counterparts. The viewer can then be impressed by the faithfulness of the striking similarities between actor and real person in an attempt to confirm the "expressive coherence" of the performances in the film.[28] However, the montage highlights the authenticity of the image, not the performance, which is largely achieved through replicating clothing, hairstyles, and accessories, thus underscoring the importance of the fidelity of the image to the biopic.

Attempts to re-create performance are more problematic. This is exemplified in a review for the *Washington Times* that argued that "even if the actor's histrionics accurately reflect those of Harvey, it comes across on-screen as hopelessly stereotypical. Penn would surely have been better off moderating his performance a la Tom Hanks in 'Philadelphia.'"[29] It would seem that it is impossible for the straight actor to get it right: Tom Hanks does not read gay remotely, and Sean Penn's performance requires moderation. Whether or not such actors are able to be believable as homosexuals is a moot point, however, and is largely open to subjective interpretation. Yet what is telling about the critic's comment is the implied difference between

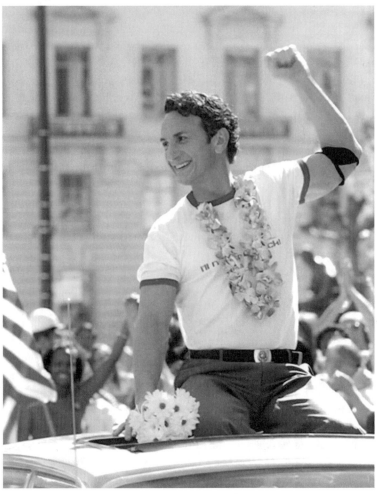

Sean Penn portrays the historical title character in *Milk*.

fact-based and fictional filmmaking. The real Harvey Milk may have been histrionic, and Penn is able to accurately reflect this reality, but the performer comes across as over-the-top and flamboyant precisely because he is playing someone else.

Despite Penn's "fully embodied impersonation," the comment by the *Washington Times* critic also suggests that what is accepted in reality is less effective or believable when fictionalized.[30] In this case, *Milk* can be read alongside other recent biopics such as Oliver Stone's *W* (2008) and dramatizations such as *The Special Relationship* (2010) that blur the line between impersonation, mimesis, and parody.[31] In playing a historical figure, the

Donna Peberdy

performer always invites a comparison to the source text (the real person). If he moves too far away, the performance lacks authenticity; if he is too close, then the performer is criticized for mere imitation and poor performance. Yet as Bruce Shapiro argues, "No matter how hard actors may try, they cannot become other things, not even other people, because their consciousnesses are inaccessible to actors."[32] The performer, then, is always distinct from the person being played, even if the final performance is a shot-for-shot re-creation of actuality.

Crucially, the identity of the performer is even more distinct when the actor playing the historical figure is a star. In any performance, the meanings change according to who is performing. For example, Richard Nixon has been played by five different actors—Philip Baker Hall in *Secret Honor* (1984), Anthony Hopkins in *Nixon* (1995), Dan Hedaya in *Dick* (1999), Frank Langella in *Frost/Nixon* (2008), and Robert Wisden in *Watchmen* (2009)—each bringing different meanings to the role via performance style, idiosyncrasies, and their reading of the character and context. At the same time, the performance is read differently depending on the actor or star; the more knowledge we have about an actor, whether textual or extratextual, the more such knowledge informs out interpretation and reading of the screen performance. According to George Custen, "Every famous figure . . . is filtered through the persona of the star image in two ways: inside the film by the tradition of the actor's performance, and outside the film by publicity and public relations materials. Because events outside the film (the life depicted) interact with our responses inside the film, the meaning of [the biopic] is both multivalent and interactive."[33] Telling Harvey Milk's story via a heterosexual Hollywood star shapes the meanings offered by the film. The association with the star, according to Van Sant, affected the film on an industrial level by assisting in getting the project the green light and potentially reaching a wider audience than it would with an unknown in the title role. More importantly, however, the very identity of the star has a significant impact on the meanings created; Harvey Milk is filtered through Sean Penn's on-screen and offscreen persona, a persona that Van Sant would have been only too aware of in choosing Penn for the role.

While Penn's on-screen performances have been critically acclaimed, including five Oscar nominations and two wins, he has received a great deal of criticism regarding his offscreen activism and engagement with world politics. The actor has adopted a number of roles within the political arena. In 2002 the actor spent $56,000 on an open letter in the *Washington Post* to President George Bush, criticizing him for violating "every defining principle of this country over which you preside."[34] In 2005 Penn was personally involved in New Orleans recovery efforts after Hurricane Katrina and

made the headlines again in 2010 when he assisted in the Haiti earthquake relief. He has also written news stories for the *San Francisco Chronicle,* the *Nation,* and *Huffington Post* based on humanitarian visits to Iran and Iraq.[35] In 2008 Penn was widely condemned for his interviews with Hugo Chávez and Raúl Castro as the actor responded to what he referred to as the "demonizing of foreign states and leaders."[36] Penn's involvement in world politics has generated more negative press than positive, something the actor is only too aware of: "I do know how hard I make it to appreciate me often," Penn joked during his Oscar acceptance speech. As a political figure playing a political figure, Penn's performance of Harvey Milk is affected and inflected as a result of the identity of the performer. It does not automatically follow, however, that both identities are compatible. A reporter for the gay magazine the *Advocate* castigated the actor for his support of the Cuban and Venezuelan regimes that contradicted Harvey Milk's views on human rights: "Why should anyone care about an actor's politics?"[37] These brief examples illustrate the complex relationship between star and character and correspond with Richard Dyer's notion of a star's "structured polysemy" whereby the star image is revealed for the "multiplicity of its meanings" that can both support and contradict each other.[38]

This complex relationship is echoed in Penn's on-screen persona and performance style. Penn's performances are informed by method acting, an acting process that requires the actor to "find characters *within* themselves, through 'substitutions' of personal experiences for the 'facts' of the text."[39] Penn attributes much of his acting success to Peggy Feury, his first acting coach, who was interested in "how you are going to bring yourself to the material rather than the material to you," a statement that underscores the relationship between actor and character in performance.[40] Penn brings himself to the material in *Milk* not necessarily through the specificity of his politics but instead through his ties with political activism in general. *Milk* is less concerned with one man's sexuality than it is with calling attention to the political struggle over human rights in the 1970s, which speaks to contemporary debates regarding same-sex marriage in the wake of Proposition 8. Similarly, it is not Penn's specific political agenda that interacts with the character of Harvey Milk but rather the more general sense of Penn as a political and politicized figure.

Ultimately, what is at stake in *Milk* is not how believable a performance is—whether or not Penn accurately performs homosexuality—but the performative nature of sexuality and identity that is context-specific and highly affected by intertextual and extratextual information about the performer. The performance of homosexuality is a multifaceted construction that involves more than simply playing gay on-screen. *Milk,* in the final analysis,

Donna Peberdy

self-consciously and explicitly engages not only with the politics of playing gay but also with the politics of performance. Performance is ultimately revealed as a synergistic event characterized by negotiations between the sociocultural, historical, industrial, political, and cinematic nature of identity.

NOTES

The epigraph is from Susan Sontag, "Notes on 'Camp,'" in Fabio Cleto, ed., *Camp: Queer Aesthetics and the Performing Subject; A Reader* (Edinburgh, UK: Edinburgh University Press, 1999), 56.

1. Judith Butler, "Performative Acts and Gender Constitution: An Essay in Phenomenology and Feminist Theory," *Theatre Journal* 40, no. 4 (1988): 520.

2. Judith Butler, *Bodies That Matter: On the Discursive Limits of "Sex"* (London: Routledge, 1993), 95.

3. Judith Butler, "Critically Queer," *GLQ: A Journal of Lesbian and Gay Studies* 1, no. 1 (1993): 24.

4. Phillip Brian Harper, *Private Affairs: Critical Ventures in the Culture of Social Relations* (New York: New York University Press, 1999), 38–39.

5. Donna Peberdy, *Masculinity and Film Performance: Male Angst in Contemporary American Cinema* (Basingstoke, UK: Palgrave Macmillan, 2011), 169–73. See pp. 19–43 for a longer discussion of Butler in relation to masculinity and film performance. Nikki Sullivan provides an accessible and detailed consideration of the theoretical distinctions between performance and performativity in relation to queer theory in *A Critical Introduction to Queer Theory* (Edinburgh, UK: Edinburgh University Press, 2003), 81–98.

6. Wheeler Winston Dixon, *Straight: Constructions of Heterosexuality in the Cinema* (New York: SUNY Press, 2003).

7. Richard Dyer, *The Culture of Queers* (London: Routledge, 2002), 33.

8. Jude Davies and Carol R. Smith, eds., *Gender, Ethnicity and Sexuality in Contemporary American Film* (Edinburgh, UK: Keele University Press, 1997), 104.

9. Ibid.

10. Vito Russo, *The Celluloid Closet* (New York: Harper and Row, 1981).

11. Ibid., 322.

12. Adam B. Vary, "The *Brokeback Mountain* Effect," *Advocate*, no. 957 (February 28, 2006): 39; Harry M. Benshoff and Sean Griffin, *Queer Images: A History of Gay and Lesbian Film in America* (New York: Rowman and Littlefield, 2006), 254.

13. Dyer, *The Culture of Queers*, 133.

14. Erving Goffman, *The Presentation of Self in Everyday Life* (London: Penguin, 1959), 22.

15. Dyer, *The Culture of Queers*, 33.

16. Butler, "Performative Acts and Gender Constitution," 526.

17. Harry M. Benshoff, "*Milk* and Gay Political History," *Jump Cut: A Review of Contemporary Media*, no. 51 (Spring 2009), http://www.ejumpcut.org/archive/jc51.2009/Milk/index.html.

18. Quoted in Lucy Fisher, "Can Macho, Non-Metro Actors Play Gay?," *ABC News*, December 3, 2008, http://abcnews.go.com/Entertainment/Movies/story?id=6378749&page=1.

19. Richard Dyer, "*A Star Is Born* and the Construction of Authenticity," in *Stardom: Industry of Desire*, edited by Christine Gledhill (London: Routledge, 1991), 137.

20. Sonny Bunch, "Sean Penn Overacts as Gay Leader in *Milk*," *Washington Times*, November 26, 2008, http://www.washingtontimes.com/news/2008/nov/26/milk-man/.

21. Scott Mendelson, "*Milk*," *Huffington Post*, December 24, 2008, http://www.huffingtonpost.com/scott-mendelson/review-milk-2008_b_153377.html.

22. Sontag, "Notes on 'Camp,'" 53.

23. Jack Babuscio, "The Cinema of Camp (*aka* Camp and the Gay Sensibility)," in Fabio Cleto, ed., *Camp*, 123.

24. Moe Meyer, "Introduction: Reclaiming the Discourse of Camp," in *The Politics and Poetics of Camp*, edited by Moe Meyer (London: Routledge, 1994), 5.

25. Eric Patterson, "From *Brokeback* to *Milk*: Progress in Hollywood's Representation of Sexual and Gender Minorities," *Rowmanblog*, March 19, 2009, http://rowmanblog.typepad.com/rowman/2009/03/from-brokeback-to-milk-progress-in-hollywoods-representation-of-sexual-and-gender-minorities.html.

26. Dyer, "*A Star Is Born* and the Construction of Authenticity," 138–39.

27. Dustin Lance Black, *Milk: The Shooting Script* (New York: Newmarket, 2008), 6.

28. Goffman, *The Presentation of Self in Everyday Life*, 22.

29. Bunch, "Sean Penn Overacts as Gay Leader in *Milk*."

30. Dennis Bingham, *Whose Lives Are They Anyway? The Biopic as Contemporary Film Genre* (Piscataway, NJ: Rutgers University Press, 2010), 159.

31. In this context, I use Barry King's definition of impersonation as distinct from mimesis to describe the act whereby "in playing any character, the 'real' personality of the actor should disappear into the part." See Barry King, "Articulating Stardom," *Screen* 26, no. 5 (1985): 27–51.

32. Bruce G. Shapiro, *Reinventing Drama: Acting, Iconicity, Performance* (Santa Barbara, CA: Greenwood, 1999), 63.

33. George F. Custen, *Bio/Pics: How Hollywood Constructed Public History* (Piscataway, NJ: Rutgers University Press, 1992), 45.

34. Sean Penn, "An Open Letter to the President," *Washington Post*, October 19, 2002, C3.

35. Sean Penn, "An Open Letter to the President . . . Four and a Half Years Later," *Huffington Post*, March 24, 2007, http://www.huffingtonpost.com/sean-penn/an-open-letter-to-the-pre_2_b_44172.html; Sean Penn, "Mountain of Snakes," *Huffington Post*, November 30, 2008, http://www.huffingtonpost.com/

sean-penn/mountain-of-snakes_b_146765.html; Sean Penn, "Sean Penn in Iran," *San Francisco Chronicle*, August 22, 2005, http://www.sfgate.com/cgi-bin/article.cgi?f=/c/a/2005/08/22/DDGJUEAF041.DTL.

36. Sean Penn, "Conversations with Chavez and Castro," *Nation*, November 25, 2008, 11.

37. James Kirchick, "A Friend to Gays and Antigay Dictators Alike," *Advocate*, December 9, 2008, http://www.advocate.com/Arts_and_Entertainment/Film/A_Friend_to_Gays_and_Dictators_Alike/.

38. Richard Dyer, *Stars* (London: British Film Institute, 1979), 72.

39. Sharon Marie Carnicke, "Lee Strasberg's Paradox of the Actor," in *Screen Acting*, edited by Alan Lovell and Peter Krämer (London: Routledge, 1999), 81.

40. John Lahr, "Citizen Penn: The Many Missions of Sean Penn," *New Yorker* 82, no. 7 (2006): 55.

NEAL KING

Feelings and Firefights

Gendered Performance in Cop Action Climaxes

What are masculinities, and how do we spot them on-screen? Scholars agree that men have found many ways to show that they are not women—for example, as Candace West and Don Zimmerman have shown—by acknowledging ideals of manly behavior even when they don't live up to them.[1] R. W. Connell has argued that a few of those ideals become the most popular and hegemonic at any time and place, known as what makes a man a man and secures men's privileges over women.[2] Scholars of Hollywood action films such as Susan Jeffords have linked several of those ideals to heroism. Men in movies may be "competitive," "athletic," "decisive," "unemotional," "strong and aggressive," and "powerful."[3] In Hollywood action blockbusters, Richard Sparks points out, "an heroic masculinity [includes] principles of absolute individualism, solitude, probity, and personal resourcefulness."[4] Analysts of cop films such as Melvin Donalson describe masculine "attributes of physical violence, emotional stoicism, and heterosexual proficiency."[5] Philippa Gates, another scholar of cop cinema, makes note of "the qualities associated with traditional masculinity—strength, heroism, virility, and violence."[6]

Because these lists are easy to build but tricky to test, I propose a content analysis to show how masculinity appears in one cinematic context. In any community, masculinity is simply the ideals and behaviors that distinguish men from women. I therefore contrast the depictions of women and men within the climactic scenes of combat in the cop action genre (318 Hollywood films released between 1967 and 2010). Doing so allows me to isolate a single dramatically compelling and structurally consistent forum in which similar character types distinguish themselves by gender.

By definition, heroes perform the most idealized behaviors on-screen, although they also have flaws, and so I pay as much attention to heroic womanhood as to the manhood of starring characters. Only a contrast of women to men among heroes will tell us which stories and cinematic styles define masculinity.

This study is limited in a number of ways by its restriction to a single (broadly defined) genre and within that to a single concluding scene. For instance, my early study of the genre found extensive evidence of bigotry among male heroes but not among female heroes, which expressions tend to cease by the films' climaxes. That aspect of masculinity—another type of corruption—does not appear here as a consequence. In all likelihood, other elements of cop action masculinity are missing as well.

GENRE

The genre in which these climactic scenes appear was developed in Hollywood toward the end of the 1960s, in the context of shifts within that industry and public tension over white male domination in U.S. labor markets and the brutality of police. Notable factors in the process by which producers constructed this genre are abundant. For instance, the releases during 1967–73 of studio franchises about police were significant, such as *In the Heat of the Night* (1967) and its two sequels; *The French Connection* (1971) and its sequel; *Dirty Harry* (1971), which spawned four sequels; and *Walking Tall* (1973), which has led to three sequels and a remake in the intervening decades. The same years saw the proliferation of blaxploitation and other low-budget crime films in the wake of an industry-wide crisis in (white) family-film production and proliferation of tax shelters for low-budget filmmaking. Many of these centered their stories on cop heroes, leading to the early 1970s' assessment of the cycles and dozens of other such movies by critics as policiers, procedurals, police films, cop movies, etc. And not coincidentally, industry professionals from these years (e.g., Clint Eastwood, Al Pacino, William Friedkin, Robert De Niro, Michael Mann, and John Badham) would go on to star in and/or direct many other such films over the course of the following three decades, providing a certain continuity.

The genre formed from repeated successes written, produced, and marketed in similar ways, often with overt references to the most profitable hits. Such production waned toward the end of the 1970s (after the U.S. government ended the tax breaks for low-end production) but resumed in the 1980s and enjoyed greater output due to many other developments. Successes included such early interracial male-buddy cycles as *48 Hours*

(1982), *Beverly Hills Cop* (1984), *Lethal Weapon* (1987), and *Die Hard* (1988) and then later *Men in Black* (1997), *Rush Hour* (1998), and *The Fast and the Furious* (2001) and the eventual involvement of women in such buddy films in the 1990s and 2000s. R-rated action was also injected into the cop-centered serial killer film, with the inclusion of women as stars to further add audience appeal; the most popular examples would be in the Hannibal Lecter cycle (five films from 1986 to 2007, two of which star women). Also crucial was the stardom of behemoths such as Arnold Schwarzenegger, Sylvester Stallone, Bruce Willis, Denzel Washington, and Steven Seagal and some female stars with much shorter cop action resumes, including Jennifer Lopez, Sandra Bullock, and Angelina Jolie.

Over the course of these developments, Hollywood's repeated use of stars, settings, plot points, and marketing materials taught audiences to recognize instances of the genre well enough that consumers often refer to generic precursors in their assessments of new films.[7] Still, as a joint accomplishment on the parts of so many producers and consumers over decades, cop action maintains unstable boundaries and overlaps with such genres as comedy, drama, science fiction, and horror. For the purpose of this study, however, I impose criteria for selecting the 318 cop action films as the population that this study samples. This population includes every feature film produced by U.S.-based companies and released to cinemas between 1967 and 2010 that focused on heroes publicly employed or recruited to solve crime and/or protect citizens and featured the PG- or R-rated violence of the post–Production Code era.

An explanation of the term "cop action hero" will clarify the criteria by which I chose films. A cop is a current or retired public law enforcement employee engaged in the solving of domestic criminal cases or the protection of people from violence.[8] Action refers to the prominent display of violence graphic enough to earn (depending on year of release) the PG, PG-13, or R ratings given by the Motion Picture Association of America since the end of the Production Code's ban on graphic violence in the 1960s.[9] A hero is the character who spends at least as much time on-screen as any other character and whose personal trials receive as much attention as those of any other character. Some films feature pairs of heroes (and in two cases three heroes) who receive comparable amounts of screen time, billing as stars, and attention to personal lives and contributions to the solutions of the cases. For the sake of convenience, the following discussion refers to heroes as women and men.

I analyze climactic scenes by viewing the final passages of the seventy-eight films in this sample. I define the climax as beginning at the moment when the hero and villain meet on the scene of their final conflict and

The surviving hero of *Brooklyn's Finest*, himself a customer of the sex trade, strangles a brutal pimp.

ending once the film cuts to the credits or to another location when that battle is done. The average scene is five to six minutes long (the women's last a minute longer than the men's on average).

RELEVANT ELEMENTS OF THE FILMS

Scholars of gender in film have identified a range of sex differences in cop action, which provide a template of expectations to which I compare what I actually found. Beginning with performance, Sparks argues that even the "hyperbolic" masculinity of contemporary cop movies constricts expression to a narrow compass featuring grief and rage.[10] Nicole Hahn Rafter observes that men in cop movies indulge in tough talk and gallows humor, whereas women comport themselves with fewer insults to others.[11] Gates contrasts the empathy, nurturance, and gentleness that women display to the violence with which men express themselves.[12] She also notes how this can play out at the level of physical activity: "the male model, despite being the object of the gaze, must disavow his seeming passivity if he is to remain aligned with the dominant ideal of masculinity as a body of action."[13]

In terms of film style in crime cinema, Rafter notes both the visual depiction of Mike Hammer as larger than other characters and that of "Dirty" Harry Callahan as master of his urban domain through the use of tracking long shots on his movements.[14] Yvonne Tasker argues that "image-makers sought to present women as active and as powerful, mobilizing already-existing types and conventions ... such as the leather-clad dominatrix."[15] She also notes a fetishistic representation of female power in blaxploitation.[16]

Cop action plotting also differs by gender of hero. Linda Mizejewski describes a decades-old "FBI-girl" plot in Hollywood police stories in which a

heroine operates as a rookie undercover, romancing the criminal she is assigned to bring down and thus mixing sex with her work.[17] Dole and Gates contrast the independence and nonconformity of male heroes to the dependent, cooperative virtue that women more often evince, suggesting that men are more likely to conflict with superiors at work.[18] Tasker also reports the "emergence of a generation of action heroines who are positioned in a very close relationship to the law" in the cinema of the 1980s and 1990s.[19] Sparks observes that in Hollywood police and private eye movies, there is a heroic masculinity that distinguishes itself with its integrity from a "constraining (and frequently corrupt) social world."[20]

A number of scholars note the large size and physical toughness of male heroes and suggest that contemporary cinema has offered an especially hard or "hyperbolic" version of such manhood.[21] Dole and Gates contrast the physical dominance of the traditional hero role to the relative weakness of conventional womanhood.[22] And men may be crude as well as hard. Donalson notes the sight gags and one-liners about homosexuality that litter cop movies such as *Bulletproof* (1996).[23] Tasker further suggests that sexual threats to men are more heavily veiled than are those to women.[24] In an early study I found evidence of such sexual violence allusion in battles between men across the genre, all that talk about "fucking" "assholes" that amounts to a sexual subtext.[25]

Dole argues that women have traditionally been cast in the roles of protected ones, with male characters serving as their violent protectors.[26] Indeed, when women do engage in violence, it may be more constrained by narrative context than men's violence would be. Tasker argues that the rape-revenge motif of women's heroism maintains the understanding of "the heroine as vulnerable figure alongside her move into action, into a narrative of revenge."[27] Tasker also argues that for female characters of action genres, "vulnerability is expressed through the mobilization of traits associated with femininity, most particularly with a softness or lack of definition that might allow the body to be fatally penetrated."[28] Thus, we might expect to find men to be larger, stronger, more profane, and more mobile but less emotionally expressive on-screen, fetishized as more powerful but less sexually available than women tend to be. Men should appear more independent, less tied to lovers, their bosses, and the forces of corruption around them. Women, by contrast, should appear more often in roles as victims requiring salvation.

The narrative, stylistic, and behavioral details that convey these differences between the sexes are difficult to study over a large set of films, even as they play out in a single type of scene. I therefore resort to a sample of 52 of those starring men (randomly selected from the original population of

The hero of *Demolition Man* beheads his opponent at the end of several minutes of battle.

318 films) to compare to the 26 films that star women in the genre. I focus on cop action because film types can differ widely in their presentations of heroic characteristics. Study of the generic repetition of this one scene allows us to answer questions about collective understandings of masculine heroism. Although this analysis involved several hundred individual observations, I report only the most relevant gender differences here for the sake of brevity.

Emotions and Film Style

Women are more than twice as likely as men to exhibit, in a single scene, a range of emotions from grief to fear, perhaps because they are more likely than men to be doing violence to (former) loved ones in their climactic battles. Men, by contrast, are twice as likely to express only rage and are more apt to mask their feelings. These films frame emotional display in a variety of ways, from the larger structure of the plot as well as the design of sound and editing to the composition of shots. The most striking gender difference is that men are only one-fourth as likely as women to be photographed in close-up for more than an exceptional instant. Quick close-ups for men are mostly limited to dramatic entrances, sympathetic glances at hostages, or grief, whereas a number of the women's films feature many close-ups, drawing repeated attention to their heroes' unspoken responses.

Men are also far less likely than women to appear in nonrealistic costumes that call attention either to sexual display or to the awkward positions of undercover operations (nearly a third of the women appear so, contrasted to just one of the men). The most outlandish costumes appear in the blaxploitation films (DEA agent Cleopatra Jones dresses like a model

in designs that appear garish even for the 1970s), the serial killer fantasy *The Cell* (2000), and the comic *Miss Congeniality* films (2000, 2005), which put their undercover hero through a beauty pageant and a Vegas floorshow. I found no corollary to such costuming among the men, although *Lethal Weapon*'s hero is topless for a final duel.

Only men in the genre use motor vehicles and artillery to kill. Only men engage in the *Lethal Weapon/Die Hard*–style wrestling matches that end in coups de grâce delivered by handgun. These large-scale forms of combat distinguish masculinity, whereas women are more likely to use handguns after long moments staring into the eyes of those they must kill. Women's battles are more emotionally laden and more intimate, even if they result in death just as often.

Thus far, we have learned that divergences by gender confirm hypotheses derived from the scholarship on masculinity in film. I turn next to findings that come as more of a surprise.

CORRUPTION, VULNERABILITY, AND SEXUAL VIOLENCE

Men are far more likely than women (60 percent compared to 16 percent) to fight those who have attacked them in the past and to fight corrupt colleagues and bosses. Women, by contrast, are a lot more likely to battle intimates and other loved ones (38 percent to 4 percent).

As expected, men are more likely to disobey their orders, but that difference is accounted for by men's relatively high chances of having dirty bosses who give wrongful orders rather than any greater tendency to break rules or the law. In other words, the finding is not that women are more rule-bound as they do their cop work (as expected by the literature) but rather that they do not battle corrupt authorities. Contrary to Sparks's argument about such battles over corruption, more than a third of all of the dirty cop stories feature heroes who have sins on their heads (and one of those, in *Insomnia* [2002], dies for his crimes). None of the women are so tainted. Corruption, not vigilantism, thus turns out to mark masculinity. And that manly taint extends to violence as well.

In a counterintuitive finding, men turn out to be twice as likely as women to require the intervention of others in order to survive. For example, the hero of *Blown Away* (1994) is pulled from an inferno by his partner, and similar last-second rescues by otherwise nebbishy sidekicks occur often enough in male-bonding buddy movies that it amounts to a cliché of the genre.[29] Such masculine vulnerability is further highlighted in films in which men die despite attempts at rescue by loyal sidekicks, as in *Insomnia*, *FeardotCom* (2002), and *Brooklyn's Finest* (2009). And such films represent

the genre's larger pattern in heroic mortality: only male heroes die, and they do so only when involved either in corruption (a popular male-centered plot type in which only one female hero, such as *Rush* [1991], is featured) or in struggles against supernatural villains. The latter may be a product of the genre's overlap with horror; the former is a convention shared with hard-boiled fiction and is virtually a masculine preserve.

To see the moral contrast most starkly, consider the distance between the simplicity and minimalism of the woman-centered detective thriller *Untraceable* (2008) and the extensive moral complications of the dirty cop stories in *L.A. Confidential* (1997) and *Brooklyn's Finest*. The former plot features the straightforward tracking and shooting of a serial killer, complicated only by the hero's brief time as the killer's bound potential victim. In the climax of *Untraceable,* a ten-minute scene extended in length by being intercut with the fruitless attempts of her colleagues to intervene, the hero barely touches the criminal. She burns him with a steam pipe so that she can free herself from her bonds, briefly beats him in order to take control of his sidearm, and shoots him to death with no further discussion. The fight takes a minute. She then displays her police badge to indicate that crime is stopped and that spotless law is back in control of the situation. On-screen text shows that the attention-hungry killer has gained a supportive audience, but their voyeurism does not sully the hero. The film paints its tale of crime's defeat in moral black and white. The hero is waylaid by a madman but is untouched by his deviance.

On the opposite end of the genre's continuum of complexity, the stories of *L.A. Confidential* and *Brooklyn's Finest* tell of three heroes each, all six of them steeped in police corruption. Three of those men die on-screen, shot by criminals and fellow cops (who, in one case, is both police captain and crime boss), and the other three barely survive their descents into organized crime and vice. *L.A. Confidential* climaxes with a firefight between two groups of cops that lasts nearly six minutes. The two heroes each watch as the other is nearly shot to death. One is rescued by the physically intimate violence characteristic of men's fights (his partner stabs the villain in the leg, only to be shot through the face in return). Once rescued by his wounded partner, a hero negotiates with his villainous boss. After that hero appears ready to descend even deeper into corruption, he instead shoots his boss in the back. (And in the film's coda, he covers up the corruption in trade for advancement of his career.)

In extended conclusion of *Brooklyn's Finest,* three heroes end their stories on the same night in an urban apartment block. There, one is killed as he attempts to steal money from a drug gang he has just slaughtered for that purpose. Another hero is shot to death by a fellow cop for

assassinating an unarmed man on the street outside. In the final climax, which lasts for about four minutes, the third hero rescues enslaved prostitutes from brutal pimps, whose crimes he had ignored in his own exploitation of women on the street where they work. He cuffs one pimp and draws his weapon on the other, who mocks him for his vice ("Your motherfucking ass was running around Chinatown with your dick in your hand, right?"). The hero shoots the defiant pimp point-blank and then grapples with him for more than a minute. As terrorized women scream and stay clear of the fight, the male combatants pummel and throw each other around the room in a vicious struggle, which ends with the pimp's strangulation. (The rescue of sexual slaves by otherwise compromised heroes amounts to a salvific trend, appearing in such dirty cop movies as *The Corruptor* [1999] and *Street Kings* [2008]; sullied cops who free the slaves survive the final battles.)

These physical fights are extended and bloody (the conclusion of *Brooklyn's Finest* features eight killings, while *L.A. Confidential*'s includes nine). The carnage and the blood-spattered heroes' roles in it suggest that men involved dive deep into pools of vice. By contrast, the hero of a serial killer movie such as *Untraceable* dispatches her duty with a minimum of fuss, bears no stain of crime, and requires no aid from others. Thus does the genre divide women from men, efficient keepers of the law on the one side and hobbled players soaked with blood and vice on the other.

This matter of corrupt masculinity extends to its presentation of sexualized violence, one complicated enough to merit its own discussion. The short version is that the sexuality of violence becomes less obvious but more allusively pervasive when men assume hero roles. Men exchange blows at greater length than women do, but men's exchanges are rendered sexual by implication. The long version of that theory requires a review of the politics of sexual violence across the genre.

In an initial study of cop action I found that sodomite puns occur in all types of dialogue between men but that women who speak of sex tend to do so in literal fashion.[30] In *Demolition Man* (1993), for instance, the female sidekick confuses the impulse to "blow [the male criminal] away" with a desire to "go blow this guy." After watching two men fight, she notes that one has "matched his meat" and the other has "licked his ass." The hero corrects her usage ("Blow this guy *away.*") and thus returns the dialogue to the fuzzy allusion that men in the genre prefer.

High-status men have long maintained rules against overt sexual receptiveness, marking as it does submission to a penetrator. They have deferred the receptive position to women and subordinate men. Nevertheless, men's

popular culture teems with allusions to sex and bodily penetration between colleagues and combatants. Historians and analysts of classical literature have argued that such blurring of the boundary between the erotic and the emotionally or physically intense allows people to stigmatize men for the bonding and competing that they do as they struggle over and exchange precious resources.[31] Because the deviance or perversity of men's exchanges can be redefined at any time by anyone, that redefinition amounts to a tool with which people can gain the moral leverage—of blackmail or scandal—on those who might otherwise be too powerful to manipulate. For that reason, the expectation is that allusion to sexual penetration, as opposed to its denotation, would appear most often in the popular depictions of struggles between men.

Indeed, we find overtly sexual contact only in a few of the women's climaxes and in none of the men's. (For example, the titular serial killer of *Hannibal* [2001] dreams of intimacy with the hero and speaks to her of love during their climactic fight. He forces a kiss.) By contrast, violence aimed at men is less overtly sexual but suspiciously dirty instead.

Because *Demolition Man* appears in this study's sample, let us consider its climax as an example. The hero John (Sylvester Stallone) finds the criminal Simon (Wesley Snipes) working in a lab to revive cryogenically frozen convicts. (The story is set in the near future, in which Simon has been revived and the hero has been tormented by a dishonest, totalitarian governor, thus raising the issue of corruption.) The two men set upon each other in a several-minute battle that begins with a round of handgun fire. Bearing in mind the film's dialogue that describes each man's skill at combat, it is tempting to infer that they mean to prolong the fight when they miss with every shot. This foreplay shifts to Simon's use of an industrial claw to grab John by the torso and suspend him in air, who moans in pain as Simon misses with dozens more rounds from his assault weapon. John frees himself from the claw, Simon runs out of ammunition, and the two face off with bare hands.

The scene slows and, in this one passage, resorts to the close-ups that convey depth of feeling. Matching eye lines in wordless close-ups suggest that the two stare each other down as if anticipating the blows to come. Their ensuing dialogue, spoken in slow deliberation, recalls words from a previous battle. They note that they've done this before and imply that they are fated to do it again. A full minute of groin kicks and body blows passes before the two pant their way to a climax. John leans, spent, against a cell holding a prisoner, just as naked and solidly built. Simon approaches this pair with a short spear held erect, savoring the imminent violation of

his longtime foe. "This is the best day of my life," he exults as he prepares to penetrate the man he has known for so long. But John grabs an even more phallic tool (a steel rod, enlarged at one end, containing a bright blue seed that contains the power to kill a man) and brings it down with all his strength, freezing Simon so that John can knock off his head.

It would be difficult to render in clearer terms the allegorical castration of an erect man bent on fucking another. But the phallic metaphor not exhausted, John notices that their violence has shaken the building such that huge rods and balls drop from the killing machinery and shatter on the floor. As explosive pressure builds, John runs for his life, bellowing as balls of steam and flame erupt. A fireball spews from the side of the building as John escapes, and the scene sputters to a halt. John and Simon have fulfilled at last their joint, dirty destiny.

I require of the reader some Freudian indulgence, to be sure. The sexual nature of this scene's violence remains allusive, even if in other moments the characters move toward denotation with their joking dialogue. That battle's fuzzy blend of sex and violence, rather than any clear definition of either, matters most. These combatants have met to fight again only because of corruption on high, which has brought them both to this arena, where their gladiatorial bloodshed serves to contain and resolve state-level strife by settling a personal score. These are powerful men, and the popular culture represented by cop action pictures their struggle as more than slightly perverse, as if to suggest that powerful men are always just a bit too close. The crowds of helpless citizens that team in other scenes are absent from this climax, making it a man-only turf. The combatants wallow in the ill-defined sexual violence that has so often figured in the stigmatizing public depiction of corrupted male bonding. They settle matters between themselves, as if to prevent anyone else from getting dirty or hurt.

My take on such spectacle, framed by this narrative, is that male heroes object both to the violation of others, especially women, by such villains as Simon and his dirty boss, and to the inclusion of those others in the combat at which they are uniquely gifted. Men interpose themselves as the only fitting participants in allusive assault and combat for state power. During their battles, the heroes wallow in the very sodomite bloodshed that they say they aim to quell and demonstrate the combat skills that they say they alone possess. The political move appears to be less cessation of this destructive play than constriction of the dirty, powerful fun to men. Having barred women and most weaker men from the skewering assaults, male heroes hurl themselves into perversity in ways that can seem awfully enthusiastic.[32] In other words, it is not that heroes

find such battles distasteful (at least they never claim that they do and seem to belabor them instead) but rather that they work to keep such intimate violence between men.

The same goes for corruption, the sharing of too many resources between powerful men, the abuse of authority that distinguishes manhood in this genre. Men are often tempted by certain forms of police corruption and are more often victimized by it. They seem keen to keep such struggle to themselves, however, away from women. Along these lines, consider the climax of the cop action episode of *Sin City* (2005), in which the hero interrupts the sexual torture and murder of a woman by the son of a U.S. senator. The hero interposes himself, intending to sacrifice his life for her safety.[33] In the agony of a heart attack, he shoots a few dirty cops dead and then savages the serial killer, ripping his testicles from his body and beating his head to a pulp. The hero sends the surviving female victim away and shoots himself in the head so that the corrupt authorities who wish him dead will finally leave her alone. This is a purely male-oriented story line, full of the political dirt and sodomite brutality in which female heroes rarely engage as well as the physical mortality that they never evince. The story line provides the purest vision of masculinity that the genre offers (emphasizing those qualities by rehearsing the story lines of hard-boiled novels). The mark of this manhood is not towering strength but rather wallowing in power and dirt.

Does this mean that only men engage in cop action's sodomite combat and banter? Systematic analysis of allusion is difficult by definition, and I can provide no counts of its incidence across films. Women among the heroes do at times refer to the men they shoot as "assholes"; women among the sidekicks in this sample sometimes address the men's penchant for sexualized violence, as in *The Enforcer* (the female sidekick remarks upon the phallic metaphors that abound in the hero's dialogue) and the jokes from *Demolition Man* noted above. Female heroes joke about their own reputations for phallic behavior in such films as 2002's *Murder by Numbers* (the hero's colleagues call her "the hyena" for her "mock penis") and draw attention to men's sexual vulnerability with strikes to groins in *Miss Congeniality* and *Fatal Beauty* (1987) and with mocking dialogue in *Copycat* (1995). The hero in *Out of Sight* (1998), threatened with rape by a thug who boasts that he means to "tussle" with her, uses an extending steel rod to beat him and walks away with a dismissive "You wanted to tussle. We tussled." *Cleopatra and the Casino of Gold* (1975) is one of many cop films to make fun of the homoerotic bond between the same-sex cop partners, in that case between women. Nevertheless, the vast majority of sodomite allusion occurs in the conversation and tussling between men.[34]

For a final lesson in gender, power, and eroticized corruption, contrast the finales of *Point Break* (1992) and *Whiteout* (2009). In both films, heroes face off against people for whom they had come to feel trust and affection, both of whom have taken lives in the pursuit of stolen wealth. But these face-offs differ in respect to both violence and vice.

Whiteout tells the story of a U.S. marshal who has chosen an isolated turf, hopefully far from crime, where she hopes to heal the emotional scars left by having killed her dirty partner. Never tempted herself, she has traveled to Antarctica to do her job free of corruption's influence. There she encounters theft and murder nonetheless, and in the climax she discovers its agent, bringing him to justice. *Point Break*, by contrast, tells the story of an FBI agent who sinks deep into corruption as he becomes intimate with a serial armed bank robber. The agent learned halfway through the story who the criminal is but finds himself drawn even closer to the man in a series of scenes notable for their sexual tone, only bringing him to justice at the very end.

In these climactic face-offs, both pairs trade dialogue about greed for money and betrayal of friends. Both criminals regret that anyone was hurt, and both appeal to heroes to be allowed to walk to their deaths in the storms that rage around them. Both heroes concede and watch their former friends wade into forces of nature to die. The similarities in these two scenes are striking.

The difference is that *Point Break* precedes this with a tale of the hero's complicity in some of the destruction caused by male bonding, born of his desire for the intense but ethically questionable comradeship of the criminal. *Point Break* also interrupts their conversation (featuring as it does the sodomite puns characteristic of dialogue of men: "You've got to go down!") with a wrestling match, a couple of minutes of violence in which he gains the upper hand and captures the elusive criminal. In *Whiteout*, by contrast, the criminal's guilt comes as a surprise to the hero (she discovers his guilt by following clues), and they engage in no violence. He is a middle-aged physician who has been kind to her while concealing his crimes, and he is finally contained by the storm and in no position to escape.

After watching his tempter die, *Point Break*'s hero tosses his badge into the water, as if to suggest that he has come to resemble the criminal (which, physically, he does) too closely to enforce the law. By contrast, *Whiteout*'s hero withdraws her letter of resignation, her commitment to the enforcement reaffirmed by her success. These are the gender contrasts drawn by scenes that are otherwise alike: Although heroes solve cases and defeat criminals, enforcing rules about greed and destruction, the men among them wallow in corruption and violence as they do, often

to the point where little separates them from the criminals they hunt. Women, by contrast, dispatch their duties with little fuss and remain incorruptible.

CONCLUSION

This study analyzes masculinity by contrasting the behaviors and cinematic framing of male and female heroes during their climactic battles in cop action films. With this method, the study tests and extends the insights offered by analysts who viewed a few films each by checking them against larger numbers and a systematic sample. This allows both for quality control over generalizations and for a better sense of what men and women do *not* do and thus what defines fictive masculinity. This part of a single genre reveals that to be the emotionally constricted display of an allusively sexual rage in which men hurl themselves into such furious combat against corrupt colleagues and longtime rivals that some require rescue by friends if they are to survive.

This study serves as a corrective to the impression that heroic masculinity entails individualist, virtuous, invincible killing. But what importance might these findings have for films beyond cop action? Winnowing of men's emotions to rage, scorn, and grief comes as little surprise, and the queer reinterpretation of men's bonds in popular culture went far toward exposing the operation of sexual allusion. But the focus on the kinds of relationships that these climactic scenes resolve—with bent colleagues and former tormentors—suggest that combat over state power and the ancient impulse toward personal revenge remain masculine pursuits and might do so in other genres as well. Women engage in the more fearful but also more instrumental dispatch of predators, taking as many lives as men do in these scenes. Women get the job done as well as men do and without dying. Men's violence is both more personal and more central to negotiations of state power because of the corruption so often involved. In that sense men are dirty, caught up in police abuses and personal impulses, less inclined toward dispassionate enforcement of the law. The genre could thus appear to condemn men as the most tempted by corruption and most apt to police it.

Finally, that men more often require rescue by others suggests not hysterical feminization but rather a dual fantasy of victimization and neglect on the one hand and of a warm embrace by those who side with men on the other. By the time they reach the climaxes of their stories, alienated heroes of *The Corruptor, Thunderheart* (1992), *The Enforcer* (1976), *Virtuosity* (1995), and other such films have won, with their violent efforts, the affection of sidekicks and civilians they have recently met or from whom they have

been estranged. Estrangement tends to result from the taint of corruption that hangs over so many heroes, whether they have been falsely accused or have exploited others. Those others are moved by heroes' plights to risk their lives to defend them. As with the final bear hug in *Lethal Weapon,* the hero is made vulnerable by the chances he takes to defend his oppressed world (i.e., the black sidekick and his family from their corrupted military comrades). In return, he comes at last to enjoy that community's protection. "I've got you, partner, I've got you," assures the black senior partner as he wraps his arms around the bloodied and shirtless white man. The dejected hero of *Lethal Weapon,* saved in every way he could be, has found a home at last (and that black sidekick saves the white hero's life at the climaxes of all three sequels). This is cop action masculinity: aggrieved, made vulnerable by its imbrications in corruption and the wild man violence of its sexual battles. The dream is that once men have spent themselves in rivalries and struggles for power, others will rise to their defense.

At this point, with further study needed, we can say that heroic masculinity at least includes elements of corruption, a narrow emotional range, physical vulnerability, a taste for large weapons and sodomite puns in combat, and professional rivalry. These men are hardly paragons, and they don't slaughter more people in their climaxes than women do. They just know how to get their hands dirty.

Notes

1. Candace West and Don Zimmerman, "Doing Gender," *Gender & Society* 1, no. 2 (1987): 125–51.

2. R. W. Connell, *Masculinities* (Berkeley: University of California Press, 1995).

3. Susan Jeffords, *Hard Bodies: Hollywood Masculinity in the Reagan Era* (New Brunswick, NJ: Rutgers University Press, 1994), 35.

4. Richard Sparks, "Masculinity and Heroism in the Hollywood 'Blockbuster': The Culture Industry and Contemporary Images of Crime and Law Enforcement," *British Journal of Criminology* 36, no. 3 (1996): 353.

5. Melvin Donalson, *Masculinity in the Interracial Buddy Film* (Jefferson, NC: McFarland, 2006), 73.

6. Philippa Gates, *Detecting Men: Masculinity and the Hollywood Detective Film* (Albany: SUNY Press, 2006). 29.

7. Space does not permit demonstration of audience attunement. The most obvious incidence of such intertextual reference by fans can be viewed in customer reviews of video releases on such online forums as those provided by Amazon.com. Fans often describe movies by comparing them to others and by doing so attest to their generic status.

8. Private detectives, bounty hunters, and bodyguards count only if they were once publicly employed in the profession and work with cops during the story. Soldiers belong only if they have been recruited to work with police (e.g., with the Secret Service or U.S. Marshals Service) during the stories to solve cases or are employed as military police officers. This definition excludes spies such as CIA agents and many private investigators as well. However, civilians can star as heroes so long as they are recruited by and partner as fellow heroes with appropriate public employees to solve cases.

9. The Motion Picture Association of America once gave relatively violent films PG ratings but no longer does. This study therefore includes PG-rated films only if they were released before the creation of the PG-13 rating in July 1984.

10. Sparks, "Masculinity and Heroism in the Hollywood 'Blockbuster,'" 356.

11. Nicole Hahn Rafter, *Shots in the Mirror: Crime Films and Society,* 2nd ed. (New York: Oxford University Press, 2006), 120, 127.

12. Gates, *Detecting Men,* 28–29.

13. Ibid., 41.

14. Rafter, *Shots in the Mirror,* 120, 122.

15. Yvonne Tasker, *Spectacular Bodies: Gender, Genre, and the Action Cinema* (New York: Routledge, 1993), 19.

16. Ibid., 21.

17. Linda Mizejewski, *Hardboiled & High Heeled: The Woman Detective in Popular Culture* (New York: Routledge, 2004), 113.

18. Carol Dole, "The Gun and the Badge: Hollywood and the Female Lawman," in *Reel Knockouts: Violent Women in the Movies,* edited by M. McCaughey and N. King (Austin: University of Texas Press, 2001), 79; Gates, *Detecting Men,* 35.

19. Tasker, *Spectacular Bodies,* 31.

20. Sparks, "Masculinity and Heroism in the Hollywood 'Blockbuster,'" 353.

21. Ibid., 356.

22. Dole, "The Gun and the Badge," 79; Gates, *Detecting Men,* 35.

23. Donalson, *Masculinity in the Interracial Buddy Film,* 127.

24. Tasker, *Spectacular Bodies,* 169.

25. Neal King, *Heroes in Hard Times: Cop Action Movies in the U.S.* (Philadelphia: Temple University Press, 1999).

26. Dole, "The Gun and the Badge," 79.

27. Tasker, *Spectacular Bodies,* 20–21.

28. Ibid., 17.

29. Jeffords (*Hard Bodies,* 140–77) and Gates (*Detecting Men,* 41) both argue that action genres shifted gears in the 1990s, toning down the violence and depicting heroes as more emotionally expressive. I found no evidence of such shifts at that time, although levels of violence in the genre at large did diminish in the late 1990s when studios began to demand PG-13 ratings. Jeffords also notes an instance in which a cop needs saving by a sidekick, in the 1990 film

Kindergarten Cop (142). Contrary to the implication of her discussion, however, such salvations do not increase in frequency after the 1980s.

30. King, *Heroes in Hard Times,* 156.

31. See Michel Foucault, *The History of Sexuality,* 3 vols. (New York: Vintage, 1988). See also Eve Kosofsky Sedgwick, *Between Men: English Literature and Male Homosocial Desire* (New York: Columbia University Press, 1985).

32. Although the moment precedes the climactic scene, the hero of *Demolition Man* requires his female sidekick to save him from a gunman. The hero thanks her by excluding her from the final battle.

33. This episode of a film anthology stars the frequent cop action actor Bruce Willis and amounts to a short addition to the genre, broadly defined.

34. Jennifer DeVere Brody, "The Returns of *Cleopatra Jones,*" *Signs* 25 (1999): 91–121.

II

PATRIARCHAL PROBLEMS

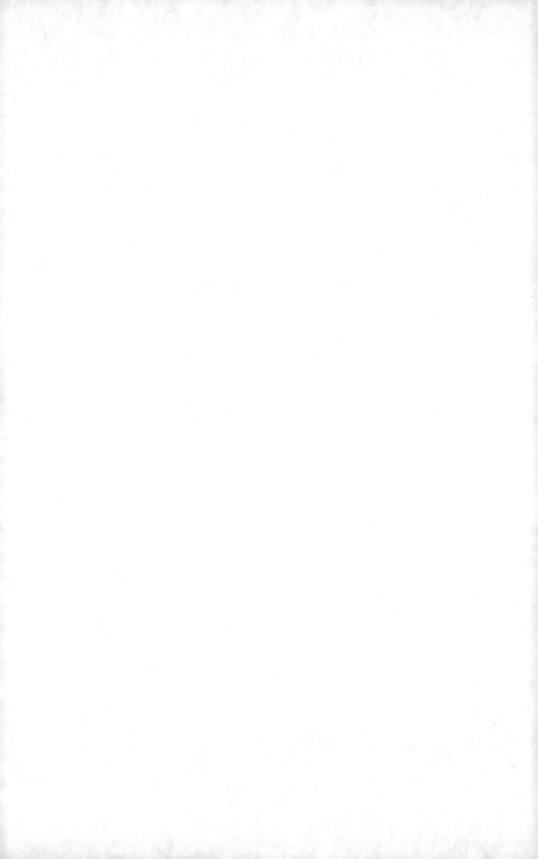

MIKE CHOPRA-GANT

"I'd Fight My Dad"

Absent Fathers and Mediated Masculinities in Fight Club

While there is broad consensus that *Fight Club* (1999) is centrally con-
cerned with masculinity in crisis, there has been less agreement between
scholars about the textual mechanisms through which this crisis is articu-
lated in the film or about how the crisis depicted on-screen relates to lived
experiences of contemporary masculinity. Henry Giroux and Imre Szeman
consider that the film's evident discontent with capitalism and its attendant
social structures is central to the staging of the crisis, which is precipitated
by men's loss of "authentic" masculine identity within a highly developed
consumer culture that "weakens and domesticates men, robbing them of
their primary role as producers."[1] For Giroux, *Fight Club*'s violence offers a
way of restoring a coherent sense of collective masculine identity, provid-
ing men with at least some sort of "concrete experience that allows them
to connect at some primal level."[2] Another academic commentator on the
film, Terry Lee, also regards *Fight Club*'s violence as being the key feature
of the film's ideological economy but argues that this serves a different pur-
pose from the nihilistic last-ditch means for establishing some kind of mas-
culine community that is suggested by Giroux and Szeman's reading of the
film. According to Lee, the violence depicted in *Fight Club* functions as an
allegory, representing the inner turmoil experienced by men as they strug-
gle to develop socially acceptable mature masculinities; the violence is not
literal but instead is a "virtual violence" that allows men to "destroy harm-
ful masculine gender roles, rather than letting harmful masculine gender
roles destroy them."[3] Karen Lee Ashcraft and Lisa A. Flores also focus on
the role of violence in the film, suggesting that it is presented as having a
redemptive quality for men who have lost their sense of an authentic primal

masculine essence as a result of their social positioning within late capitalist consumer cultures in which masculine identities have been transformed into a "fraudulent masculinity akin to femininity."[4]

All of these readings of the film fail to recognize the degree to which *Fight Club*'s treatment of the issues of masculine crisis and the film's use of violence as a way of articulating that crisis are secondary to—and disrupted by—the blurring of the distinction between reality and representation that is the movie's central representational strategy. The stances taken by these scholars assume that there is a fairly straightforward referential relationship between the film text of *Fight Club* and an unmediated exterior social reality. The problem with relying on this assumption when attempting to interpret this particular film is that the vision of social reality presented by *Fight Club* is one in which the dichotomy between reality and representation, between social structures and mediated images of those structures, has broken down within the diegesis to the extent that it is impossible to determine where reality ends and its representational mirror image begins. Representation is *Fight Club*'s major theme, and an awareness of its preoccupation with representation is vital for understanding the way the film depicts masculinity in contemporary society. In this respect, Robert Westerfelhaus and Robert A. Brookey's reading of the film as one that functions as a "ritual exploration of masculinity . . . [that] . . . possesses the attributes of a rite of passage" comes closer than other accounts to recognizing the importance of the film's blurring of the boundaries between reality and representation to its staging of masculinity in crisis.[5] However, while Westerfelhaus and Brookey do identify some of the key ways in which the film articulates its exploration of the real/representational dichotomy, their focus on other questions moves their analysis in a different direction, with the result that the implications of the film's treatment of this dichotomy are not worked out in detail.

In this essay I attempt to address this issue by presenting an analysis of *Fight Club* that focuses on aspects of the film where the blurring of the boundary between real and representational is particularly marked. Although there are numerous elements in this highly intertextual movie that reference this dichotomy, the most sustained exploration of this theme is pursued through the film's deployment of the figure of the absent father and its exposition of the role of this figure in precipitating the crisis of masculinity staged in the movie. This essay therefore focuses specifically on the film's use of this figure and on the narrative devices that follow from its use.

Fight Club's narrative revolves around two key male characters, the unnamed narrator (Edward Norton) and the enigmatic Tyler Durden (Brad Pitt), whose true status as an alter ego of the narrator—a projection of a

Mike Chopra-Gant

fantasy self—is not revealed until late in the film. The narrator is dissatisfied with his professional life, working as a corporate drone for a major automobile company. Equally unfulfilling is his personal life, which is dominated by the consumption of the glossy but ultimately hollow products of global corporate capitalism. As a result, he becomes enervated and develops insomnia. Denied medication by the doctor who examines him, the narrator begins to attend support groups for sufferers of a variety of terminal illnesses and rapidly becomes a support group junkie. Within the nurturing setting of the support groups, the narrator experiences a reconnection with real emotions and achieves an affective release that temporarily cures his insomnia. This is short-lived, however, as the arrival of another tourist, Marla Singer (Helena Bonham Carter), at these support groups begins to restrain the narrator's emotional release and presages the return of his insomnia. The narrator eventually confronts Marla, and they agree to divide the groups between them.

During a business flight the narrator meets Tyler; at this point in the film Tyler is apparently a real individual character. Returning home from his business trip, the narrator finds that his apartment has been destroyed by an explosion. After he explains his situation to Tyler at a local bar, the latter agrees that the narrator can come live with him. Before they return to Tyler's house, however, Tyler asks the narrator to "hit me as hard as you can" in the parking lot of the tavern. The narrator obliges, and a fistfight between the two men follows during which the narrator experiences a far greater emotional release than he had experienced in the support groups. The two men subsequently establish an underground bare-knuckle fighting club that quickly becomes popular with a growing number of men, all anxious to relieve their own dissatisfaction with their lives.

Marla returns to the narrative when Tyler thwarts her suicide attempt and they begin a sexual relationship. As the membership of the fight club grows, Tyler instigates Project Mayhem, ostensibly an anticapitalist movement organized along paramilitary lines and populated by fight club members who under Tyler's instruction conduct attacks on key capitalist institutions. The film ends (as it began) with Tyler holding a gun in the mouth of the narrator (who is now intent on halting Project Mayhem) while they await the destruction of several tower blocks, housing the headquarters of the major credit card corporations, in which members of Project Mayhem have planted explosives. Having discovered late in the film that Tyler is in fact his own alter ego, the narrator realizes that *he* is actually holding the gun. He fires the gun into his own mouth, killing Tyler but only injuring himself. Finally the narrator realizes that *he,* rather than Tyler, has been involved in the relationship with Marla all along. The narrator's

acceptance of their status as a romantic couple is confirmed in the closing scene of the film when he takes her by the hand as they turn to face the new beginning represented by the exploding tower blocks upon which they gaze with anticipation. Conspicuously missing from this description of the film's narrative, however, is the figure whose shadow dominates its inquiry into masculine identity, the absent father.

THE ABSENT FATHER IN POSTWAR AMERICAN CULTURE

The figure of the absent father is not a particularly recent arrival within American popular cultural forms. As I have argued elsewhere, the absent father became an important representational figure in Hollywood movies and other American popular cultural forms after World War II.[6] In the films released immediately after the war, it is possible to identify two distinct modes in which this figure is deployed in Hollywood films. In one mode, the appearance of the figure of the absent father referenced the disruptions to gender relations and familial structures that resulted from America's involvement in the war. This backward-looking use of the figure registered the fact of the mass conscription of men into the armed forces during the war and their consequent absence from family life. The second mode of deployment of this figure, however, looked to the future, to a stable postwar society in which the absence of fathers—by reason of work or business obligations or otherwise as a result of the increase in the breakdown of marriages that began in the early postwar period—would become an unexceptional facet of family life for the baby boomers and later generations. The ubiquity of this pattern of American family life in the decades following World War II is supported by Joseph Pleck's observation that "in the 1950s and 1960s, [the father] became a dominating figure, not by his presence, but by his absence."[7] While I would caution against collapsing this ongoing discourse about absent fathers together with another, more general, transhistorical discourse concerning the crisis of masculinity, the fact that there has in recent years been a rash of publications relating to the effects of absent fathers on the development of masculine identities suggests that the figure of the absent father persists—or otherwise has returned—as a key trope concerning the formation and maintenance of masculine identities.[8]

The absent father is central to the narrative of *Fight Club* and connects the movie to the broader context of contemporary capitalist consumer culture in which the effect of routine paternal absence from the family home on the development of young men's identities has become a recurring theme of discourses about the male subject. As Chuck Palahniuk, the author of the novel upon which the film is based, observes, "Almost all of the book was

based on stories my friends told me. . . . The rest was just a matter of looking for the themes, the topics that brought people together in excited conversation. *The longing for fathers was a theme I heard a lot.* . . . The goal all along was to write a novel based on being with people and listening to them."[9] Fincher's *Fight Club* inherits this concern with the figure of the absent father from the novel. The theme is brought to the foreground shortly after the narrator moves into Tyler's house. While Tyler sits in a bath, he and the narrator have the first of several conversations in which they discuss who they would most like to fight. When Tyler states that he would fight his father, the narrator explains that he had never really known his father:

NARRATOR: I don't know my dad. I mean I know him but he left when I was, like, six years old, married this other woman and had some other kids. He, like, did this every six years. He goes to a new city and starts a new family.

TYLER: Fucker's setting up franchises.

In addition to the literal, corporeal absence of the father from the narrator's family that is apparent from this quotation, the film also represents fathers (who may be physically present) as being so hopelessly deficient in their provision of the guidance and direction needed by their sons that they are absent in a second, more abstract, sense as the crucial socializing influence capable of directing young men toward the development of mature masculine identities:

TYLER: My dad never went to college, so it was real important that I go.

NARRATOR: That sounds familiar.

TYLER: So I graduate, I call him up long distance, I say "Dad, now what?" He says, "Get a job."

NARRATOR: Same here.

TYLER: Now I'm twenty-five. I make my yearly call again, say "Dad, now what?" He says, "I don't know, get married."

NARRATOR: I can't get married. I'm a thirty-year-old boy.

TYLER: We're a generation of men raised by women.

The father constructed by *Fight Club* is therefore physically absent and/or hopelessly deficient as an inspirational role model for young men, incapable even of imagining a role for his sons beyond the restrictive and

stultifying options of corporate careerism and familial reproduction: get educated, get a job, get married. The absence or inadequacy of fathers appears to be a recurring theme in some of Fincher's subsequent movies. In *Panic Room* (2002), for example, the father's absence is instrumental in creating the initial situation that places the family in danger, and when the father arrives in response to their cries for help, he quickly reveals his ineffectiveness against the threat. In *The Curious Case of Benjamin Button* (2008), Fincher combines a father who quickly absents himself from his family with a narrative that places the fatherless hero on a trajectory that sees him move from maturity to infancy, thus recalling one of the key themes of *Fight Club*. Finally, in *The Social Network* (2010) we are given a glimpse of the ultimate result of a culture not as far removed from the pugilistic all-male milieu of the fight club as it might first appear, a corporate masculine culture in which maladjusted loners, bordering on the sociopathic, create fortunes by indulging their unrestrained, infantilized desires: websites that spitefully objectify women replacing the physical brutality of the fight club. In all of these films, the failure of parental socialization—often specifically paternal influence—to provide an effective socializing force leaves young men permanently infantilized.

In addition to linking parts of Fincher's oeuvre, this recurring theme also connects *Fight Club* to a wider range of contemporary discourses about the figure of the absent father expressed in other cultural forms. In his self-help book *Absent Fathers, Lost Sons,* for example, Guy Corneau identifies the absence of fathers as a key source of the identity crises experienced by men today. Corneau adopts a broad definition of "absence," similar to that articulated in *Fight Club:* "the term *absent fathers* . . . refers to both the psychological and the physical absence of fathers and implies both spiritual and emotional absence."[10] According to Corneau, the lack of engaged father figures in modern societies leaves men without a clear sense of identity, since it deprives them of the role models that are crucial to their development into mature men. Corneau suggests that paternal absence inhibits the development of mature masculinities by denying men access to the rituals of manhood that are a distinctive feature of preindustrial societies in which fathers are more involved with their sons. Such rituals are a key element in the development of mature masculinities in those societies, ceremonially marking the end of childhood and the passage into adulthood.

Fight Club's concern with lost rites of passage to manhood is recognized by Westerfelhaus and Brookey, who argue that the film is an example of a recently developed genre of "psychopath" films in which the lost rites of transition to manhood have been replaced with symbolic rituals that guide young men through liminal phases into normative mature

Mike Chopra-Gant

masculine identities.[11] For Westerfelhaus and Brookey, the film itself is a symbolic ritual of transition: "As an expression of this genre, Fincher's *Fight Club* provides its mostly male cultic devotees with a ritual exploration of masculinity, one which we argue possesses the attributes of a rite of passage."[12] Key to this ritual aspect of the film, according to Westerfelhaus and Brookey, is its deployment of the Oedipus myth, which provides "ritual and rhetorical support for mainstream heteronormativity."[13] Westerfelhaus and Brookey are chiefly concerned with questions of male sexuality, with what they see as the film's concern to deploy the Oedipus myth in order to direct male viewers toward the development of mature heterosexual masculine identities, permitting symbolic play with homosexual possibilities only in order to reinforce the inevitability of ultimate submission to the Law of the Father and the compulsory heterosexuality that the normative resolution of the Oedipal scenario entails. As such, their conceptualization of the deployment of the myth in *Fight Club* differs only slightly from the way in which this myth has been deployed in countless earlier Hollywood films and discussed exhaustively in a long line of film scholarship. While I agree with Westerfelhaus and Brookey's analysis in many respects, I view the mode of *Fight Club*'s deployment of the Oedipus myth as different from that observed in many other films: the use of the Oedipal narrative in *Fight Club* should not be understood in the conventional way, simply as evidence of the unconscious operation of powerful psycho-social or cultural forces. Rather, I would argue that the myth is self-consciously deployed in *Fight Club* as an element in the film's critique of late capitalist consumer culture, which routinely absents fathers from family life and attempts to replace the lost father with representations of aspirational masculine figures as substitutes for real fathers in the crucial role of socializing young men to mature masculinities.

FIGHT CLUB, REPRESENTATION, AND OEDIPUS

Fight Club provides numerous hints of its anxiety about the replacement of absent real fathers with iconic images of masculinity and its concern with the impact that this substitution has on the development of coherent, mature masculinities in young men. In one scene this preoccupation is particularly foregrounded. Tyler and the narrator are shown walking down a street and boarding a bus. Standing in the aisle of the bus, the narrator notices an advertisement for Gucci underwear for men. The advertisement features two idealized images of masculinity: images of a model's perfect body, front and rear, stripped almost naked to expose the advertiser's (and the dominant culture's) conception of lean, unblemished, muscular

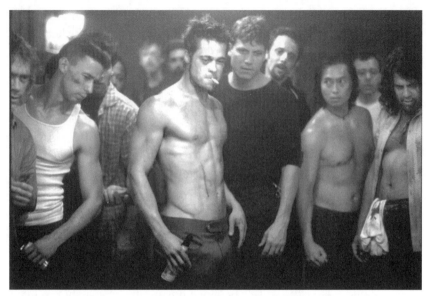

Tyler strikes an iconic pose in *Fight Club*—dangling cigarette, washboard abs, beer bottle alongside bulging crotch—leaving no doubt about the leader of this pack.

masculine perfection. Looking at this image of perfected masculinity, the narrator's voice-over signals the film's rejection of the model of manhood offered by the image and the culture that produced it: "I felt sorry for guys packed into gyms trying to look like how Calvin Klein or Tommy Hilfiger said they should. Is that what a man looks like?" The narrator's mocking question posed to Tyler provokes derisory laughter in response.

Fight Club goes further than simply rejecting the culture's conception of masculine perfection by linking its rejection of idealized images of masculinity offered by the culture more specifically to the figure of the father. Mirroring the scene discussed earlier in which Tyler revealed his desire to fight his father, several other scenes in the movie also feature discussions between the narrator and Tyler about who they would most like to fight. As they board the bus in the scene discussed immediately above, the protagonists talk about which celebrities they would fight, identifying Ernest Hemingway and William Shatner as their targets. In another scene they identify Gandhi and Abraham Lincoln as the historical figures they would most like to confront. Although all of these figures function at the most superficial level simply as iconic, aspirational images of masculinity circulating widely within the culture, they all additionally possess clear associations with paternalism and the figure of the father: "Papa" Hemingway; William Shatner, best known for his role as Captain James T. Kirk in *Star*

Mike Chopra-Gant

Trek, a powerful paternalistic authority figure within the diegetic world of the series and for its legions of fans; Gandhi, the father of the Indian nation; and Lincoln, the father of the Union. These associations signal the film's rejection of the images of paternalistic masculinities offered by the culture in substitution for the absent real father that is also a product of the cultures of the advanced capitalist societies of the West.

Alongside these fragmentary references to the film's ideological rejection of the images of masculinity and fatherhood supplied by the culture, *Fight Club* also engages in a more sustained critique of the replacement of the real by the representational through its incorporation into its own narrative of the Oedipus myth, a key narrative that shaped the understanding of the development of mature masculinities within mass-mediated Western capitalist cultures for much of the twentieth century and one that still retains much of its aura of explanatory power. Sophocles's rendering of the myth of King Oedipus has been comprehensively reworked over time, most notably by Sigmund Freud in his quest for an explanation of the development of male sexuality and subsequently by numerous popularizers of Freud's ideas. However, the basic story of the royal son who unwittingly kills his father and enters a sexual relationship with his mother remains intact in its various manifestations and serves as a highly adaptable cautionary tale about the dangers presented by young men's unwillingness to submit to the authority of their fathers and to conform to the patterns of mature masculinity that are exemplified by the father.

The incorporation of the Oedipal narrative into *Fight Club* is facilitated by the use of the plot device that makes Tyler's character a phantasm of the narrator—an alter ego that has no existence other than as a fantasy projection of the narrator's longing for coherent identity, conditioned by his lifelong exposure to the impossible ideals of masculinity provided by the culture—while withholding knowledge of this status from the viewer until the closing moments of the film, thus preserving Tyler's appearance as an autonomous character in the diegesis for most of the film's duration. When Tyler intervenes to prevent Marla's attempted suicide, they begin a sexual relationship that resurrects the familial setting of the narrator's childhood and enables *Fight Club* to stage its reenactment of the tale of Oedipus. As the narrator's commentary informs us, Tyler and Marla form a couple that is highly reminiscent of his parents: "Except for their humping, Tyler and Marla were never in the same room. My parents pulled the exact same act for years." Caught in a domestic setting with these substitute parents, the narrator experiences a return to infancy, which he explicitly acknowledges at one point: "I'm six years old again, passing messages between parents." For that part of the film in which Tyler

maintains an autonomous existence separate from that of the narrator, therefore, the movie constructs the trio comprised of the narrator, Tyler, and Marla as a familial unit, a simulacrum of the narrator's real family, with Marla and Tyler in the parental roles and the now clearly infantilized narrator positioned as the child of the family.

Tyler's dual identity in the film, being both an autonomous character in his own right and simultaneously an extension of the narrator's identity, is key to the film's reenactment of the Oedipus myth. All of the scenes depicting sexual intercourse between Tyler and Marla take place before the revelation of Tyler's status as a mere projection of the narrator's imaginary. But the later revelation of Tyler's true identity reveals the Oedipal aspect of this relationship within the familial economy established by the film. Although it is only explicitly shown in a flashback sequence late in the film, after the narrator has become aware of his own dual identity, it is the narrator—whom Marla understands to be Tyler—who is her sexual partner. Thus, the child-narrator becomes the sexual partner of the symbolic mother, Marla. The final element necessary for *Fight Club*'s reenactment of the Oedipal scenario is provided when the relationship between Tyler and the narrator becomes increasingly antagonistic later in the film: the ritualized aggression of the fight club mutating into a genuine hostility that culminates in the narrator's killing of Tyler, the symbolic father, in the film's final moments. The death of Tyler, while the narrator is merely wounded, is an aspect of the film that critics have tended to regard as a mysterious or anomalous element, but this evaluation is indicative of a tendency to approach the film from an overly literal realist perspective that is insensitive to the figurative representational strategies that are central to *Fight Club*'s symbolic economy. Viewed from a realist perspective, to call this aspect of the film "mysterious" is a considerable understatement. From a realist viewpoint, this incident and much of the latter part of the film verges on the nonsensical. Viewed as a self-conscious symbolic reworking of the Oedipus myth, however, the death of Tyler and the survival of the narrator is not only entirely coherent but is essential to the resolution of the Oedipal narrative, representing the killing of the symbolic father by the symbolic son who then becomes the sexual partner of the symbolic mother.

It is important to recognize that there is a difference between the modality of *Fight Club*'s incorporation of the story of Oedipus into its narrative and that through which this tale has been inserted into countless other Hollywood productions. The idea that many of Hollywood's films symbolically restage the tale of Oedipus has been a cornerstone of film studies for several decades, and the presence of the Oedipal scenario in mainstream movies has generally been understood as symptomatic of underlying,

Mike Chopra-Gant

unconscious, and inescapable preoccupations of the cultural surround in which these movies were produced and in which they circulate. In *Fight Club*, however, the incorporation of this myth does not signal the operation of the cultural unconscious but is a cognizant act that is key to the movie's articulation of its vision of masculinity in crisis and its exploration of the central role played by the absent father in producing that situation. In *Fight Club*, the restaging of the Oedipus myth is worked into the narrative as yet another—and perhaps Western capitalist culture's most pervasive—representation of masculinity: a narrative, self-consciously told within the film's own narrative, of a boy's accession to manhood through his destruction of and substitution for the symbolic father.

As discussed earlier in this essay, the bifurcation of the narrator's persona into two individuated characters—Tyler and the narrator himself—is crucial to the staging of the Oedipus myth within *Fight Club*'s narrative. Also key to the film's solution to the masculine identity crisis is that it causatively relates to the replacement of absent fathers with symbolic, ideal masculinities. Near its end, the film reveals that the narrator's dual identities are embodied in the one person. This quality of being simultaneously two-yet-one facilitates the resolution to *Fight Club*'s problematic. For that part of the film in which the separation of the characters of the narrator and Tyler serves this end, the tension between these two characters represents the conflict between son and father in the film's Oedipal subtext. However, because both identities are also embodied in the same person, the film's proposal is that the problems of masculinity presented by the movie—the loss of a clear sense of masculine identity, the infantilization, and the feminization of the male—are ultimately internal psychological problems of the male subject that can and must be confronted and overcome internally. At certain points the film seems to want to attack the culture of late capitalism that has habitually absented fathers from family life and to ridicule the therapy culture that this situation has produced. However, by making the destruction of Tyler, the father figure, the gateway to a new beginning for the bloodied but still surviving narrator, *Fight Club* ultimately reproduces the very same idealist remedies at the heart of the therapy culture that the film appears to set out to satirize. *Fight Club* proposes that the solution to the problems of masculinity that flow from the absence of fathers lies not in social change—the creation of a culture in which fathers are not routinely alienated from family life—but instead in individual men reconciling themselves to paternal absence as an inevitable fact of life within advanced capitalist cultures and investing their energies in the pursuit of the heterosexual romantic relationships that will ensure their own eventual accession to the role of (absent) father.

The final element of *Fight Club*'s examination of the importance of representation in the development of masculine identities and the maintenance of patriarchal gender relations is its development of its narrative along lines that closely follow the generic structure of the romance. Scholars of the romance genre have developed a detailed picture of the structural and thematic elements of romance narratives. While there are, of course, variations in detail, romance narratives generally describe the formation of a relationship between a woman and a man of higher social status. The relationship is initially antagonistic and remains so for some time until a misunderstanding is clarified, allowing a new tenderness and intimacy to develop between the protagonists, who are finally able to declare their mutual love and enter fully into a committed romantic couple.[14]

Although the narrator of *Fight Club* may not be precisely the "aristocratic male" Radway identifies as the hero of the romance, there is undeniably a chasm between the social status of this professional white-collar high-rise condominium–dwelling man and that of impoverished bohemian outsider, Marla: the heroine of this unusual romance.[15] Conforming to the generic pattern of the romance, the relationship between Marla and the narrator is highly antagonistic at the outset. When he regularly begins to encounter Marla at the support group meetings he has been attending, the narrator finds that he can no longer achieve the emotional release he had been experiencing at these meetings—he just cannot cry with another "tourist" present—and so his insomnia returns. He confronts Marla, and while she appears to regard the encounter as a prelude to the development of an intimate relationship with the narrator—her facial expression revealing evident pleasure as she rests her head on the narrator's chest during their one-on-one session—the narrator is determined to maintain the emotional distance between them: he insists that they split the groups so that they need not encounter each other again.

Central to the generic romance narrative is a concern with problematized identity. According to the model offered by Radway, in the conventional romance narrative the identity of the heroine is cast into doubt early in the story. *Fight Club* reverses the gendering of this aspect of the generic narrative structure, making the male protagonist's identity its central problematic. Adopting a different name for each of the support groups he attends, the narrator's real identity is never revealed. Marla receives no reply when she asks directly, "Who are you? Cornelius? Rupert? Travis? Any of the stupid names you give each night?" Her conversation with the narrator is abruptly terminated before an answer can be given, and the viewer is left

Tyler and the narrator form a most unconventional couple in *Fight Club* through crime, consumption, and contempt.

with no clue as to the narrator's true identity. In the early part of the film the only indication given of the narrator's identity is inextricably linked to his status as a consumer. In one of the film's most visually striking scenes, the narrator is shown in his apartment ordering goods over the phone from an IKEA catalogue. At the same time he reflects on the key role played by consumer goods in defining identities in late capitalist consumer culture: "What kind of dining set defines me as a person?" This link between consumption and the narrator's sense of the coherence of his own identity is reinforced in a later scene, shortly after the destruction of his apartment and its contents, when he remarks to Tyler, "I had it all. I had a stereo that was very decent; a wardrobe that was getting very respectable. *I was close to being complete*" (my emphasis). The fragility and instability of an identity founded on consumerism is, however, exposed by the destruction of the goods by which he has defined himself. In a later scene he explains to the detective investigating the explosion, "That was not just a bunch of stuff that got destroyed; *it was me*" (my emphasis).

With the problematic nature of the narrator's identity established in its early parts, the film then progresses through a sequence of narrative events that closely follows the generic narrative structure described by Radway. There is clear antagonism between Marla and the narrator throughout most of the film, and as a result of the duality of the identity of the narrator/

Tyler, the narrator's response to Marla clearly exhibits the ambiguity that, according to Radway, characterizes the early relationship between the hero and heroine of the romance. Marla explicitly registers this ambiguity when she later summarizes their relationship: "You fuck me then snub me. You love me, you hate me. You show me your sensitive side, then you turn into a total asshole." This antagonism results in the separation of Marla from the narrator. However, when the narrator realizes that he and Tyler are one and the same person, his attitude toward Marla and their relationship changes. The later parts of the film thus deal with the reconciliation of this romantic pair. This is clearest in the closing moments of the film in which the narrator, now fully self-aware, assures Marla that "everything's gonna be fine" and embraces a traditional masculine role within the heteronormative romantic couple, taking Marla by the hand as they turn to watch the destruction of the tower blocks containing the records of the credit card companies, an event that symbolizes the erasure of existing identities and the creation of a new identity for the narrator—as lover and inheritor of the father's authority—as he accedes to his normatively prescribed role within the generic romance script.

CONCLUSION

In his account of the political and social realities that confront individuals living in the advanced capitalist economies of the West, Guy Debord suggests that the defining characteristic of these societies is a separation between lived reality and its representation: "All that was once directly lived has become mere representation."[16] Although at one level on which *Fight Club* can be understood the alienation of men from authentic lived experience within late capitalist consumer society appears to be the target of the film's critical impulse, ultimately the film ends up endorsing the conformist vision of social organization reified in late capitalism. For this reason, critics who view the film as a kind of call to arms for disgruntled males and perceive a worrying celebration of male violence, misogyny, and neofascistic homosociality in the film's superficial paean to a more authentic masculine experience actually have very little to fear from *Fight Club*. The film ultimately rejects the possibility of a reality that is clearly distinguishable from representations of itself and resolves the problematic of masculine identity in late capitalist consumer culture not by reconnecting the male subject with a more authentic primal masculinity (as some critics suggest) but instead by reinserting the male subject into one of the culture's most traditional and conservative narrative forms, the romance. Although *Fight Club* does interrogate the problem of masculinity in capitalist culture, it

Mike Chopra-Gant

does so only in order to ultimately assure us of the inevitable continuation of long-established traditional structures of gendered identity and relationships between men and women.

For all its appearance of hip cultishness and its superficial rhetoric of subcultural resistance to the norms of late capitalist consumer culture, *Fight Club*'s ultimate message is a highly regressive one: the crisis-ridden masculinity that it makes its key theme is the result of nothing more than individual maladjustment that can only be addressed by individual men becoming reconciled to their prescribed positions in a long-established network of rigidly normative familial and work relationships. Although the film appropriates—at least superficially—the rhetorical tone of writers such as Robert Bly, who sought to promote in modern men a greater consciousness of the "essential" primal masculine instincts of the hunter-gatherer past and who envisaged a strengthening of the uniquely masculine bond between fathers and sons as being key to the development of mature masculinities, in *Fight Club*'s worldview there is not destined to be a cathartic rapprochement between fathers and sons, leading to the development of new, more nurturing, forms of masculinity.[17] Fathers will remain absent, distant figures, alienated from family life, their role in socializing their male children to more mature masculine identities having been passed on to media representations of manhood. While the film acknowledges that a prolonged period of male infantilization may be a result of this estrangement, the eventual movement of young men toward more mature masculine identities will continue to be conditioned by representations of the idealized masculinities provided by myths, narratives, and other representations and by generic/gender scripts that guide young men and women to what *Fight Club* presents as their inevitable place in an essentially unaltered patriarchal order.

NOTES

1. Henry Giroux and Imre Szeman, "IKEA Boy and the Politics of Male Bonding: *Fight Club*," *New Art Examiner* (December 2000–January 2001): 60.

2. Henry Giroux, "Private Satisfactions and Public Disorders: *Fight Club*, Patriarchy, and the Politics of Masculine Violence," *JAC: A Journal of Composition Theory* 21, no. 1 (Winter 2001): 16.

3. Terry Lee, "Virtual Violence in *Fight Club*: This Is What Transformation of Masculine Ego *Feels* Like," *Journal of American and Comparative Cultures* 25, no. 3 (2002): 419.

4. Karen Lee Ashcraft and Lisa A. Flores, "'Slaves with White Collars': Persistent Performances of Masculinity in Crisis," *Text and Performance Quarterly* 23, no. 1 (2003): 15.

5. Robert Westerfelhaus and Robert Brookey, "At the Unlikely Confluence of Conservative Religion and Popular Culture: *Fight Club* as Heteronormative Ritual," *Text and Performance Quarterly* 24, no. 3/4 (2004): 307.

6. Mike Chopra-Gant, "Absent Fathers and 'Moms,' Delinquent Daughters and Mummy's Boys: Envisioning the Postwar Family in Hitchcock's *Notorious*," *Comparative American Studies* 3, no. 3 (2005): 361–75; Mike Chopra-Gant, "Representing the Postwar Family: The Figure of the 'Absent Father' in Early Postwar Hollywood Films," in *Screen Methods: Comparative Readings in Film Studies*, edited by J. Furby and K. Randell, 109–17 (London: Wallflower, 2006); Mike Chopra-Gant, *Hollywood Genres and Postwar America: Masculinity, Family and Nation in Popular Movies and Film Noir* (New York: I. B. Tauris, 2006).

7. Joseph Pleck, "The Theory of Male Sex-Role Identity: Its Rise and Fall, 1936 to the Present," in *The Making of Masculinities: The New Men's Studies*, edited by H. Brod, 21–38 (New York: Routledge, 1987), 35.

8. See, for example, S. Osherson, *Finding Our Fathers: How a Man's Life Is Shaped by His Relationship with His Father* (New York: Fawcett Columbine, 1986); A. Pirani, *The Absent Father: Crisis and Creativity* (London: Arkana, 1989); A. Mitscherlich, *Society without the Father: A Contribution to Social Psychology* (New York: HarperCollins, 1993); J. M. Ross, *What Men Want: Mothers, Fathers and Manhood* (Cambridge, MA: Harvard University Press, 1994); P. Rosefeldt, *The Absent Father in Modern Drama* (New York: Peter Lang, 1995); M. E. Lamb, ed., *The Role of the Father in Child Development* (New York: Wiley, 1997).

9. Chuck Palahniuk, *Fight Club* [DVD booklet] (London: Vintage, 2003), (my emphasis).

10. Guy Corneau, *Absent Fathers, Lost Sons* (Boston: Shambhala, 1993), 12–13.

11. Westerfelhaus and Brookey, "At the Unlikely Confluence of Conservative Religion and Popular Culture," 306.

12. Ibid., 307.

13. Ibid.

14. See the "narrative structure of the ideal romance" described by Janice Radway, *Reading the Romance: Women, Patriarchy and Popular Literature* (Chapel Hill: University of Carolina Press, 1984), 134–35, and the account of the formula of Harlequin romances in Tania Modleski, *Loving with a Vengeance: Mass-Produced Fantasies for Women* (New York: Routledge, 1990), 27–50.

15. Radway, *Reading the Romance*, 150.

16. Guy Debord, *The Society of the Spectacle* (New York: Zone Books, 1994), 12.

17. Robert Bly, *Iron John: A Book about Men* (Shaftesbury, Dorset, UK: Element, 1991).

Chris Robé

"Because I Hate Fathers, and
I Never Wanted to Be One"

Wes Anderson, Entitled Masculinity, and the "Crisis" of the Patriarch

Within masculinity studies, it has become something of a mantra to proclaim white heterosexual American masculinity in "crisis." According to Bryce Traister, this "crisis theory" relies upon a two-pronged approach: "One is rooted in a new historiography of American masculinity that locates instability at the base of all masculine identities constructed within American cultural matrices; the second is derived from Judith Butler's influential theoretical account of gender as always performative and contingent."[1] Men's anxieties supposedly result from their unstable identity formation and tentative control of public and private realms. Yet many scholars remain skeptical of the ability of such crises to significantly threaten patriarchal power. In *Feminism without Women*, Tania Modleski warns that in addressing any "crisis" in masculinity, "we need to consider the extent to which male power is actually consolidated through cycles of crises and resolution."[2] Recent U.S. cinema provides a germane example of masculine crisis and consolidation at work through its ambivalent stance toward the traditional authoritarian father operating within films such as *Magnolia* (1999), *American Beauty* (1999), *There Will Be Blood* (2007), *The Road* (2009), and, most recently, *Tree of Life* (2011). Stella Bruzzi notes that "Much of 1990s' Hollywood dispenses with him, but ultimately it seems to protest that the traditional father is what we want." Along similar lines, this attraction/repulsion toward the authoritarian father pervades recent commercial cinema.[3]

Strangely absent from Bruzzi's account, however, are the films of Wes Anderson in which ambivalence toward the traditional father plays a central role. In particular, *Rushmore* (1998), *The Royal Tenenbaums* (2001), and *The Life Aquatic with Steve Zissou* (2004) share a central tension that

simultaneously venerates the patriarch while also exposing the psychic traumas that result from men's desire to perform what I call entitled masculinity: a form of masculinity that embodies the mandates of social privilege of the white upper-class heterosexual male world.[4] On one level, Anderson's films explore the emotionally debilitating crises that result from the affective foreclosures necessitated by entitled masculinity. Yet on another level, they remain entranced by the patriarch and consolidate his power by making him their narrative focus while marginalizing alternative viewpoints that detract from his centrality. As a result, Anderson provides us with a nuanced body of work to investigate the contradictory ways in which entitled masculinity operates within contemporary Hollywood cinema.

In general, Anderson's films interrogate the central tenets that have defined entitled masculinity since its origins. As Michael Kimmel notes, masculinity gradually replaced the notion of manhood during the fin de siècle:

> *Manhood* had been understood to define an inner quality, the capacity for autonomy and responsibility, and had historically been seen as the opposite of *childhood.* . . . At the turn of the century, *manhood* was replaced gradually by the term *masculinity,* which referred to a set of behavioral traits and attitudes that were contrasted now with a new opposite, *femininity.* Masculinity was something that had to be constantly demonstrated—lest the man be undone by a perception of being too feminine.[5]

Unlike manhood, which was defined as a stable "inner quality," masculinity must be constantly performed, always threatened by its immediate feminine undoing.[6] As a result, socially privileged white heterosexual men have employed three predominant coping strategies to vainly fortify their masculine psychic security: escape from feminine realms, emotional self-control/repression, and psychic projection onto marginalized groups.[7] Anderson's films highlight these coping mechanisms' inability to compensate for the psychic instabilities produced by entitled masculinity's highly performative nature.

All of Anderson's fathers reveal a profound unease with the domestic, feminine realm. *Rushmore* opens with a family painting that suggests Herman Blume's (Bill Murray) alienation from domestic life. Blume stands in the forefront, located on a different plane from his wife and two children. His off-center body spills out of the frame's left side. A cigarette dangles from his mouth. This is the picture not of a man lauding his control but instead of someone disconnected from his family and trapped in an ill-suited role, grimacing as the frame cuts into his painted flesh. To escape its confines

he moves into a hotel indefinitely. *The Royal Tenenbaums* picks up where *Rushmore* left off. After having lived in a hotel for twenty-two years, Royal (Gene Hackman) decides to reclaim patriarchal sovereignty within the Tenenbaum home. One of his first tasks is to locate his stuffed javelina head that his wife, Etheline (Anjelica Huston), has removed from the wall. This trophy represents Royal's desire to colonize a part of the home as his own masculine space, just as men during the early part of the twentieth century used their dens as a masculine sanctuary.[8] But unlike the enclosed sanctuary of a den, Royal's trophy is dwarfed by the home's feminine surroundings: its ornate moldings and pastel-colored walls. Just as the painting in *Rushmore* suggests Blume's domestic imprisonment, Royal's trophy reveals his marginalized position within the Tenenbaum home. Finally, in *The Life Aquatic with Steve Zissou*, Steve (Bill Murray) attempts to escape from the domestic altogether by engaging in masculine adventures at sea. His ship, the *Belafonte*, a long-range submarine hunter from World War II, emphasizes Steve's desire to connect with a war emblematic of American masculinity at its supposed prime. Yet Anderson undercuts Steve's sense of masculine autonomy by making him well aware that his wife's parents' money made possible two of his adventures and the purchase of his island sanctuary. Likewise, interviewers constantly challenge Steve's masculine authority by suggesting that Eleanor (Anjelica Huston), his wife, is the real brains behind Team Zissou. Overall, Anderson's films reveal men's pervasive fears about the feminine restricting their autonomy both within and outside the home.[9]

DISTANCE AND ALIENATION

Underlying this desire to escape lurks a more pervasive psychological issue: men's childhood training to psychologically distance themselves from the feminine through what Nancy Chodorow calls "the division of psychological capacities." According to Chodorow, the physical and psychological absence of men from the fin-de-siècle bourgeois home caused male children to primarily adopt a negative definition of masculinity as a rejection of women's learned nurturing capacities.[10] Although the broad historical sweep of Chodorow's theory can be questioned, it nonetheless offers a valuable interpretive framework to examine how the various models of masculinity found within Anderson's films—Herman Blume as self-made millionaire, Royal Tenenbaum as Victorian patriarch, and Steve Zissou as intrepid explorer—channel men's emotions into socially sanctioned masculine forms such as assertiveness, anger, and pride while repressing their more feminine ones. The patriarchs are locked into stoic roles that alienate them from their families.

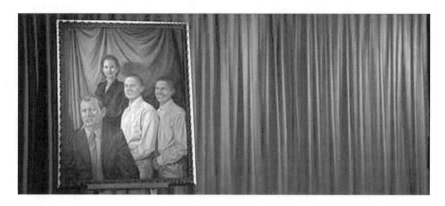

The off-center placement of both painting within the frame and Blume within the painting suggests a life out of balance and unhappiness with Blume's domestic arrangement in *Rushmore*.

The pool party sequence in *Rushmore* best exemplifies how Blume's performance as self-made millionaire has stunted his emotional development and alienated him from his family. Blume sits alone, indifferent to his twin sons' birthday while noticing his wife flirting with her tennis instructor. The Blume family painting that opened the film is intercut but this time with a close-up on Blume, symbolizing not only the metaphorical decapitation that his performance entails but also a disconnection between his head and body, his intellect and emotions. Blume's alienation is further reinforced by the scene's allusions to *The Graduate* (1967). The soundtrack plays The Kinks' "Nothin' in This World Can Stop Me Worryin' 'Bout That Girl," a song reminiscent of Simon and Garfunkle's "Mrs. Robinson." After downing his glass of scotch, Blume cannonballs into the pool. An underwater shot follows of him sinking to its bottom still in cannonball/fetal position, a direct homage to Benjamin Braddock's (Dustin Hoffman) similar descent in his parents' pool. Like Braddock, Blume remains locked into emotional arrested development, despite being twenty years Braddock's senior, a grown man who can only indirectly gesture at his alienation from underneath the hidden safety of his pool.

The Royal Tenenbaums more pointedly reveals the alienation that results from Royal's performances as Victorian patriarch. We see this in the scene when Royal lies to his children about having cancer. Before entering the house, Royal's performance is highlighted as Pagoda (Kumar Pallana) answers the door. Neither man speaks as they compose themselves for their roles. Royal nods, suggesting that he is in character, with the doorway

Chris Robé

serving as a proscenium arch. The Victorian patriarch, with his trustworthy Indian servant by his side, enters, armed with a string of sentimental clichés. The scene's tight framing and relative lack of movement reveal the strained relations between father and offspring. Royal's emotional distance dramatically contrasts Richie's (Luke Wilson) genuine emotive responses. When Richie embraces his father, Royal looks skeptically toward his son as if he cannot understand this breach of masculine protocol and reluctantly responds with a weak embrace and cliché as an emotional buffer: "Thank you, my sweet boy." The scene reveals Royal's performance as emotionally manipulative, more about reasserting patriarchal control than connecting with his children.

Steve Zissou also uses performance to emotionally distance himself from his alleged son, Ned (Owen Wilson). Yet unlike the earlier films, *The Life Aquatic with Steve Zissou* emphasizes the mass media's role in influencing men's performances. Steve uses his cinematic role as oceanographic explorer to mediate his relationship with his son. For example, during a filmed dive, Ned asks Steve if he can call him "dad." Steve says "No" but then immediately rethinks his decision by calculating how a nickname might enhance his screen presence: "It's not a bad impulse, though. Some kind of nickname. Not that one. It's too specific. How about 'Stevesy'?" Under the pretense of not having audiences see him in a fatherly role, Steve uses his cinematic role as a weapon to emotionally distance himself from his son and domestic responsibilities, as is indicated by the scene's framing that juxtaposes a three-shot of Steve and his men with a solo shot of Ned.

Furthermore, *The Life Aquatic with Steve Zissou* explicitly identifies a central resentment that haunts all of Anderson's fathers. When Ned asks Steve why he never contacted him, Steve replies, "Because I hate fathers, and I never wanted to be one."[11] This underlying truth punctuates the silences of every Anderson father, a buried emotion that informs all of their performances. Lacking the needed emotional resources to deal with the psychic complexities that fatherhood and (family) life entail, Anderson's fathers resent those who make such demands on them.

MELANCHOLIC FATHER FIGURES AND LOSS

Yet Anderson's films go beyond simply illustrating the emotional distance that entitled masculinity entails. More importantly, they reveal how their protagonists' masculine performances serve as hyperbolic compensatory acts for the loss of a significant loved one they are unable to mourn. According to Freud, mourning can only take place when every "single one of

the memories and expectations in which the libido is bound to the object is brought up and hypercathected, and detachment of the libido is accomplished in respect to it."[12] Yet as Judith Butler notes, because "forms of social power emerge that regulate what losses will and will not be grieved," mourning is not simply a personal issue but instead is a deeply political one.[13] In regard to Anderson's films, we see how entitled masculinity forecloses any possibility for men to adequately grieve loss, since it forces them to repress the very emotions that are required for mourning to take place. As a result, melancholia—the inability to acknowledge the significance of the lost object and psychologically move beyond its trauma—substitutes for mourning. The ego, unable to detach the libido from the lost object, instead unconsciously incorporates it and becomes redefined by that very loss.[14]

Anderson's protagonists incorporate their loss through their hyperbolic performances, which signal how the dead serve as ego ideals for their actions. These performances illustrate a variation of the fort/da game that Freud saw operating in his nephew's actions in *Beyond the Pleasure Principle.* The child was greatly attached to his mother, who occasionally had to leave him. Rather than explicitly expressing his resentment toward his mother's departures, the child invented a game of fort/da whereby he would throw a reel attached to a thread underneath his cot's skirt, thus making it disappear, and saying, "Fort." He would then pull the reel back into view and claim, "Here." For Freud, the child uses this game to sublimate his anger toward his mother: "At the outset he was in a *passive* situation—he was overpowered by the experience; but, by repeating it, unpleasurable though it was, as a game, he took on an *active* part. . . . Throwing away the object so that it was 'gone' might satisfy an impulse of the child's, which was suppressed in his actual life, to revenge himself on his mother for going away from him."[15] Similarly, Anderson's protagonists transform their losses into recuperative, performative actions, a type of endless "game" in which they unconsciously seek revenge on those who have abandoned them. Rather than mourning, they unconsciously incorporate aspects of the deceased into their very being and actions.[16] Therefore, the characters' over-the-top personalities reveal an even greater loss that their performances cannot fully efface, hence the emotional and professional stasis that plagues all of their lives despite their seemingly assertive and self-confident attitudes.

However, it is easy to miss the importance of the specific losses that haunt Anderson's films. As Kent Jones observes, Anderson "always gives you just enough to get by, and if you blink you may just miss a gesture or a line of details that imparts a crucial aspect of his characters' emotional lives, the core dilemma that they're hiding for fear of being embarrassed before the world."[17] Unfortunately, many reviewers have mistaken Anderson's subtlety

as stylistic superficiality. Maximilian Le Cain calls *The Royal Tenenbaums* a "stylized soap opera" that never causes any emotional discomfort.[18] Stanley Kauffmann similarly refers to the film as "too much creaky cuteness."[19] David Thomson dismissively lists under Anderson's entry in his biographical dictionary: "Watch this space. What does that mean? That he might be something one day."[20] Missing from such accounts is how Anderson's films stylistically emulate the very repression of loss that their protagonists feel. The films embody a melancholic structure whereby loss serves as an absent presence, not often directly addressed but nonetheless significantly influencing both narrative momentum and mise-en-scène.

Two important losses affect the male protagonists' performances in *Rushmore:* Max Fischer's (Jason Schwartzman) dead mother, Eloise, and some unnameable loss that occurred in Vietnam for Herman Blume. By investigating how loss dictates Max's performances as patriarch-in-training, we understand how loss informs Blume's performances too, since the film clearly establishes Max as a younger version of Blume.

A theatrical curtain segments the film's sections, highlighting how Max's ill-suited "adult" performances serve as compensatory acts for his mother's death. The first curtain opens with Max being threatened with expulsion by Dr. Guggenheim (Brian Cox). Max feigns an air of confidence, acting more as a colleague than a student, and claims, "If that means I have to stay on for a postgraduate year, then so be it." After this tactic fails, he reminds Guggenheim that Rushmore Academy accepted him because of a one-act play he wrote on the Watergate Scandal during the second grade: "My mother read it and felt I should go to Rushmore. And you read it, and you gave me a scholarship, didn't you? Do you regret it?" Max's dialogue reveals the encouragement and emotional support provided by his mother, who believed that her working-class son was smart and talented enough to attend one of the most privileged prep schools in the nation. Without her, Max lacks a central nurturing presence in his life and engages in negative behavior under the misguided belief that Guggenheim might serve as an adequate substitute.

Max's failure to adequately mourn the loss of his mother leads him to seek a surrogate in Rosemary Cross, a new teacher at Rushmore. Max often associates Cross with his mother. For example, he initially becomes enamored with Cross when he reads a quote she inscribed in one of the library's books: "When one man, for whatever reason, has the opportunity to lead an extraordinary life, he has no right to keep it to himself." The quote reveals how Cross holds a similar belief in the individual's innate abilities that Max's mother held when she enrolled her son in Rushmore. Additionally, just as Max impressed his mother with his play on Watergate, he attempts

to impress Cross by getting Latin reinstated after he learns of her love for the language. Unable to see Cross for who she is, Max force-fits her into an idealized role, which eventually leads her to confront him in her kindergarten classroom. The scene is shot with a shaky handheld camera, suggesting Max's emotional instability at Cross's de-fetishization of herself:

CROSS: What do you really think is going to happen between us? Do you think we're going to have sex?

MAX: That's a kind of cheap way to put it.

CROSS: Not if you ever *fucked* before, it isn't.

MAX (*to himself*): Oh my god.

CROSS: How would you describe it to your friends? Would you say that you fingered me? Or maybe I could give you a hand job. Would that put an end to all of this? Please get out of my classroom.

As Cross questions Max, he is pushed back by her words as they pierce his idealized illusions. Cross's sexual descriptions force Max to view her as a living and breathing woman full of carnal desires and experiences like any other person, not some idealized figure for Max to hang his grief upon. The scene is pivotal for Max's realization that no individual can substitute for his mother. We soon afterward observe Max reconciling with Blume by his mother's grave, indicating that Max's ability to address the significance of his mother's death has allowed him to come to better terms with the complexities of his present relationships.

Blume, on the other hand, suffers some unnameable loss during his tour in Vietnam. At best, the film can only imply this loss. During one scene Max asks Blume about his Vietnam experiences, something that Blume had never mentioned on-screen but that seems to hover between his silences: "Were you in the shit?" Blume replies, "Yeah, I was in the shit." Blume's matter-of-fact posture toward the traumas of Vietnam is not unlike Max's own posturing as an adult: their masculine performances repress emotional pains that they both would rather deny.

Yet Max forces Blume, Cross, and himself to deal with the significance of their losses in his final play, *Heaven and Hell*. Max types the play in front of his mother's grave site and dedicates the play to his mother and Edward Appleby, Cross's deceased husband. The play takes place during the Vietnam War, when an American soldier meets and marries a Vietcong woman. Essentially, the play exposes how political trauma is inextricably linked with the personal. The inability of the United States to recognize the loss

Chris Robé

of Vietnam directly forestalls Blume from naming and mourning the losses he experienced there. By Max's play reopening the wounds of the war, he forces the school's audience to confront this national trauma. Blume becomes deeply moved as he stands up during the play's end and clenches his fist with tears welling up in his eyes, seeming to want to express more but suddenly catching himself and looking down to hide his vulnerability. He has recognized his own experiences in the play but still hasn't yet found the ability to express them. Vietnam serves as a metaphor to reveal how recognition and mourning one's losses are the preconditions for the development of new intimate relationships, represented both by the transnational romance between American soldier and Vietcong woman and the interaction between Blume and Cross during the play's intermission. After being asked by Cross what he thinks of the play, Blume responds plaintively, "It's good. But let's hope it's got a happy ending." She then touches his hair, brushing it back: a protective gesture that recognizes Blume's emotional vulnerability. By creating the play, Max has provided a collective moment of mourning in which Blume, Cross, and himself can recognize and share their own and each others' traumas so that genuine intimate connections and psychic growth can begin.

Three central losses affect the men's performances in *The Royal Tenenbaums*: Royal's mother, Helen O'Reilly Tenenbaum; his father, never mentioned by name; and Chas's (Ben Stiller) wife, Rachel. Although Helen is only mentioned three times throughout the film, her influence on Royal's actions is immense. We see this in the aforementioned sequence when Royal lies to his children about having cancer. After Royal enters the house, we see a painting of his mother in a World War II Red Cross uniform hanging over the family mantel. The camera tracks in and tilts down to Royal sitting beneath it, linking her influence over Royal and his ensuing performance. Additionally, Helen's association with World War II, an event that normally signifies American masculine valor, further emphasizes her idealized status. Just as the Blume family painting represents an impossible patriarchal ideal for Blume, Helen's image, bathed under a golden light, literally hangs over Royal's head, representative of another impossible ideal that Royal must abandon if he is to ever emotionally reconnect with his family.

Additionally, Helen's visual centrality in the scene and association with World War II draws attention to the glaring absence of Royal's father. Overall, this narrative absence emulates the melancholic state in which Royal regards his father. As Freud explains, "One cannot see clearly what it is that has been lost, and it is all the more reasonable to suppose that the patient cannot consciously perceive what he has lost either."[21] The film stylistically

The looming presence of Royal's mother, Helen, in *The Royal Tenenbaums*.

embodies this unconscious melancholic loss that Royal suffers from in its refusal to visualize his father. Nonetheless, the impact of his father's neglectful influence in Royal's own twenty-two-year absence and dysfunctional familial interactions is obvious. The cyclical nature of patriarchal estrangement becomes apparent as we watch Chas, one of Royal's sons, alienate his own two boys. Just as Royal's actions have been affected by the death of his mother and the absence of his father, Chas's actions have been partially affected by the unexpected death of his wife. Afraid of losing his children, Chas becomes an overly protective father, keeping them underneath constant surveillance by making them incessantly crunch numbers for his business and exercise fifteen times a week. Ironically, in his attempts to avoid being physically and emotionally absent in his kids' lives, Chas smothers them with an overbearing presence that alienates them from him just as effectively as his own father did to him. Lurking beneath both Royal's and Chas's grief for the loss of an important woman in their lives is the figure of the father they never had.

Finally, *The Life Aquatic with Steve Zissou* addresses loss by providing two opposing models for dealing with it: (1) rejecting mourning for a misguided quest for vengeance, represented by Steve's desire to avenge the death of his best friend, Esteban (Seymour Cassel); and (2) mourning that abandons a facade of masculine stoicism for an ability to speak about the significance of one's losses, represented by Ned's (Owen Wilson) relationship with Jane Winslett-Richardson (Cate Blanchett).

Steve's desire but inability to mourn the death of his friend Esteban in *The Life Aquatic*.

Steve is unable to properly mourn the loss of his friend, since his own life has become a hyperreal masculine performance. This is shown early on in the film. After screening his most recent film that recounts Esteban's death by shark attack, Steve watches an old televised interview with him and Esteban. In the interview Steve is asked, "People say Eleanor is the brains behind Team Zissou. What is Steve?" Steve chuckles yet remains at a loss to explain his purpose. He begins to look despondent, but Esteban then responds, "He's the Zissou," and touches Steve's arm, causing Steve to look back and smile. While watching the interview, Steve is visibly moved by Esteban's support and raises a finger to the television screen to Esteban's face. Static electricity zaps between Steve's flesh and the screen, revealing both an emotional connection between the two men and an incredible distance as Esteban's memory remains locked within these images. Both men's feelings are mediated by their hyperreal performances, restricting their emotions into tiny gestures of affection both on and off the screen.

REGENERATION THROUGH VIOLENCE

Because of the stoic mandates of entitled masculinity, Steve must instead use vengeance, the only socially sanctioned way for "real" men to express their feelings, as a substitute for mourning.[22] By hunting down and killing the jaguar shark, Steve thinks that he can purge his pain. But vengeance simply blocks Steve from mourning Esteban's death and coming to terms with its

emotional resonance with the more pervasive fears of declining professional importance and aging that have haunted him since the film's opening. We observe Steve's difficulty acknowledging Esteban's death when Eleanor warns Steve, "Don't go on this voyage right now, Steve. One of you is already dead after all." Steve responds, "Who? Oh, you mean Esteban? Thanks for bringing that up." As Steve answers, the film cuts to a painting of Esteban, a symbol once again of emotional stasis whereby an idealized reified image haunts the thoughts and actions of an Anderson protagonist. The painting suggests the disjunction between Steve's image of Esteban as still alive and the reality of his death, the masculine ideal and the need to mourn.

Furthermore, the film exposes how vengeance blocks Steve's ability to foster a relationship with his son. Locked within a melancholic state, Steve lacks the needed emotional resources to form new bonds. Only by jettisoning his stoic masculine facade can he rectify this impasse, which he finally does near the film's end by sharing his vulnerabilities with his son: "I'm sorry I never acknowledged your existence all those years. It won't happen again. I mean it. See, for me to meet a guy like you at this time in my life . . . I don't know. It's just . . . I want to communicate my feelings to you, but I think I might start to cry." By accessing his repressed emotions, Steve is eventually able to abandon his quest for vengeance. When he finally confronts the jaguar shark, Steve contemplates, "I wonder if it remembers me," and cries. Rather than viewing the shark as a source of anger, Steve recognizes how it symbolizes his last moments with Esteban. All of the crew members place their hands on Steve as he touches Jane's pregnant belly, suggesting a new bond being born at this moment. Steve has finally initiated the mourning process, which provides him with the ability to truly connect with those around him, including the very shark that caused him pain.

Steve learns how to mourn through his son's example. Ned refuses to adopt the masculine ways that Steve embodies and therefore has access to the emotions that allow him to mourn his mother's death. We see this when Ned offers to Jane a detailed description of his mother's death from ovarian cancer, implying his acceptance of it. Her death, he further explains, led him to seek out Steve, showing once again how mourning provides for psychic growth and the ability to foster new relationships.

Furthermore, Ned's ability to access his emotions allows him to connect with Jane and recognize her own emotional impasse. We witness this when he gives Jane a pen and fifty self-addressed envelopes with three blank pages in each one so that she will write him. Ned's gesture reveals his recognition of how Jane's job as a journalist has caused her to adopt some of its stoic masculine ways. For example, when Jane leaves a message for her editor, Ross, the married man who has impregnated her, she says, "I'm

not coming back. It's over. Please don't try to contact me, okay? You'll hear from us sometime. We got attacked by pirates. I feel as if life is . . . Well, you get the idea. Anyway, take care of yourself. Jane." Her short declarative sentences are indicative of journalese terseness, perhaps best represented in Hemingway's writing that never directly states the deep emotional turmoil that underlies his stories. And just when she is about to express her feelings, she stops short. Because Ned identifies this emotional impasse on Jane's part, he uses his gift to encourage the expression of her repressed emotions that her profession, and most likely Ross, dismisses as "unprofessional" and "weak."

CLASS RESENTMENT AND SUBLIMATION

Yet despite all of the films' complex representations of the psychic traumas that result from entitled masculinity, they become increasingly problematic as they try to address issues outside of a limited racial and sexual scope. The fear of the Other looms large in all of Anderson's films. In particular, *Rushmore* exposes the fear of returning to the lower class, *The Royal Tenenbaums* deals with the fear of African American male sexuality, and *The Life Aquatic with Steve Zissou* reveals a fear of queer sexuality. However, these fears become increasingly ill-addressed in each subsequent film, so in contrast with *Rushmore's* incredibly acute representation of class anxiety, *The Royal Tenenbaums* underplays Royal's racist tendencies, and *The Life Aquatic with Steve Zissou* fully demonizes its sole queer character, Alistair Hennessey (Jeff Goldblum).

From its opening scenes, *Rushmore* shows how class anxiety structures the masculine performances of Blume and Max, both of whom come from the lower class. The artifice of Blume's upper-class life, represented by the family painting that opens the film, is contrasted with the chapel speech he gives at Rushmore. Blume stands in medium long shot behind a podium on frame left, the exact location of the painting, and expounds: "You guys have it easy. I never had it like this where I grew up. For some of you, it doesn't matter. You were born rich, and you're going to stay rich. But here's my advice for the rest of you: take dead aim on the rich boys. Get them in the crosshairs and take them down. Just remember: they can buy anything, but they can't buy backbone. Don't let them forget that." Ironically, Blume reads this speech from his company's letterhead, suggesting the class resentment that he feels even while at work within the very company he founded. Max listens attentively to Blume, emphasized by shot/reverse-shot structure and increasingly closer framing between Blume and Max. Max parallels Blume's actions by writing in his hymnal:

Rushmore—best school in country

Rich kids—bad?

This guy—best chapel speaker I have ever seen.

Like Blume, Max scribbles his own class anxiety on the symbols of wealth and power. The question mark following "bad" reveals Max's mixed emotions. Since he strives for wealth and power to escape his own lower-class origins, he is reluctant to admit that the very goal of what he is striving for might be harmful to his well-being.

Wealth is problematic for both Blume and Max because it necessitates the denial of their working-class origins. They must both perform as if they are the rightful inheritors of the socially privileged environments that they inhabit. These performances mandate Blume's relative silence about his socioeconomic background (it is never mentioned again in the film) and Max's fabrication of his past by claiming that his father is a neurosurgeon rather than a barber. Because Max lies about his father's occupation, he must then exclude his father from any of the school's social functions that might reveal the working-class chink in his armor of a smartly pressed blue blazer. Similarly, Blume so well apes upper-class privilege that Max at times forgets that they share the same background. This is revealed when Blume asks Max to work for him. Max replies, "Look, I may not be rich, Mr. Blume. My father may only be a doctor, but we manage." By feigning wealth, Max becomes alienated from his father, Bert Fischer (Seymour Cassel), and the surrogate father he seeks in Blume.

Despite the blue-blood performances of Blume and Max, working-class resentment seeps through the film's soundtrack. Anderson uses the songs of the 1960s' British Invasion not only to emphasize the youthful rebellion that Max enacts but also to accent the working-class anger that fuels both Max's and Blume's attitudes toward the entitled. The British Invasion was comprised of bands mainly from working-class origins, yet their heavily sexualized songs and aggressive sounds overthrew the more suburban friendly songs that once dominated major radio airplay. Notably absent from Anderson's soundtrack is the most famous working-class band: the Beatles. Yet this absence is understandable, since the early Beatles tamed their sounds for a radio-friendly format that groups such as the Who, the Rolling Stones, the Kinks, and the Animals did not. Also, Anderson only uses songs foreign to contemporary top-forty sensibilities in order to represent to us some of the original rawness and anger that they possessed at the time of their release. The film's music represents both Blume's and

Blume's off-center framing mimics the placement of the family painting found at the beginning of *Rushmore*.

Max's repressed desires to claim and express their working-class inheritances that places such as Rushmore and Blume's factory dismiss. Music within the film functions much the same way as excess emotion operates within melodrama: "The undischarged emotion which cannot be accommodated within the [narrative] action . . . is traditionally expressed in the music and, in the case of film, in certain elements of the mise-en-scène. That is to say, music and mise-en-scène do not just heighten the emotionality of an element of the action: to some extent they substitute for it."[23] Because Rushmore Academy and Blume's factory psychically limit Max's and Blume's ability to express their working-class anger, these emotions are sublimated into the film's soundtrack.

LIBERAL HOLLYWOOD RACISM

In *The Royal Tenenbaums*, Royal's desire to move back into the Tenenbaum home is mainly predicated on his racist fears of Henry Sherman (Danny Glover) marrying his wife. Pagoda initially informs Royal about Henry's proposal: "The black man ask her to be his wife." Pagoda's referring to Henry as "the black man" articulates Royal's own stereotypical racist fears. The film takes pains at exposing the disjunction between Royal's conception of Henry as a black stud on the prowl and Henry's polite and intelligent demeanor. We see this most explicitly when Royal speaks to Richie about Henry:

ROYAL: So what do you think of this big old black buck moving in up there?

RICHIE: Who?

ROYAL: Henry Sherman. You know him?

RICHIE: Yeah.

ROYAL: Is he worth a damn?

RICHIE: I believe so.

The dialogue emphasizes how Royal unsuccessfully attempts to foster racial resentment in his son.

The Tenenbaum home as the prime site of racial conflict and Etheline representing white woman as symbolic collateral becomes apparent when Royal flexes his patriarchal privilege against Henry in the kitchen:

ROYAL: Are you trying to steal my woman? You heard me, Coltrane.

HENRY: Did you just call me "Coltrane"?

ROYAL (*acting absent-minded*): No.

HENRY: You didn't?

ROYAL (*innocently*): No.

HENRY: Okay.

ROYAL: But if I did, you wouldn't be able to do anything about it, would you?

HENRY: You don't think so?

ROYAL: No, I don't.

HENRY: Listen, Royal. If you think you can march in here . . .

ROYAL: You wanna talk some jive? I'll talk some jive like you never heard.

HENRY: Oh, yeah?

ROYAL: Right on!

Royal's reference to Henry as "Coltrane" and then trying to outblack him by speaking jive reveals a man whose racist stereotypes are derived from his haphazard gleanings of popular culture. On one level, Anderson critiques Royal as only able to perceive Henry's presence as nothing more than an affront to his white racist privilege that desires to claim paternalistic protection over a home and a wife he has neglected for more than twenty years.

Yet at the same time, *The Royal Tenenbaums* offers nothing more than racism-lite. Not wanting to alienate Royal too much from (white) audience sympathy, Anderson only addresses Royal's racism in passing. Unlike the class anxiety of *Rushmore* that is rarely explicitly mentioned but nonetheless permeates the film and is integral to the development of its two main male protagonists, racism is mentioned only to be dismissed in *The Royal Tenenbaums*. The film, at its worst, relies on an all-too-typical Hollywood solution to racial problems: a racist white person learns to abandon his or her racism after befriending an African American. What such a solution fails to address is not only how a genuine coming to terms with racism necessitates a dramatic alteration in identity that we never see but also the systemic way in which racism predicates the white privilege that the Tenenbaums hold. Racism, in *The Royal Tenenbaums*, remains only an individual problem in Royal, which he easily overcomes by film's end.[24]

Fascist Queers versus the Heterosexual Working Class

The Life Aquatic with Steve Zissou is the most problematic of the three films in the way it portrays queer sexuality as Other. Alistair Hennessey—the man who hogs the oceanographic grant money and has slept with Steve's wife, Eleanor—is Steve's nemesis. Rare for an Anderson film that usually shows remarkable sympathy for all of its characters, *The Life Aquatic with Steve Zissou* fag bashes Alistair throughout by referring to him as a "slick faggot," a "closet queer," and diminutively as "Allie."

The Life Aquatic with Steve Zissou demonizes Hennessey so that the white-collar company man, Bill Ubel (Bud Cort), might be both humanized and masculinized. Ubel, initially introduced as nothing more than a "bond company stooge" who is overseeing the expenses for Zissou's next adventure, embodies the beaten-down white-collar worker: short, balding, pencil mustache, thick brown glasses, calculator in one pocket, pens in the other. Steve, when he first meets Ubel, says, "I hope you're not going to bust our chops, pal." Ubel responds, "Why would I do that?" Steve answers, "Because you're a bond company stooge." Ubel, defending himself, says, "Well, I'm also a human being." And for the rest of the film we watch Ubel prove his humanity, valor, and masculinity. When the *Belafonte* is shanghaied by pirates, Bill speaks with them because he is the only member of Team Zissou who knows Filipino. Subsequently, because of his language skills, he replaces Ned as their hostage. As Steve observes at the end of this episode, "I never saw a bond company stooge stick his neck out like that." By film's end, when Hennessey asks how his stolen espresso machine got aboard the

Belafonte, Bill replies, "We fucking stole it, man." It is fitting that Bill would challenge Hennessey at this moment, since the film implies that Hennessey represents the effete queer rich who are mainly responsible for disempowering the white-collar workforce that Ubel symbolizes. The narrative, in part, concerns the white-collar workforce proving its masculine vitality and no longer taking any shit from people like Hennessey. Essentially, the film rewrites the Left cliché of class warfare of the masculine proletariat against the effeminized bourgeoisie into the individual resistance of the masculine white-collar company man against the effeminized queer wealth of Hennessey, which necessitates all the homophobic baggage that has always accompanied this gendered reading of class divisions.

THE DIALECTICS OF ENTITLED MASCULINITY

The increasingly problematic nature of Anderson's films toward issues of race and sexuality can partially be explained by Anderson's limited perspective. The films suggest Anderson's intimate familiarity with issues of class but increasing distance to issues of race and incomprehension toward queer sexuality. These deficiencies do not necessarily undercut his films' insights into the psychic traumas that result from entitled masculinity, but they expose their representational limits in being written from an insider's viewpoint. Although the claim can certainly be made that all the films provide a recuperative function by making white straight men the center of their narratives at the expense of alternative perspectives, they also offer sophisticated representations of the widespread debilitating psychological effects that result from men's adoption of entitled masculinity. Yet as Stella Bruzzi has shown in her book *Bringing Up Daddy,* this fundamental ambivalence toward the traditional father is not unique to Anderson's films but instead is a recurrent theme in many contemporary Hollywood films. What distinguishes Anderson's films from the rest is their consistent emphasis on this ambiguity without ultimately resolving into a pro or con stance. They identify the complex cultural matrices that surround representations of twenty-first-century entitled masculinity and the traditional father, exposing how even within their critiques an aura of nostalgia often slips through. The final shot of *The Royal Tenenbaums* brings this point home. We read on Royal's gravestone:

> Royal O'Reilly Tenenbaum
> Died tragically rescuing his
> family from the wreckage of a
> destroyed sinking battleship

Although Royal still utilizes a World War II cliché as an epitaph, by film's end we realize the hollowness of such a claim. While he poses as patriarch in death, we know that in life he was an absent father who created incredible psychic pain for his family. But the one redemptive moment on the gravestone is Royal's adoption of his mother's maiden name as his middle name. Bookended by his absent father's last name and his own, his mother's name provides the ballast between the two, covertly admitting the centrality she provided in his life. Not willing to totally abandon the patriarchal pose, the tombstone becomes both a hollow yet appealing gesture of masculine valiancy and a genuine acknowledgment that entitled masculinity alone is not enough to provide for an emotionally rich life. Somewhere between the awe of the pose and the trauma of its pain lie Anderson's films.

NOTES

1. Bryce Traister, "American Viagra: The Rise of American Masculinity Studies," *American Quarterly* 52, no. 2 (2000): 276.

2. Tania Modleski, *Feminism without Women: Culture and Criticism in a "Postfeminist" Age* (New York: Routledge, 1991), 7.

3. Stella Bruzzi, *Bringing Up Daddy: Fatherhood and Masculinity in Post-War Hollywood* (London: British Film Institute, 2005), 191.

4. Although *The Darjeeling Limited* (2007) and *Fantastic Mr. Fox* (2009) continue this trend, they do not significantly develop upon the primary elements of the patriarch as established by the three aforementioned films. As a result, these two later films will only be referenced when they provide added insight into the dynamics of the main films under discussion.

5. Michael Kimmel, *Manhood in America: A Cultural History* (New York: Free Press, 1996), 119–20.

6. This does not suggest that manhood was any less performative than masculinity but more so that it was *perceived* as less performative. Therefore, the illusion of stability that provided middle-class white men with a sense of psychic gender security was lost with the emergence of masculinity.

7. Kimmel, *Manhood in America,* 9.

8. Ibid., 111.

9. Similarly, in *Fantastic Mr. Fox*, Mr. Fox (George Clooney) decides to purchase a new home within close proximity to three slaughterhouses, starkly revealing the constant tension between family life and Fox's older desires as poacher.

10. Nancy Chodorow, *The Reproduction of Mothering: Psychoanalysis and the Sociology of Gender* (Berkeley: University of California Press, 1978), 176.

11. This rejection is stated in even more naturalistic terms in *Fantastic Mr. Fox*. When Fox's wife (Meryl Streep) asks him why he returned to poaching after having promised to abandon his old profession after the birth of their

son, he replies, "Because I'm a wild animal." Mrs. Fox counters, "You also are a father." This shows Anderson's men not simply rejecting fatherhood but more importantly general enculturation, which is associated with women, domesticity, and fatherhood. Needless to say, Anderson is developing upon a dominant masculine anxiety found within U.S. culture, perhaps most notably found with Huckleberry Finn's rejection of Aunt Sally's desire to "sivilize" him by escaping to the West by novel's end.

12. Sigmund Freud, "Mourning and Melancholia," in *The Standard Edition of the Complete Psychological Works of Sigmund Freud, Vol. XIV (1914–1916)*, translated and edited by James Strachey (London: Hogarth and the Institute of Psychoanalysis, 1957), 245.

13. Judith Butler, *The Psychic Life of Power: Theories in Subjection* (Stanford, CA: Stanford University Press, 1997), 183.

14. Ibid., 183, 169.

15. Sigmund Freud, *Beyond the Pleasure Principle*, translated and edited by James Strachey (New York: Norton, 1961), 15.

16. Francis (Owen Wilson) in *The Darjeeling Limited* repeats the same line of controlling behavior that his absentee mother (Anjelica Huston) once foisted upon the family.

17. Kent Jones, "Family Romance," *Film Comment* 37, no. 6 (2001): 26.

18. Maximilian Le Cain, "Storytime: *The Royal Tenenbaums*," *Senses of Cinema* 20 (2002), http://www.sensesofcinema.com/2002/feature-articles/tenenbaums/.

19. Stanley Kauffmann, "On Films—Promises, Promises," *New Republic*, December 31, 2004, 24.

20. David Thomson, *The New Biographical Dictionary of Film* (New York: Knopf, 2003), 18.

21. Freud, "Mourning and Melancholia," 245.

22. For an excellent account of the long-held cultural belief in the curative powers of vengeance within the United States, see Richard Slotkin, *Regeneration through Violence: The Mythology of the American Frontier, 1600–1860* (Norman: University of Oklahoma Press, 2000), *The Fatal Environment: The Myth and Frontier in the Age of Industrialization, 1800–1890* (Norman: University of Oklahoma Press, 1998), and *Gunfighter Nation: Myth of the Frontier in Twentieth-Century America* (Norman: University of Oklahoma Press, 1998).

23. Geoffrey Nowell-Smith, "Minnelli and Melodrama," in *Home Is Where the Heart Is: Studies in Melodrama and the Woman's Film*, edited by Christine Gledhill (London: British Film Institute, 1987), 73.

24. Racism becomes even more pronounced within *The Darjeeling Limited* and its Orientalist vision of India. Bathed in soft light and colorful dress, India and its people serve as an exotic backdrop for the three white characters to work out their psychic traumas. This is most dramatically seen when the three characters attend an Indian child's funeral that serves as a catalyst to descend into their own self-absorbed memories concerning missing their own father's

funeral. Eurocentric pain and desires consistently trump that of the Indian characters. Jack (Jason Schwartzman) not only sleeps with an Indian server due to his loneliness from his Western girlfriend having left him, but he also imposes upon her by stating, "I feel like I need someone to talk to, and I feel that you might be really important in my life." Unasked is what might be important to her life. The widowed mother of the three brothers escapes family obligation by becoming a nun and joining an Indian monastery. The train becomes a metaphor for the film's and white characters' touristic vision of India, not a place to learn about but instead to superimpose their wishes and desires.

R. BARTON PALMER

Allegory of Deliverance

Class and Gender in Scorsese's Bringing Out the Dead

THE WOUND, THE POWER

In their provocative introduction to a collection of essays dedicated to "exploring masculinities in Hollywood cinema," Steven Cohan and Ina Rae Hark point out a conceptual problem at the heart of how the representation of maleness in film might be theorized. On the one hand, they suggest, since the 1970s critics have been "preoccupied with lack and castration," the psychological dynamics thought to underlie "the narrative and visual regimes of Hollywood cinema." Such films, so the theoretical argument runs, would thus offer a straightforward rendering of "masculine subjectivity in patriarchy," a position that, according to this perspective, would be far from empowered.[1]

On the other hand, film theory has also emphasized the power to dominate of male protagonists, who act while women are acted upon, who look while women are looked at, who lead the narrative devoted to solving the question that the presence of the woman poses. As a result, "film theory has for the most part confidently equated the masculinity of the male subject with activity, voyeurism, sadism, fetishism, and story" instead of exploring "the paradox of a masculinity that derives considerable social and sexual . . . power from being castrated, wounded, and lacking." "What," as Cohan and Hark so well put it, "are we to make of a masculinity that can preserve its hegemony only by confessing its anxieties at every turn?" Like the contributors to their anthology, Cohan and Hark illustrate how a masculinist criticism might move beyond the "monolithic, homologous terms" that have dominated the discourse of gender in film studies.[2] My intention is that this

present essay do much the same, exploring the disempowering empowerment experienced by the protagonist in one of the most unjustly neglected films of the 1990s, Martin Scorsese's *Bringing Out the Dead* (1999), adapted from Joe Connelly's best-selling novel of the same name.

In this film the male characters are all represented, to use the terms of Cohan and Hark, "overtly performing their gender" even as "socially unacceptable and heterogeneous cultural constructions of masculinity" are screened out, including the crucial connection between male self-image and social class, an aspect of the empowering/disempowering dynamic of representation that has often been ignored.[3] The repression of these diverse cultural constructions is in large part a function of this film's self-conscious auteurist agenda: to be precise, the way in which the spiritual, universalizing, and essentializing dimensions of the narrative are strongly thematized. In this double dynamic of revelation and concealment, *Bringing Out the Dead* becomes an interesting sequel to Scorsese's *Taxi Driver* (1975), a connection that the relevant production histories point toward. Both films were scripted by Paul Schrader and, from an auteurist point of view, can be seen as embodying the obsession that screenwriter and director display with representing transcendental experience.

While still in galley proofs, *Bringing Out the Dead* came to the notice of agent Scott Rudin, who quickly purchased the film rights and brought the project to Scorsese.[4] The director was immediately taken with it and realized that Schrader would be the only one to do the screenplay. Scorsese saw that *Bringing Out the Dead* would both reprise and modify considerably themes that he and Schrader had earlier developed in *Taxi Driver.* Scorsese admitted in an interview that "There's a correlation to *Taxi Driver,* there's no doubt . . . only it's twenty-five years later and we're a little mellower now. Instead of killing people, our protagonist is trying to save people. We were all about thirty, thirty-one years old—Schrader, De Niro, and myself—when we made *Taxi Driver.* But now we're fifty-six. It's a different world, and we're different too."[5] Scorsese rightly underlines both the similarities and differences between the two films. Travis Bickle (Robert De Niro) is undoubtedly deranged, subject to paranoid fantasies, but his urge to purify the city of corruption is eventually directed toward the more manageable double task of ridding the city of men running a downtown brothel while rescuing the innocent and vulnerable girl they have victimized. Like other Scorsese and Schrader protagonists, Travis Bickle and *Bringing Out the Dead*'s Frank Pierce (Nicolas Cage) are in the end both seekers after "lost sheep" whom they, if in intriguingly different ways, rescue from a degrading imprisonment within a corrupt material world. And yet if Travis finds himself beyond redemption (his alienation is imaged in terms of social class

difference), Frank experiences, at the end of his moral struggle, a profound transcendence, a sense of accomplishment and inner reformation that gives meaning to the dirty, dangerous, and unpleasant job that he proves himself so well qualified to perform.

FEELING THE BOTTOM FALL AWAY

Before embarking on his murderous crusade, Travis admits that "All my life needed was a sense of direction, a sense of some place to go." Connelly's Frank Pierce similarly finds his life falling apart despite his efforts to have it mean something. As he confesses, "Help others and you help yourself, that was my motto, but I hadn't saved anyone in months. It seemed all my patients were dying, everything I touched turned to shit. I waited, sure the sickness would break, tomorrow night, the next call, feeling the bottom fall away."[6] Episodic rather than tightly plotted, the novel traces Frank's Dantean journey through the grim underworld of New York's night town, a depraved public sphere populated by hordes of the disaffected, the discarded, and the dysfunctional. It is easy to see why this book appealed to Scorsese.

Frank's intense experiences with attempting—but often failing—to bring others back to life impel him to both transcend and also embrace his (dis)connection to those who share the world with him. Frank yearns for and yet fears release from his job as an emergency medical technician (EMT), which he feels inwardly compelled to do, for it holds out the promise of the ultimate high, bringing the dead back to life and therefore defying, if only for a time, the existential limits of the human condition. At those moments of medical resurrection, he confesses that God is in him or that he has in some mysterious way become God. But not everyone, given circumstances and human imperfection, can be saved. So, Frank is also doomed to experience devastating failure. As the novel begins, he finds this devastating guilt impossible to expiate. Only then can he sleep again.

Frank is especially haunted by the memory (or perhaps it is her spirit, glimpsed in moments when the mask of everydayness seems to fall away) of Rose, a young girl who died despite Frank's desperate ministrations. The novel's decisive moment, however, comes after Frank has saved an older heart attack victim, Patrick Burke, only to see him enter the living purgatory of irreversible brain death and constant heart failure. Because Burke's wife refuses to forbid resuscitation, the man's natural death is staved off each time by that dubious miracle of modern medical technology, the defibrillator. Life for the old man has thus become a succession of shocking, painful returns to an unconsciousness that is merely the shadow of meaningful existence. Tortured by the consequences of his successful yet also

failed act to save, Frank finally allows the man to die by subverting any further heroic measures in an act of mercy that cures his own malaise. Frank's violation of professional ethics acknowledges the paradox of the power he possesses. He can give back life but must always and ultimately fail to reverse the course of natural deterioration that is the essential fact of the human condition.

In a sense, Frank saves his patient by allowing him to die, a grace that Mary, the man's daughter, with whom Frank had become romantically involved, must hate him for offering. Frank describes her reaction to the old man's passing: "She turned to me: 'You killed him.' What was there to say? I could only marvel at the power of her hate. Enough to smash atoms if she wished, turn me to dust with the smallest snap of it, yet all she did was leave. That was the miracle."[7] Mary refuses to destroy Frank with the power he has granted her to wield over him, returning, if ironically and appropriately, the mercy Frank has shown her father. Mary hates Frank because the man's death deprives her of his presence, and so Frank's kindness to the old man, in an ironic twist, means that he must forfeit the connection with Mary that had been developing because Frank had at first brought the old man back to life.

A giver and then taker of life, Frank is loved but then hated for his charity. And yet there is more than a bitter paradox at the heart of his experience, for it is truly a miracle that as Mary leaves without saying more, Frank feels his spiritual crisis end. Mary delivers Frank from his "sickness" to an unguilty secret sharing with Rose, whose spirit now seems quiet and appeased. Frank is allowed the final blessing of sleep, drawing inward from an engagement with the outer world. These are his final words: "I listened to her breathing and I felt myself sleeping before I was asleep. The sound of her breathing. I was going to sleep."[8]

NOIR ALLEGORY?

In both *Taxi Driver* and *Bringing Out the Dead*, the narrative climax is the protagonist's deliverance from inner psychological and spiritual demons. The viewer is therefore positioned to read the often detailed, if highly stylized, portrayal of cultural space (in both films the seedier parts of Manhattan) allegorically rather than realistically. What is weakened, if not discredited completely, is the claim of the dark nighttime cityscape of New York City (in its pre- and post-Giuliani versions) to represent the discontents of 1970s' and 1990s' urban society, including and especially the unhappiness of the economically marginalized working-class male struggling to find work that confers both dignity and respect.

This auteurist agenda, prominent and intellectualizing, is of course a common element in the work of Hollywood Renaissance directors such as Scorsese and Schrader. And it promotes a complex series of intertextual connections, and not just to their own previous releases. Like *Taxi Driver* and like some of Schrader's own directorial efforts, such as *Hardcore* (1979) and *Light Sleeper* (1992), *Bringing Out the Dead* offers an extensive homage to the films of Robert Bresson, especially *Pickpocket* (1959).[9] In a highly stylized and complexly antirealist fashion, *Pickpocket* traces out a gloomy vision of human destiny that owes its intellectual force to the twin notions of predestination and irresistible grace, reflecting the director's religious vision.

Prominent in Bresson's films is the ever-present possibility of deliverance from a dark being-in-the-world. In speaking of Bresson's films, Schrader observes that "grace allows the protagonist to accept the paradox of predestination and free will. . . . But it is not enough for grace to be present, man must choose to receive it." It is in such an assent to the irresistibility of election that the paradox of free will and predestination is resolved: "Man must *choose* that which has been predestined."[10] These moments of spiritual turning make a dramatic, usually climactic, appearance in the narrative but remain as inexplicable in psychological terms as they are irresistible, spiritually speaking, being powerful infusions meant to enact the divine movement of grace. Such flashes of enlightenment do not flow from the protagonist's intentions, being instead the indirect, unforeseen result of his actions.

In his own transcendental cinema, notably *American Gigolo* (1980), Schrader makes it clear how the utter depravity that is the human condition must be endured rather than worked through. *Gigolo* is an antitraditional Hollywood film in many ways, particularly in its dramatization of how individual effort only progressively disempowers the feckless protagonist, Julian Kaye (Richard Gere), who cannot free himself from the frame-up engineered by a malevolent employer. Julian is eventually saved from his spiritual isolation (and also perhaps from a murder rap) by the sacrificing, self-abasing love of a woman whose affections he had previously scorned. *Gigolo*, it might be argued, follows a clear Oedipal trajectory, tracing Julian's passage through the dangers of phallic narcissism toward a nurturing secondary attachment. And yet this movement toward restoration depends on the progressive deterioration of Julian's power over his own destiny (including his carefully practiced facility in turning others into objects to advance his lavish lifestyle). Instead of symbolically restoring the power of patriarchy, the finale demonstrates Julian's inability to master his world or dominate the woman from whom he, because she wills it, draws what little

R. Barton Palmer

strength he comes to possess in the end. His wound is closed, his lack fulfilled, but by the surrender of self-control to another.

Scorsese's *Bringing Out the Dead* adopts a similar approach to the problem of demonstrating how the wholeness of the only seemingly powerful male may be restored by a triumphal surrender. *Bringing Out the Dead* sends its alienated and anguished protagonist on a penitential journey that, only when he chooses correctly, allows him to overcome the guilt he feels from the unintentionally harmful power he wields in his work as an EMT. Frank in fact finds himself paradoxically subjected to the power that his skill and modern technology have given him to bring the seemingly dead back to life. He is trapped by his failure to save everyone and haunted by the memory of those seemingly lost souls. *Bringing Out the Dead* thus nicely exemplifies what Cohan and Hark term "the paradox of masculinity," the ways in which the male self is poised unstably between mastery and submission or, to put it more paradoxically, the way in which his mastery is in fact a kind of submission.[11]

In the end Frank spiritually resuscitates himself, in a pointed contrast to the protagonists of both *Pickpocket* and *Gigolo*, but this transformative moment requires the surrender of the resurrecting power he had otherwise claimed as his own. Frank thus functions within the film both as the protagonist (the male actant who propels the narrative) and as the goal toward which the action irrevocably tends, which is putting right a mistake he had made with the best intentions: keeping Patrick Burke alive. If Frank Pierce seemingly proves more able than Julian Kaye to act in aid of his own deliverance, *Bringing Out the Dead*, like *American Gigolo*, makes manifest as well the greater power possessed by Mary (Patricia Arquette) to heal the psychic wound that the man she has come to love suffers from.

Schrader and Scorsese emphasize this interpersonal connection in their rather radical revision of the novel's conclusion. Throughout the film, a different sense of community emerges as the spirit of Mary's father continually speaks to Frank, asking to be released from the existential misery in which the technician's ministrations have confined him. From the hospital bed he begs Frank, "Let me go." To perform this act of mercy, Frank disconnects the man from his monitoring equipment and attaches it to his own body, thus subverting the alarm that would otherwise go off when the patient's heart stops beating. In a larger sense Frank takes on the burden of the other, in fact becomes the other, transcending his sense of self through an intimate gesture of empathy. Here there is no release from the materiality of existence; instead, it is embraced. When the old man is finally at rest, Frank goes to Mary's apartment to tell her the news. In his mind, she

becomes Rose (Cynthia Roman), the inner vision merging with existential reality, and Frank asks for her (their?) forgiveness.

The camera shows us Rose's face, but it is Mary's voice we hear, speaking the words that release Frank from his self-inflicted pain: "It's not your fault. No one asked you to suffer. That was your idea." Because, as Rose appears to affirm, Frank's embrace of human brotherhood causes his spiritual crisis, it is fitting that this display of love finds itself acknowledged and reciprocated. As the scene ends, Mary, no longer the bearer of transindividual truth, becomes Mary again, marking the return to the communal, material world. She asks Frank, "Would you like to come in?" And, like the thief in *Pickpocket* and Julian Kaye in *American Gigolo,* Frank says yes to this simple offer of fellowship and communion. In the film's last image, he and Mary have assumed the archetypal position of Mary and Jesus in the Pietà: fully clothed they are on her bed, where, sitting up, she cradles his head on her breast.

In one sense, this rewriting of Connelly's less obviously triumphal finale, which confirms Frank in his isolation, makes the film more conventional. It is undoubtedly true, as Amy Aronson and Michael Kimmel observe, that "the transformative power of women's pure love has been one of America's most resilient cultural tropes."[12] If we understand Mary's gesture as more romantic than spiritually revelatory, *Bringing Out the Dead* shows itself as culturally retrograde, a throwback to classical Hollywood plot construction and a rejection of the changes that second-wave feminism wrought in American culture. Aronson and Kimmel show convincingly that women in contemporary films rarely devote themselves to healing the men in their lives, despite the fact that these same films demonstrate a felt lack of such resolution in that "ethics still seem to reside in some mythic Other, waiting to be inhaled."[13] Even so, the kind of masculinist reading of *Bringing Out the Dead* pursued here usefully emphasizes how Scorsese's film differs from the classical model, at least if we accept that, ideologically speaking, Hollywood films have customarily worked to reinstall patriarchy after first problematizing its dominance. Frank finds the power to give over what power he possesses and in return can grasp the power of powerlessness, surely a most untraditional finale.

In what follows, I will pursue this line of gender analysis in a bit more depth. However, it is important to recognize from the outset the limitations of such an approach, with its intellectual roots in a politics that seizes on gender as the most important component of identity. Gender analysis can easily fall into an essentialism that, like the film's self-conscious transcendental or even religious themes, ignores or at least minimizes its complex engagement with diverse cultural materials. *Bringing Out the Dead* speaks

to more than the pervasive reluctance of the post–Vietnam War Hollywood cinema, that "cinema of loneliness" as Robert Kolker tellingly terms it, to represent a traditional ascendant masculinity. It is also a film that speaks to how social class shapes what men can do and what men can be. *Bringing Out the Dead* can also be read as offering a utopian version of working-class life that dramatizes Frank's transcendence of isolation, anomie, and marginalization. He finds power in a form of labor (recast in terms of his personal ethics) that the film represents as capable of providing individual experience with its essential meaning.

From this point of view, the film is archly patriarchal in the sense that it discovers a way for Frank to understand being-in-the-world that elevates him above the impersonal machinations of an economic system that otherwise keeps him in subordination. In this regard, *Bringing Out the Dead* can be seen as contesting the similar, though ironically conceived, movement of *Taxi Driver* in which Travis Bickle finds a job that answers only paradoxically to his needs and disabilities. Driving a cab, it is true, provides Travis with a cure for his sleeplessness, but it also confirms him in his isolation while ironically offering the insubstantial trace of a connection to a world of others. Travis's work holds out no possibility of being fulfilling; it is the reflex of his being shut out from any respectable version of the American dream. It is a form of service, not a path to self-actualization. Looking at the interplay of social class and gender in *Bringing Out the Dead* returns us to an auteurist analysis of sorts that seems particularly revealing when we see how in an earlier and (once again) unjustly neglected film, *Alice Doesn't Live Here Anymore* (1974), Scorsese offers a strikingly similar analysis of the meaning of work for those in the working class. In fact, these three Scorsese films—*Taxi Driver, Alice Doesn't Live Here Anymore,* and *Bringing Out the Dead*—can be read as providing a complex series of meditations on the lived experience of social class, even as they engage deeply with gender.

SPEAKING THE UNSPEAKABLE

My argument is hardly revolutionary and is in some ways entirely obvious. It is that these films respond as much to their cultural moment as they do to their ostensible auteurist agenda, which has not surprisingly been the focus of most critical work. It seems likely, however, that Scorsese's oeuvre has not been approached culturally because of a pervasive, if not complete, failure within film studies to acknowledge how representations of gender have been shaped by the dynamic of class relations and class ideologies. David James is surely correct in observing that within the field of the humanities, "the topic of class has become all but unspeakable," an unintended result

of the ways in which "feminism and other forms of sexuality studies, and projects mobilized by and on behalf of people of color," have utterly transformed the field. That questions of class have, in particular, been pushed to "the margins of the academic study of cinema" is particularly disturbing as we witness a "devastating global assault on the working class," which has seen itself split into a "small, more skilled sector" and a "very much larger, less skilled sector," the latter sunk into "irregular employment or even permanent unemployment," while the former "has gravitated toward and identified its interests with the capitalists and top business managers." It would be hard to argue that this development does not constitute what James terms "an overall immiseration of barbaric proportions."[14]

This is especially ironic, since the politicization of the academy since the 1970s has given energy to the growth of a "bourgeois identity politics" that has "concealed and so facilitated class polarizations," rendering irrelevant, or so it now seems to many in the postmodern intelligentsia, "the vision of a rational, nonalienated, nonexploitative, and fully participatory democracy that had been the great imaginative achievement of Marxism."[15] With the working class "not generally admitted into higher education" to constitute an identity group large and vocal enough to demand "a theoretical offensive," we have witnessed instead, among other intellectual disappointments, the conspicuous failure of film studies to generate "any single systemic or comprehensive theory of the way class could inform the study of cinema." James provides a fascinating narrative, too complex to summarize here, that traces how this has come about. However, the main villains of the piece appear to have been *Screen* theory (accused of essentialism because of its basis in Lacanian psychoanalysis) and cultural studies (whose "lowlier ambitions . . . drained the Marxism out of Gramsci").[16]

Cultural theorist Fredric Jameson does not offer the kind of analytic schema that James might find either systemic or comprehensive, but Jameson has long acted as a kind of *vox clamantis in deserto* arguing for this kind of theoretical engagement. For example, in an essay first published in *College English* (1977) titled "Class and Allegory in Contemporary Mass Culture: *Dog Day Afternoon* as a Political Film," Jameson does at least provide a model for a textual analysis that could locate a submerged discourse about class in the contemporary commercial film.

Like James, Jameson views with no little dismay the advent of an identity politics whose values are "eminently cooptable because they are already— as ideals—inscribed in the very ideology of capitalism itself." Capitalism, Jameson reminds us, has "a fundamental interest in social equality to the degree to which it needs to transform as many of its subjects or its citizens into identical consumers interchangeable with everybody else." If identity

R. Barton Palmer

politics offers schemes for social transformation, these are "theoretically subordinate to the categories of social class," but the difficulty is that race, gender, and sexual orientation are experienced and "lived" in ways that class differences no longer are. In other words, what is crucial is the fact of "class consciousness," or "the requirement that, for people to become aware of the class, the classes be already in some sense perceptible as such."[17]

Here the role of artistic representation is indispensable because "the classes have to be able to become in some sense characters in their own right." Embodied in characters, classes play a role in fictions that are, in essence, allegories that when properly read will permit the better understanding of the real that they figure. Conceived as entertainment, commercial films nonetheless cannot avoid giving representational shape to "the political content of daily life." They are privileged sites for reading culture. The material with which the filmmaker works possesses a "political logic" that will manifest itself not in some overt message, but rather through "the emergence of profound formal contradictions to which the public cannot be sensitive." And, I might add, these are contradictions to which the director and screenwriter might not be sensitive either. In fact, *Bringing Out the Dead*, it can be shown, speaks about "the political content of daily life" through the same kind of ideological contradiction.[18] *Alice Doesn't Live Here Anymore* was obviously designed to give expression to the feminist politics then prominent in American culture, but unwittingly in so doing it offers a profound commentary on class-bound economic realities and on the inseparable connections of those realities with gender.

ALICE CAN'T AFFORD TO LIVE HERE ANYMORE

Fresh from receiving critical acclaim for his *Mean Streets* (1973), a gritty and highly stylized film about small-time gangsters in New York City's Little Italy, Scorsese somewhat improbably agreed to direct *Alice Doesn't Live Here Anymore* (1974), a project conceived by lead actress Ellen Burstyn to capitalize not only on her recent spectacular success in *The Exorcist* (1973) but also on the increasing cultural prominence of what soon became known as second-wave feminism. *Alice Doesn't Live Here Anymore* was the result of a close collaboration among Burstyn, writer Robert Getchell, and Scorsese, who observed that "we tried to make the film a distillation of sociological and celluloid ideas regarding women" while conceding that "it's still a movie about a woman directed by a man."[19] And the project, with the director's blessing, did make room for the involvement of women in key production roles, including associate producer Sandy Weintraub, production designer Toby Rafelson, and film editor Marcia Lucas. Reviewers

noted the film's engagement with something like the problem of identity anatomized by cultural critics such as Betty Friedan in *The Feminine Mystique* (1963) and, more radically and confrontationally, Germaine Greer in *The Female Eunuch* (1970).

For Vincent Canby, this was a story in which a "young widow finds herself," and he praised Scorsese for bringing to the screen such a "fine, moving, frequently hilarious tale of Alice's first lurching steps toward some kind of self-awareness and self-sufficiency." In Canby's view, the narrative's most significant moment occurs when "suddenly and fortuitously everything changes. Donald, Alice's husband (Billy Green Bush), is killed in a highway accident and Alice must take charge of her own life, which, until this time, she has always left in the care of others."[20] This is a key point. The scene of the accident reveals that Donald was a truck driver; this sequence helps place the family in class and thus economic terms at the very moment that the narrative seems otherwise occupied exclusively with the war between men and women.

"I can live without a man," Alice confesses to her neighbor and confidante after hinting at the continuing difficulties she finds in living with Donald. "I'd be just fine if I never saw one again." But the narrative goes on to prove that this fish does need a bicycle, refuting the era's oft-repeated figuration of female independence. Ironically enough, what was then known as the women's liberation movement was significantly furthered by this film, as Alice became something of a cult figure in the era; her "refusal" was a mark of her willed freedom from bondage to male control, her resistance to the suppression of her claims on individuality within the patriarchal system. Having proclaimed that a manless life would be just fine, Alice and her friend fall into a kind of sexual reverie, imagining sex with a very "gentle" Robert Redford, who "wouldn't just roll over when he was finished with you." The conversation turns to somewhat girlish and embarrassed speculation about the size of Redford's penis (said to be predictable from his feet, but who had ever seen them?), and it is at this very moment that Alice receives the phone call from the police that her husband, previously shown to be a mindless brute no longer interested in making love, has been killed in a car accident. Are men dispensable? This is the question that the film's narrative then explores.

Framed as a kind of wish fulfillment (and perhaps, more grimly, a reminder of just how dependent on men women like Alice can be), the husband's unexpected death proves crucial in two connected but divergent ways. Certainly, it seems, as Canby suggests, his death is "fortuitous" because Alice is faced with the necessity to "take charge of her own life." An important element of this sudden release into maturity is the chance Alice

is thereby afforded to pursue the career as a singer she had always dreamed of. But there is a darker side as well, for the death of the husband means that Alice must support herself and her young son Tommy. Her journey toward the future is motored to a large extent by the penury she finds herself in. In the great American tradition of the "new beginning," Alice sets out west for California, hoping to create there a career in the entertainment business for herself. But this journey has another side; she must move somewhere else to find remunerative work. Alice has no training and no skills, no college degree to serve as an entrée to the white-collar world, only a fair to middling voice and a modicum of performing talent.

On its face, the narrative struggles to place Alice somewhere between dependence and self-sufficiency by dramatizing her subsequent relations with men. However, at a deeper, less acknowledged, level, the film also traces the economic consequences of her sudden widowhood, which means that because she is working class and there is thus no financial inheritance to cushion the blow, she now must in effect be the man of the family. Unlike the Ivy-trained professionals of the upper middle class whose discontents with a life of genteel pointlessness Friedan is so successful at portraying, Alice is not prevented from pursuing a life of self-actualizing work (in middle-class parlance "a career") simply by her assumption of the roles of stay-at-home wife and mother. The housework and childcare must be done by someone, and this family obviously cannot afford paid help with such tasks.

With her husband dead, Alice soon discovers that her dream of a show business career is not likely to be fulfilled. Finding little choice, she accepts employment instead in what is euphemistically known as the service industry, making use as a waitress of her wifely and motherly skills. To make good tips, moreover, she must, as a colleague informs her, encourage and allow a certain amount of flirtation from the mostly male customers of the diner. Alice, in other words, finds herself trapped within what David James tellingly terms the "objective reduction of the life opportunities of *all* working-class people." James reminds us that "the same era that saw gender and ethnic identity politics make their momentous ideological advances also saw the 'feminization of poverty.'" From this point of view, the film's insistence on the priority of gender lends unconscious support to the general movement of a "bourgeois identity politics [that has] concealed and so facilitated increased class polarizations."[21]

What would be the resolution of both Alice's need for a man (with its post-Kinsey desire for satisfactory sexual relations) and the economic dead end she finds herself stymied by? Along with Burstyn, the screenwriter and director struggled mightily to discover a conclusion that would provide some sense of an ending for Alice's journey toward self. The ending decided

upon was to make permanent Alice's relationship with David (Kris Kristofferson), a good-looking ranch owner, who humbly and penitentially agrees, after acting like a male chauvinist pig, to "support her aspirations." This seems to mean that when they are married Alice can pursue her singing career without worrying about the remuneration it might provide, since as the wife of a man of means she will no longer bear the burden of supporting herself and Tommy.

The film strains to make this finale a victory for Alice by having David propose marriage in the diner while she is waitressing. He admits to one and all that he will not demand that Alice be a traditional stay-at-home wife and mother. The staging of this scene, however, reveals that gender politics cannot be separated from class politics. Rewarding and fulfilling work, as becomes clear, is a middle-class ideal. It is a cultural luxury not generally available to the barely skilled working class, whose members in order to support themselves must take, as Alice does, whatever jobs they find available and for which, lacking specialized training, they qualify. Alice's journey out finds her circling back to her starting point. Dependent on a man's paycheck in the beginning, Alice finds herself agreeing to rely in the end on another man's wealth and social position.

In the sense of her position within society, Alice hasn't been liberated at all. This movement of the film strongly contradicts the sense in which it wishes to celebrate her ostensible "victory" in male-female relations. Freed from the prospect of unending and unrewarding labor, Alice has entered into a relationship that solves, on one level, her need for equal respect but, on a deeper level, reinforces her need for economic support. Alice, we might say, has proved fortunate enough to move up the class ladder in the most traditional fashion, using her beauty and attractiveness in order to marry out of economic marginalization. As Stephen Farber perceptively observed at the time, the case could be made that "the movie ends as a simple celebration of Hollywood fantasies . . . just another Technicolor advertisement for cotton candy romance," with the ruggedly handsome Kristofferson as a suitable working-class stand-in for the more refined and genteel Robert Redford conjured up in Alice's reverie.[22] But this is not how for the most part audiences in 1974 as well as the creative team involved in the making of the movie were able or inclined to understand Alice's story.

WORTHY OF HIS HIRE

Tellingly, *Alice Doesn't Life Here Anymore* cannot imagine its heroine discovering the meaningful and rewarding work that American culture of the era emphasized was the right of every individual, regardless of gender

David offers Alice a domesticated version of companionable and supportive maleness as her hopes for independence and a satisfying career reach a dead end and the liberationist plot of *Alice Doesn't Live Here Anymore* moves toward a more traditional conclusion.

or ethnicity, to pursue. The film locates a victory of sorts for the feminist agenda by dramatizing how David is humbled by Alice's refusal to accept his violent temper and verbal abuse, thereby demonstrating that she will no longer "live here anymore," that is, in a domestic arrangement in which her individuality is not respected. But the film also speaks to the occulted presuppositions of what was essentially a middle-class political program, founded at least in part since Friedan's *The Feminine Mystique* on advocating the entrance of women into the ranks of the nation's professionals. Part of the mythology that the film unmasks is the notion that being a stay-at-home wife and mother is a financially unconditioned choice of lifestyles rather than an ever-precarious economic niche made possible by a man's labor.

Alice Doesn't Life Here Anymore, as pointed out earlier, was conceived by its director and the other professionals involved in its production as a "distillation of sociological and celluloid ideas regarding women." It was financed by a major player (Warner Brothers), at least in part, because of the felt need within the industry, Marjorie Rosen reports, to provide "more and better on-screen roles for women."[23] Ironically, Ellen Burstyn reaped considerable financial rewards and added to her reputation in Hollywood (in

terms of bankability and artistic talent) by portraying a woman who cannot find meaningful and appropriately remunerative employment. My point is that it is not surprising, given these conditions of production, that the film romanticizes working-class life, asking us to see Alice's grittiness, her occasional foul mouth, and her often embarrassing lack of social polish as the signs of her authenticity. As Farber points out, in fact, the film's radicalism and deep engagement with contemporary social change is only apparent. The film's sense of being drawn from real life instead depends heavily on it being "less sophisticated than the romantic comedies of the thirties and forties . . . [which] concerned professional women . . . who could survive quite effectively on their own."[24]

Bringing Out the Dead, it must be emphasized, can hardly be said to be a "simple celebration of Hollywood fantasies," but this film also offers a displaced romanticized vision of the world of service industry work, generating a different kind of utopian finale because it presupposes a different class position for its protagonist. In the manner of many films from the last two decades (other prominent examples would be *Backdraft* [1991] and *The Perfect Storm* [2000]), *Bringing Out the Dead* heroicizes skilled blue-collar labor that requires strength, ingenuity, and more than a little physical courage. To be sure, Frank Pierce's profound discontents with his job as an EMT echo Travis Bickle's violent disgust for the venal cityscape that he feels compelled to traverse for seemingly endless hours. Travis feels deeply dissatisfied by a world that not only seems hopelessly sunk into depravity but also offers him no direction for a life devoted to its reformation and perhaps apocalyptic cleansing. Frank, in contrast, confesses that EMT work is robbing him of his sanity, not because he finds it disagreeable or unrewarding but because it places demands on his skill, energies, and moral sensibilities that he seems, at least temporarily, unable to meet. The narrative that catches him up provides him with the opportunity to practice his profession according to what the vision comes to have of it, thus restoring dignity to his labor. It is on that labor that everything crucially depends, as Frank's compassionate and skillful performance in two moments of crisis enables him to seek out the forgiving acceptance that he then receives from Mary.

The film establishes early that Frank's life is in some sense his job, that his work defines who he is. Because there is a shortage of EMTs, his unending attempts to get himself fired succeed no more than his always short-lived, if despairing, walk-offs. For reasons both within and without, he cannot escape the destiny that has caught him up. As he admits in voice-over, here is work that offers unmatchable satisfaction: "Saving someone's life is like falling in love, the best drug in the world. For days, sometimes weeks

afterward, you walk the street making infinite whatever you see. Once, for weeks I couldn't feel the earth. Everything I touched became light. Horns played in my shoes; flowers fell from my pockets."

Alice can triumphantly abandon her waitressing because it means "nothing." It defines her no more than Travis Bickle's job as a taxi driver defines him. Instead, the work that these characters do indexes their place on the bottom rung of the social order, the place where, as David James puts it, one walks "down the road to poverty and hopelessness."[25] For Alice, deliverance means that she can leave the diner behind in the hope, someday at least, of building a career. For Travis, the dead-endedness of his existence is tellingly represented by the film's final sequence, in which the social (as well as the spiritual) distance that separates him from his erstwhile inamorata Betsy (Cybill Shepherd) is dramatized by their distinct places within the economic order. Scorsese's camera locates them in Travis's cab, where he is the driver and she is the generously tipping passenger; their relationship appropriately closes with a financial transaction, all personal connection between them having been much earlier foreclosed by Travis's unwitting revelation of his ignorance of bourgeois norms when he takes her to a porno film on their first (and only) date. Because *Bringing Out the Dead* deals with work within the skilled sector of the service industry, the film is able to fashion a fantasy of deliverance that confirms Pierce within a world that, if somewhat uneasily, might be termed "professional" and thereby self-actualizing in the sense of not only calling upon but also allowing the rewarding exercise of his individual talents.

In the film's initial voice-over, Frank, with evident pride and self-confidence, describes the career crisis that has descended upon him: "I was good at my job. There were periods when my hands moved with a speed and skill beyond me and my mind worked with a cool authority I had never known. But in the last year I had started to lose that control. Things had turned bad. I hadn't saved anyone for months. I just needed a few slow nights, a week without tragedy followed by a couple of days off." But "cool authority" is a pose of remote professionalism that cannot be easily regained after it is shattered by the nightly experience of administering to and ferrying those dying and suffering to the hospital named "Our Lady of Perpetual Mercy," whose street name is, more simply and accurately, "Misery." Frank's addiction to the successful and hence miraculous performance of his job is the outer compulsive sign of his commitment to professional excellence, but he must recognize that the job also requires compassion and self-abnegation, as a culturalist rather than an auteurist reading might emphasize.

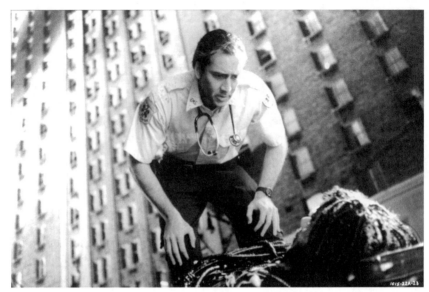

In *Bringing Out the Dead*, EMTs Frank and Larry perform a kind of skilled labor that, however harrowing, dangerous, and morally challenging, offers them both dignity and a sense of accomplishment.

Only Frank among his fellow workers seems to be suffering from such a crise de conscience, which the film encourages us to read as the reflex of his deeper sensitivity to the professional problems that life as an EMT poses. The film does so by developing a gallery of contrasting male types in the other EMTs Frank is teamed with on three successive nights. For Larry (John Goodman), dealing with the various shocking forms of human suffering is just a job like any other that he makes tolerable by thinking of what to have for a midnight dinner. For him, these difficult hours in the ambulance may be the way to an even better, because more independent, form of employment. When Frank asks him if he's ever thought of doing anything else, Larry replies, "Sure, I'm taking the captain's exam next year. After the kids are in school, Louise can go back to the post office and, I thought, what the hell, I'll start my own medic service. Out on the Island the volunteers are becoming salaried municipal. It's just a matter of time and who you know. Someday it's going to be Chief Larry calling the shots." Although undoubtedly competent, Larry is not inclined to make any more effort than the minimum that the job actually requires. He is untouched by the venality and suffering of the social dregs he comes into contact with, content to spend an hour hauling an old drunk to the hospital because, though in some sense a waste of time, it would be easier to

R. Barton Palmer

do than handling a shooting or any other case that might require him to deliver medical treatment.

Marcus (Ving Rhames) is a born-again Christian who nevertheless enjoys the finer things of life (in his view, booze and women). His rule is to never become involved with the patients. Marcus is no optimist, although he tries to look on the sunny side. Responding to Frank's observations that they were enjoying a quiet night, Marcus cautions that "It can always get worse. You can't change what's out there, only where you're coming from." He too, much like Larry, trusts to a solid inner self that cannot be affected by the anxieties and dangers of the work he does. But unlike Larry, Marcus can feel genuine joy for a case that turns out well, such as when he assists in the successful delivery with a woman who protests that she is not pregnant even as her newborn child appears. Half in jest, he carefully stages a "resurrection" of an overdosed punk rapper, self-named IB Bangin, whom his stoned and ignorant companions believe has died. Before administering the shot of Narcon into the man's heart that he knows will revive him, Marcus says to the assembled group, "Oh Lord, here I am again to ask one more chance for a sinner. Bring back IB Bangin, Lord. You have the power, the might, the super light, to spare this worthless man." Marcus jokes his way through what he sees as a somewhat disagreeable but finally tolerable form of employment. Like the other EMTs, he rejects the possibility of reviving a junkie in cardiac arrest through mouth-to-mouth resuscitation on the reasonable (but finally unacceptable) grounds that he might in the process get a "mouthful of puke." Walls (Tom Sizemore) reflects Frank's anger at the helpless, self-destructive clientele he must serve and thus almost lures Frank, his partner, into the same kind of mindless and sadistic fury that he is hell-bent on pursuing. Walls suggests that the two find some pathetic derelict upon which to vent their anger, a plan to which Frank agrees. But once Walls decides to murder a brain-damaged troublemaker named Noel (Marc Anthony), Frank revives the man, who is near death, by giving him mouth-to-mouth resuscitation (the rescue is less dramatic and intimate in the novel, in which Frank gets Noel breathing again by intubating him). Having come to the end of his anger, Frank makes his way to Mary, there to receive her forgiveness for letting her father die. After "becoming" Patrick Burke in order to provide him with a dignified death and after saving Noel from the cruelty he had encouraged Walls to indulge, Frank finally understands the meaning of the self that, by circumstance and choice, he has come to be.

It is certainly true that 1990s' American cinema seems in retrospect reverentially devoted to a heroicization of the working-class male. Consider M. Night Shyamalan's *Unbreakable* (2000). With its emphasis on male

physicality (and the problems for gender politics that male strength might be seen as raising), this film speaks directly to and with greater psychological insight into the growing self-doubts and halting self-redefinition that deeply marked the maturing process of many American men in the wake of second-wave feminism. *Unbreakable* engages social issues whose most important cultural symbol is what critic Susan Jeffords calls the male "hard body," featured most prominently in the *Rambo* and *Rocky* franchises during the 1980s. In its spectacularization of male power and strength (but not the ripped male torso), *Unbreakable* can be said to look backward to the 1990s, in which, as Jeffords points out, the preoccupation of 1980s cinema with hugely muscular, physically imposing action protagonists underwent "reevaluation." Key films from the Hollywood of the 1990s, as Jeffords suggests, took up the "rearticulation of masculine strength and power through internal, personal, and family-oriented models."[26] In other words, the hard body narrative was thoroughly melodramatized in the period, as in *Kindergarten Cop* (1990), which features Arnold Schwarzenegger as a children's caretaker but also as an action hero, albeit fully clothed.

Unbreakable is certainly in this tradition. Unlike *Bringing Out the Dead*, however, Shyamalan's film quickly abandons its engagement with the discontents of working-class life. Protagonist David Dunn (Bruce Willis) is a stadium guard who discovers that his real avocation is a secret life as a superhero. David confirms himself in that mission by destroying a sociopathic usurper from the lower orders bent on rape who, in a seeming mockery of normalcy, goes out to his job in the morning, only to return to his depredations in the evening. Ironically, his wife Audrey (Robin Wright Penn) finds herself marginalized as the narrative draws to a close. She is never afforded the opportunity to revise her reflexive antimasculinism in light of the transformation that has caught up her husband. What is allowed to stand is her initial refusal to accept the kind of masculinity that she was in some sense attracted to in David but, perhaps influenced by feminist currents, ultimately rejected, refusing to marry him until he abandoned playing college football.

Unbreakable's ending thus has little to do with the reconciliation between husband and wife, which is apparently as complete as it is sudden (briefly dramatized in a morning-after breakfast scene that had followed David's discovery of self-assertion). David's embrace of this new identity is a secret to be shared with his adolescent son Joseph (Spencer Treat Clark), whose desperate anxiety about his father's true nature is thereby relieved. But this archmaleness, perhaps because it confirms Joseph's adolescent wish for a father stronger and less vulnerable than other men, must be concealed from Audrey, who cannot, so they silently agree, be given the opportunity

R. Barton Palmer

to pass judgment upon it. And so it is deeply ironic that the renewed relationship between husband and wife will be founded on a fundamental deception in which their son must be made complicit. Their moment of intensely shared sentiment is thoroughly and exclusively masculinist, as David's wound is healed by his discovery of a different self within.

In true Hollywood fashion, *Bringing Out the Dead* similarly offers, through the moral and spiritual triumph of its hero, a metonymically utopian solution to the profound discontents of postindustrial urban life, including an increasing dependence on those within the service industry who are called upon to do dirty and dangerous work in order to prop up a crumbling social infrastructure that has stranded legions of the hopeless poor. But Scorsese's film is quite different from not only fantasies of transcendence such as *Unbreakable* (with its marginalization of the feminine and its invocation of metaphysical renewal) but also straightforward glorifications of blue-collar labor such as *Backdraft* and *The Perfect Storm*. With its focus on a masculinity defined by meaningful work whose aim is the sustaining of the community as well as its poignant critique of male power (expressed in part by Frank's "professional" rejection of the less committed or even lethally selfish masculine styles of his partners), *Bringing Out the Dead* does more than offer a comforting, entertaining fantasy about empowered men. Reading through the auteurist foregrounding of transcendental experience, we are able, as Fredric Jameson suggests is sometimes possible in watching a commercial film, "to begin to sense the abstract truth of class through the tangible medium of daily life in vivid and experiential ways."[27]

NOTES

1. Steve Cohan and Ina Rae Hark, *Screening the Male: Exploring Masculinities in Hollywood Cinema* (New York: Routledge, 1993), 2.

2. Ibid., 3.

3. Ibid.

4. These negotiations are discussed briefly in Jim Sangster, *Scorsese* (London: Virgin Books, 2002), 263.

5. Ibid., 266.

6. Joe Connelly, *Bringing Out the Dead* (New York: Vintage, 1998), 26.

7. Ibid., 321.

8. Ibid., 322.

9. Particularly relevant here is Paul Schrader's own critical book on the subject, *Transcendental Style in Film: Ozu, Bresson, Dreyer* (Berkeley: University of California Press, 1972).

10. Ibid., 92–93.

11. Cohan and Hark, *Screening the Male*, 3.

12. Amy Aronson and Michael Kimmel, "The Saviors and the Saved: Masculine Redemption in Contemporary Films," in *Masculinity: Bodies, Movies, Culture,* edited by Peter Lehman (New York: Routledge, 2001), 44.

13. Ibid., 49.

14. David James, "Is There a Class in This Text? The Repression of Class in Film and Cultural Studies," in *A Companion to Film Theory,* edited by Toby Miller and Robert Stam (Oxford: Blackwell, 2004), 182–83, 186, 197.

15. Ibid., 197.

16. Ibid., 186.

17. Frederic Jameson, "Class and Allegory in Contemporary Mass Culture," in *Signatures of the Visible* (New York: Routledge, 1992), 36–37.

18. Ibid., 38.

19. Quoted in Marjorie Rosen, "Isn't It about Time to Bring On the Girls?" *New York Times,* December 15, 1974, 169.

20. Vincent Canby, "'Alice,' Young Widow Finds Herself," *New York Times,* January 30, 1975, 28.

21. James, "Is There a Class in This Text?," 197.

22. Stephen Farber, "Has Martin Scorsese Gone Hollywood?," *New York Times,* March 30, 1975, 79.

23. Rosen, "Isn't It About Time to Bring On the Girls?," 169.

24. Farber, "Has Martin Scorsese Gone Hollywood?," 79.

25. James, "Is There a Class in This Text?," 184.

26. Susan Jeffords, *Hard Bodies: Hollywood Masculinity in the Reagan Era* (New Brunswick, NJ: Rutgers University Press, 1994), 13.

27. Jameson, "Class and Allegory in Contemporary Mass Culture," 38.

David Greven

American Psycho Family Values

Conservative Cinema and the New Travis Bickles

The late 1990s prognosticated a new form of depraved masculinity, one in which queer and straight modes of intransigent manhood joined forces in their attack on the Law of the Father. Films as distinct as David Fincher's *Fight Club* (1999) and Wes Craven's late 1990s' *Scream* trilogy featured violent young men whose penchant for carnage suggested a new form of aberrant, ecstatic lawlessness. If representation has been any indication, however, reports that the millennium would usher in a new breed of patriarchy-defying American psychos were greatly exaggerated. While the number of scary males in the movies has endlessly grown, it is also true that far from waging campaigns *against* the normative social order, these oppressors have most frequently toiled, for all of their ostentatious menace, in support of it. Spanning the scope of genre films, the psycho males of postmillennial comedy as well as horror don't fight the power but instead fight on its behalf.

Slavoj Žižek writes that "Given the central status of deception in relation to the symbolic order, one has to draw a radical conclusion: the only way *not* to be deceived is to maintain a distance from the symbolic order, i.e., to assume a *psychotic* position. A psychotic is precisely a subject who is *not duped by the symbolic order*."[1] For Lacan and Žižek, the symbolic order is the father's order—his language, his law, and his name—through which subjectivity is formed, in part as a rejection of the pre-Oedipal world of the mother. No greater representatives of the symbolic order exist than Hollywood narrative and the nuclear family, mythologies that cross-fertilize and mutually support one another. Traditionally, the American movie psycho specifically threatened the linked institutions of conventional films

and families. Following Žižekian lines, the psycho—a figure who opposes the normative social order and whose challenge to it is so vexing that the psycho must be actively destroyed—traditionally did this because he saw through these institutions, refusing to be seduced by their siren-like power. Psychos such as Robert Mitchum's Max Cady in *Cape Fear* (1962) or the cannibal psychiatrist serial killer Hannibal Lecter (Anthony Hopkins) in *The Silence of the Lambs* (1991) oppose normative structures such as families, marriage, and middle-class morality. Max Cady threatens to destroy the pious middle-class family of the lawyer (Gregory Peck) who put him behind bars as well as to ravish the lawyer's wife and daughter. Hannibal Lecter flagrantly mocks the senator whose daughter has been kidnapped by the serial killer Buffalo Bill/Jame Gumb (Ted Levine). Lecter intimately ridicules the senator's motherly role, bewilderingly asking her, but with his full psychiatric authority, if she breast-fed her daughter. When she answers "Yes!" emphatically, he responds, cruelly and humorously, "Toughened your nipples, didn't it?" Adding camp to his mockery, he delivers the exit line: "Oh, and Senator, one more thing. *Love your suit!*"

The psychos of the first decade of the twenty-first century have not followed suit. Indeed, rather than stand as the enemy of the family and the normative, they have exuded a penchant for *upholding* family values, a disturbing trend for characters who might be imagined to be vehemently opposed to either families or values. Prior Hollywood versions of deviancy, such as the giggling psychopath Tommy Udo (Richard Widmark) in Henry Hathaway's *Kiss of Death* (1947), did not help to facilitate the marriage or the well-being of tormented hero Nick Blanco (Victor Mature). Rather, Udo infamously pushed a wheelchair-bound woman down a flight of stairs, and it was precisely his brazenly asocial glee that gave *Kiss of Death* its jolt.

An ideological sleight of hand has defined genre films of the first decade of the twenty-first century especially. Providing the continued thrills of menace and mayhem traditionally embodied by the psycho, genre films have also reconfigured the psycho so as to deploy the figure as a proponent of the correct—that is, normative—social values. Genre films, in other words, want to provide their perverse pleasures while establishing themselves as morally conscientious, an unwieldy project at best. This retooling of the genre film probably has its genesis in James Cameron's *Terminator 2: Judgment Day* (1991). Like Arnold Schwarzenegger's terminator in that film, contemporary psychos are reprogrammed monsters, monsters for *good.* The deviant Other of contemporary cinema is a kinder, gentler advocate for the very normative values that deviant Others have characteristically opposed. The titular figure of Bret Easton Ellis's Zeitgeist-defining late 1980s novel *American Psycho* embodied his greed-is-good consumerist era

and enforced its most poisonous values, taking the shallowness and social indifference of the Reagan era to the most violent extremes. It is impossible to imagine Patrick Bateman (the protagonist of Ellis's novel) or, for that matter, the 2000 film adaptation of the novel directed by Mary Harron and starring Christian Bale, fighting for family values or emerging as an allegory for their validity. Yet such has been the imperative that defines the postmillennial genre film; contemporary psychos primarily seek to uphold conventional morality.

Jigsaw, the villain of the ongoing *Saw* films since 2004, the seventh of which was released in 3-D in 2010, tortures his victims in all manner of baroquely hideous ways, not for the pleasure of inflicting pain but in order to remind them of their wasted opportunities, moral failures, or inability to appreciate how good they have it. We have returned to the morality plays of the 1950s and 1960s, such as *The Twilight Zone,* in which gothic scenarios that turn out badly for the protagonists redress their smugness and moral callowness (although few genre productions match that indelible series' plangent, melancholy tone). The psychos of films from the early years of the millennium established a precedent for the new-style psycho, the psycho who does not oppose the Law of the Father but instead works to establish, maintain, and ensure it. For all of their creepy, obsessive oddness, the psychos of *One Hour Photo* (2002), *Phone Booth* (2002), and *Anger Management* (2003) primarily serve as bulwarks against the shearing structures of American family values, commonly conceived as white, middle class, and heterosexual. I will first revisit these films and then turn to a different subject, the transition from the homosexual to the pedophilic male as a site of cultural phobia and retributive wrath.

A SIGHTED OEDIPUS

In Mark Romanek's *One Hour Photo,* Robin Williams plays Seymour "Sy" Parrish, a photo-lab technician at the local SavMore grocery store. Sy develops an obsession with the Yorkin family, Will (Michael Vartan), Nina (Connie Nielsen), and especially their son Jake (Dylan Smith). Seemingly perfect, the attractive Yorkin family secretly suffers from the pain of Will's adulterous affair with redheaded Maya Burson (Erin Daniels). Even before learning about the affair, Nina accuses Will of neglecting Jake. Will's hangdog-guilty expressions amply convey his helpless inadequacy, which Sy witnesses through their family photos as he develops them over time. Sy thereafter inserts himself into this Oedipal family crisis.

Sy was immediately compared by many reviewers to Robert De Niro's indelible Travis Bickle in Martin Scorsese's *Taxi Driver* (1976), scripted by

Paul Schrader. Sy, however, shares few of that memorably unhinged character's frightening opposition to social conventions. Travis maintains a fierce fixation on Jodie Foster's underage hooker Iris. At the climax of the film, he kills her flashy cowboy-hat-wearing pimp, Sport (Harvey Keitel), and others involved in his prostitution ring. While Travis initially presents himself as Iris's customer, he very adamantly rebuffs all of her professional sexual ministrations. Indeed, he seems horrified by them and perhaps even by sex in general, a disposition confirmed, rather than disputed, by his endless immersion in the world of pornography. Travis is frequently shown staring blankly at pornographic screens, in bleak isolation; although he is an incessant viewer of sexual spectacle, his own desiring experience is left pointedly obscure. With certain similarities to the depiction of masculinity in Scorsese's film, Sy is represented as nonsexual. His interest in the young Jake, which we are primed in thriller fashion to see as pedophilic and increasingly dangerous, never actually crosses over into the erotic; indeed, Sy is vehemently *opposed* to the sexual exploitation of children, having been himself the childhood victim of pedophilia.

Sy is a denatured Travis Bickle. Whereas Travis attempts to assassinate a presidential candidate to impress a woman who works on his behalf (Betsy, played by Cybill Shepherd), Sy's murderous campaign on Jake's behalf only *appears* murderous. While he threatens to torture and murder the philandering father Will and his mistress, Sy's real goal is to produce a nonlethal *moral* terror that will force them to recognize the error of both of their ways. In contrast, Travis's revenge on Iris's oppressors—Sport and the various mob-funded men who facilitate his pimping—truly *is* lethal, an apocalyptic climactic bloodbath shot in muted, dehumanizing tones and colors. (Ostensibly, the color schemes that Scorsese used were meant to calm the censors who protested the film's violence. But aesthetically, they work to provide a powerful sense of alienation.)

Travis Bickle is shown to be opposed to sex with Iris. As noted, one of the teases of *One Hour Photo* is that for much of the time, it suggests that Sy has hopes of sexually seducing the young Jake. The film certainly gives Sy, with his icy white hair, thick ugly glasses, and antiseptic furtive-eyed look, the appearance of a classic pedophile. The cinematic typing of deviants has begun to reach new levels of commonality in postmillennial cinema. In Mira Nair's *Monsoon Wedding* (2001), the heroine has an uncle who sexually abused her as a child. Given shock-white hair, blighted skin, and a leering look, the pedophilic uncle is made to look like an outer space alien. In the well-received *The Deep End* (2001), a remake of *The Reckless Moment* that has nothing on the desperate violence of Max Ophuls's original 1949 film, a mother must contend with her gay teenage son's evil gay lover. Cast

David Greven

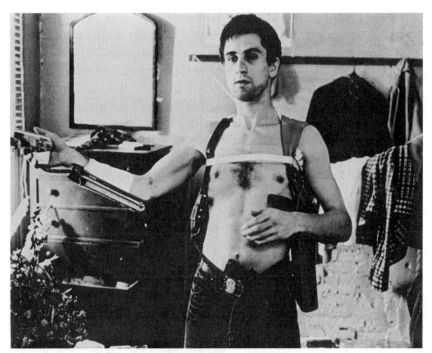
Travis Bickle is the archetypal psychopath in *Taxi Driver,* traumatized by the world around him and delusional to the point that he builds his body into a killing machine.

in this role, Josh Lucas, normally a handsome heterosexual romantic lead, looks unrecognizably effeminate and cruel. Whether Hollywood or indie, movies remain altogether effective at helping us spot deviants. What is especially interesting here is that although *The Deep End* was made by gay filmmakers, the film is no less helpful in this regard.

Alarmingly high-strung at work, Sy behaves like the standard psycho for much of the film. Before he learns of Will's affair through the telltale photographs that he develops, Sy fetishistically reverences the Yorkins in their seeming familial bliss. A loner with no friends, alarmingly high-strung and frequently belittled by his cold, unfeeling boss, Sy makes his own secret copies of photographs of the Yorkin family's happy occasions, such as birthday parties in which the photogenic parents hug their son. In classic sexual-obsessive fashion, he covers his walls with these photographs. He breaks into and loiters in their house when they aren't home, soaking up the presumably warm, loving atmosphere. In classic pedophile fashion, he stalks Jake after school and walks home with him. Yet unlike Mitchum's Max Cady, who terrorizes the teen daughter of his upstanding lawyer-man target even while she is at school presumably within its

institutional protection (as does Robert De Niro in the same role in Scorsese's 1991 remake), Sy only wants to offer Jake tender concern and empathy. What drives Sy is first his envy for what the Yorkins have—a "normal" family life and each other—and then rage against Will for being such a neglectful father and poor husband.

Sy makes sure that Nina gets the photos of Will and his mistress, and at the film's climax, Sy bursts in on Will and his lover Maya during an afternoon tryst in their hotel room. Taking out both his camera and a large phallic knife, Sy—finally appearing to fulfill all of the worst expectations planted in us by the movie—forces Will and Maya to assume "sexy" poses as he photographs them. This effective scene makes us squirm in horror: the surprised, terrified adulterers comply with Sy's demands that they smile and look happy as they pose with a knife held at their throats. The juxtaposition between their terror and their posed expressions of joy is unsettling.

As it turns out, however, Sy was only taking pictures of objects in the room; he takes no pictures of the adulterous pair themselves. Sy proudly examines these photographs as he explains his motivations to the detective who later interrogates him, revealing that he was himself abused as a child, forced to do terrible sexual acts. The sympathetically anguished look on the detective's face signals to the audience that we too must feel pity for Sy and empathy for his wrongheaded but morally conscientious actions. *One Hour Photo* thus taps into the social animosity and disgust toward the pedophile that has exponentially grown in the twenty-first century, in which residents are by law alerted to the presence of a convicted pedophile within their midst. Strangely, however, the film converts the loathsome pedophile into his opposite, not the monster who threatens the child but instead this child's advocate, however quirky and off-putting.

In one of the most memorable moments in the film, Sy has a dream in which he stands, all by himself, in an aisle of the SavMart. A Kubrickian chill hangs harshly over the air. Everything is barren, the shelves having all been denuded. Then a globule of blood gathers in one of Sy's eyes, and gradually both eyes swell in this crimson tide. In an extreme close-up, we see this blood bursting out of his eyes and pouring down his face. Sy has seen it all, has seen too much. The film frames him as a sighted Oedipus, who can see the pain that others cause, who can solve the mystery of other people's traumas, neither because of his own traumas nor despite them but rather because he is the one person who can see through everything. He can see through the symbolic order, not because he is *not* duped by it but because he can see the rot at its heart. The symbolic order has begun to decay because the fathers have failed to uphold patriarchal principles. Sy's

psycho corrects the grievous mistakes of these irresponsible fathers as he restores the father's order.

PHONING IT IN

Phone Booth boasts a screenplay by Larry Cohen, the great "guerrilla" film-maker of the 1970s, as Tony Williams praises him in his superb study of Cohen's work.[2] *Phone Booth* is also a welcome display of effective crafts-manship from its wildly uneven director, Joel Schumacher. In this enter-taining and ingeniously conceived film, a scuzzy philandering New York City talent agent, Stu Shepard (Colin Farrell), steps into the phone booth that, in this cell phone era, he uses to make illicit phone calls to his mistress Pamela (Katie Holmes), who is unaware that he is married to Kelly (Radha Mitchell). Sadly unbeknownst to Stu, a serial-killer sniper (Kiefer Suther-land) has targeted him. After getting Stu on the phone, the killer keeps him there by threatening to shoot him. The killer demonstrates the seriousness of his murderous intentions by firing on a belligerent pimp who wants ac-cess to the phone booth on behalf of his harem of hookers. The killer man-ages to get both Pamela and Kelly at the increasingly frenzied site in order to humiliate Stu, who is forced to reveal his duplicity and betrayal of both women *to* both women.

In Larry Cohen's horror film *God Told Me To* (1977), a serial killer also shoots people from a great height. But in this film a higher malevolent force motivates this particular killer as well as another killer who recounts, with a terrifying serenity, the tale of annihilating his entire family. In *Phone Booth*, the killer's chief motivation is to force the adulterous Stu to become a better husband and to stop exploiting impressionable young actresses. Indeed, the killer allows Stu to live only if he promises to *be* a better husband. One of the killer's scare tactics is to reveal his past murders to Stu, including that of a European kiddie-porn magnate. Obviously, this psycho kills with a politi-cal conscience. Neither some random madman nor the obsessed minion of a malevolent deity, this killer targets society's worst offenders: pedophiles and adulterers.

In *Anger Management*, directed by Peter Segal, Jack Nicholson plays Dr. Buddy Rydell, an anger management guru whose mission is to rehabili-tate Dave Buznick (Adam Sandler), a nondescript man who is accused of exploding into rage on an airline flight. "Sir, *calm* down," a tall black man, who appears to be a plainclothes marshal, instructs Dave, signaling that straitlaced white masculinity has gone out of control. Enter Nicholson's Buddy. Hirsute, wild-eyed, and self-contentedly antic, Buddy follows Dave around incessantly, prodding into his life and even stealing girlfriend Linda

(Marisa Tomei) from him. Not only insisting on sharing a bed with Dave but also removing his underwear when in bed with him, Buddy threatens Dave with an omnipresent homoerotic threat, one rendered comic by both the intergenerational gap between them and Nicholson's trademark devilish, anarchic persona. Adding to Buddy's provocations and Dave's troubles is Linda's ex-boyfriend. Although not particularly attractive, he does wield one special invincible power: his enormous penis. He waves this Homeric phallus before a flabbergasted Dave at a urinal, proudly exposing his majestic organ with a flagrant "Oh, yeah!" as he looks at Dave in triumph. Both of Dave's sexual rivals for his girlfriend, then, taunt him with homoerotically tinged masculine threat.

Buddy reveals himself to be part of a vast plot on Linda's part to detoxify Dave of his rage. As it turns out, none of the nightmarish events have been real; even the airline incident was staged. In this plot twist, the film recalls David Fincher's far superior 1997 film *The Game,* in which Michael Douglas's wealthy corporate raider is harassed by a series of increasingly baroque, violent, and titular "games." It turns out that the protagonist's brother, played by Sean Penn, has "bought" the rich man these games in order to snap him out of his emotionally deadened life. In a similar way, *Anger Management's* Buddy, like other recent movie psychos, has expended his frenetic energies on making Dave a better boyfriend and future husband for Linda.

Although seemingly devoted to the antics of their psychos, ultimately these films chiefly concern themselves with their wayward, heterosexually inadequate, and, in the case of Sandler's Dave, phallically challenged protagonists. Characters such as Will Yorkin, Stu Shepard, Dave Buznick, and their ilk not only fail to achieve heterosexual male perfection but also squander their rank and privilege. The psycho thus comes to the rescue. The psycho has been revised as the Mrs. Doubtfire of current straight male anomie, a nanny or governess in male masquerade ministering to men whose childish failures have denied them their rightful privileges. Surprisingly enough, this theme also animates the hyperhip *Fight Club,* in which Brad Pitt's pimp-dressing fight-club guru Tyler Durden effects a gendered makeover on Jack (Edward Norton), helping him to remasculinize his softened corporate-sad-sack life. Unquestionably, the rescue mission that these male nannies carry out is as racialized as it is gendered. In *Anger Management,* the physically imposing black man who instructs Dave to dial down his rage on the plane is revealed to be in on Linda's/Buddy's plot. Far from being a plainclothes air marshal, he is merely a disgruntled passenger who, before being enlisted to help, spouts incoherent dissatisfaction in his seat. He too is employed to ensure white sexual male normativity. (What's subtly

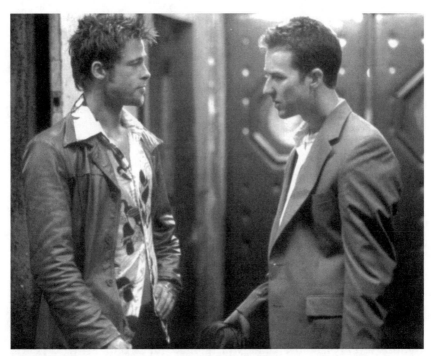

The Brad Pitt and Edward Norton characters in *Fight Club* deteriorate into menacing maniacs as their numerous pathologies overtake their identities.

racist about this is the man's demotion to a nonprofessional role after he was initially presented as someone in an official capacity. It is as if the film were reassuring us that this black man is "just" an ordinary passenger, not someone in whom our air safety has been entrusted.)

THE BETA MALE STAR AND GENRE HYBRIDITY:
OBSERVE AND REPORT

Two titles of recent books bemoaning the childish regressive state of American masculinity are telling: *Manning Up* and *Save the Males*.[3] Inciting this glut of alarmist literature and embodying the male crisis at their core is the series of so-called beta male comedies that have been emerging in the past decade and forming a new genre unto themselves, a new genre to which I now turn. With the key exception of the horror genre, these comedies, pioneered by the wildly successful director Judd Apatow, have become, in their recurring problems and themes, the primary means whereby the contemporary (read: the latest) crisis in masculinity can be explored.[4] The

"losers" in beta male comedies—physically unconventional looking, out of shape, and jobless (although in this last regard they seem increasingly less unconventional)—defy leading man standards, but these surface distractions should not obscure their access to an enduring male privilege.

In contrast to the now-diminished teen comedy genre of the late 1990s and early 2000s, beta male comedies skew older, with male protagonists in their early twenties or, in the case of the Steve Carrell sleeper hit *The 40-Year-Old Virgin* (2005), their forties. Representative films include Apatow's *Knocked Up* (2007), Greg Mottola's *Superbad* (2007), David Gordon Green's *Pineapple Express* (2008), Nicholas Stoller's *Forgetting Sarah Marshall* (2008), and Todd Philips's *The Hangover* (2009) and its 2012 sequel. While most beta male comedies focus on male group dynamics, films such as David Dobkin's *Wedding Crashers* (2005), David Wain's *Role Models* (2008), and John Hamburg's *I Love You, Man* (2009) reflect a larger trend of "double-protagonist" films.[5] In whatever form, the beta male film takes the traditional genre of the buddy film to an expansive new genre-crossing level.[6]

Issues of star acting in beta male comedies relate to the distinctive kind of masculinity they shape, develop, and put forth. The genre hybridity that informs several beta male films, which reflect the larger blurring of genres in contemporary Hollywood films, needs to be considered in terms of the ideological character of the films, which is appositely hybridic as well. If postmillennial Hollywood film has spectacularly returned us to the power genres of the 1980s—that is, horror and comedy (as well as the action film)—and if as in films previously discussed as well as recent television series, such as *Breaking Bad* and *Dexter*, comedy and terror have become fused in male characters, the beta male complements or reflects this fusion, producing works that tonally evoke terror and comedy at once. Directed by Jody Hill, the deliberately odd *Observe and Report* (2009), starring Seth Rogen, is exemplary of this tonal intermixture.

Praised as a sex symbol by conservative gay pundit Andrew Sullivan, Seth Rogen stars in several of the Judd Apatow films that have established the chief elements of beta male comedies. Rogen is an unlikely movie star and, pace Sullivan, an even unlikelier sex symbol. With his thick inexpressive voice, irregular features, and nonchiseled body, Rogen reflects a more recent trend away from the physical perfection, reaching unto surgically enhanced posthuman limits, that has governed bodies in popular representation from at least the late 1980s forward. (Chiseled male flesh has only been on increasingly public display in both film and television since the 1980s' era of hypermasculine action stars; the popularity of the television series *Sex and the City* established male bodies as objects of erotic

contemplation, provided that these bodies were as physically alluring as those of screen women have typically been.) While Rogen's comedic gifts make him an appealing screen presence at times and while his unusual star physique or lack thereof is a welcome break from Nautilized uniformity, he also as a star has some of the same troubling characteristics of previous stars who were put forth, as much by themselves as by their movies, as the voice of the "real" America.[7] Rogen's persona presents itself as hapless, sweet souled, and in need of rescue. Yet a palpable narcissistic vitriol often seeps out in the characters he plays, a quality that his films work to disavow. The menace and the sheer potential for rage in Rogen that inform all of his performances cannot be distinguished from the new type of masculinity he embodies.

If Rogen is often a leering satyr in his roles, a movie such as Apatow's *Funny People* (2009), the director's transparent bid to be taken more seriously as a film artist, presents us with an infantilized Rogen who asks to be coddled, thereby infantilizing the audience. In this film, Adam Sandler stars as a crude, selfish, famous comedian who discovers that he's dying; Rogen plays the up-and-coming stand-up comedian whom Sandler hires to write jokes for him and who becomes a kind of private nurse to him as well. While Sandler gives a surprisingly nuanced performance, Rogen, looking both leaner and less interesting here, inhabits his victim role far too unironically, as if he and his character were soliciting our pity. But the characters in which Rogen presents himself as a genial foul-mouthed everyman, such as in *Pineapple Express,* are not all that distinct from his role in *Funny People* in their appeal to the audience for sympathy; *Funny People* simply makes this appeal more directly.

The haplessness and discombobulated sluggishness of Rogen's character in *Knocked Up* distracts us from the sexual conservatism and heterosexual male privilege that inform this ur-Apatow movie. All the elements of the film make it appear that his conflicts with the uptight, anxious Katherine Heigl character, who bears his child and whose heart he eventually wins, stem from her tensions. In order to focus on these conflicts, we must ignore the grinding obstinacy and narcissistic rage that palpably inform Rogen's character in order to join him in his child-man fantasies of mastery. The reason to be critical of the Rogen persona is that as the chief screen embodiment of the beta male, he represents a potential for the critique of normative masculinity but instead recuperates and perpetuates its worst excesses *while* claiming to be the victim of larger forces, chiefly embodied by strong, tough, demanding women and nonwhites.

Observe and Report simultaneously draws out the disquieting misogyny, racism, and general misanthropy in the Rogen persona while also being no

less idealized a platform for it. Writing in the *Guardian,* Peter Bradshaw expressed the viewpoint that generally characterized the film's critical and box office reception (the lowest to date for any starring Rogen):

> For Seth Rogen fans like me, this charmless, heavy-handed and cynical comedy is an uncomfortable experience. Rogen plays Ronnie Barnhardt, a sad-sack loser who is a security guard in a shopping mall. In this, he of course resembles Kevin James's similar deluded jerk in *Paul Blart: Mall Cop.* But where Blart was supposed to be basically pretty nice, Ronnie is a nasty piece of work with a bipolar condition, who uses his meds to effect what is almost—but not quite—a drug rape on the mall's similarly unpleasant cosmetics salesperson, played by Anna Faris. (The movie makes a careful point of showing her semi-conscious and fully willing.) Again and again, you almost laugh at something that is almost good, and then there is a clumsy and misjudged moment of crassness. I'm all for bad taste and black comedy and grossout. But it has to be funny.[8]

Bradshaw suggests that the film's misogyny and racism would be excusable had it made him laugh. The difficulties posed by a film such as *Observe and Report* stem precisely from the metatextual and hyper–self-conscious awareness that the film exudes of its own ideological vexations. It is precisely from its ideological vexations, of which the film repeatedly shows us that it is aware, that the film's humor is meant to flow. The film calls itself misogynistic and racist so that the audience doesn't have to or before anyone gets the chance to do so.

The fusion of horror and comedy in twenty-first-century male movie genres has its precedent in the films of the 1980s, a decade in which much genre splicing occurred. Some prime examples include Brian De Palma's suspense comedies *Dressed to Kill* (1981) and *Body Double* (1984), horror comedies such as Tom Holland's *Fright Night* (1985) and Ivan Reitman's *Ghostbusters* (1985), and Paul Verhoeven's science fiction comedy-thriller *Total Recall* (1989). In recent years, films such as Ruben Fleischer's *Zombieland* (2009)—which some fans call a "zombedy"—reflect the merger of both genres. Featuring Bill Murray both as himself and as a zombie, which recalls Murray's role in *Ghostbusters,* Fleisher's film notably fuses the horrific (the opening sequence provides graphic zombie gore) and the comedic, ending up in the fulfillment of heterosexual romance.

The ever-increasing predilection for genre hybridity has many different valences and implications. The most disturbing of them is that these genre hybridic films can quite thoroughly pursue a conservative reactionary

agenda while proclaiming that they are doing just the opposite, undermining or critiquing this adamant agenda. If *Observe and Report* exposes Rogen's Ronnie character as a monstrous presence, it nevertheless not only idealizes him but also vindicates the intolerance he exudes, which is the basis of his obsessions, desires, and actions.

Ronnie is a mall cop in love with dim-witted blond Brandi (Anna Faris, a star in distaff versions of the beta male comedy), who works in cosmetics. When a flasher scares women in the parking lot, exposing himself and using foul language, Ronnie immediately seizes upon the flasher's threat as an opportunity to promote himself: by catching the elusive flasher, Ronnie will become a hero. While pointedly ironizing the shallowness and self-delusion in Ronnie's fantasies, the film also does everything in its power, after inflicting copious amounts of pain, humiliation, and defeat upon him, to allow Ronnie to realize these fantasies. By the end, he really is a hero; by the end, he really has gotten the blond girl. That she happens to be a different blond girl is part of the point. He rejects the insipid Brandi—although not before he also manages to have sex with her—in favor of her moral superior, Nell (Collette Wolfe), who works in the food court and who, at the start of the film, has one of her legs in a cast. By the end of the film she has been freed from her physical handicap, and he much more dramatically has been freed from his lack of virility. She becomes the desirable woman, and he apparently becomes the desirable man.

As it does *One Hour Photo*, *Taxi Driver* haunts *Observe and Report*. Hill's film incorporates the same themes of racism as well as the search for an unattainable heterosexual ideal that animate Scorsese's work. Whereas *Taxi Driver* is alternately mournful and lyrical before its terrifying climax, *Observe and Report* reflects the genre hybridity of the 2000s, playing out as a bleak comedy. In genre terms, the fusion style reflected in the film also has its roots in *Taxi Driver* as well as the earlier films of Brian De Palma, although *Observe and Report* frequently eschews their joint political valences. *Taxi Driver* inverts the romantic comedy genre, transforming its protagonist Travis Bickle's winsome wooing of the unattainable, glassy Betsy, who works for the presidential candidate Charles Palantine (Leonard Harris), into an ultimately despairing take on modern urban disconnection and sexual alienation. Travis quite improbably takes the obviously uneasy, wan, remote Betsy, of all people, to see a pornographic film and is bewildered when fairly soon afterward she strides out of the theater. Travis's romantic ineptitude signals a much deeper social estrangement on his part as well as an ever-deepening misogyny, one subtly conveyed through his idealization of the teen prostitute Iris. Travis, never depicted as a sexually functional male, can only "come through" for this child-woman, whose

rescue he effects through a barbaric show of climactic violence that doubt-lessly leaves Iris, caught within the violent melee, traumatized. Moreover, in returning her to the very family she ran away from, Travis's rescue may, it is quietly suggested, be no rescue at all but rather an even deeper form of oppression and imprisonment for her.

One of the major themes in *Taxi Driver*, one that I believe the film ac-tively critiques rather than indulges in, is Travis's racism, his sense of horror at but also fascination with African American men especially. Scorsese and screenwriter Schrader, while admittedly not entirely immune from charges of racism themselves, make it materially clear that Travis's racism stems from his own sense of impotence, literal as well as symbolic. (We never see Travis having sex, and it is strongly suggested that his sexuality is as limp as his social life.) While *Observe and Report* plays with this idea—the idea that its protagonist's racism stems from his own pain, failure, and anger—more emphatically the film makes Ronnie's racism a comic function that is designed to gain our sympathy for how goofy and clueless, rather than offensive and frightening, this hero is.

Ronnie loathes Detective Harrison, played by Ray Liotta. Assigned to the mall-flasher case, Harrison threatens to steal Ronnie's thunder and does steal his girl: Brandi and the detective make feverish love in his car as the wounded, betrayed Ronnie watches from outside. While Ronnie's hatred of Harrison is motivated by the film's plot, his rage-filled hatred of the charac-ter Saddamn (Aziz Ansari) is not only unmotivated by the plot but is quite gratuitously obtrusive. Ansari plays an Iraqi mall shopkeeper whom Ronnie believes is the masked thief robbing several mall shops simply because Sad-damn is Iraqi. In one admittedly funny scene, the two confront each other with a series of mutual "Fuck yous," each distinctly inflected, but the scene's humor stems largely from the tenacity of Ansari's comedic delivery.

The film surrounds Ronnie with nonwhite characters with whom he gets along reasonably well, alternately befriending and bossing them around. His assistant is the Mexican American Dennis (Michael Peña), who backs up Ronnie in every instance, and the Asian American Yuen twins (John Yuan and Matthew Yuan), comedic roly-poly types whose status as twins adds to their comic effect. Saddamn seems to exist in order to give Ronnie an appropriate vent for his rage—physically, Ronnie dwarfs the shopkeeper—and in the climactic scene in which Ronnie successfully chases down the pervert, he also gratuitously punches out Saddamn. Evok-ing Robert Ray's theory of the simultaneous appeal that films make to both the ironic and the nonironic audience, this moment seems designed to convey, at once, that Ronnie is a bad person on the one hand or a funny and bracing underdog finally getting his day on the other hand.[9] The film

thus appeals to the diverse ideological sensibilities of its audience. But in its desire to establish some white male payback for mysterious wrongs that seem committed by the mere presence of the Iraqi Other, the film performs an inescapably racist maneuver even as it critiques—for the benefit of the ironic audience—Ronnie for being racist.

But the film's fascination with Ronnie's misanthropy is actually quite *un*ironic. Given that we are meant to root for Ronnie despite the unsavory aspects of his character and given that he can maintain friendships of a sort with nonwhites, his hatred of the Iraqi shopkeeper takes on an entirely different aspect. His relationships with the other nonwhite characters inoculate, in the Barthesian sense, him and the film from charges of racism as they fully indulge in this racism in their treatment of the Iraqi character.[10] In his famous *Mythologies*, Roland Barthes discusses the ways in which society ingeniously acknowledges a small local evil so as to camouflage the workings of a much larger and broader one. Ronnie's borderline contemptuous treatment of the Asian twins, presented as big blobby blanks who numbly submit to his will, and his comfort with treating Dennis as his sidekick let us in on the casually exploitative aspects of Ronnie's behavior. But the fact that the Mexican Dennis turns out to be the mall thief begins to suggest that Ronnie's problem is not his racism but instead his naïveté. Dennis not only betrays Ronnie's trust but actually clobbers him, leaving his supposed best friend unconscious. Subtly, the movie prepares us to accept that Ronnie's disposition toward the Iraqi character, who could not be more polemically named, is, in addition to being humorously over the top, justified. We are encouraged to believe that despite his bluster, Ronnie is essentially genial, as the numerous scenes of him tending uncomplainingly to his ever-drunken mother (Celia Weston) attest. Ronnie really only exhibits, the film suggests, the put-upon white guy's understandable had-it-up-to-here exasperation with brown and black people who keep coming into this country, taking our money, and duplicitously convincing us of their friendship. The outré humor and the genre-hybridic black-comedic elements all add up to distractions from the film's own racism as well as misogyny.

The film very carefully shows us that when Ronnie does have sex with a near-comatose pill-taking drunken Brandi, she is *still conscious*, even asking him, if robotically, "Why are you stopping?" when he pauses during his sexual exertions with her. He is no Travis Bickle. Ronnie gets to have sex with the woman of his dreams. But he also gets to expose her as a degenerate and pathetic loser once she rejects him. The flasher had traumatized Brandi earlier in the film by exposing himself to her, leading to her high-pitched shrieks. As a good indication of the film's disposition to her, Brandi's cries of trauma at having been flashed make her look imbecilic; everything

about her is tacky and apparently hilarious, especially her belief in her own victimization. Having raced to the cosmetics store to flash Brandi again, the flasher is now caught and shot, seemingly to his gory death, by Ronnie. As it turns out, the injury to the flasher was only a flesh wound, although the sight of the culprit crumpled on the ground covered in blood looks like the worst of bloody crime scenes. After Brandi congratulates Ronnie on his success, he tells her off, calls her a traitorous whore before the crowd in the cosmetics shop, and generates applause from all onlookers. The film provides a narrative version of the current real-life fixation with "ex-girlfriend porn" in which guys can get revenge on their exes by leaking videos and photos of them to sites that will turn these paraphernalia into the ingredients for the ultimate cyberrevenge.[11] The point for revenge-porn sites as well as the movie is to make the vengeful humiliation of the woman as public as possible.

When Travis Bickle goes crazy because Betsy won't return his calls and storms into the campaign headquarters and verbally assaults her, the entire scene, while not particularly interested in Betsy and her reactions, in no way makes us cheer for Travis or invites us to share vicariously in his triumphant misogyny. One of the chief differences between *Taxi Driver* and *Observe and Report* is that the first film deliberately presents us with a man whose psychological problems afflict others as much as himself. Moreover, his mental breakdown is a mirror held up to the deeper psychosis of the social order itself. (One of Travis's fares, played by Scorsese, is a psychotic misogynist who plans to shoot his wife and her black lover, she in her vagina. "Have you ever seen what a .44 Magnum can do to a woman's pussy?" the cuckold cheerfully asks. Travis may be crazy, but the world around him is crazier.) In contrast, *Observe and Report* makes Ronnie an essentially tenderhearted guy who looks after his drunken Mom; regains his job; rebonds with his mall-cop underlings, including the Asian twins now relegated to the sidekick roles once occupied by Dennis; and gets a new and improved version of the girl. Being utterly on the margins turns out to be the most expedient means whereby today's beta men triumph over adversity and realize their dreams.

NORMALIZING THE PSYCHO

One of the many ironies within the contemporary normalization of the psycho is that we are living in a fairly psychotic time. World leaders deploy airpower against their own citizenry as former leaders responsible for innumerable ills cheerfully make themselves over as rehabilitated media celebrities. Acts of mayhem and their perpetrators routinely fill myriad

screens. To look at network television drama alone—to say nothing of reality television—the level of increasing violence never ceases to astonish. Indeed, what may be just as terrifying is that it is becoming so rapidly rote. On J. J. Abrams's television series *Fringe*, as with his previous show *Alias*, it is not unusual to see torture scenes, now enhanced with grotesque scientific anomalies, depicted with a harrowing verisimilitude. On any given episode of *Criminal Minds, Law and Order*, or *CSI* and the spin-offs of these shows, we typically not only see the evidence of terrible murders and those who commit them but also spend languorous hour-long minutes closely analyzing the ravaged, violated bodies in every detail along with the crimes. The evidence of murder and its fastidious, fetishistic analysis constitutes the chief drama in these entertainments. It is the new criticism of murder, close readings of killings and other horrible deaths. Certainly the movies generally feature bad people doing horrible things, but the police procedural genre alone produces innumerable tales of ever-grislier deaths, ever more menacing and terrifying villains and monstrous acts.

If there is no dearth of death-dealing villains in contemporary movies or of prolonged and overwhelmingly vivid depictions of murder, what has changed is the social role of the psycho. Whereas the psycho of previous movie generations implicitly and sometimes even explicitly challenged normative social codes, the current crop of movie psychos seem hell-bent on enabling, facilitating, and realizing those codes. The earlier movie psychos carried the burden of representing and giving vent to "unspeakable" social energies. When codes of silence muffled the articulation of deviant desires, the psycho by his very presence spoke of the reality of perspectives and experiences that refused to accommodate or conform to mainstream culture. As I have been adumbrating here, the psycho was, among other functions, an allegorical representation of the homosexual, which could have both radical and phobic dimensions. Certainly in the Cold War 1950s, when homosexuality was rarely *explicitly* discussed or depicted on the screen, the psycho could play a vital role in reminding the audience that not all social energies or identities could be contained within the apparent conformity of 1950s' redomestication.[12] Psychos such as Bruno Anthony (Robert Walker) in Hitchcock's 1951 thriller *Strangers on a Train* performed a vital function. Bruno's sly flirtatiousness with the stolid (yet also oddly feminine) Guy Haines (Farley Granger) jazzes up the film, gives it a frisson of dangerous perverse excitement in which homoerotic threat and murderousness fuse into a general aura of unseemliness. Bruno's perversity, with its homoerotic threat, contrasts with the stiffly conventional all-American Guy's tennis-pro fame, implying good health and athleticism, and the respectability of his potential marriage to a senator's daughter. Similarly, Guy's current wife,

the troublesome, adulterous Miriam (Kasey Rogers), is as threatening in her display of female sexual appetite as Bruno is in his brazenly homoerotic overtures. Her trampy life-loving shenanigans with young men on the fairground put her in league with Bruno, who relishes social deviance: driving a car blindfolded and wanting to kill his stuffy, disapproving patrician father. In terms of vitality and interest, Bruno and Miriam are the heroes of the film. They rivet and arouse, while the other characters react and recoil.

To use another Hitchcock example, Anthony Perkins's immortal Norman Bates in *Psycho* (1960) represents, among many other things, the social usefulness of the psycho. He is easily read as either repressed homosexual or heterosexual; his sexuality, such as it is, is a useful blank. When he takes down a replica of the painting *Susanna and the Elders* (a depiction of the biblical story of a classical rape) and looks at Marion Crane (Janet Leigh) undressing before her fateful shower, he represents an entire continuum of sexual identities and desires simply by voyeuristically staring at her. His voyeurism implies a masturbatory interest, but despite Marion's presence on the other side of the peephole, his erotic object-choice is left unclear. He could just as easily be staring at Marion in an effort to *locate* heterosexual desire—to inspire it within himself—as he is in craven lust. If Norman can easily be read as homosexual, he can just as easily be read as a sexual blank, as someone with no clear sexual orientation at all.

Certainly, Norman Bates has American psycho family values in that he represents an interest in maintaining endogamous family ties to a monstrously perverse degree. Yet it is precisely in his monstrous perversity that Norman is transgressive, an affront to mainstream morality, a satirical response to Mom and apple pie versions of American family values. His murders, the result of his insanity, convey a terrible message about the dark side of American conformity, the shiny blandness of normality. Our current movie psychos, however, seem to convey a different message: these mainstream American values have become so obscured, so elusive, that it takes a deviant to remind us of their importance and to lead us back to them.

The Larry Cohen–scripted William Lustig film *Uncle Sam* (1997) is an example of a subversive film in which the psycho functions as social critique. An allegory of American manhood, *Uncle Sam*'s titular figure, Sam Harper (David "Shark" Frahlich), is a Gulf War vet who simply won't die, even when killed during Desert Storm. He comes back to the United States primarily to ensure that his feminized yet oddly hero-worshipping nephew will emulate Sam's own murderous ways. In the course of the film, it is revealed that Sam brutalized both his sister and his wife sexually and physically, just as he continues to brutalize his nephew with what the film

depicts as a monstrous, unrelenting jingoism. This film uses the American movie psycho politically. The differences between *Uncle Sam* and *Phone Booth* are striking and disturbing, the former a critique of the jingoism and reactionary strains of the larger culture, the latter an embrace of these conservative values. In each case, the psycho makes the film's political concerns palpable, alerting us to the metaphorical significance of the figure as well as its ideological malleability.

Of the many disturbing aspects of this conservative makeover of the psycho, happening across distinct genres and having many distinct yet interrelated effects, perhaps most troubling of all is the evidence it presents that possibilities for resistance and subversion in mainstream film have considerably narrowed (being narrow to begin with, of course). If Hannibal Lecter bracingly mocked our pieties and standards of decorum in *The Silence of the Lambs,* he began to emerge, over the course of films that made him the central figure, as something like a Dexter figure—a serial killer of other serial killers—although with high-culture polish and panache. But he became something else entirely in *Hannibal Rising* (2007): a victim and an avenger. As a child, Hannibal witnessed his younger sister being devoured by starving soldiers in their homeland of Lithuania. Hannibal avenges not only his sister but also other families similarly victimized in World War II. The makeover of the perverse Hannibal Lecter into a comic book hero who rights national wrongs is indeed telling as being exemplary of our cinematic times. Something strange has happened in American movies when the psycho becomes the last best hope for social justice.

NOTES

1. Slavoj Žižek, *Looking Awry: An Introduction to Jacques Lacan through Popular Culture* (Cambridge, MA: MIT Press, 1992), 79.

2. Tony Williams, *Larry Cohen: The Radical Allegories of an Independent Filmmaker* (Jefferson, NC: McFarland, 1996).

3. Kay Hymowitz, *Manning Up: How the Rise of Women Has Turned Men into Boys* (New York: Basic Books, 2011); Kathleen Parker, *Save the Males: Why Men Matter, Why Women Should Care* (New York: Random House, 2010). Of special interest is that these are books written by women about the afflictions of men in a postfeminist age.

4. While horror has come to dominate almost all representation, ranging from the police procedurals that abound on television, with their often shockingly grisly crime scenes, to the glut of science fiction films made by Hollywood today that eschew the cerebral in favor of blood and guts, comedy has been the chief site for explorations of beta male anxieties. Horror, comedy, melodrama, and pornography, which Linda Williams famously called the "body genres,"

share a predilection for submitting the body to extremes. Linda Williams, "Film Bodies: Gender, Genre, and Excess," in *Film Genre Reader III*, edited by Barry Keith Grant (Austin: University of Texas Press, 2003), 141–60.

5. For a discussion of the double-protagonist film, see David Greven, *Manhood in Hollywood from Bush to Bush* (Austin: University of Texas Press, 2009). The crop of more adult-focused comedies that has flourished in the wake of the teen comedies of the late 1990s focuses on a male duo, yet this new comedic form evinces some of the trends that I locate in "Bush to Bush" cinema: a focus on pairs of men rather than the hero or the male group in which the themes inform the very nature of masculinity in contemporary comedy, a split between narcissistic and masochistic modes of male identity.

6. For discussions of the buddy film, see Robin Wood, "From Buddies to Lovers," in *Hollywood from Vietnam to Reagan* (1986; reprint New York: Columbia University Press, 2003): 198–219; Robert Kolker, *A Cinema of Loneliness: Penn, Stone, Kubrick, Scorsese, Spielberg, Altman,* 4th ed. (New York: Oxford University Press, 2011).

7. Rogen recalls the late Rodney Dangerfield, a comedian whose most famous tagline was "I don't get no respect," especially in films such as *Back to School* (1986). The problem with Dangerfield's on-screen persona in particular was that his respect-seeking bids for sympathy often served as a cover for his odious lack of respect or sympathy for those around him. One needn't be a pretty camera object to be narcissistic, and Dangerfield's on-screen narcissism was of a particularly noxious intensity.

8. Peter Bradshaw, "*Observe and Report,*" *Guardian*, April 24, 2009, http://www.guardian.co.uk/film/2009/apr/23/observe-and-report-film-review.

9. Robert B. Ray, *A Certain Tendency of the Hollywood Cinema, 1930–1980* (Princeton, NJ: Princeton University Press, 1985).

10. Roland Barthes, *Mythologies* (New York: Macmillan, 1972): 150.

11. Tracy Clark-Flory, "The Twisted World of 'Ex-girlfriend Porn.'" Salon.com, February 28, 2011, http://www.salon.com/life/feature/2011/02/28/exgirlfriend_porn/index.html.

12. The mental asylum setting and the female hysteria of *Suddenly, Last Summer* (1959) allowed that film to approach an explicit discussion about homosexuality and provided a powerful critique of American psychiatry's treatment of homosexuality as well as an enduringly controversial treatment of the figure of the homosexual.

III
EXCEPTIONAL SEXUALITIES

CHRISTOPHER SHARRETT

Death of the Strong Silent Type

The Achievement of Brokeback Mountain

> That evening, I asked Larry how he would feel if any staunch *Lonesome Dove*
> fans turned against him for being involved with a film that subverts the myth of
> the West and its iconic heroes.
>
> Diana Ossana on the writing of *Brokeback Mountain* with Larry McMurtry

Diana Ossana's question to her cowriter Larry McMurtry speaks to the radicalism of Ang Lee's 2005 film *Brokeback Mountain*.[1] Even if she were joking, the evidence of the film reveals its profoundly subversive concerns, which are focused on nothing less than foundational social and political assumptions of the American community embodied in the Western and its central figure, the charismatic male hero. By courageously examining the sexual orientation of its central figure, Ennis del Mar (Heath Ledger), and the implications for the bourgeois community of the hero's repressed self, *Brokeback Mountain* offers a devastating critique of American society and the unraveling of its assumptions in the early twenty-first century.

The Western has long been regarded as the most endemically American genre, not only because of its literary and cinematic origins (the Western film genre begins in the United States with *The Great Train Robbery* [1903]) but because of its tendency, in its classical phase at least, to tell a deeply conservative utopian story about the civilizing process, that is, the white-dominated project of expanding and conquering the American continent for patriarchal capitalist interests. At the heart of this story is a very precise image of the male that went only slightly inflected for decades. This is the strong silent type, crucially incarnated in

Gary Cooper and perhaps best rendered in Cooper's famous terse line in *The Virginian* (1929), "When you say that, smile." The man of few words who speaks with his fists and guns was conceived long before the cinema, but he has an impressive film lineage beginning with Cooper (William S. Hart may be the first incarnation, but his importance to film history seems less durable) and continuing in spiritual progeny with Randolph Scott, the more voluble John Wayne, and later Clint Eastwood, whose hyperbolic realization of the stoic American killer owes to the genius of his key directors, Sergio Leone and Don Siegel, just as Wayne owes virtually everything to John Ford. Through the history of the self-sufficient heterosexual male's celebrity, the truth of the image was always manifest: Kenneth Anger reports that Gary Cooper "went thataway" (for gay sex) and allowed virtually anyone to "grope his buckskin basket" during his career climb in Hollywood.[2] This may be apocryphal, but it doesn't violate common sense. The male image cultivated by popular culture is a ludicrous lie needed to authorize patriarchal authority. John Wayne's preening narcissism and tendency toward a *contrapposta* leg stance, intelligently noted by Garry Wills, are not insignificant indices of a fundamental insecurity beneath the foundational masculine movie icons.[3]

The strong armed man who keeps his thoughts and feelings largely to himself has a central role in the mythology of the American community and its supporting institutions. The male's strength and silence are predicated first on a profound anti-intellectualism dating at least to the Jacksonian era, in which action and achievement are valued over Old World "book learnin'" and associated loquaciousness. Basic to the image is emotional self-control, with the assumption that the male in fact has nothing he needs to contain. His emotions are healthy precisely because they are in check, and his sexual needs are channeled toward labor and the family (and the genocide associated with conquest), with occasional allowances for tomfoolery with women. All sexual dalliances are within prescribed codes that do not upset the gender assumptions of the community that the male builds and polices. The male hero isn't neurotic, because neurosis tends to indicate a contemplative personality; such a male subject is unthinkable within an ideological system that demands his services as conscienceless executioner. The frontier killer can be an antisocial psychopath (a notion that goes largely unnoticed, although occasionally actually celebrated, in hagiography lionizing Jesse James, Billy the Kid, Wild Bill Hickock, and the like) but not an anguished soul. Recent analyses of Abraham Lincoln's alleged chronic depression tend to add to the gravitas of the former president. Neurosis can be associated with the serious-mindedness of revered state figures, especially in the age of the media confessional, but mental

infirmity is hardly what is most celebrated in mass culture renderings of the masculine image.

The American ideal of the strong silent male depends upon the acceptance and even idealization of repression, of concealing the deepest need behind a facade of denial (which is the stony-faced visage of the archetypal cowboy), and may be seen as a gender code adjacent to a national program of annihilation and conquest whose coming home to roost is the terrain explored by *Brokeback Mountain.* The repression contained in the hero is close to a sketch of Wilhelm Reich's notion of "character armor" whereby the male in effect creates armor from his very musculature, channeling emotional repression to a point that the body is refashioned as an instrument in service of state power and bourgeois sexual mores (marriage, family).[4]

Ennis del Mar represents the Western's destruction of the stolid male icon in a manner evoking incarnations of this romanticized hero in any number of films. The performance's significance resides in its understanding of the impossible contradictions within the image, the tensions and inherent hypocrisy roiling underneath the posture imposed upon American masculinity both during the nation's initial expansionist phase and thereafter, particularly as rigid gender images became calcified in the age of media representation.

The gay relationship between Ennis and his lover Jack Twist (Jake Gyllenhaal) is, of course, the basis for the hero's destruction or, rather, the destruction of the figure he represents. While Jack is the one who perishes—the circumstances are a bit ambiguous to Ennis's tortured mind (his envisioning of a lynching seems wholly justified), as he gets the news from the possibly dissembling wife, Lureen (Anne Hathaway)—Ennis's devastation is total, suggesting the utter destruction not only of this relationship but gay life itself under an oppressive America. More significantly, the film's final images suggest that the failure of the American project is also complete, so intricately entwined is the Ennis/Jack story with popular representations of the American West: its communities, families, and rituals. For this reason, the film's assertions were the cause of considerable outrage in reactionary circles and more than a little nervous chatter and hand-wringing in liberal ones. The rather condescending montage of male buddy scenes in the Western, hosted by Jon Stewart at the 2006 Oscars, is representative of this anxiety. Since the repression of the male relationship beyond its good-friends aspect is ultimately paramount if the American conquest is to remain unquestioned, the complexities of male sexuality represented in cinema are resolved not with eroticism but instead with violence in conventional narrative and social practice, the male bond recognized but

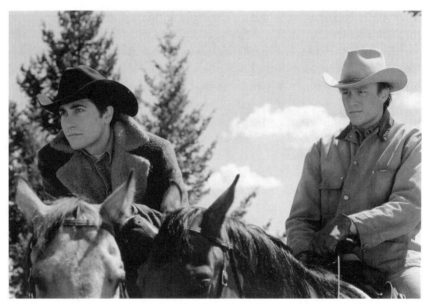

Initially strangers to each other, Jack and Ennis set out on an assignment in *Brokeback Mountain* with no evident anticipation of the bond they will forge.

thrown onto the altar of national blood sacrifice along with the body of the racial Other.

It is something of a truism that the male homosocial/homoerotic dynamic is transparent in the Western. The genre's rigid gender conventions, with the female the keeper of the hearth or else the dance hall girl—in either instance a marginal figure however venerated or reviled—are among the Western's most recognizable features, making the genre less than favored by many female viewers. The issue here is not so much the demonizing of the female via the madonna/whore construct than the simple fact that the male world is absolutely at the genre's emotional center. What men do with each other, the complicated bonds they create, is manifestly the core of the Western in its most noble or degraded phases. Examples saturate the form.

Robin Wood has written perceptively of the gay subtext (it is hardly "sub," given the transparency of the film's interests) in Howard Hawks's *Rio Bravo* (1959), a film obsessed with male beauty and posturing.[5] In this film, the male group's disciplining and eventual embrace of its members through a variety of rituals, including the sing-along/serenade ("My Rifle, My Pony, and Me") are far more to the forefront than the film's halfhearted siege narrative. Hawks's earlier *Red River* (1948) and later *El Dorado* (1966) are

similarly obsessed, the latter so unconcerned with plot that it merely re-works *Rio Bravo*.

The Westerns of Anthony Mann are intelligently concerned with the male's sexual anxieties, usually figured in the hero's dark doppelganger. The anxieties reach hysteria as the male hero (usually portrayed by James Stewart) comes perilously close to understanding that he is unable to integrate within the community and domestic life. In *The Far Country* (1955), the hero actually seems about to set up housekeeping with his much-older traveling companion. The sidekick's death, here and in other films, allows the normalization of the hero and his recuperation by domestic heterosexuality.

Even John Ford, whose Irish Catholicism takes pains to locate Western adventurers within the range of the domestic environment, cannot help but partake of the genre's fascination with the emotional power of the male bond. Ethan Edwards and Martin Pawley are at the heart of *The Searchers* (1956), not their pursuit of Debbie; the Wyatt Earp–Doc Holliday relationship is what is most interesting about *My Darling Clementine* (1946), not the Wyatt/Clementine tentative affair or the vanquishing of the evil Clantons.

Sam Peckinpah was a filmmaker intelligent enough to understand the sexual dynamic of the Western and for that matter most male-oriented cinema. His persona of a typically hard-drinking crusty Hollywood maverick overlooks the slight shy man who self-medicated with alcohol the trauma brought on by the recognition—one can only imagine—of sexual politics he could confront only through the fantasy of art.[6] *The Wild Bunch* (1969) gains its terrible force not from violence alone but also from the transformation of Eros into Thanatos through cataclysmic bloodshed. Since the heart of trauma cannot be addressed, the subject must obliterate himself. The Pike Bishop–Deke Thornton relationship, which runs through the narrative and provides its coda, can be resolved by Peckinpah only through apocalypse, so threatening are the relationship's implications. One of the most telling scenes in all of Peckinpah's films is the moment in *Pat Garrett and Billy the Kid* (1974) when Garrett very tentatively opens the gate in the white picket fence leading to the domestic household; he can't leave his home fast enough, quickly telling his wife a ridiculous lie so that he can rejoin the guys. And Larry McMurtry's *Lonesome Dove* (1987), a work on the mind of Diana Ossana at the time of *Brokeback Mountain*'s production, is a neoconservative Western whose real-West emphasis on grit and grime does nothing to conceal the impossibly committed relationship between Gus McRae and Woodrow Call. Call, the hyperbolic retrograde realization of the strong silent type, allows his humanity to show in the serene seclusion of a pecan orchard, his tears flowing over the long-dead body of his

lifelong companion Gus. For Call (and the narrative, with the exception of Clara, played by Anjelica Huston as an earth mother of the prairie), the female, even the mother of his son, is a whore and a subhuman worthy of not a moment's consideration, while the male companion is worth his life. Call shares a final refrain in common with Ennis del Mar: "I swear." His emotions remain ineffable; in *Lonesome Dove* they underscore his nobility. In *Brokeback Mountain,* the hero's eventual isolation, unlike Woodrow Call's, is simply unbearably poignant. Ennis, like Call, may be able to carry on but only at the price of repressing his knowledge about himself.

Of course, the obvious question centers on whether or not traditional cowboy buddies are really gay, the same question asked by progressives of the sexual orientation of Ennis and Jack. When the inherently gay underpinnings of the Western are refuted, it is almost always from a position that insists upon genital sexuality alone as an index of sexuality in general, with the human body itself denied its libidinal dimension. Indeed, the person is deemed this or that sexually based on the acts that he or she performs, placing incredible obsessive emphasis on the sex act to the exclusion of all other manifestations of sexuality in human existence (the obsessions of the puritan and the pornographer are complementary in repressed society). In a culture governed by divisions at all levels (gender, labor, play), with the body conditioned mostly to work, make war, and produce, the sex act is signifier of the person crossing the line, even when the line of bourgeois morality has been crossed by all manner of physical and psychological refutation. Genital sex in *Brokeback Mountain* seems important but also incidental in and of itself; it is part of the lives of human beings. The crisis of Ennis and Jack centers on the threat that their presence represents and the obvious impossibility of finding happiness in a society based on repression.

THE RISE AND FALL OF JETT RINK

It is a matter of justice to note that the achievement of *Brokeback Mountain* (that is, the revelation of the archetypal male hero's emotional instability as a consequence of repression) has a few progenitors, notably James Dean's portrayal of ranch hand-turned-tycoon Jett Rink in George Stevens's *Giant* (1956). The makers of *Brokeback Mountain* obviously screened this film and studied Dean's performance carefully.[7] The argument can be made that Dean understood most clearly of any actor the contradictions of the American male, perhaps especially because his own sexual self was so tormented. In all three of his major screen roles but especially in *Giant,* Dean gave us instruction on the nature of the strong silent type by exploring this persona with his method acting–influenced approach to performance. The man of

few words is revealed in *Giant* to be a man so at war with himself that words cannot be found, the internal emotional struggle all the more profound when the man is illiterate.[8] Jett Rink is a seething mass of resentments, the first being located in his strange alienation from his boss, the cattle baron Bick Benedict (Rock Hudson), whom Jett will displace when he makes his oil fortune. (The Bick-Jett relationship becomes more meaningful with our knowledge of the gay sexuality of Rock Hudson and James Dean, even if this knowledge is extratextual.) Jett becomes smitten with Bick's wife Leslie (Elizabeth Taylor) and over the years with Leslie's daughter, but there is the strong sense that we are dealing with homoerotic jealousy and resentment being displaced onto the female. Bick resents Jett's freedom more than his "white trash" origins, sensing that Jett is "the embodiment of the dark forces that have been foisted upon him."[9] Jett Rink is the prototypical agent of social disruption whose very presence is a provocation, but lacking an awareness of what he represents (beyond the financial stature he eventually gains), Jett merely reimposes with a vengeance the authoritarian rule of his own oppressors, including Bick's racism, which Jett's wealth systematizes in a way that doesn't detract from the nouveau riche allure of the New South. Jett Rink anticipates Ennis del Marr's crisis in the character's sense that the male's ability to conceal his authentic inner life becomes a source of agony and self-defeat. Like Jett, Ennis opts for violence, picking fights because he cannot deal with the battle within himself. *Giant* and *Brokeback Mountain,* in their respective (conservative) decades, provide challenges to the myth of the West and the Western by their comments on the end product of expansionism in the twentieth century. The West of *Giant* becomes increasingly vulgar and lurid; in *Brokeback Mountain* it is desolate and emptied of promise. The West, the symbol of repression and oppression—precisely because of its association with conquest—starts faltering in its ability to inspire the utopian imagination even as it enjoys primacy in 1950s' media culture as fantasy landscape, the place where men and boys look for consolation and escape.

LANDSCAPE AND ICONOGRAPHY

In *Brokeback Mountain,* the first emblem of the traditional hero's disintegration is found in the failure of an empathetic relationship between hero and landscape. Ennis del Mar arrives via a hitchhiked ride in a truck to Signal, Wyoming. The truck and landscape emerge from near-total darkness, an image that will be repeated toward the end as Ennis's isolation becomes complete. He is hardly Shane (the lead character in the 1953 film *Shane*), the savior-martyr descending from verdant hills on horseback. And Signal

hardly offers the promise of Joe Starrett's meager but welcoming farmstead. The title card that precedes Ennis's arrival at Joe Aquirre's (Randy Quaid) awful trailer/office says "1963, Signal, Wyoming." The place and date would ordinarily have epic portent in the Western's history: recall "Texas 1868" at the beginning of *The Searchers.* But heroic achievement or the possibility of personal fulfillment is off the table in Ennis's story. Max Steiner's heroic score, announcing the arrival of Ethan Edwards in Ford's film, is replaced by the sparse atonal chords of Gustavo Santaolalla's main theme, whose eventual lushness is always in counterpoint to its sense of aridity.

The town of Signal seems largely deserted, a representation of postindustrial America a bit before the fact. This de-romanticized West highlights the erosion of promise through the transformation of much Western iconography. In the bleak opening scenes, Ennis's and Jack's cowboy hats, horses, and 30-30 Winchester carbines are Western signifiers mostly dissociated from heroism, suggesting that such notions have been relegated to the popular imagination courtesy of media representation, the allure of the frontier over and done with. Ennis is allowed heroism but mainly to Jack's eyes and to a very bewildered family and community under a shot of fireworks. Six-guns are noticeably absent from this version of the West, perhaps because there is no need for those revolvers' manifest Freudian connotations. Scenes such as the Montgomery Clift–John Ireland handgun swap in *Red River* are simply replaced by Ennis and Jack's genital sexuality.

The genre trappings that do appear in the early scenes on Brokeback Mountain make it clear that the film's central meditation focuses on Ennis. He is the quintessential westerner of the film but one whose crisis, like Jett Rink's, threatens the tranquility of the world he occupies. Ennis is also marked as hero by certain proficiencies that Jack lacks. Ennis kills a deer, impressively sighting down the barrel of his Winchester, and then chides Jack for his inability with guns ("Tired of your dumb-ass missing!"). Jack stumbles and laughingly crashes into camp gear while amusing Ennis with his rodeo antics. When Ennis has a serious confrontation with nature (a bear at a stream), he is able to save himself and at least a few provisions. Yet proficiency and the cult of male professionalism, absolutely central conventions of the Western, amount to little by way of saving American society, since its hero is revealed as alienated within himself, internalizing the hatred of that society for him (as in Ennis's story of the murder of Earl and Rich).

The mountains themselves, while imposing, are oppressive, with the overcast skies above them always threatening disaster. The sun shines infrequently in *Brokeback Mountain,* the imagery mostly gray or in nighttime shadow. The sense here is that America's period of fertility has passed. Ennis

truly fulfills the hero's archetypal role, if in the inverse, as his emotional constriction is figured in the wasteland surrounding him. Yet the meeting of Ennis and Jack and the beginning of their sheepherding on Brokeback constitute the film's single moment of (tense) joy and possibility, a peaceful pastoral interlude for tormented lives, as this traditional black hat–white hat male buddy construct develops, and the strong silent male comes out of his shell with his tale to Jack of miserable family origins ("Hell, it's the most I've spoke in a year!").

Childress, Texas, the place of Jack's marital home and uneasy employment, counters his natural good humor. It is almost as desolate as Signal, the originary town of the narrative. Newsome Farm Equipment, where Jack hustles his bullying father-in-law's high-line tractors, is a reminder of the triumph of new capital over the ranch life of an older West, a notion of other modern Westerns such as Larry McMurtry's *Horseman, Pass By* (filmed by Martin Ritt as *Hud*, 1962). Texas is a site of a faux cowboy culture that contains little romance: rough-talking businessmen wear Stetsons and speak with drawls but are otherwise indistinguishable from bourgeois males anywhere in the nation. As the small shreds of potential fulfillment for Ennis and Jack deteriorate, the film strips Western sites and iconography of their mystique. The saloon and the workplace are reduced to their essential function as places where masculinity is judged. Among the most chilling moments are Jack's rebuff by Jimbo, the rodeo clown at the Country and Western bar (one of those places that speak all too emphatically of the inauthenticity of modern cowboy culture), and the derisive remarks about Jack, seen through a window selling tractors, by two good old boys hanging out at Newsome Farm Equipment ("Ain't that the piss-ant who used to ride the bulls?"). At some points Jack is mindful of how he measures up in the hypermasculine Texas culture, such as when he watches Jimbo hobnob with the guys after rebuffing Jack's cautious advance, but at other moments (the Newsome Equipment scene) he is oblivious to the low esteem in which he is held by masculine society. He seems to be the flawed hero whose openness and basic humanity make him susceptible to moral lapses, like Gil Westrum (Randolph Scott) in *Ride the High Country*, but if Ennis is the self-possessed competent male, the absurdity of the construct is visible. Jack's flamboyance is his flaw given the terrible nature of the society around him, but Ennis's rigidity offers not a solution but rather an inescapable conclusion: there is no hope of a sane life in patriarchal capitalist America. Yet the film wants to return the genre to us as it reconsiders its strict assumptions. After Ennis's breakdown in Jack's arms during their quarrel in what turns out to be their last meeting, the film cuts to a scene from their early Brokeback days, with Ennis embracing a drowsy Jack from behind ("You're

sleeping on your feet like a horse") and then riding off, an admiring Jack looking on. The scene, not shown in the film's early moments, emphasizes Ennis's heroism, his emotional self fully and spontaneously shining. The moment cuts back to the 1980s, showing a middle-aged haggard Jack looking at Ennis's truck recede in the distance. The film recapitulates the lost innocence of *Shane* but with the sense that such innocence may have always been a deceit.

THE FORDIAN CEREMONY

The Western hero gains considerable authority and affirmation of his image by presiding over the community ritual (weddings, church gatherings, funerals, dances, dinners), a device given special dramatic privilege by John Ford. In *Cimarron* (1931), one of the first big-budget Westerns of the sound era, Yancey Cravat violates one ceremony—the dinner with his wife's unreconstructed Southern family—in order to preside over many others as he creates white civilization in Oklahoma. The ultimate expression of community celebration as validation of the hero's centrality is perhaps Wyatt Earp's dance with Clementine Carter in *My Darling Clementine.* Wyatt escorts his lady fair to the new church whose foundation has just been laid, its periphery decorated with flags. The couple's approach, shot with dramatically high and low angles, is nothing less than a benediction for the hero and the nascent soon-to-be-settled civilization he represents. If the hero violates the community ritual, his authority is sustained and even bolstered (Ethan's angry, impatient "Put an 'amen' to it!" in the funeral scene of *The Searchers*). In *Brokeback Mountain,* the town/family ceremony reveals the hero's instability and that of the community that (marginally) sustains him. Most notable is the Fourth of July fireworks display during which Ennis challenges two foul-mouthed bikers, ostensibly to protect the ears of his little girls and the relative tranquility of the moment. A little band plays a fractured "Battle Hymn of the Republic" on the sidelines. Jim Kitses remarks that the moment marks Ennis as a "transcendental character of agency and action" whose role as community defender at that instant makes him a genre archetype.[10] The film's signature still is taken from this confrontation, but it is not, as Kitses remarks, the shot of Ennis bending angrily over the flattened bikers, his right fist clenched. Rather, the signature still is the next shot, one used by advertisers in the campaign of normalizing the film (the gay element unmentioned) to suggest that it is a tried-and-true tale of love, adventure, romance, and sorrow. The image shows Ennis standing proudly on-screen left, looking at his wife on-screen right, the exploding fireworks filling the center of the shot. Taken by itself, the image is a remarkably

deceptive evocation of Ford. Within the context of the narrative, the scene suggests Ennis's attempt to assure himself of his masculinity, to prove to himself that he is content in heterosexual marriage, and, alternatively, to discharge his rage centered on his profound doubts about his marriage. Jack is involved in a similar project through his dangerous rodeo stunts, which seem of a piece also with his sexual flamboyance, all careless acts centered on self-destruction (since he is deprived of Ennis). Jack is a cruising gay male (the rodeo clown at the bar, the trip to Mexico) aware of his needs and not content with a life of pretense but dangerously unaware of the world around him. His courting and marriage to Lureen is, like Ennis's marriage to Alma (Michelle Williams), an expression of his bisexuality, but like Ennis he is driven more by the demands of normativity and security. For Jack, the gambit more or less pays off by his uneasy integration into the wealthy Newsome family.

At regular intervals the film answers Ford's community rituals in ways underlining the torture and alienation of the hero. Ennis's wedding to Alma follows immediately after a shot of Ennis retching in a Signal, Wyoming, alleyway upon leaving Jack after the initial Brokeback summer. The image suggests Ennis's self-loathing and emotional confusion. In context, it also suggests his aversion to his future. The wedding scene that immediately follows is dreary, like so much else in the film, lightened only a touch by the preacher's little joke. The scene, bookended by Ennis's divorce in a similarly dank setting, is devoid of music. There is no "Shall We Gather at the River?" here, the closest correlate being Jack's comical rendering of "Water Walkin' Jesus," a moment that renders irrelevant and distasteful religion's consolations ("I don't know what the Pentecost is") as the two young men, in their early brief moment of freedom and rebellion, reject all that produced them. The point is made emphatically by Alma's later suggestion to a married Ennis that they "smarten up" and go to a church supper. Ennis scorns "that fire and brimstone crowd" as much out of contempt for his marriage as for the church.

The community ceremony is associated with the female and the burdens of heterosexual domestic life, especially noticeable in the Thanksgiving scenes. L.D., Jack's "stud duck" father-in-law, insists that he take over the carving tasks at the Thanksgiving table while Jack's young son fixates on a televised football game. Jack turns off the TV (at this moment an obvious conditioning tool of patriarchal society), insisting that his son eat the meal and watch the game later, using Lureen's hard hours at the stove as a rationale for his assertion of will. L.D. countermands Jack, wanting his grandson to "become a man" (suggesting that Jack isn't one) by watching football. In an atypical angry outburst that suggests his utter dismissal of family life,

Jack finally dresses down his "old son of a bitch" father-in-law, to his wife's momentary enjoyment. The scene addresses the unstable awfulness of the bourgeois household, the fake bonhomie of the holiday season, and above all the competition that is a constant of the male group, a dynamic that clearly holds small interest for Jack. Such competition becomes manifest in his dangerous attempts to assert machismo by rodeo riding (which only leaves him "too busted up," as he tells Ennis, for recruitment by the postwar peacetime army, a fact that clearly pleases both men). It is tempting to say that Jack should take a lesson from Ennis's quite stoicism, but the point here is explicit: male styles become irrelevant when human authenticity threatens the established social order.

The Thanksgiving sequence cuts to Alma's house, with the same ceremony in a decidedly poorer setting. She is divorced from Ennis and married to Monroe, the storekeeper who is the source of her livelihood (marriage again as a mean of economic survival), but Ennis joins them and the daughters of their marriage, Alma Jr. and Jenny, for Thanksgiving turkey. The tense tableau, during which Alma eyes Ennis with some contempt (long aware of his passion for Jack), ends in a bitter confrontation over the kitchen sink. Alma is fully aware of the true nature of Ennis's fishing-trip reunions with Jack over the years, a fact that suddenly causes Ennis nearly to strike Alma. He restrains himself sufficiently to storm out of the house, saving his violence for a random purposeless fistfight with a trucker who nearly runs him over at an icy crosswalk. The scene ends with Ennis being pummeled by the trucker, the notion being that not only is Ennis losing the fight but also that his crisis is spiraling toward a terrible conclusion that follows the expectations imposed on him.

SEX, WORK, VIOLENCE

Heterosexual domesticity is consistently associated not with the development of civilization but instead with the corrosion of the male hero's emotional life and even the decay of the society he has traditionally been charged to protect and nurture. Ennis's life is particularly one of drudgery, with the film insisting that a person's labor is not his own. Among Ennis's first jobs after marriage to Alma is spreading tar on a Texas state highway. As is so often the case, Ennis is a listener, but his impassive bearing comes to suggest helplessness rather than stoicism. The film's significance is its perceptive association of class division and wage labor with the stultification of monogamous heterosexual marriage.[11] After the marital honeymoon (the sledding scene), domesticity becomes hardscrabble drudgery for the clearly downwardly mobile Ennis and Alma. Alma's toiling in the kitchen (washing

clothes in the sink, with the truth of pioneer life shrewdly represented as still with the lower class) and Ennis's ranch labor are temporarily leavened in the marriage's early years by entertainment (the drive-in movie) that becomes less satisfactory as pop culture becomes more degraded (they watch *Kojak* on TV) and their marriage becomes more untenable. But the diversions of mass media, suggested as oncoming replacements for community life itself, are small compensation and are appropriately given short shrift in the film. The unrewarding toil of ranch life and small-town markets are reminders that the body's energies are constantly channeled toward work over which the individual has no control. The point, almost Marcusean, seems to be the transformation of preferred sexual gratification into capital for others. The work world becomes a symbol of an entire precarious sexual/social construction that threatens to explode, just as Ennis explodes with fits of violence. A representative moment is his child's accidental destruction of a display of peanut jars in Monroe's market just after a squabble between Ennis and Alma over which partner's work is more important. Indeed, conflicts over work and income are connected to sexuality—including the sex act itself—and its oppressions.

Ennis's status as a gay man doesn't prevent his assertion of patriarchal will. As his marriage to Alma fades, she shows reservations about having sex with him. She claims worry over more pregnancies given their shaky economic position, but the moment could be read as her increasing contempt for his obvious love of Jack or simply her hatred of homosexuality. Whatever may be the case (this, like so many moments, is very resonant), Ennis cold-bloodedly mumbles, "If you don't want no more of my kids, I'll be happy to leave you alone." On one level Alma is the breed sow, the status traditionally assigned to women; on another level she represents the necessary and thoroughly unsatisfactory choice that Ennis thought he had to make. It is telling that in their one scene of intercourse, Ennis flips Alma on her stomach. Whether their sex is rear-entry or anal is irrelevant; the suggestion is that Ennis can find pleasure with her only through associating the sex act with Jack. But Ennis's attempt to return to the falsely idyllic world of Brokeback Mountain contains a note of violence and the typical subjugation of the female. In this moment the film is a compelling revisionist Western, questioning the male privilege that has been the genre's preoccupation.

The film's violence flows naturally from the hero's frustrations at all levels, especially his sexual rage and confusion. The violence also responds to the Western's conventions, with the showdown now reduced to Ennis's angry fisticuffs. The film comments on the foundational violence that produces a mythology upon which civilization is built (think of the Alamo or

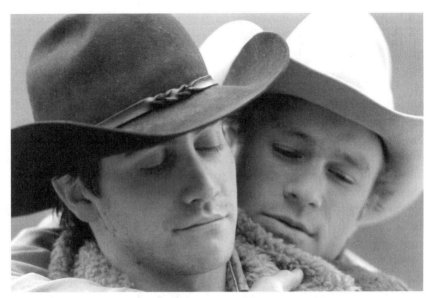

Despite their deepening love for each other and their recurring escapes to Brokeback Mountain, Jack and Ennis slowly confront the troubles that surround them.

Custer's Last Stand), reduced here to the murder of Earl and Rich, a killing of two gay men used to instruct the young in proper behavior. Ennis believes, probably correctly, that his own father, the teller of the tale and the giver of the law, "done the job." The evidence may be in the film's final scenes.

AMERICAN GOTHIC

Ennis's visit to the Twist homestead in the penultimate scene provides clues to much of the film and explains why he is necessarily the strong silent male. If the Twists are representative of the American family, then there is little choice, failing truly revolutionary options, but to shut up and put on a determined look that projects courage and conceals pain. The Twist farmstead, weathered and tumbledown on the outside, incredibly stark and chilly in the interior, is a version of Grant Wood's much-debated omnipresent 1933 painting, *American Gothic*. The painting is indeed gothic, conveying the horror of Middle America as the seat of repression and absolute order.[12] The film has its correlates for Wood's glaring farmer, his hand clasping threatening pitchfork; his female companion averting her gaze,

her dress fastened tightly at the neck; and the peaked gothic (which is to say barbaric) gable of their wooden house behind them. John Twist (Peter McRobbie) is almost an Expressionist ghoul from the Weimar cinema, his words to Ennis (laying down the law about Jack's final resting place) threatening beyond their actual content. Jack's meek frightened-looking mother (Roberta Maxwell) is not mentioned by name even in the final credits, so irrelevant is she to the world around her and even her own household. If Lureen and Alma are marginal to their worlds (Lureen less so than Alma, since Lureen is a somewhat phallicized woman, internalizing the father's values and running his affairs), Jack's mother is the film's final statement about women in patriarchal society: she has learned to mind her place to survive. Her small kindnesses to Ennis certainly don't go unnoticed by her husband; they are permitted since they don't disturb the way things are. The mother might be said to suggest a tiny potentiality within an awful setting, but her presence seems more involved in suggesting how the best of humanity can survive regardless of social systems than in hope for transformative change in the future. This small economical scene is one of the film's most devastating portraits of patriarchal society. Jack's early comments about the father's utter failure ("Can't please my old man, no way"), especially as a mentor ("Never taught me a thing"), find pointed meaning in the scene, as does Ennis's story about his own father forcing him to look at the body of a dead gay man in a Wyoming drainage ditch, the patriarch both outright murderer (one tends to accept Ennis's conclusion about the father's complicity) and child abuser, his legacy forever imprinted on Ennis's shattered psyche.

The last scene, with Ennis alone at his trailer, is exceptionally bleak, modified only a little by the arrival of Alma Jr. and her announcement of her wedding, which momentarily cheers her father, inasmuch as the word has any application to him. Contrary to several critics, I don't read this scene as a poignant affirmation of marriage, with Ennis, alone after Alma Jr.'s departure, sadly mourning the marriage to Jack that never happened. The scene's emphasis is on desolation rather than what might have been. After all, there is no evidence that Ennis would have accepted a union of any sort to Jack, his every gesture refusing that kind of intimacy out of fear of society and himself. The film's last shots are of the bloody shirts, the postcard of the mountain, and the trailer window pointing to a frontier that no longer exists as all possibility is foreclosed. The strong silent American male has come to a cul-de-sac that was the American ideal of civilization at its inception. Ennis's stoicism, his playing by the rules in the hope of something better, has simply led to his erasure.

Notes

This essay was published in different form in *Film International* 7, no. 1 (2009): 16–27.

1. Diana Ossana, "Climbing *Brokeback Mountain*," in *Brokeback Mountain: Story to Screenplay* (New York: Scribner, 2005), 145.

2. Kenneth Anger, *Hollywood Babylon* (Phoenix, AZ: Associated Professional Services, 1965), 185. This early printing of Anger's legendary chronicle of Hollywood excess is infinitely preferable to sanitized versions that followed in later years.

3. Garry Wills, *John Wayne's America* (New York: Simon and Schuster, 1997), 195–97.

4. A superb explication of Reich's theory is in Paul Robinson, *The Freudian Left* (Ithaca, NY: Cornell University Press, 1969), 9–73.

5. Robin Wood, *Rio Bravo* (London: British Film Institute, 2005), 71–75.

6. David Weddle, *"If They Move, Kill 'Em": The Life and Times of Sam Peckinpah* (New York: Grove, 1994), 278. In an interview for my work on the TV Western *The Rifleman* (October 14, 2002), Robert Culp informed me of Peckinpah's refusal of psychiatric help, his self-medicating with alcohol and cocaine, and the opinion of a psychiatrist (whom Peckinpah saw only once) that Peckinpah refused to confront childhood trauma. Weddle goes on to discuss at some length Peckinpah's psychological issues.

7. In the screenplay, Ennis is described in one sequence as "looking much like James Dean in *Giant*" (Ossana, *Brokeback Mountain,* 60).

8. David Dalton refers to Dean's Rink as "the existential cowboy" in *James Dean: American Icon,* edited by David Dalton and Ron Cayen (New York: St. Martin's, 1984), 111.

9. Ibid., 121.

10. Jim Kitses, "All That Brokeback Allows," *Film Quarterly* 60, no. 3 (2007): 23.

11. Roy Grundmann's crucial exploration of the film's associations of sexuality with class is in "Auteur de Force: Michael Haneke's 'Cinema of Glaciation,'" *Cineaste* 32, no. 2 (2006): 6–14.

12. For a good discussion of the painting, see Steven Biel, *American Gothic: A Life of America's Most Famous Painting* (New York: Norton, 2005).

MARIA SAN FILIPPO

More than Buddies

Wedding Crashers *and the Bromance as Comedy of*
(Re)Marriage Equality

One of 2005's top-grossing films . . . credited with transforming the U.S.
film industry . . . a queering of Hollywood genre . . . a romance between
two all-American dudes. I refer not only to *Brokeback Mountain* but also
to 2005's *other* blockbuster male-male love story, *Wedding Crashers,* that
in making $285 million worldwide served as stud horse for bromances, the
raunchy R-rated hybrid of the male buddy film and the "comedy of remar-
riage" that continues to dominate the box office.[1] *Wedding Crashers* is the
story of longtime friends Jeremy (Vince Vaughn) and John (Owen Wilson),
Washington, D.C., divorce mediators who infiltrate strangers' nuptials to
take advantage of the amorous feelings that weddings elicit in female guests.
Like *Brokeback Mountain*'s gay cowboys, *Wedding Crashers*' male duo
came branded with a label: "buddies," thus presumed to be straight. In nei-
ther film, however, is sexuality so narrowly conceived. *Brokeback Mountain*
concerns itself with how sexual identities are negotiated through emotional
alliances and material circumstances—factors that go beyond gendered ob-
ject choice—and so thwarts efforts to categorize its protagonists as either
heterosexual or homosexual, while *Wedding Crashers* enunciates bisexu-
ality by depicting same-sex and opposite-sex couplings as equally indis-
pensable and (though tacitly) romantically and erotically charged.[2] In so
doing, *Brokeback Mountain* and *Wedding Crashers* demonstrate how ac-
customed we already are to representations of sexuality that are irreducible
to the dominant paradigm of what I term compulsory monosexuality.[3] In
questioning and even rejecting this cultural logic, *Brokeback Mountain* and
Wedding Crashers contribute to discourse on realistically complex concep-
tualizations of sexuality.

Both films emerged against the backdrop of the U.S. gay marriage movement, whose defining and prioritizing of marriage equality risks enabling yet another separate but unequal doctrine that sustains otherness, rewards "family values" while punishing sexual "deviants," and ignores the variety of nontraditional households. The rise of the Hollywood bromance coincides with marriage equality advocacy and the reactionary responses it has provoked, and the shared preoccupations of both suggest mutually informing discourses. *Wedding Crashers* less overtly invoked its connection to contemporary debates over same-sex marriage as did fellow bromance *I Now Pronounce You Chuck and Larry* (2007), the Adam Sandler–Kevin James vehicle about two male firefighters who get married for the pension benefits. Yet neither was *Wedding Crashers* as defensive in its reassurances of the "we're not gay, not that there's anything wrong with that" variety, a form of pseudo-tolerance that *I Now Pronounce You Chuck and Larry* commences with a tagline ("They're straight as can be but don't tell anyone") that reeks of the "Don't ask, don't tell" ethos of the era. As queer sexualities are increasingly articulated through a normalizing model that reinforces monosexuality, monogamy, gender conformity, and the nuclear family, I wish to consider the degree to which *Wedding Crashers* (and the bromance generally) can be understood as queer, that is, how actively it opens bisexual sites and sights (ways of seeing) and to what degree such spaces and positions are expanded (or enclosed) by film's end.

If the Western is, as J. Hoberman describes it, "the most idyllically homosocial of modes—and often one concerned with the programmatic exclusion of women," the male buddy film in its postclassical incarnation during the American New Wave of the late 1960s and early 1970s clearly carried on the classical Hollywood Western's legacy.[4] Often set in the American West and updated as a road movie on wheels rather than on horseback, the buddy film remained a refuge from encroaching threats to white male privilege, heteromasculinity, and the sanctity of the family associated with the social movements of the time. The bromance resuscitates those male buddy films that flourished amid this era of gay and women's liberation and that, in their homoeroticism and habitual marginalization of women, ranged from relatively benign (*Butch Cassidy and the Sundance Kid* [1969], *California Split* [1974], *Easy Rider* [1969]) to potentially progressive (*Midnight Cowboy* [1969], *Thunderbolt and Lightfoot* [1974]) to near hysterical (*Freebie and the Bean* [1974], *Scarecrow*, [1973]). While Thomas Elsaesser sees male buddy films as "reviving the ever-present Huck Finn motif in American culture, about the male couple ganging up to escape civilisation and women," Michael Ryan and Douglas Kellner find in this era's buddy films a particularly acute "expression of a natural homoeroticism which a

pervasively heterosexual culture does not permit to flourish but which did get articulated in the liberal climate of the time."[5] In surveying the genre's path of transformation from its 1970s' tragic mode to its current comic mode, these readings remain telling for the way the buddy film continues to display sexual ambiguity and nostalgia for adolescence. Despite the shift in tone (from tragic to comic) and moniker (from buddy film to bromance), there remains a pressing need to police the borders dividing the acceptably homosocial from the unacceptably homosexual. It is this middle ground of heteroflexible conceptions of millennial masculinity and gender relations that the bromance models so evocatively.

It might appear that contemporary Hollywood filmmakers and their audience are more comfortable with the sight—or is it the sight gag?—of homoeroticism. In *Dude, Where's My Car?* (2000), *In & Out* (1997), and *Talladega Nights: The Ballad of Ricky Bobby* (2006), men kissing seems merely one more way to top all of the outrageous transgressions and gross-out moments that have come before, the latest provocation in a trend that started in the late 1990s with Ben Stiller getting his penis caught in a zipper and his bodily fluids being used for hair gel in *There's Something about Mary* (1998). By now, in 2012, ostensibly straight men kissing one another fully on the lips is a phenomenon viewable on American screens almost weekly courtesy of *Saturday Night Live.* The bromance recasts the American male as seemingly less heteromasculinist yet employs a strategy of containment designed to prevent any threat to heteromasculinity by presenting itself as intended just for laughs, in fulfillment of what Dennis Bingham observes is "the gentling of white masculinity [as] an apparent strategy for holding on to power during shifting times."[6] But granting that to comically de-eroticize male same-sex desire defuses its threat, it must also act to normalize man love, as the politics of queer visibility demonstrate. Comedy offers a particularly conducive vehicle for the articulation of bisexuality in the way that a comic work is theorized as evoking "that space of freedom between the set rules of society" that "automatically predisposes its audience to enter a state of liminality where the everyday is turned upside down."[7] Liberated from the responsibilities of realism, comedy can venture beyond the confines of everyday conventionality so as to defamiliarize the compulsory monosexuality that governs our logic of desire.

Wedding Crashers' celebrated eight-minute wedding montage is an orgiastic paean to casual sex that flows from alcohol-fueled revelry to meaningful gazes, flirtatious dancing, and the pretense of getting to know one another through exchanges selected from the pickup playbook (broken man, hidden past) and ultimately climaxes in consummation. Cynthia Fuchs notes the profusion of "psychosexual displays" of "explosive discharge" in

the buddy action genre: "Again and again, these movies conclude with the partners triumphantly detonating all villains and nearby vehicles."[8] *Wedding Crashers* orchestrates an analogous display of surging champagne bottles and commingling heterosexual bodies (rather than blasting guns and colliding homosocial bodies), filmed with the same quick cuts and slow motion that Fuchs describes as "penetration and excess at once, an image 'too much' for standard speed, a release 'too much' for the subsequently depleted partners."[9] With seamless continuity, Jeremy and John sweep women from the dance floor to bare (and bare-breasted, in the unrated DVD version titled "Uncorked") surrender on bedsheets and victoriously mount their prey. But unlike the action film's final shootout, which offers resolution by means of extreme violence, this psychosexual display introduces the conflict to be resolved.

As a postcoital Jeremy lies chuckling over another successful subterfuge, John finishes on a different note, or rather doesn't finish, for a sudden reservation ("I feel like I don't even know you") causes him to pull away from his latest casual conquest. What type of sexual crisis prompts his hesitation: moralistic concern over promiscuity, an ethical dilemma about their deceptive modus operandi, or waning interest in bedding women? Confessing his doubts over a champagne toast at sunrise atop the Lincoln Memorial's steps, John asks Jeremy, "Don't you think we're being . . . irresponsible?" Disparaging their behavior as immature, John diagnoses their crasher mentality as stalled (hetero)sexual maturity, imploring Jeremy to "Grow up, Peter Pan." As the one more attached to adolescence (he first appears with a sleeping bag tucked under his arm in preparation for a birthday sleepover at John's), Jeremy clearly is distressed by John's admonition but replies defiantly, "I'm a cocksman!" As act one closes, the monumental Lincoln gazing reprovingly down on the chastened pair might seem an appeal to honesty, a reminder of the Law of the Father, or even a sly reference to historians' indications that Lincoln himself was slow to accept heterosexuality.[10]

Robin Wood interprets Hollywood's buddies of the 1970s as negotiating their era's changing social mores by exhibiting the collapse of "'normality': heterosexual romance, monogamy, the family. . . . [But male buddies] are also the protagonists of films made within an overwhelmingly patriarchal industry: hence they must finally be definitely separated, preferably by death."[11] In *Wedding Crashers*, no longer is it necessary to separate—let alone kill off—the male duo. Instead, at film's end, Jeremy and John are joined in metaphorical matrimony, a crucial departure that works by incorporating elements of the female buddy film and the comedy of remarriage in a maneuver that has come to characterize the bromance. *Wedding Crashers* is effectively a gender-inverted update of 1953's *Gentlemen Prefer*

Maria San Filippo

Blondes, the only women-centered outing by Howard Hawks, founding fa-
ther of the male buddy film and great evader of inquiries about his films'
homosexual subtexts.[12] Nevertheless, as Alexander Doty argues, *Gentle-
men Prefer Blondes* speaks for itself as a bisexual text by giving "roughly
equal emphasis to both same-sex and opposite-sex relationships" and by
characterizing its female leads as bisexual because "Lorelei [Marilyn Mon-
roe] and, especially, Dorothy [Jane Russell] aren't like most straight women
as they make their relationship with each other the defining center of their
lives, but they also aren't like most lesbians as they allow men into their
lives as romantic/sexual partners."[13] As Doty goes on to show, dialogue,
framing, and performance create and sustain the impression (watched over
by a vigilant Production Code) of an erotic/romantic bond between the
women that "fosters bisexual spaces and spectator positions."[14]

No more explicit despite the intervening years, *Wedding Crashers* also
places equal or greater emphasis on the central same-sex relationship as on
the more conventional opposite-sex relationships. The film's promotional
campaign milked the chemistry between Vaughn and Wilson, downplay-
ing the female love interests despite costar Rachel McAdams (who plays
Claire, John's object of affection) being sufficiently bankable upon film's
release to warrant placement in print advertisements. The film's opening
sequence, in which Jeremy and John sit cozily framed as a couple, juxta-
poses their finish-each-other's-sentences intimacy against the opposite-sex
couple bickering through divorce proceedings across a boardroom table's
expanse. Within minutes, Jeremy and John effortlessly harmonize a duet of
the wedding reception standard "Shout"—like Lorelei and Dorothy, these
two make beautiful music together—and *Wedding Crashers* continuously
highlights Vaughn and Wilson's improvisatory verbal pas de deux. Rather
than repeatedly disavowing any hint of gayness, Jeremy and John eat off
one another's plate and link arms to dance the horah, exhibiting the same
"comfort with each other's bodies" that Lucie Arbuthnot and Gail Seneca
notice of Lorelei and Dorothy.[15]

Wedding Crashers' potential to critique heteronormativity is again re-
latable to its roots in the 1970s' male buddy film for what Wood notes the
genre's customary absence or insignificance of women implies: "If women
can be dispensed with so easily, a great deal else goes with them, including
the central supports of and justification for the dominant ideology: mar-
riage, family, home."[16] *Wedding Crashers* hardly dispenses with women al-
together, but like the buddy films Wood observes, it is a male love story at
heart: "In all these films the emotional center, the emotional charge, is in
the male/male relationship, which is patently what the films are *about.*"[17]
Although *Wedding Crashers* revises male buddy film tradition by making

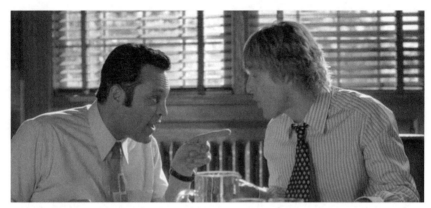

Jeremy and John making beautiful music together in *Wedding Crashers*.

its heterosexual romances significant, from the outset it does not exhibit *Gentlemen Prefer Blondes'* biphilia, of which, as Doty notes, "It's never a matter of the woman choosing either men or each other, but of having both women and men available to them."[18] That Jeremy and John face considerable difficulty in maintaining their same-sex bond suggests society's greater acceptance of close relationships between women. Jeremy and John start off as a couple but (unlike Lorelei and Dorothy) a flawed one; the foundation of their bond and its fulfilling potential is thrown into question by John's crisis of faith in crashing. As their fractiousness escalates they spend less time together, and their once enlivening riffs give way to a prolonged rift. And so *Wedding Crashers* hybridizes the buddy film with the comedy of remarriage, in which, according to Cavell, "the drive of its plot is not to get the central pair together, but to get them *back* together, together *again*."[19]

Yet the fictional duo's ease with one another contrasts with the actors' discomfort in audio commentary over certain suggestive scenes, most blatantly when John tenderly asks Jeremy, "Can I just say one thing without your getting mad? I love you." Jeremy sheepishly responds, "I love you, too."

VAUGHN [*high-pitched laugh*]: Kind of like ruining a nice moment.

WILSON: We were just kind of b.s.'ing. These guys really do have this like kinda crazy like friendship.

VAUGHN: It really solidifies their friendship but not in a way that's overly sincere. You jeopardize what you want—which is [Claire]—to check in and say I appreciate your staying. It shows that the friendship really is kind of important. I think because my mouth is so filled with food, I say

I love you too, it's not over the top, it does a lot to go okay this is a really good friendship.

WILSON: Cause you can imagine if you read in the script they argue and then I say I love you I love you too, it'd be like that stinks, it's not going in, but then right just the way you've described it it does work in a kinda funny way where you still get the emotion of it.

Their overcompensation continues into the next scene, set aboard a sailboat and thus "coincidentally" prompting their commentary to turn to discussion about the allure of a Playboy cruise ("Deal me in on that," Wilson tells Vaughn). Scrambling to brush away the implications of homosexual desire, these comments relocate to an extratextual space the crucial giveaway found in what Wood calls "surreptitious gay texts" and is identifiable "not from anything shown to be happening between the men, but, paradoxically, from the insistence of the disclaimers: by finding it necessary to deny the homosexual nature of the central relationship so strenuously, the films actually succeed in drawing attention to its possibility."[20]

Wood further notes the standard presence in male buddy films of "the overt homosexual (invariably either clown or villain) [who] has the function of a[nother] disclaimer—our boys are not like *that*."[21] Enter Todd Cleary (Keir O'Donnell), the gay son tormented by and considered threatening to his prominent political family. Despite relying on stereotypes—Todd is maladjusted and hypersensitive, paints instead of playing football, and makes a predatory pass at Jeremy—*Wedding Crashers* exhibits a measure of queer sensitivity unusual for a mainstream American comedy. Discussing his son's artistic ambitions, Secretary of the Treasury William Cleary (Christopher Walken) derides Todd's conceptual work as "crap," recalling conservative rhetoric condemning queer or otherwise "offensive" art deemed undeserving of public funding and First Amendment protection. Deferential up to now, John politely but firmly reminds the secretary that "some people consider that art." When Jeremy displays similar generosity in noticing Todd's lack of appetite, Todd's explanation ("I don't eat meat or fish") prompts his grandmother to interject "He's a homo," a non sequitur that mocks the facile maneuver that lumps nonnormative identities together. That this and other homophobic outbursts (calling Eleanor Roosevelt a "rug muncher") come from an elderly loopy character who also verbally abuses the family's black servant indicates that such a perspective is archaic and indefensible. Yet whereas Granny openly acknowledges Todd's sexual identity, Secretary Cleary refers to it with euphemistic selfishness ("Polling shows a majority of the American people would ultimately

empathize with our situation") or, when confronted with clear evidence of his son's sexual preference, feigns obliviousness. The Cleary clan's public veneer of respectability conceals a decidedly "un-American" family—philandering parents, promiscuous daughter, gay son, and bigoted grandma—wherein, predictably, only Todd is considered a political threat. Reading Jeremy's friendliness as having "had a moment," Todd pays him a midnight visit and urges him to give in to his desire: "It's ok—I was where you are a year ago." Panicked at hearing someone approaching, Jeremy urges Todd *into the closet* yet later insists upon commemorating the episode with a fig-leafed portrait by his suitor. Although it may seem merely perfunctory in its shows of support to gay identity, *Wedding Crashers* stands noticeably apart from its buddy film precursors and mainstream comedy contemporaries in the sympathy that it extends to Todd, even if he is still relegated to an abject position.

Just as Todd reassures mainstream audience members that "our boys are not like *that*," *Wedding Crashers* offers a converse figure of excessive heteromasculinity in two-timing misogynist Zach (Bradley Cooper), whose sadistic competitive streak Secretary Cleary fondly excuses as "five generations of Lodge family breeding." A reference at once eugenic and animalistic, this suggestion that Zach's cutthroat brutality could be an inherent rather than an acquired trait—in the secretary's words, "Nature versus nurture, nature always wins"—seems inane next to John's simpler explanation: "I think he's on steroids!" Rather than making "our boys" look comparatively wimpy or effeminate, Zach's testosterone-fueled ferocity reassures viewers that being manly doesn't require sadistic measures, joining with Todd's homosexuality to position John and Jeremy between "pathological" extremes. No unmanly lack of footballing prowess leads to Jeremy's thumping on the field, but rather it is Zach's unbridled aggression in this and another Cleary family tradition: quail hunting. Jeremy snarkily assesses the "sport" and its rabid practitioners as hypocritical ("Mr. Environmental is also a hunter?" he challenges Zach) and ludicrous ("Why do I have to be in camouflage—so the big bad quail doesn't see me?"). John's game attempt at enthusiasm ("Why can't we hunt something cool like a hawk or an eagle, something with some talons?") is met by Jeremy's sarcastic contempt: "That'd be awesome. Even like a gorilla or a rhinoceros . . . or a fucking human being? That'll get you jacked up!" This mockery of the rugged pursuits associated with Hemingwayesque masculinity is rare in a mainstream American film, especially in being voiced by a straight-identifying male. "There's something not right about these guys," Zach says, and in what seems like punishment for Jeremy's dismissive attitude toward homosocial ritual, Zach "accidentally" causes Jeremy to be shot, in the rear and at close range.

Yet Zach and the crashers employ similar strategies in their pursuit of women: deception, surveillance, and a bogus sensitive-guy routine (Mr. Environmental's stories of rescued sea otters, Jeremy and John's choked-up remembrances of tragic feats of courage ["We lost a lot of good men out there"]). Jeremy and John's growth relies on them gaining empathy by experiencing sexism from women's perspective: for John, through appreciation of Claire's integrity; for Jeremy, by undergoing the figurative transvestism that Wood finds a necessary component in evening the inequality of the sexes, which "can only be resolved when the boundaries of gender construction become so blurred that men can move with ease, and without inhibition, into identification with a female position. . . . [O]ur culture's inherent sexism has always encouraged women to understand and accept the 'superior' male position, while making it unnecessary and even demeaning for men to lower themselves to identifying with the female."[22] Jeremy, the more remorseless crasher, meets his worthy adversary in the perpetually randy Gloria (Isla Fisher), who administers an overdose of his own medicine: a torturous stream of sex (Jeremy snaps at John, "Why don't you go enjoy yourself while I go ice my balls and spit up blood?"). Recounting to an oblivious John how he was forcibly bound and gagged by Gloria in preparation for "making all his fantasies come true," Jeremy refers to this episode as rape, striking terminology for a male character describing a heterosexual encounter (no matter how violent or nonconsensual). Forced to experience rape as a victim—complete with intimations of having asked for it and of finding it enjoyable, and with his next-day traumatized account falling on deaf ears—Jeremy says, "I felt like Jodie Foster in *The Accused* last night," a comment that initially maligns Gloria as a sexual freak and does so with *Disclosure*-style backlash of the women-can-be-rapists-too variety. But Jeremy becoming smitten suggests his pleasure in submission and his respect for an assertive woman. Initially depicted as a psychotic nymphomaniac ("Never leave me," she warns Jeremy, "because I'll find you."), Gloria ultimately resists vilification/punishment *and* redemption/domestication. Ultimately, the man changes to suit *her*, as Jeremy comes to dig her BDSM proclivities.[23] "That ain't normal," he confesses to Father O'Neil (Henry Gibson), "but maybe that's what it takes to make you feel like you're connected to somebody."

Although they arrive with their own ulterior motives, openly scoping out contenders, the other female wedding guests who fall for Jeremy and John's charms are implied dupes rather than partners in a consensual transaction: easily taken in by tall tales and unwilling to go through with sex if called by the wrong name. Yet these women also defy the chastity and sanctity of the marriage myth by asserting their desire not to be domesticated

Jeremy as the submissive in his relationship with Gloria.

but instead to enjoy virtually anonymous sex. When Jeremy proposes marriage, Gloria interjects with a proposal for group sex, reversing the typical gender dynamic even if it is still the man who pops the question and even if marriage to some degree legitimizes their queer desire. Gloria's proposition undercuts the common perception that commitment inevitably leads to vanilla sex, celibacy, and/or adultery and suggests that queer desires of some kind may be expressed even within the context of heterosexual coupling. While she never quite shakes off her reverse-stereotypical characterization as a male's nightmare-turned-fantasy, Gloria's casual encounter with Jeremy blossoms into a loving relationship without losing its sexually subversive edge, and therein the conventional good/bad woman dichotomy is undermined.

Wedding Crashers negotiates between the men's emotional allegiance and their respective heterosexual couplings without sacrificing sexual adventure or female independence. Historically linked to the generation following the suffragettes' movement that won women the vote in 1920, classic comedies of remarriage, according to Cavell, offer "parables of a phase of the development of consciousness at which the struggle is for the reciprocity or equality of consciousness between a woman and a man."[24] *Wedding Crashers* stems from a similarly (third-wave) feminist moment when struggles for gender equality have waned in the wake of women's stronger presence in the workforce and greater access (for now anyway) to reproductive freedoms, even as persistent glass ceilings and inequitable salaries send women scrambling for marriage as a way out of professional disappointment. The result is the reinforcement of gender binaries as a generation of American women, assured that they could have it all,

find themselves stymied by occupational discrimination and an inadequate child care system yet goaded into marriage and motherhood by domestic benefits and alarmist admonitions that the biological clock is ticking.

With the first Cleary wedding off to a predicable start, with John guessing accurately that the reading will come from 1 Corinthians, the bride and groom having written their own vows to draw on their shared devotion to sailing ("Sailing is like sex to these people," Jeremy tells John) suggests a more progressive pledge to come. The groom's "I, Craig, take you, Christina, to be my wife, my best friend and my first mate" implies a union based on equality. Yet the bride's reply ("I, Christina, take you, Craig, to be my best friend and my captain") just as quickly restores her to the traditionally inferior role in conjugal duties (of all sorts, given the sailing-sex association). But unlike the similarly themed *My Best Friend's Wedding* (1997) in which Cameron Diaz's character, a budding architect, drops out of the University of Chicago to accompany her sportswriter husband on business trips, *Wedding Crashers* does not endorse the bride's subordination of her professional ambitions but instead encourages our identification with Claire, who audibly conveys disdain by tittering at every sailing metaphor and consequently endears herself to (as cutaway shots reveal) a mesmerized John.

Their ensuing flirtation continues this cynicism, with John exposing the crass commercialism of giving wedding gifts (no less predictable and depersonalized than the Bible readings) by correctly guessing the "useless consumer products" encased within fussy wrapping. Claire disparages the wedding guests as attending only for the privilege of "suckling at the power teat" of her father. John, having just engaged in such toadying himself, offers another rationale, redolent of religious conviction and a far cry from his known motives: "People come to weddings because they want to believe in true love." Claire pushes John to define true love. The definition he provides ("True love is your soul's recognition of its counterpoint in another") succeeds in overcoming her skepticism. "Well, it's a little cheesy, but I like it," she concedes. "I saw it on a bumper sticker," he admits. Delivering her bridesmaid's toast a while later, Claire's honest poke at the newlyweds' superficiality receives silent stares until she draws on John's homily in a last-ditch rescue that finally earns an approving response, demonstrating just how profoundly the sentimental concept of soul mates is lodged in our collective consciousness.

Defending her long engagement to Zach on grounds that "We still have a lot that we want to accomplish," Claire's choice of pronoun belies the reality that marriage is predominantly a hindrance on *women's* goals. As the enduring tradition of wives taking their husbands' surnames makes clear,

marriage marks a woman's handover from being her father's property to her husband's. Confirming Gayle Rubin's observation that marriage functions as a patriarchal traffic in women,[25] Claire is relegated to an object of political leverage with her father's remark that "Once Claire and Zach tie the knot, two of the great American families, the Clearys and the Lodges, will finally unite." John's sardonic response—"And then you can challenge the Klingons for interstellar domination"—undercuts this upper-crust amassing of influence; the fact that only Claire laughs demonstrates that the power elite's devotion to dominance is no joke. When Zach announces their engagement without ever having proposed, Claire's disempowerment is made shockingly clear. Despite qualms, Claire resolves to marry Zach. "I figure everyone feels that way before they get married," she says. "That's my rationalization and I'm sticking to it." Claire ultimately breaks tradition by opting out of the arranged marriage designed around the consolidation of power, which makes for another transgression of heteropatriarchy.

Wedding Crashers takes place in a fantasy version of our nation's capital and its neighboring enclaves of the elite, a milieu that underlines how privilege and power—political, ecclesiastical, patriarchal, socioeconomic, and heteronormative—are connected and handed down through generations. The recurring low-angle shots of church steeples, looming alongside the Washington Monument, repeatedly emphasize the twin towers of church and state—presided over by the legacy of two founding fathers—in contemporary American ideology. Forgoing the bootstraps defense that typically creates sympathy for characters empowered by wealth and status, Secretary Cleary laments his son's lack of gumption: "Twenty-two years old, the whole world in front of him. Every advantage in life, advantages I never had. Ah, that's not exactly true—he has the same advantages I had, which is a hell of a lot of advantages." Looking the part of all-American WASPs, Jeremy and John assimilate into this world far more smoothly than does Ben Stiller's character in *Meet the Parents* (2000), who endures endless humiliation in pining after his blond shiksa fiancée before eventually proving worthy of marrying into her tony family. Unlike Stiller's visible ethnic otherness, Jeremy and John's bisexual otherness can be hidden. The crashing metaphor analogizes their talent for blending in to so-called bisexual privilege even as it allows them to penetrate this privileged sphere, showing how permeable are its barriers to those with the appropriate look and deportment. Moreover, that this wedding is interchangeable with the previous Jewish, Italian, Indian, and Chinese ceremonies (the same church standing in for synagogue, cathedral, and Hindu and Buddhist temples) suggests the diluted cultural specificity that Western cultural imperialism has wrought and reveals the marriage myth's universal sway as an ideological tool of

heteronormativity. What cultural markers are on display are superficial, stereotypical trappings such as costumes, songs, and cuisine. "They'll have great tempura!," John predicts of a Japanese wedding.

In joining contentious couples together in amicable divorce, Jeremy and John reverse the priest's role and debunk the marriage myth as a reversible property-based legal contract. "The real enemy here is the institution of marriage," Jeremy proclaims. "It's not realistic, it's crazy!" Divorce is the commonsense solution, and their greatest selling point is the freedom it offers for sexual adventure ("Get out there and get some strange ass!"). Their mediation tactic succeeds by reminding estranged couples of the "good times," namely the wedding, in such a way that returns marriage to the realm of romance even while crashing all it holds sacred by boiling it down to pop standards (the aforementioned "Shout") and crab cakes. As the life of the party, Jeremy and John are indefatigable envoys for these ritualized nuptials, but their desanctification of holy matrimony through deceitful procurement of casual sex and by professionally greasing the wheels of divorce proceedings unleashes a disruptive force onto compulsory monogamy, just as bisexuality does. To "mediate," according to the *Oxford English Dictionary*, is to "try to settle a dispute between two other parties."[26] Bisexuality works as a negotiator between (or beyond) heterosexuality and homosexuality, acknowledging the fluidity and complexity of desire and thus destabilizing the rigid binary that polices it. As metaphorical mediators, Jeremy and John practice the same sexual realism that they, as literal mediators, persuade their clients to embrace.

Zach's outing of Jeremy and John as wedding crashers falsely masquerading as brothers, followed by Todd's accusation that "Jeremy made a pass at me," analogizes their ruse to gay partners passing as straight. Questioning John's culpability, Claire demands, "Is it true? It's a yes or no question." John's equivocal reply, "Yes—with shades of gray," alludes to his crisis of conscience and sincere feelings for her but also to his refusal to concede that his behavior with Jeremy is worthy of guilt or that sexuality is reducible to an either-or response. Nonetheless, the boys are expelled from the Cleary compound, with Jeremy hauling Todd's portrait along as if burdened with a brand of their (sexual) dishonor. With opposite-sex and same-sex couplings continuing to mirror one another, Claire's banishment of John is followed by him breaking off his relationship with Jeremy upon discovering his friend in flagrante delicto with Gloria, another in Jeremy's ongoing efforts to hide his heterosexual activities from view. (Jeremy previously struggled to remain inconspicuous while receiving a hand job under the dinner table and also endured a fatherly chat while naked and tied to bedposts, among similar sticky situations.) He "didn't know how to tell" John,

Jeremy apologizes. "I'm sorry you had to find out that way." The analogy in this scene to the discovery of adultery again sexualizes the men's relationship, as does the subsequent heartbreak montage with its melancholy ballad and scenes of romantic loss (watching the same televised ballgame across the divider of their respective apartments).[27]

Rebuffing Jeremy's attempts at reconciliation, John invents a new male companion to make Jeremy jealous ("He's a great guy. We've been having a ball together."). Like the flaming Todd and the meathead Zach, the eleventh-hour appearance of witless man-child and frenzied womanizer Chazz (Will Ferrell) offers one last reassurance that "our boys are not like *that*." This middle-aged man embodies all the elements of the Peter Pan syndrome: he still lives with his mother, watches cartoons, and jeers at the news of Jeremy's engagement ("What an idiot, what a loser! Good—more for me and you."). On cue, a gorgeous woman descends from an upstairs bedroom and bids Chazz a sensuous farewell. "I'm just living the dream," Chazz preens. So implausible is it that Chazz's charmlessness gets results that he remains as pathetic as he initially appears. *Wedding Crashers'* penultimate scene shows Chazz with a woman improbably draped on each arm, purposefully catching Todd's eye to gesture lewdly. Needing to prove his straightness in the eyes of other men by objectifying women, he instead provokes the exact thing that the gesture was designed to prevent: a homosexual come-on by Todd. Although this last sight of Todd keeps him pitiable and alone in a manner that is hardly queer-affirming, the moment seems designed primarily to render Chazz the more abject, with the suggestion that his macho swagger is but the overcompensation of a closet case.

Jeremy and John's reconciliation amid the merriment of their double wedding to the Cleary sisters again recalls *Gentlemen Prefer Blondes*, in which Lorelei and Dorothy marry their rich man and poor man, respectively, and also symbolically each other, undermining church and state consecration of heteronormativity, as Doty observes: "the double-double nature of the wedding (men marrying women, women 'marrying' women) makes it no 'normal' ceremony."[28] *Wedding Crashers* concludes similarly, with men marrying women and men "marrying" men. John arrives in medias res at Jeremy and Gloria's wedding just as Father O'Neil intones, "While each man thinks he knows love, love we have learned is a mystery." First glimpsed peering through a chapel window in homage to *The Graduate* (1967), John arrives not to prevent but instead to join the proceedings as Jeremy's best man, in both senses. John (rather than the bride) is seen advancing down the aisle to come face-to-face with Jeremy, take his hand, and speak lines of devotion. Predictably, actor commentary goes into overdrive to justify this reaffirmation of vows: Vaughn explains, "It's a real guy

Maria San Filippo

Jeremy and John reaffirming their vows.

thing too where it's like that's enough, you don't have to talk about it a lot. You don't want to."

As if to signify this overcoming of religious opposition to same-sex unions, John takes up a position at the altar that obscures a crucifix previously visible. As the scene progresses, its shot–reverse-shot construction keeps Jeremy and John tightly framed and without any reassuring female presence. Instead it is Todd who is positioned between the men as they recite their "vows."

Once reconciled and metaphorically remarried, John moves to Jeremy's side in support of the conventional nuptials taking place and, facing Claire, declares his love in a stage whisper that disrupts the solemnity of the proceedings by refusing to yield the floor to the priest, who is never heard to utter the all-important "I now pronounce you man and wife." Neither do we see Secretary Cleary engage in the traditional giving of the bride. When commanded by Zach to intervene, Secretary Cleary refuses to exert patriarchal authority, telling Claire that "It's up to you." Whereas earlier John issued his own command ("You can't marry [Zach]!"), now he acknowledges Claire's agency and professional ambition: "I'm not asking you to marry me; I'm just asking you not to marry him." Doty notices that *Gentlemen Prefer Blondes'* wedding scene "connects male-female and female-female couples to each other rather than separating them into two opposite sex couples," and *Wedding Crashers* employs similarly inclusive framing at this moment.[29] Over John's right shoulder, Jeremy holds Gloria's hand; over John's left shoulder stands Todd. Having embraced his bisexual desire and now offering a nontraditional proposal, John is not just in between the (queer) heterosexual couple and the gay character but instead joins the two together.

Notice the inclusive framing for this queer wedding.

The four newlyweds speeding into the sunset may appear to capitulate to conventional marriage rhetoric as well as Hollywood formula, but this queer wedding affirms female independence and partnerships between same and differently gendered individuals. John and Jeremy continue crashing (with a man still at the wheel), but now Claire sets the agenda, consenting to crash a wedding in progress and concocting their sham identities. No longer an exclusively male domain, the previous driving forces of female objectification and sexual conquest take a back seat to the subversive—if celebratory—transgression of wedding ritual by this newly formed nontraditional household. Modernizing the comedy of remarriage by refusing to curb liberated women's (professional and sexual) independence, *Wedding Crashers'* genre revisionism moreover undermines the male buddy film's work to reaffirm heteromasculinity; these male buddies work out their attraction neither by retreating into overdetermined heterosexual couplings nor with explosive psychosexual displays. Jeremy coaxes John into reaffirming their relationship and accepting his crasher identity, metaphorically translated as affirmation of bisexuality. John convinces Jeremy to convert bisexual desire into something less irresponsible and concealed. They each find love with an unconventional "good woman" but not at the cost of their own relationship; they'll even be honeymooning together. Borderline assimilatory in its utopian marriage-for-everyone plea, *Wedding Crashers* revises rather than rejects overall the marriage institution yet dares to visualize a bisexual, feminist, sex-positive, nontraditional household version of happily ever after.

In their engagements with pro–marriage-equality discourses, *Wedding Crashers* and its bromance brethren—*Old School* (2003); *Anchorman: The Legend of Ron Burgundy* (2004); *The 40-Year-Old Virgin* (2005); *You, Me and Dupreee* (2006); *Superbad* (2007); *Blades of Glory* (2007); *The Hangover*

(2009) and *The Hangover Part II* (2011); *I Love You, Man* (2009), *The Other Guys* (2010); and many others—released in the past decade alternately endorse and contain queer images and attitudes. At its most conservative, the bromance sells marriage at the same time that it works to restrict the definition of marriage and reconcile male buddies to compulsory monosexuality. At its most progressive, the bromance works to challenge the gay marriage movement's reinforcement of sexual binaries and an us-versus-them mentality that threatens to blind us ever more acutely from an understanding that the only thing constant about human sexuality is that it is completely variable, with as many manifestations as there are humans.

NOTES

1. Gross cited on boxofficemojo.com. The term "comedy of remarriage" was coined by Cavell to refer to a subgenre of American romantic comedy made between 1934 and 1949. See Stanley Cavell, *Pursuits of Happiness: The Hollywood Comedy of Remarriage* (Cambridge, MA: Harvard University Press, 1981). I thank Vernon Shetley for the initial insight to regard *Wedding Crashers* as a comedy of remarriage and for the many other insightful observations he has shared. The term "bromance" reportedly was coined in the late 1990s by writer-editor Dave Carnie in the American skateboarding magazine *Big Brother* to refer to the close relationships between skate-buddies. It is not clear when or by whom the term was first applied to film.

2. *Brokeback Mountain* is treated to an extended reading in my book *The B Word: Bisexuality in Contemporary Film and Television*, forthcoming in 2013 from Indiana University Press.

3. Monosexuality, signaling desire enacted with partners of only one gender, is systemically reproduced by pressing social-sexual subjects to conform to either heterosexuality or homosexuality. This neologism along with the attendant compulsory monogamy are of course drawn from Rich's seminal concept of compulsory heterosexuality, by which she indicated one facet of the ideological and institutionalized means of suppressing lesbianism so as to control women. I have adjusted Rich's formulation to account for contemporary society's accommodation of gay identity, albeit within certain boundaries of homonormative acceptability. In the contemporary United States, these boundaries get largely defined as assimilated and domesticized but not (to use the sacrosanct term) married. See Adrienne Rich, "Compulsory Heterosexuality and Lesbian Existence," in *The Lesbian and Gay Studies Reader*, edited by Henry Abelove, Michele Aina Barale, and David M. Halperin, 227–54 (New York: Routledge, 1993).

4. J. Hoberman, "Blazing Saddles," *Village Voice*, November 30–December 6, 2005, C48.

5. Thomas Elsaesser, "The Pathos of Failure: American Films in the 1970s; Notes on the Unmotivated Hero," in *The Last Great American Picture Show: New*

Hollywood Cinema in the 1970s, edited by Thomas Elsaesser, Alexander Horwath, and Noel King (Amsterdam: Amsterdam University Press, 2004), 286; Michael Ryan and Douglas Kellner, *Camera Politica: The Politics and Ideology of Contemporary Hollywood Film* (Bloomington: Indiana University Press, 1988), 151.

6. Dennis Bingham, *Acting Male: Masculinities in the Films of James Stewart, Jack Nicholson, and Clint Eastwood* (New Brunswick, NJ: Rutgers University Press, 1994), 4.

7. Andrew S. Horton, "Introduction," in *Comedy/Cinema/Theory,* edited by Andrew S. Horton (Berkeley: University of California Press, 1991), 5.

8. Cynthia J. Fuchs, "The Buddy Politic," in *Screening the Male: Exploring Masculinities in Hollywood Cinema,* edited by Steven Cohan and Ina Rae Hark (New York: Routledge, 1993), 195.

9. Ibid., 202.

10. See, for example, C. A. Tripp, *The Intimate World of Abraham Lincoln,* edited by Lewis Gannett (New York: Simon and Schuster, 2005).

11. Robin Wood, *Hollywood from Vietnam to Reagan . . . and Beyond,* rev. ed. (New York: Columbia University Press, 2003), 204–5. Wood traces the genre's trajectory to the explicitly gay films of the early 1980s (*Making Love* [1982], *Victor Victoria* [1982]), at which point Reagan-era backlash compensated with the testosterone-fueled competitive twosomes of action flicks such as *48 Hrs.* (1982), *Lethal Weapon* (1987), and *Top Gun* (1986).

12. For example, Joseph McBride's interview with Hawks features the following exchange:

> *McBride*: What do you think when critics say, as some in fact have, that the male characters in your films border on homosexuality?
>
> *Hawks*: I'd say it's a goddamn silly statement to make. It sounds like a homosexual speaking.

Quoted in Scott Breivold, ed., *Howard Hawks: Interviews* (Jackson: University Press of Mississippi, 2006), 80. See also Joseph McBride, *Hawks on Hawks* (Berkeley: University of California Press, 1982).

13. Alexander Doty, "Everyone's Here for Love: Bisexuality and *Gentlemen Prefer Blondes,*" in *Flaming Classics: Queering the Film Canon* (New York: Routledge, 2000), 132, 149. I thank Alex for his comments on this essay and for the informing and inspiring influence that his scholarship has had on my own.

14. Ibid., 140.

15. Lucie Arbuthnot and Gail Seneca, "Pre-Text and Text in *Gentlemen Prefer Blondes,*" in *Issues in Feminist Film Criticism,* edited by Patricia Erens (Bloomington: Indiana University Press, 1990), 121.

16. Wood, *Hollywood from Vietnam to Reagan,* 204.

17. Ibid., 204.

18. Doty, "Everyone's Here for Love," 136.

19. Cavell, *Pursuits of Happiness,* 31.

20. Wood (*Hollywood from Vietnam to Reagan,* 204–5) clarifies that the "surreptitious gay text" designation problematically "rests on that strict division of

heterosexual and homosexual which is one of the regulations on which patriarchy depends."

21. Ibid., 204.

22. Ibid., 260.

23. BDSM refers to the diverse identities and practices associated with bondage and discipline, dominance and submission, and sadism and masochism.

24. Cavell, *Pursuits of Happiness*, 17.

25. See Gayle Rubin, "The Traffic in Women: Notes on the 'Political Economy' of Sex," in *The Second Wave: A Reader in Feminist Theory*, edited by Linda Nicholson (New York: Routledge, 1997), 27–62.

26. *Oxford Dictionary of Contemporary English*, 3rd ed., edited by Catherine Soanes (New York: Oxford University Press, 2001), 560.

27. A near-identical montage follows a short-term spat between Starsky (Ben Stiller) and Hutch (Owen Wilson) in *Starsky and Hutch* (2005), the highly bromantic remake of the 1970s' buddy cop television series.

28. Doty, "Everyone's Here for Love," 146.

29. Ibid., 134–35.

CAETLIN BENSON-ALLOTT

The Queer Fat of Philip Seymour Hoffman

"Look at my belly," Perry Smith (Clifton Collins Jr.) orders Truman Capote (Philip Seymour Hoffman) as Perry prepares to offer his account of the night he and Richard Hickcock murdered the Clutter family of Holcomb, Kansas. Before unveiling this, the primal scene of both Bennett Miller's film *Capote* (2005) and the book on which it is based, Capote's *In Cold Blood*, Perry and the camera pause and contemplate a photo of him posing with his sister in childhood innocence. "There must be something wrong with us to do what we did," Perry hypothesizes, although the photo bears no such witness. His belly is the widest, whitest thing in the frame, the riveting *punctum* of an unself-conscious boy, but it refuses to reveal how he became the death row inmate now staring at it. The belly also cannot communicate the full extent of Perry's enigmatic homoerotic relationship with Truman, but Perry's request that we look to it for clues about his character remains instructive for unpacking the unique roles that body and belly have played in Hoffman's oeuvre. Although Hoffman never shows the spectator his belly in *Capote*, Perry's request should remind us that *Capote* tells a story about bodies as well as marginalization and that, for a while, Hoffman made a career out of enacting a link between the two. In some ways, it is ironic that Hoffman won his Best Actor Oscar for sublimating his body to play the diminutive writer, because in the years prior he also provided startling visible evidence of what bodies can tell us when we are made to look at them.

During the years between his emergence as a character actor and his Oscar win for *Capote*, Hoffman's physical performances rendered marginalized genders and sexualities visible through unique comportments of his flesh. As Judith Butler observes, sex and gender are not merely cultural constructions imposed on an embodied subject. Sex is "not simply what one has, or a static description of what one is"; rather, it shapes "the norms

by which the 'one' becomes viable at all, that which qualifies a body for life within the domain of cultural intelligibility."[1] Consequently, bodies without legible genders and sexes are considered and treated as less than human in our culture of compulsory heterosexuality.[2] However, the norms of sex depend on more than just anatomy for cultural intelligibility, and disability theorists quite rightly contend that the limits by which our culture defines a life or a life worth having are much tighter than social constructivist discourses on sex, race, and sexual orientation reflect.[3]

Cultural intelligibility hinges on far more than sexual difference, because intelligibility implies not only that the dominant ideology recognizes and interpellates the subject but also that it assigns him a place within its order. Let us therefore extend Butler's question—"how are we to understand the 'matter' of sex, and of bodies more generally, as the repeated and violent circumscription of cultural intelligibility?"—to interrogate other determinants of sex besides traditional interpretations of sexual difference, such as weight.[4] This essay will focus on the relationship of body mass to gender and cultural intelligibility, noting that fat bodies have rarely been invited into the sexual order of cinema except perhaps as an Other that affirms the attractive quality of the physically fit star. Indeed, U.S. film history is for the most part a heteronormative system that perpetuates the myth that all sex is heterosexual (i.e., between a masculine man and a feminine woman) and casts fat bodies as outside the bounds of gender, sex, and social recognition.

From the mid-1990s through the mid-2000s, Hoffman contested this foreclosure of fat genders and desires in films as varied as *Twister* (1996), *Boogie Nights* (1997), *Capote,* and *Mission: Impossible III* (2006) by using his body to demonstrate that Hollywood's compulsory sex-gender system operates at the material level of the actor's body and that it can be contested with that body.[5] In these films, the actor manipulates his physical breadth and weight as well as his gestural scale to draw the viewer's attention to how compulsory heterosexuality marginalizes certain lives and bodies. These physical techniques help Hoffman visually exceed the fat male stereotypes of his early career, stereotypes that coded his body as immoderate, less than masculine, and thus most suited for minor roles, comedic turns, and pathetic losers. In such cases, fat male stereotypes rely on stock meanings attached to the actor's stockier build. Hoffman transcends these roles with nuances of movement and deft exploitations of gesture and in so doing illuminates the process through which overweight male bodies are made unintelligible by a filmic culture that denigrates fat genders even among the gender and sexual alterities that it occasionally exploits.

Several noteworthy studies have explored how overweight female bodies have been ignored or exploited by Hollywood's fitness culture, but far

less attention has been paid to how fat men look in movies or how their bodies are cast in relation to normative masculinity, which demands that men display virility, strength, and physical prowess through visible fitness.[6] Sander Gilman and Jerry Mosher observe that overweight men are often represented as childlike or grotesque by American film and visual culture, but neither author has yet offered a close reading of the ways in which the fat male body moves through these stereotypes.[7] However, an actor's (alleged) physical excess can become a tool for larger and more nuanced portrayals of alternative masculinities and counternormative orientations to space and embodiment. As Andrew Klevan notes, it is an actor's job "to *flesh* out the synopsis" of a film with his body, and Hoffman's work suggests that not all bodies perform in the same ways.[8] Indeed, his physical gestures "technicize the body," making it a tool in the "renegotiation of the *representational contract* between one's body and one's world."[9] The flesh of the overweight male actor has been so overdetermined by cultural stereotypes that it comes to the screen already invested with meanings that make signification on an individual level difficult. However, because "gesture performs a becoming spatial and becoming technical of the body," it creates new opportunities to qualify and critique (inherently) static stereotypes.[10]

Hoffman's physical acting exemplifies the gendered as well as sexual potential of gesture and performance, for he uses his corpulence to visually refuse the traditional masculine-feminine gender binary and dramatize orientations and physical expressions of the body otherwise excluded from heteronormative American cinema. Hoffman has appeared in forty-four feature films so far, and in each he offers another version of what has remained a pale, overweight male body. Often less than fat and almost never obese, Hoffman uses his *polysarkia,* the ancient Greek medical term for "too much flesh," to portray a series of sexual outsiders, perverts, and otherwise queer characters.[11] As James Lipton notes, these relentlessly physical performances suggest that "Philip Seymour Hoffman may be the archetypal sex symbol of our time" in that he gestures toward new approaches to representation for marginalized sexualities and genders.[12] In *Red Dragon* (2003), Hoffman plays a voyeuristic and corporeally immoderate tabloid reporter whose mobile gaze is impaired when Francis Dolarhyde (Ralph Fiennes) superglues him to a wheelchair and burns him alive as punishment for colluding with a beautiful male FBI agent (Edward Norton) and for embodying "the fat boy [who] is characterized as hypersexual as well as asexual."[13] For Todd Solondz's *Happiness* (1998), Hoffman makes a spectacle of himself prank-calling New Jersey women. Here the actor's mouth breathing and masturbation exhibit his fear of and desire for intimacy with both the emaciated object of his desire, played by Lara Flynn Boyle, and a

similarly isolated and rotund woman played by Camryn Manhiem. Both Hoffman and *Happiness* present his character as morally and physically repellant, yet the actor nonetheless toys with Parveen Adams's observation that "it is in general a supplementary feature of any perversion to incite a spectator," for the banality of his antisocial sexuality both humanizes the character's aggression and loneliness and excites the spectator's more prurient interests.[14]

Moreover, such embodied performances of social marginalization deserve to be read as political statements, because Hoffman keeps them in constant conversation with the history of the fat male body on-screen, where "fat and masculinity are often seen as incompatible" and fat men regularly appear as "stereotypes of failed masculinity" and the antitheses of "a 'modern' body, if by modern we imagine the body as trained, lithesome, strong, active, and thus supremely masculine."[15] Hence, fat actors have been typecast as overgrown children ("Fatty," played by Roscoe Arbuckle), fools (Pseudolus, played by Zero Mostel), grotesques (John "Bluto" Blutarsky, played by John Belushi), corporeally intuitive detectives (Hercules Poirot, played by Peter Ustinov among others), appetitive villains (Kasper Gutman, played by Sydney Greenstreet), and effeminate failures (Del Griffith, played by John Candy).[16] Yet by supposing "fat's capacity as social articulation," Hoffman manipulates his performances of these stereotypes to challenge the specific anxieties about masculinity and embodiment that they hide in plain sight.[17] Despite being faced with a filmic tradition in which "invisibility is the performativity most expected from fat," Hoffman thus fashions new deportments and material articulations of the body that make visible the ubiquity of heteronormative masculinity and the power of gesture for social critique.[18]

Hoffman's rearticulations of fat male stereotypes are most apparent in his late 1990s' work when the actor was often asked to play clichéd supporting roles. As Dusty Davis in Jan du Bont's *Twister*, Hoffman uses his corpulence to subliminally fulfill the narrative functions assigned to his character while also making visible the exploitation of fat sexualities in thin heterosexual romances. For this movie, Hoffman inhabits the stereotype of the pothead—the ineffectual hedonist of mass culture—and camps the sexual threat that it rests on before dissolving that threat and revealing it to be only another element of heteronormativity. Dusty begins the film as a recognizable spectacle, singing along to Eric Clapton and dressed in baggy androgynous clothes with long unkempt blond hair. Although lazy in appearance, "The Dustman" springs into action when his former boss, Bill (Bill Paxton), shows up at the mobile weather lab where he works and, as Dusty puts it, "a manly handshake ensues." Dusty's ironic citation of

professional etiquette demonstrates that he is not particularly invested in either conventional masculinity or (sexual) maturity, which may be why Bill selects Dusty to keep his fiancée, Melissa (Jami Gertz), entertained while Bill finalizes his divorce from Dusty's current boss, Jo (Helen Hunt). As he departs, Bill suggests, "Dusty, why don't you explain to Melissa why you are . . . the way you are," to which Dusty grins knowingly. The camera then follows Bill through his interactions with Jo until she realizes that Melissa is at the camp and objects: "You left her alone with Dusty? What's the matter with you?" *Twister* corroborates Jo's concern by immediately cutting to Dusty as he explains "the suck zone. It's the point, basically, at which the twister . . . sucks you up." Throughout this silly come-on Dusty smiles suggestively at Melissa, but she seems more disgusted than intimidated, encouraging the spectator to understand Dusty's sexuality as a joke. Dusty's innuendo is so amateurish and so transparently performed that it actually inspires sympathy for his character. Thus, Jo's suggestion that Dusty might be sexually threatening only improves the joke, because it allows the spectator to believe that she or he knows more about fat sexuality (or rather its impossibility) than the characters.

Hoffman emphasizes the humor of Dusty's desire by keeping his movements large, ungainly, and childlike, and these gestures help obscure the extent to which *Twister* needs and insists upon Dusty's sexuality to build a romantic reunion between Bill and Jo. Throughout the film, Dusty continues to pursue Melissa by dragging her around by the hand, whispering to her, and insinuating an increasingly unwelcome relationship between them. These overtures facilitate *Twister*'s remarriage plot because they distract Melissa while Bill and Jo reestablish their relationship. When Bill gives Jo a salacious look as she leaves to take a shower, Melissa does not see his desire because Hoffman as Dusty is maniacally attempting to load her plate with mashed potatoes and gravy. Dusty also distracts Melissa with childlike buffoonery after Bill consigns her to Dusty's school bus so that he and Jo can chase tornadoes alone. When Melissa finally does overhear Bill declaring his love to Jo, Dusty's physical affections limit the pathos of her rejection as he stands behind her with a broken umbrella, trying in vain to shelter her from the rain and the end of her engagement. This gesture is ultimately as ineffectual as his come-ons, but its kindness retroactively clarifies Dusty's motivation for hitting on Melissa. During this sudden transition from lust to concern, it becomes clear that Dusty fabricated his sexual threat for Melissa's benefit. The grotesque was in on the joke; he wanted to make Melissa feel wanted while she came to the realization that her fiancé wanted someone else.

After Melissa's epiphany releases Dusty from his diversionary ruse, he actively works to accelerate Bill and Jo's reunion, and Hoffman works to

hide Dusty's utility behind a new set of gestures. Dusty transforms from a grotesque parody of Bill's normative masculinity into an agent of narrative closure, which means that he must restrain his previously exaggerated gestures and disappear into the plot. His childish hedonism turns into a childlike investment in Bill and Jo's reunion, and he becomes the audience's avatar for the resolution of *Twister*'s classic double plot. In *Twister*'s final scene, Dusty and the rest of the research team find Jo and Bill romantically, professionally, and literally tied together after the successful launch of their tornado-tracking technology, but husband and wife are interrupted in their reconciliation by a graduate assistant who wants to congratulate them on their professional achievement. Another researcher asks them to look at the sky, but Jo asserts "I think we've seen enough" and climbs onto Bill's lap for a kiss. Their team seems oblivious to this breach of professional etiquette, perhaps too distracted by scientific breakthroughs to recognize the real climax of their movie. Dusty sees the embrace, however, and raises his arms over his head, yelling "Awesome!" His cheer signals *Twister*'s conclusion and affirms that its true culmination was not the acquisition of meteorological data but rather the reinstatement of heteronormative order and the married couple. Dusty thus becomes both a surrogate for the audience, which was long ago trained to be more invested in romantic subplots than the main story, and the arbiter of narrative closure, which is in keeping with his indispensable contributions to the movie's narrative.

Yet even as he draws out Dusty's narrative utility and stereotypical construction, Hoffman must still perform the invisibility traditionally associated with fat bodies on-screen or risk violating *Twister*'s already tenuous verisimilitude. The genius of Hoffman's performance is that he manages to do both by exploiting the cultural unintelligibility of obesity; he uses the spectator's own tendency to dismiss fat men to camouflage Dusty's narrative centrality. Because Hoffman is the only overweight actor in this film, his girth emphasizes Dusty's position as the film's fool, which helps disguise his formulaic responsibilities. Hoffman's weight opens up a dramatic tradition through which he can exacerbate his character's hedonistic qualities and conceal his intelligence and manipulative capacity. By making his body both overly visible and easily overlooked, Hoffman obscures Dusty's generic necessity. For that reason, one wonders whether Dusty could have been played by a thinner man and whether the audience would not then have believed his sexual threat to be real. They might have noticed the extent to which his buffoonery helps the film push Jo and Bill closer together. However, as a moderately overweight performer (in this case), Hoffman uses the cultural invisibility already associated with overweight bodies to act his character's outlandish persona into the background. As a result,

Dusty becomes an exemplum of sexual alterity's necessity and marginalization in heteronormative film.

Hoffman continues this critical project in his next film, P. T. Anderson's *Boogie Nights,* in which Hoffman explores how sexual alterities are also integral to the *production* of heteronormative films. In this, Hoffman's breakout role and perhaps his most nuanced work as a physical actor, he employs "the already culturized physical 'givens' of the body, among them ones— size, color, gestural scale—that may have near-ineffaceable associations of power or stigma or both" to dramatize unmentionable identity categories in heterosexual porn production, namely fat and homosexuality.[19] *Boogie Nights* re-creates Los Angeles' straight porn industry from 1977 through 1984 as it transitions out of the sexual revolution and into the video revolution. The film's protagonist in this ensemble investigation is "Eddie Adams from Torrance" (Mark Wahlberg), who becomes the industry's leading star, Dirk Diggler, and the enduring fantasy object of Scotty J., the boom operator on Dirk's pictures. As Scotty J., Hoffman uses the excess of his body to represent Scotty's excess as a gay man in straight porn. In short, Hoffman effectively reterritorializes Scotty's body to make the character's desires visible outside the bounds of heteronormative masculinity.

Scotty first appears in *Boogie Nights* during an idyllic pool party at the home of Jack Horner (Burt Reynolds), a renowned porn director. As Scotty enters the party through the back gate, the soundtrack begins to play Hot Chocolate's "You Sexy Thing." The song is something of a joke at Scotty's expense, however, since the lyrics reflect his desire for somebody, anybody, although nobody desires him. The camera follows Scotty as he enters the party unobserved (fortunately, since the gate almost hits him on the way in), surveys the crowd, and sighs. A pan of the pool reveals Scotty's disappointment to be an incredible array of beautiful women. Assuming Scotty's perspective, the camera casts over the women without distinction until it reaches Eddie, whereupon Scotty's field of vision condenses into an iris-shot of Eddie's well-muscled form reclining on a deck chair. Scotty races across the lawn to introduce himself, whereupon his sexual interest in Eddie and Eddie's obliviousness become immediately apparent:

SCOTTY: Hey, Reed.

REED [ROTHCHILD, PLAYED BY JOHN C. REILLY]: Hey—Scotty, how are you?

SCOTTY: You know, you know. [*Scotty pulls down his shirt.*] Who's this?

REED: Eddie—meet Scotty J. He's a friend. He works on some of the films.

EDDIE: Nice to meet you.

SCOTTY: Oh yeah, me too. Are you going to be working?

EDDIE: Maybe . . .

REED: Probably.

SCOTTY: That's great. That's great. Where did you meet Jack? 'Cause I work on the films, you know, so if you ever, yeah . . .

Throughout this dialogue, Hoffman emphasizes Scotty's social awkwardness with a grand gestural scale, including flamboyant hand movements, hair tosses, and eye rolls. His relentless fidgeting isolates him as a spectacle of sexual anxiety, but Eddie fails to discern the reason for Scotty's malaise and quickly rushes away to speak to Jack. Despite its brevity, their scene crystallizes how Hoffman's deportment will make Scotty's desire visible to the spectator even as it remains diegetically invisible to Dirk and Reed.[20] Hoffman uses the diegetic invisibility of his overweight body as a metonymy for the invisibility of Scotty's homosexual longing while simultaneously exploiting the objective gaze of the camera to make his fat desire visible to the spectator. Through ambivalent attempts to expose and conceal his flesh—especially his protuberant stomach—Hoffman conveys Scotty's ambivalent relationship to the heteronormative film culture that provides him with community and sustenance but chooses not to see his homosexuality, just as it politely ignores his girth.

Hoffman begins to draw our attention to Scotty's social invisibility through his nervous manipulation of Scotty's wardrobe. Scotty arrives at Jack's party dressed in a nondescript brown and white scoop-necked tank top, denim short-shorts, and aviator sunglasses. This sartorial emphasis on brown, taken in combination with Scotty's pale freckled skin and strawberry blond Prince Valiant haircut, effectively blends Hoffman's body into one bland expanse, a beige canvas interrupted only by the blue shorts that stretch across his hips and below his stomach as if to emphasize the pallor of the former and the breadth of the latter. This belly and the tank tops that barely cover it become Scotty's motif in *Boogie Nights* and a material metonymy for his open secret. Scotty's tank tops frankly do not fit him: their scooped necks reveal an unflattering amount of his undefined chest and shoulders, and their hemlines regularly allow a sliver of stomach to creep out. Scotty's belly is in truth the only anatomical feature highlighted by his tank tops, which is unattractive but appropriate since Hoffman orients Scotty's physical expression of his sexuality around his belly.

Because Scotty is written as inarticulate and suffering from unspeakable desires, Hoffman uses his body, specifically his largest and perhaps least mentionable feature, to communicate Scotty's unmentionable orientation.

Hoffman thus borrows a technique from gay male fat pornography and "displaces erotic pleasures [or their symbolic representation] from the genitals and disperses it to other parts of the body, thereby reconfiguring what can count as a pleasurable body."[21] From the moment Scotty enters the party and stops to survey the crowd, Hoffman demonstrates Scotty's physical discomfort with his fat as metonymic of his disappointment in the straight party scene. When Scotty sighs in sexual frustration and hunches his shoulders forward to grip his right elbow in his left hand, even this small gesture manifests his social malaise through the physical straining that it requires. However, the beauty of this gesture lies in its exploitation of the frame, since Hoffman's arms and torso are actually offscreen during this shot. Therefore, the spectator only sees the strain (of the gesture, of the straight party scene) and not the symbolic movement itself. Hoffman insinuates physical discomfort in order to imply sexual discomfort by suggesting that it is no easy task for Scotty to reach across his belly or shoulder the burden of his unarticulatable desire.

Hoffman crystallizes this convergence of bodily and sexual anxieties during one specific gesture, a nervous tank top tug that confirms the centrality of excess and flesh to Scotty's experience of his sexual orientation. This tug occurs shortly before Scotty demands to be introduced to Eddie, when Scotty pulls down on the bottom hem of his shirt in an attempt to cover the embarrassing swath of belly it exposes. As soon as he releases the shirt, however, it immediately springs back to its previous position at his navel. This tug reveals Scotty's anxious awareness of his sexual intent, as does all of his nervous hunching and fidgeting, but Hoffman's attention to the tank top offers a particularly apt metaphor for Scotty's homosexual excess in this heterosexual scene. Scotty's failed muscle shirt, which cannot cover him and does not fit, speaks to both Scotty's attempt at normative masculinity and his inability to conform, to contain himself within that order. The futility of Scotty's tug thus anticipates the futility of his desire for Eddie, as Scotty can no more make these clothes work for him than he can make that straight man want him. Nevertheless, Scotty is no mere fashion victim, for although he may appear self-conscious in his ill-fitting shirt, he (theoretically) chose that top and chooses to draw attention to it—and his belly—by pulling on it.

Hoffman's gestural use of the tank top also allows it to expose the differences between Eddie's and the spectator's perceptions of Scotty, since Anderson blocks the tug so that the spectator sees Eddie *not* seeing it from Eddie's perspective. While the spectator appreciates the tug's bittersweet comedy (not to mention its centrality in the frame), the other actors ignore

Caetlin Benson-Allott

Scotty J. prepares to tug in *Boogie Nights.*

it as a minor detail of their diegesis, and these vectors of attention exactly parallel who perceives Scotty's desire and who cannot. When Scotty comes over to talk to Reed and Eddie, the spectator regards him through a long shot over their shoulders, a framing technique that presents Scotty to the spectator from the other actors' mutual point of view. The spectator thus observes Scotty's homosexual anxiety through Eddie and Reed's shared perspective as heterosexual males, in short the very ideological position that prevents them from really seeing Scotty. Hoffman also encourages the spectator to contemplate this optical arrangement by fiddling with his sunglasses throughout the shot. As tools of vision, the glass should remind the spectator of Scotty's awareness of his liminal position in the heterosexual male field of vision (aka porn). The trendy aviators thus represent both Scotty's attempt to conform to normative masculinity and his anxiety about being seen or, rather, recognized. For while this fidgeting draws the spectator's attention to Scotty's bid for inclusion, it also implies that he does not know what to do with the sunglasses, with straight masculinity. Instead of simply wearing his glasses and looking into his problems with visibility, Scotty carries the glasses in front of the belly that everyone knows about but no one sees.

Scotty does force Dirk to see him at one point in the narrative, however, during Jack Horner's calamitous 1980 New Year's Eve party. After trying cocaine for the first time (the inauguration to his eventual undoing), Dirk steps outside and immediately runs into Scotty, who has been waiting to show Dirk his new car. Scotty eventually succeeds in dragging his beloved away to the parking lot, where he sits down on the hood, crosses his arms

across his belly, and calls "Here, here, here, here," begging Dirk to open his eyes and admire both the car and Scotty. As Scotty arranges himself, the spectator realizes that his "used candy-apple red Toyota Corolla" is a cheaper version of Dirk's red Corvette, an automotive imitation meant to associate Scotty with someone Dirk could love, namely Dirk.[22] Yet as soon as Dirk opens his eyes, Scotty hops out of his pose and steps forward to speak to Dirk, thus postponing the moment when he will have to acknowledge Dirk's obliviousness or, worse, his lack of interest. Instead, Scotty asks Dirk if he wants to go for a ride, the same question Dirk asked Amber Waves (Julianne Moore) after he bought his new car, but Dirk protests, "Wait, wait, wait—how much time is left?" Rather than responding, Scotty rushes forward and kisses Dirk on the mouth. Dirk pushes him away, and Scotty begins to beg:

SCOTTY: You look at me sometimes. I want to know if you like me.

DIRK: Of course . . . Yeah, I like you, Scotty.

SCOTTY: Can I kiss you? Please? Can I kiss you on the mouth?

DIRK: No!

SCOTTY: Please let me.

After asking "Do you want to kiss me? . . . No?," Scotty tries to reinterest Dirk in his car, but Dirk only entreats him to rejoin the party. When Scotty refuses to be drawn into any discourse about leaving the driveway, Dirk finally walks off without him.

At this point Scotty gets into his car and begins to cry, repeating "I'm a fucking idiot . . . fucking idiot" nine times. A streetlight shines through the open car window onto Scotty and reflects off the red door, Scotty's red jacket, and his pale pink face and blond hair. This illumination makes Scotty's jowls and double chin increasingly prominent as he shakes his head in anguish; the light catches their every jiggle and wobble, while his face remains in shadow. These movements tie the spectator's attention to Scotty's humiliated flesh for a full sixteen seconds, during which the handheld camera remains nearly still. Its slight adjustments actually heighten the shot's focus, however, because they remind the spectator of her or his active look and mark the passage of time in the shot. This emphasis on duration changes the subject of the shot from narrative to emotional content. Because the long take does not advance the plot at all, "duration has become an independent dimension of the image, and is no longer a function of the time needed for cognition and action."[23]

Caetlin Benson-Allott

To be sure, duration is not entirely independent in Anderson's shot, given that he holds it for as long as it takes Scotty to repeat "fucking idiot" nine times. It is divorced from "the time needed for cognition and action," however, since the duration is contingent upon Scotty's obsessive self-condemnation, not simply his reaction to Dirk's rejection.[24] Instead, Anderson prolongs the shot until Hoffman's chins accumulate an almost unbearable affective load, for as the shot's duration becomes more divorced from narrative, the spectator has no choice but to linger on and contemplate Scotty's anguish and mortified flesh. Thus, Hoffman uses this protracted moment and the spectator's growing discomfort to force her or him to reckon with the pain of Scotty's excess in the heterosexual porn milieu. These sixteen seconds give the spectator time to recognize the banality of Scotty's rejection and identify with it, because in the end, Anderson only holds the shot for as long as it takes the spectator to realize that Scotty is just another guy sitting in his car crying because the person he loves does not love him back.

The duration of Scotty's infamous sixteen seconds thus forces the spectator to recognize that she or he possesses a certain "lipoliteracy," or ability to read the actor's fat.[25] The chins occupy a space just off the middle of the screen, at the edge of his car's unilluminated interior. By placing the chins so close to the shadow line, Anderson and Hoffman draw attention to the chins' pallor and fleshiness through their contrast with the black hole of the car's interior. This black hole obscures the actor's face as he sobs, and although his speech causes the chins to wiggle and bounce, they remain ever present in the scene; indeed, they almost become his face for this scene. The chins function as the visual referent for Scotty's refrain ("fucking idiot") and thus the metonymic stand-in for the humiliated body whose desires bring Scotty such unhappiness. Unlike his belly, then, which Scotty employs in a pornographic reterritorialization of the male body, the chins do not empower him. For whereas Scotty displays his belly as a sexual signifier, the chins do not appear in control of their gestural significance; instead, they embody the anguish that Scotty cannot hide.

Despite the masochism and abjection implied by Scotty's facial fat in this scene, Hoffman's portrayal of Scotty never reduces the character to such overdetermined terms or normative understandings of male corpulence. Reading Scotty as abject would suggest that Scotty is alienated from his body and its excess flesh, yet his reterritorialization of his stomach indicates otherwise. For the same reason, Scotty should not be interpreted as masochistic simply because he doggedly prolongs his inevitable rejection. Hoffman's rapid movements at the pool party and his pose on the hood of Scotty's car demonstrate that Scotty is ambivalent about making his desire visible. That very ambivalence suggests that Scotty recognizes the pros and

Scotty J. embodies anguish.

cons of visibility as well as his own agency in deciding when and how to become visible. However, if the car scene is approached from the perspective of Kaja Silverman, who reads male masochism as "'perverse' with respect not so much to a moral as to a phallic standard," then Scotty might be masochistic, but his masochism, his self-alienation from having the phallus, ironically rescues him from the phallocentrism of normative masculinity.[26] Silverman quotes Serge Leclaire as observing that "because the man has in his body a relation with his *penis as the representative of the phallus,* schematically, his natural inclination leads him to forget the fact that the phallus ('God') is invisible, unseizable, unnameable."[27] That natural inclination can be disrupted by some physical or social alienation from the dominant ideology such as disability, homosexuality, or fat. Then the man may recall the original meaning and location of the phallus and enter into a new relationship with his body.[28] Because Scotty's penis may be literally invisible to him and because the mechanics of seizing it may be a bit challenging as well (if his efforts to wrap his arms around his belly are any indication), the very size of Scotty's body may excuse it from normative masculine relations to the phallus. Scotty's masochism would then set him free to coin a new language for the male body to speak.

Scotty's body should therefore remind the viewer to regard "masculinity as a masquerade" rather than corpulence as abjection, because it implies that the body's representational contract is a social construction, just like any other element of gender.[29] If, as Julia Kristeva argues, the feeling of abjection arises from the subjective paradox "I *am* my body, and for that very reason it resists my intelligence, I am unable to possess it," then Scotty's

renegotiation of bodily signification indicates that he has disrupted the ready identification upon which abjection relies.[30] Scotty does not possess his body or its meanings but instead lives through a constant struggle to make new meanings for it, meanings that both construct the self (Scotty's desire, his anxiety, his humiliation) and undo it. Without making the body a mirror of the soul—an epistemology that has a long history in Christian symbolism, especially for the overweight—Hoffman uses the body's materiality as a moving negotiation of Scotty's relationship to normative masculinity.[31] The actor's excess corpulence becomes a tool to release his acting from the overdetermined "social codes, laws, norms, and ideals" of conventional masculinity and remap the male body for potentials beyond compulsory heterosexuality.[32]

To that end, Hoffman remaps his own body for each role that he takes on, and these nuances of corpulence are themselves challenges to the fat-thin binary perpetuated by Hollywood films. Although we tend to speak about bodies as fat or thin, they come in an endless array of sizes, and Hoffman's physical adjustments from role to role demonstrate that despite our limited vocabulary, we do recognize that different girths mean differently. Thus, in Spike Lee's *25th Hour* (2002), the actor slims down to just over an average weight, to the sort of physique that any moderately inactive high school English teacher might develop. This soft all-over padding allows Hoffman to portray Jacob as a philophobic who uses his fat as insulation against any intimacies that might force him to face his bourgeois self-hatred. In *Along Came Polly* (2004), on the other hand, Hoffman's stomach expands voluminously for Sandy Lyle, the onetime child star who refused to grow up and became a grotesque. Here Hoffman cites the cinematic tradition of fat infantilization begun by Roscoe "Fatty" Arbuckle eighty years prior but pairs it with the sexuality that was associated with Arbuckle in the tabloids yet never approved for his film personae. And in *Owning Mahowny* (2003), Hoffman's stockiness becomes Dan Mahowny's suitcase, the padded envelope that he needs to shuttle money undetected across the U.S.-Canadian border.

By 2006, Hoffman's success as an actor enabled him to bring his experiments with corpulence, representation, and movement to a Hollywood blockbuster and reimagine old stereotypes about fat, masculinity, and villainy for a much wider audience. As the black market arms trafficker Owen Davian, Hoffman glides through *Mission: Impossible III* expressing no interest in anyone or anything except the Rabbit's Foot, an obscure Mac-Guffin of destruction that one Impossible Mission agent merely guesses must be "the anti-God" itself.[33] When Ethan Hunt (Tom Cruise) captures

Davian, Hoffman uses Davian's restraints to emphasize his stillness and single-minded desire, his control over the appetites that typically characterize and overwhelm fat villains.[34] In fact, Davian acknowledges neither his body nor his emotions as he slowly plots his revenge in a beleaguered monotone:

HUNT: You're going to tell us everything—every buyer you've worked with, every organization.

DAVIAN: What the hell is your name?

HUNT: Names, contacts, inventory lists.

DAVIAN: Do you have a wife, a girlfriend?

HUNT: It's up to you how this goes.

DAVIAN: Because you know what I'm gonna do next? I'm gonna find her, whoever she is, I'm gonna find her and I'm gonna hurt her.

HUNT: You were apprehended carrying details of the location of something code-named the "Rabbit's Foot."

DAVIAN: I'm gonna make her bleed and cry and call out your name.

HUNT: What is the Rabbit's Foot?

DAVIAN: And then I'm gonna kill you right in front of her.

HUNT: I'm gonna ask you one more time.

DAVIAN: What is your name?

HUNT: What is the Rabbit's Foot . . .

DAVIAN: Who are you?

HUNT: and who is the buyer?

DAVIAN: You don't have any idea what in the hell is going on, do you?

As Davian delivers his threat, the camera moves from a close-up to an extreme close-up of his face, emphasizing first his sloping shoulders and casual seated position and then the gentle shaking of his head and his smooth brow, soft cheeks, and slight smile. In contrast with Tom Cruise's strong jaw and hard muscles, Hoffman's relaxed flesh becomes a manifestation of his confidence; Hunt is tense, but Davian is at ease. This lack of visible affect exempts Davian from the tradition of fat villains whose bodies incarnate their overabundance of desire, appetite, or greed. His smooth contours and the reflection of light off the broad planes of his golden skin allow Davian to transcend associations of his body with appetite as he refuses to show

Caetlin Benson-Allott

interest in Hunt's interrogation or subsequent threats to his mortality. Hoffman's elimination of gesture thus helps Davian become a new kind of fat villain, one whose body suggests a lack of interest in the physical world rather than an excess thereof.

In short, Davian exceeds the stereotype of the appetitive villain by becoming as blank as the MacGuffin he chases, a cipher that reveals what the fat villain really does. Hoffman's refusal to exhibit appetite suggests that the typical fat villain criminalizes desire in order to affirm corporeal representations of virtue. The fat villain's lumbering, unfit body warns the spectator about the dangers of excessive appetite, of desiring goods that one's class or social position forbids. Cast against a physically fit detective—be he an übermensch like Hunt or merely ruggedly masculine like Humphrey Bogart's Philip Marlow—the fat villain demonstrates that desiring beyond the capitalist, patriarchal, heteronormative universe that governs Hollywood detective movies corrupts the body as a symbol for the corrupt soul. Davian's body does not feel this weight, however; indeed, Hoffman and his doubles execute Davian's stunts as though he does not feel any weight or pain. Davian's body refuses to be bound by the laws of physics or the laws of typecasting. Perhaps for this reason, it can never be penetrated or destroyed; when Davian is hit and killed by a bus at the end of the film, his body simply disappears, leaving nothing behind but one empty and untarnished black shoe.

Hoffman thus marks Davian as divorced from the physical world. Not only does he move through space without regard for the physical limits that U.S. film culture assumes his heft should place upon him, but also there is no physical object attached to his desire, at least none that the viewer ever sees or hears defined. The Rabbit's Foot is not simply a MacGuffin, in other words, but instead is an empty signifier that prevents any easy association of fat with appetite. Unlike the secret information of *North by Northwest* (1959) or the $40,000 that sets off *Psycho* (1960), the Rabbit's Foot never appears in *Mission: Impossible III*.[35] Like all MacGuffins, it is merely a plot device that catalyzes the characters into action, but as a code name for all MacGuffins, it suggests the uncanny power of an object (or body part) to produce meaning. When all that is left of Davian at film's end is his left shoe, he comes to (dis)-embody the emptiness of his pursuit. His missing foot (the one that should be in that shoe) conveys not appetite incarnate—as the fat villain's body typically does—but rather the refusal of the body to accept meaning. Like a good MacGuffin, Davian slips from the film when his purpose has been served. He refuses to contribute his body to narrative closure.

Hoffman's physical acting thus upsets the boundaries placed on fat bodies and the desires that they are either allowed or made to exhibit. This in

turn disrupts the order of sexual difference that the cinema relies on. Hoffman's oeuvre shows repeatedly that the male body can be organized around other symbolic structures besides the phallus, a project that includes exposing how the fat male body has been commandeered to service normalizing narratives. Within the symbolic logic of Hollywood, then, Hoffman's body offers a new vision of male embodiment outside compulsory heterosexuality, an alternative use of the flesh we might even consider queer. Kathleen LeBesco has observed that the queer and fat liberation movements share many similar projects, but watching Philip Seymour Hoffman suggests that in some cases fat is queer.[36] Like queer phenomenologist Sara Ahmed, Hoffman opens up new connotations for "orientation," or new ways of seeing the connections between sexual orientation and one's orientation of the physical world.[37] His movements propose a new way of being in one's body, for even within the highly structured heterosexual order of Hollywood cinema, Hoffman helps us envision the body outside normalizing gender strictures. Through the process of making invisibility visible, Hoffman's gestural body forges a new kind of representational politics. Thus, his performances exceed the boundary of positive or negative representations of corpulence and instead indicate that how an actor moves through a role can change what a body represents.

NOTES

1. Judith Butler, *Bodies That Matter: On the Discursive Limits of "Sex"* (New York: Routledge, 1993), 2.

2. Compulsory heterosexuality, elsewhere known as the compulsory sex-gender system or heteronormativity, perpetuates a myth that everyone is born with either a penis or a vagina, that those with penises will act masculine (aggressive, strong, virile, and so forth) and grow up to be men, and that those with vaginas will act feminine (agreeable, passive, sociable, and so on) and become women. There can be no other sexes or any other genders or sex-gender alignments, and masculine men will only desire feminine women, who will reciprocate that desire. According to this order, any homosexual or queer desires must be aberrations, and any rejections or alterations in expected gender identifications must likewise be either failures or perversions. See Adrienne Rich, "Compulsory Heterosexuality and Lesbian Existence," in *Blood, Bread, and Poetry* (New York: Norton, 1994), 28–29.

3. This is not to say that either queerness or fat are disabilities but rather to emphasize that disability studies has done important work on the role of the body in cultural intelligibility, a discursive field that also includes race, gender, and sexuality. For more on disability studies' interventions in queer theory, see Robert McRuer's excellent *Crip Theory: Cultural Signs of Queerness and*

Disability (New York: New York University Press, 2006) and Rosemary Garland Thomson's foundational *Extraordinary Bodies: Figuring Disability in American Literature and Culture* (New York: Columbia University Press, 1992). See also Tobin Siebers, "Disability in Theory: From Social Construction to the New Realism of the Body," in *The Disability Studies Reader*, 2nd ed., edited by Lennard Davis, 173–84 (New York: Routledge, 1992), and Sumi Colligan, "Why the Intersexed Shouldn't Be Fixed: Insights from Queer Theory and Disability Studies," in *Gendering Disability*, edited by B. Smith and B. Hutchinson, 45–60 (New Brunswick, NJ: Rutgers University Press, 2004).

4. Butler, *Bodies That Matter*, xi–xii.

5. *Twister* arguably provided Hoffman with his first supporting—as opposed to bit—part. During the years in question (1996–2006), he also portrayed Allen the prank caller in *Happiness* (1998), Rusty the drag queen in *Flawless* (1999), Phil the asexual nurse in *Magnolia* (1999), Jacob the potential pedophile in *25th Hour* (2002), and Dan the gambling addict in *Owning Mahoney* (2003). Hoffman's recent roles continue to include queer characters—such as Father Flynn in *Doubt* (2008)—but his performances are not, to my mind, as physically queer as his earlier work.

6. See Charlotte Cooper, *Fat and Proud: The Politics of Size* (London: Women's Press, 1998), or Marilyn Wann, *Fat! So? Because You Don't Have to Apologize for Your Size* (Berkeley, CA: Ten Speed, 1999). See also Kathleen Rowe, *The Unruly Woman: Gender and the Genres of Laughter* (Austin: University of Texas Press, 1995), and two essays in *Bodies Out of Bounds: Fatness and Transgression*, edited by by Jana Evans Braziel and Kathleen LeBesco (Berkeley: University of California Press, 2001): Le'a Kent, "Fighting Abjection: Representing Fat Women" 130–50, and Angela Stukator, "'It's Not Over until the Fat Lady Sings': Comedy, the Carnivalesque, and Body Politics," 197–213.

7. Sander L. Gilman, *Fat Boys: A Slim Book* (Lincoln: University of Nebraska Press, 2004), x; Jerry Mosher, "Setting Free the Bears: Reconfiguring Fat Men on Television," in *Bodies Out of Bounds*, 166–93, 171.

8. Andrew Klevan, *Film Performance: From Achievement to Appreciation* (London: Wallflower, 2005), 78.

9. Seth Perlow, "Moving Meaning: Notes for a General Theory of Gesture," unpublished manuscript, 21; Eve Kosofsky Sedgwick and Michael Moon, "Divinity: A Dossier, a Performance Piece, a Little-Understood Emotion," in *Tendencies*, edited by Eve Kosofsky Sedgwick (Durham, NC: Duke University Press, 1994), 230.

10. Perlow, "Moving Meaning," 22.

11. Gilman, *Fat Boys*, 37.

12. Philip Seymour Hoffman, interview, *Inside the Actor's Studio*, hosted by James Lipton, Bravo television show, August 28, 2001.

13. Gilman, *Fat Boys*, x.

14. Parveen Adams, *The Emptiness of the Image* (New York: Routledge, 1996), 91.

15. Gilman, *Fat Boys*, 63, 155.

16. See these exempla in action in *The Forgotten Films of Roscoe "Fatty" Arbuckle* (2005), *A Funny Thing Happened on the Way to the Forum* (1966), *Animal House* (1978), *Agatha Christie's Poirot* (2005), *The Maltese Falcon* (1941), and *Planes, Trains, and Automobiles* (1987). This is by no means a thorough list of fat stereotypes or actors typecast by their weight and is meant only to indicate the prevalence of the problem.

17. Mosher, "Setting Free the Bears," 167.

18. Ibid., 171.

19. Sedgwick and Moon, "Divinity," 220.

20. The camera returns to Scotty after Eddie's departure, which allows the spectator to see how the animation rushes out of Scotty's face and body after Eddie leaves. In fact, Hoffman freezes, and his subsequent two seconds of stillness emphasize the importance of gesture for his communication of Scotty's desire.

21. Don Kulick, "Porn," in *Fat: The Anthropology of an Obsession*, edited by Don Kulick and Ann Meneley (New York: Penguin, 2005), 91. For examples of fat fetish or chubby-chaser pornography, see www.chublinks.com and www.fatgay.com.

22. Paul Thomas Anderson, *Boogie Nights* (New York: Faber and Faber, 1998), scene 93.

23. Steven Shaviro, *The Cinematic Body* (Minneapolis: University of Minnesota Press, 1993), 29.

24. To merely communicate Scotty's self-disgust, Anderson could have limited the shot to only one "fucking idiot," as his distributor requested, but such concision would have furthered only the plot and not Hoffman's character development (Director's DVD Commentary).

25. Mark Graham, "Chaos," in *Fat*, edited by Kulick and Meneley, 178.

26. Kaja Silverman, *Male Subjectivity at the Margins* (New York: Routledge, 1992), 1.

27. Ibid., 43.

28. Ibid.

29. Ibid., 47.

30. Julia Kristeva, *Powers of Horror* (New York: Columbia University Press, 1982), 26.

31. Gilman, *Fat Boys*, 56.

32. Elizabeth Grosz, *Volatile Bodies: Towards a Corporeal Feminism* (Bloomington: Indiana University Press, 1994), 35.

33. "MacGuffin" is Alfred Hitchcock's term for an object or plot device that advances a story's narrative but does not have any significance beyond its function.

34. For examples of stereotypical fat villains, see *The Maltese Falcon* (1941), *I Wake Up Screaming* (1941), *The Lodger* (1944), *The Woman in White* (1948), *Goldfinger* (1964), *Return of the Jedi* (1983), *Batman Returns* (1992), and *Austin Powers: The Spy Who Shagged Me* (1999).

Caetlin Benson-Allott

35. The spectator does catch a quick glimpse of some weapon after Ethan Hunt obtains the Rabbit's Foot from another arms dealer, but this brief appearance reveals neither the nature of the Rabbit's Foot nor its destructive potential, for in fact the spectator only sees the packaging, never the Rabbit's Foot itself.

36. Kathleen LeBesco, *Revolting Bodies? The Struggle to Redefine Fat Identity* (Amherst: University of Massachusetts Press, 2004).

37. Sara Ahmed, "Orientations: Toward a Queer Phenomenology." *GLQ: A Journal of Lesbian and Gay Studies* 12, no. 4 (2006): 543–74.

IV

FACING RACE

Melvin Donalson

Inside Men

Black Masculinity in the Films of Spike Lee and John Singleton

The debates about the images of black men in American cinema have a lengthy and controversial history, as issues of race and class complicate the already problematic concept of masculinity. The contradictory bind often associated with black men in America connects historical, economic, political, and psychological dynamics that have imposed themselves from the seventeenth century to the present. Social scientists Richard Majors and Janet Mancini Billson capsulize that dilemma as black men having been

> rendered impotent in the economic, political, and social arenas that whites have historically dominated. Black men learned long ago that the classic American virtues of thrift, perseverance, and hard work did not give the same tangible rewards that accrued to whites. Yet African-American men have defined manhood in terms familiar to white men. . . . Unlike white men, however, black have not had consistent access to the same means to fulfill their dreams of masculinity and success.[1]

The ability to negotiate the American capitalistic patriarchy is indeed challenging for many men across racial lines, but Majors and Billson underscore formidable barriers that exist for African American males. Some black males indeed slip the shackles of this stratification, assuming individual success in spite of the obstacles. However, the truth is that the majority of African American males are bombarded and wounded by daily assaults that result in a noticeably uneven rate of individual and collective success.

American cinema has played an ongoing role in distorting and oversim-
plifying the experiences and participation of African American men within
American society. As film scholar Ed Guerrero observes, "Missing from
Hollywood's flat, binary view of Black manhood is the cultural, political, in-
tellectual complexity and humanity of Black men. . . . Consequently there's
much work to be done on an expanded, heterogeneous range of complex
portrayals of Black males that transcends the misshapen characters caught
within Hollywood's formulaic narratives and habitual strategies for repre-
senting Blackness."[2] Over the decades, African American male directors
have responded to those "formulaic narratives," utilizing their films to com-
ment upon and explore extensively numerous threatening issues and hur-
dles faced by African American men. With a number of black independent
filmmakers between 1918 and the late 1940s and with the breakthrough
Hollywood appearance of black male directors in the late 1960s to early
1970s, black masculinity and black manhood have been recurring themes
and plot points in numerous films. The early efforts of Gordon Parks (*The
Learning Tree* [1969], *Shaft* [1971]), Melvin Van Peebles (*Watermelon Man*
[1970], *Sweet Sweetback's Baadasssss Song* [1971]), Ossie Davis (*Cotton
Comes to Harlem* [1970], *Gordon's War* [1973]), and Sidney Poitier (*Buck
and the Preacher* [1969], *A Warm December* [1973]) resonate the impor-
tance of screen representations of black men as they respond to the po-
litical, economic, and social dynamics of the post–civil rights era. As the
blaxploitation era of *Superfly* (1972), *Trouble Man* (1972), *Willie Dynamite*
(1973), and *Three the Hard Way* (1974) came to an end, leaving a legacy
of black male characters presented as supercool, supersexual, and super-
black, by the mid-1970s Michael Schultz began his noteworthy career with
a sensitive, realistic examination of young black males in the urban drama,
Cooley High (1975).

However, with the emergence of Spike Lee in the 1980s and the mete-
oric rise of John Singleton in the 1990s, the exploration and construction
of black male images earmark the works of these two directors. Individu-
ally, the directors display their own visual expressions: Lee an independent,
quirky, and elliptical style and Singleton, a mainstream, slick, and linear
narrative style. Collectively, Lee and Singleton create a cinema of black
masculinity that disturbs, transforms, and occasionally sustains conven-
tional black male images. The limitations of space in this essay preempts an
exhaustive analysis of both filmmakers, but a sampling of four films across
the decades by each director reveals the range and nature of their depic-
tions of black masculinity.

Coming out of the New York University film school, Spike Lee completed
seventeen films between 1986 and 2011. In a visual signature identified by

idiosyncratic camera techniques as well as story lines exposing the many levels of racism in the United States, Lee focused on the black male's political challenges, economic obstacles, and sexuality. These screen delineations of black men of various ages are as groundbreaking as they were controversial. For a number of critics, Lee often pursued the elevation of black male characters at the expense of narrow depictions of black women characters. Despite the emphasis on female protagonists Nola Darling in *She's Gotta Have It* (1986), Girl 6 in *Girl 6* (1996), and Troy in *Crooklyn* (1994), black male characters dominate Lee's cinematic landscape with more complexity and self-actualization. With the films *Do the Right Thing* (1989), *Jungle Fever* (1991), *Malcolm X* (1992), *Clockers* (1995), *He Got Game* (1998), and *Bamboozled* (2000), the director delivered black male protagonists whose circumstances, professions, and relationships bring them into a reflection upon their personal perspectives on manhood. As critics Kirkham and Thumin suggest in their assessment, "Being a man implies acceding to (symbolic) patriarchal power but, precisely because this is a symbolic structure, it cannot take account of the contingencies of actual experience which may appear to deny this possibility."[3] The actual experiences for black men, Lee contends in his films, result from the intersection of race and economics, usurping black men's access into the power structure. Cognizant of the historical cinematic images of black masculinity that consistently assert what critic Charlene Regester calls "despicable portrayals" of "drawling speech, slow and lazy movements as well as scatter-brained and shiftless demeanour," Lee commits to rendering a complexity absent from earlier Hollywood depictions.[4] In addition to those films mentioned above, four specific films—*Mo' Better Blues* (1990), *Get on the Bus* (1996), *She Hate Me* (2004), and *Inside Man* (2006)—place the crisis of masculinity at the forefront of the films' story lines, forcing viewers to encounter the collision of gender notions and race relations.

The director's fourth feature, *Mo' Better Blues,* contains gender contours that were perhaps lost on the popular audience at the time of its release. With a protagonist named Bleek and a title referencing the black cultural musical form of the blues, the tone of the film is established within the opening sequence: a busy Brooklyn street and the young black protagonist forced to practice his trumpet rather than cavorting outside with the neighborhood kids. As the film jumps forward to the adult Bleek (Denzel Washington), he still lives for his music, now both his purpose and survival tool. For Bleek, manhood is inextricably linked to his identity as a jazz musician. In that identity he possesses control and creativity. In his solipsistic existence, Bleek refuses to surrender his manhood—that is, his music—to any relationship that threatens that music. With his manager-friend, Giant

In *Mo' Better Blues*, Denzel Washington plays a jazz musician named Bleek, whose very name portends the torments that surround him in his quests for success, respect, and love.

(Spike Lee), and his with fellow band members, their relationships as heterosexual men are all connected to the world of Bleek's music, and even when arguing, the world of men edifies his music and creativity. Conversely, the intimate relationships with two women—Indigo (Joie Lee) and Clarke (Cynda Williams)—seek to destroy the sanctity of Bleek's music and his manhood. By vying to be the primary love in Bleek's life, each woman wants him to deny his commitment to his music. When Clarke criticizes Bleek for refusing to choose between the two women, she urges him to "Make up your mind. Be a *man.* Don't be wishy-washy on me." Bleek assures her that "I know what I want. My music! Everything else is secondary."

Limiting his connection to both women as just a physical escape, Bleek excludes emotions, relying on the popular male-player attitude to frame his interaction with the women. His assumed indifference to either his or their emotional needs allows him to step outside of expectations of a romantic alliance, keeping his fidelity to his music. In the latter section of the film, Bleek maintains the relationship borders when he has a man-to-man chat with Shadow (Wesley Snipes), a fellow band member who strategizes his way into Clarke's affections. Establishing clarity regarding territorial rights to Clarke, Bleek tells Shadow, "Y'know, the last time I looked on Clarke's

Melvin Donalson

naked body, I didn't see my name, Bleek, on her. Not on her butt, her legs, her breast, nowhere. Nobody owns nobody." By acknowledging, or conceding, his rights to Clarke's body, Bleek dismisses the male privilege inherent in intimate relationships within the heterosexual patriarchal system: ownership of the woman's body. However, this concession is more for display, as later after hearing of the sexual liaison between Clarke and Shadow, Bleek initiates a physical fight with Shadow. The polysemic battle underscores Bleek's inner conflict regarding his music and his women. He openly displays his passion for his music but assumes a cold indifference toward the women, a position ultimately revealed as more fragile than he previously admits.

Another aspect to Bleek's manhood—the loyalty to his close male friend, Giant—sinks the musician into the nadir of his life. Defending Giant in an alley brawl, Bleek suffers a beating himself: his lips, gums, and teeth are damaged beyond repair. Unable to play and perform at his previous level, Bleek runs to Indigo for salvation and purpose. He steps into the conforming mode of manhood, becoming a husband and then a father in succeeding sequences. The very life and relationship that Bleek avoided because it threatened his version of masculinity as linked to his music now functions as the only way to save him as a man. With this ending, the director promotes the dimensions and expectations of the middle-class life as the proper role for black men.

Whether intentional or not, *Mo' Better Blues* plays as a celebration of the customary relationships between men and women, and with the ethnic accent, the message for black men appears emphatic. In order to be fulfilled, black men should pursue and sustain the conventional paradigm of the heterosexual male-female relationship, with marriage and fatherhood as the crowning results. However, in a notable contrast, *Get on the Bus* finds the director considering a variety of concerns regarding black masculine expressions. Using the factual 1995 Million Man March in Washington, D.C., as the framing device for the story, the film follows twenty fictional black male characters who take a chartered bus from Los Angeles across the country to the Capitol.

The opening film credits roll over the image of a black man in chains, evoking the weight of slavery upon the development of black masculinity in an exploitative system. This image becomes juxtaposed with the opening segment as a black father, Evan Thomas (Thomas Jefferson Byrd), is literally chained to his adolescent son, Junior (De'Aundre Bonds), due to a court order. Forcing his reluctant son to make the journey to Washington, this pair operates as a crucial symbol of generational clashing and father-son dynamics. However, other characters in this ensemble piece contribute

to the heated discourse about the variety of shapes of contemporary black manhood, among them Jeremiah (Ossie Davis), the elder with wisdom and compassion; George (Charles S. Dutton), the conscientious bus driver; Flip (Andre Braugher), the arrogant, homophobic actor; Kyle (Isaiah Washington), the gay Republican; Randall (Harry Lennix), the educated former lover to Kyle; Gary (Roger Guenveur Smith), the biracial Los Angeles police officer; Jamal (Gabriel Casseus), a former gang member turned Muslim; Jay (Bernie Mac), a small business man; and Xavier (Hill Harper), a university film student. These characters, across class and political lines, underscore the varied perspectives, lifestyles, and desires among black men. In an interview the director emphasized this objective: "The drama would come from what happens to this unique mix of individuals, this diversity of men who . . . represent African-Americans at this time. . . . [A] lot of people think we're this monolithic group, but we chose to show this isn't the case."[5]

Of the many significant issues raised within the film, the topic of homophobia receives an extended treatment by the director. Flip, a self-proclaimed ladies' man, delivers his incessant antigay statements, and at first the men collectively share a detachment from the openly gay Randall and Kyle. Kyle's patience expires as he physically confronts Flip, beating the tough-talking heterosexual. The beating demonstrates that some gay men are indeed men by the time-honored standard of physical prowess and, at the same time, implies the inevitable destruction of intolerance and bigotry. The fight also underscores the "double bind" for Randall and Kyle, who as black men are "discriminated against due to their race and their sexual orientation."[6]

Another salient message delivered in the film occurs when the bus finally reaches Washington, D.C., and senior citizen Jeremiah dies of a heart attack. Jeremiah's death and his handwritten prayer that George later reads aloud crystallize the importance of the gathering of one million black men. Walking the aisle of the bus, George, prior to finding Jeremiah's prayer, states to everyone: "The real million man march won't start 'til we black men take charge of our own lives and start dealing with crime, drugs, guns, and gangs. And children having children, and children killing children all across this country. So if . . . y'all are ready to quit your apathetic and unsympathetic ways as I am . . . if you're ready to stop being the boys that started to Washington on this bus and be the men that our wives and our mothers and our children are waiting for back home and . . . stand up against all the evils lined up against the black man back home. . . . If you're ready to do that . . . , then we got work to do. We got a lot of work to do!" In George's emotional plea for committed activism, the attitude of self-determination

reflects upon the men's faces. Then in the final scene as the men gather at the Lincoln Memorial, they deliver Jeremiah's prayer, leaving behind at the site the chains that shackled Evan and Junior, father and son, there at the feet of Lincoln.

Get on the Bus displays Lee's most penetrating exploration of black manhood, connecting the issues of male responsibility, leadership, and sexual orientation to the larger event of the Million Man March. Balancing its romantic perspectives about Africa with the characters' personal stories about urban violence, economic struggles, ambitions and disappointments, and parenting and fatherhood, the film reflects a serious and skilled handling of dramatic materials. Following that accomplished representation, eight years later Lee helms a regressive presentation of black masculinity in the convoluted film *She Hate Me*.

She Hate Me juggles numerous topics but fails to merge those areas into a unified film. Ambitious to a fault, the "movie covers sexual politics, whistle-blowers, corporate corruption, race, the scourge of AIDS and its accompanying politics, family responsibilities, *The Godfather* and Watergate."[7] As with *Mo' Better Blues*, the protagonist bears a symbolic name, John "Jack" Armstrong, that links him to black culture and notions of masculinity. "John" stirs up both the mythical John Henry, a strong black laborer who competes with the machinery of the system and the African American folktale hero John, who, like Brer Rabbit, manages to survive and triumph over insurmountable challenges.

The film's protagonist, at age thirty-one, is a vice president of a pharmaceutical company that has been developing a drug to cure AIDS. Smart, sexy, single, and affluent, John (Anthony Mackie) is also a black man with ethics; consequently, he phones the Securities and Exchange Commission (SEC) following the suicide of the company's leading scientist, who leaves a video journal detailing corruption and illegal practices by corporation executive Leland Powell (Woody Harrelson). Losing his job, John becomes blacklisted at other companies and endures the lock on his assets and bank accounts by the SEC. With John facing the inversion of his career and life, his situation is likened to whistle-blower Frank Wills, who exposed the Watergate break-in.

Unfortunately, after constructing such a noble protagonist, the director introduces a subplot involving John's ex-fiancée, Fatima (Kerry Washington), who is a lesbian or perhaps bisexual. Hearing of John's financial woes, Fatima and her partner, Alex (Dania Ramirez), propose a deal: to have John impregnate the two of them for $5,000 each with no legal responsibilities to their children. John, needing the money, consents, which sparks Fatima's entrepreneurial spirit to arrange contractual couplings between John and

her other lesbian friends wanting children, paying $10,000 per woman, with Fatima taking a 10 percent finder's fee.

With the insertion of this story line, Lee moves John from a heroic black male figure to a contemporary version of an old black male stereotype. Similar to the objectionable practices that John disdains in corporate America, he displays his own disreputable behavior to gain quick profit for sexual accommodations. Lee's political and moral messages evaporate against the simmering sexual and gender stereotypes precluding the character development in the film's opening act. Similar to the problematic message that Melvin Van Peebles extolled in *Sweet Sweetback's Baadasssss Song,* Lee amplifies the myth of the sexually proficient and phallically gifted black male who satisfies all women, including lesbians in this film.

During John's meeting with the first five women, Lee presents a scene with contradictory messages. Before giving their money, the women request that John stand nude and display his body to them. Here, the traditional cinematic male gaze at the female body is supplanted by the female gaze at the male body, as John is required to complete a 360-degree spin for their pleasure. As John turns, the shadowed interior prevents a view of his penis, but the power of the scene disturbs the standard ogling of the nude woman. However, the potency of that very scene crumbles under the weight of black sexual stereotypes. As John moves, the reluctant white woman in the group views his groin area and shouts "Sold!" as she quickly writes a check. This line and action from the white lesbian confirms John's large penis, which promises his superior sexual skills. As John completes his turn, the low-angle camera peers through his opened legs as the lines of his inner limbs frame a black lesbian with blond hair. From that angle, the black woman's head appears locked within his groin, suggesting that she is the most sexualized of all the women there. In this one scene, Lee deconstructs the legitimacy of male voyeurism but at the same time preserves the sexual myths about the black man and the black woman.

Augmenting John's hypersexuality and the blurring of lesbian sexuality, a lengthy sequence shows John's intimacy with the women. With the first five women, who are so-called lipstick lesbians in their mainstream feminine features, makeup, hairstyles, and body types, John demonstrates his ability to have intercourse with five women in one night. Despite their lesbian orientation, the women all appear to experience a rapturous coupling with John, as the director edits their orgasmic cries in a montage of sexual satisfaction. Showing John coupling with black, biracial, Asian, and white women in a sequence of successive shots returns to an imposed male gaze as the black male stud gives extreme pleasure to all the women.

Fortunately, two years later with *Inside Man,* Lee regained his bearings, presenting a more defined black male protagonist in the director's most commercial film in regard to the visual style, genre elements, and story line. The protagonist, Detective Keith Frazier (Denzel Washington), is a hostage negotiator with the New York City Police Department, and in that position and in the glimpses of his personal life, Frazier emerges as a black man of authority, confidence, vulnerability, and sensuality. Teamed with his black partner Detective Bill Mitchell (Chiwitel Ejiofor), the partnership becomes noteworthy, considering that two black male characters rarely share the lead except in an all-black cast film marketed as a comedy. However, in this production that includes characters representing an array of racial and ethnic groups, the targeted mainstream audience observes black male characters operating in a professional and supportive manner in the story beyond the limited roles of comic relief, sidekick, buddy to the white star, homicidal killer, or drug dealer.

Responding to a foiled bank robbery by several masked robbers, who are led by the icy Dalton Russell (Clive Owen), and facing the threat to kill fifty hostages, Frazier falls into the expected call-and-response between perpetrator and negotiator. Eventually Frazier, perceptive and cunning, realizes that the situation, with the unrealistic demands by Russell and his group, strikes an inauthentic note. Frazier's suspicions increase when a mysterious businesswoman, Madeleine White (Jodie Foster), uses her powerful connections with political leaders to gain access into the bank for a private conversation with Russell. Frazier and the audience eventually discover the link between Russell, the bank's philanthropic owner Arthur Case (Christopher Plummer), the Jewish Holocaust, and the Nazi looting of Jewish victims.

Frazier, however, deduces his evidence without being a larger-than-life character. As one critic remarks, "Frazier . . . is not the superstar cop you might be expecting. He is a veteran detective second grade with the slightest hint of a paunch who got the assignment only because the department's top guy was on vacation."[8] In addition, Frazier's professional reputation faces censure because suspicion of stolen money is an active case looming over him. Compounding the work pressures, he struggles with proposing to his live-in lover, Sylvia (Cassandra Freeman) while tolerating her brother sharing their apartment. Frazier manages the stress both on and off the job, but his commitment to being the best detective possible motivates his actions. He resonates as a man of virtue and compassion without being infallible. He shows street smarts, but he is not from the hood. He displays confidence with white supervisors and elite business types, but he refuses to genuflect to power. In one sequence, Frazier rejects backing down to

prominent white power brokers, including the city mayor, despite a promotion and job security given to him. Frazier knows how to navigate the system but not at the cost of his moral perspectives and professional duties.

Just as important, Frazier embraces his ethnicity as illustrated through his shifting language with other black characters, but he doesn't wear his race as a weapon of intimidation or an emblem of entitlement. In many ways, Frazier slips out of the expected protagonist for such an action-suspense genre piece, showing dimensions that suggest a fuller characterization than traditionally fills such films and modeling a black masculinity that transforms previous cinematic stereotypes.

When juxtaposed with Bleek Gilliam (*Mo' Better Blues*) and John Armstrong (*She Hate Me*), Keith Frazier emanates as a balanced character displaying attributes usually scarce in black male images. Frazier appears to be the kind of man who would have traveled to Washington, D.C., for the Million Man March and carried home the convictions that George urged near the end of *Get on the Bus*. With *Inside Man*, director Spike Lee plays off of several meanings in the title to render a black male protagonist who possesses an interior self-esteem, ambition, and mental toughness that allows him to mediate the exterior challenges in his professional life.

Following the success of *Inside Man*, Lee journeyed into black masculinity in a wartime setting with the World War II drama *Miracle at St. Anna* (2008). The feature excels in its battle scenes, but with a supernatural element imposed, the uneven film reduces the courageous exploits of the black soldiers to a fuzzy and elusive message. After that film, Lee most recently returned to producing and directing various television projects, with critical attention given to his documentaries, including *When the Levees Broke: A Requiem in Four Acts* (2006) and *If God Is Willing and da Creek Don't Rise* (2010).

With a comparable cinematic passion to Spike Lee, John Singleton has been productive as a filmmaker, directing nine feature films for the big screen between 1991 and 2011. Unlike Lee, Singleton grew up on the West Coast, raised in Los Angeles where he studied filmmaking at the University of Southern California. He won internships while still in school and eventually landed a position at Columbia Pictures, where he was able to get his screenplay for *Boyz N the Hood* (1991) to studio executive Frank Price.[9] In juxtaposing Lee and Singleton, who completed their first films only five years apart, rushing to generalizations and psychoanalyzing their backgrounds would be problematic at best. However, Lee, born in 1957 during the civil rights era, delivered his first feature when he was twenty-nine years old, and Singleton, born in 1968 and having grown up during the hip-hop era beginning in the late 1970s, completed his first feature at

twenty-three years of age. Lee's New York University environment fostered a more independent cinematic style, while Singleton's University of Southern California environment allowed him to enter more mainstream sensibilities through his network television and Hollywood studio internships. The cultivation of their stylistic tastes and the targeting of their respective audiences informed the manner in which each director explored black masculinity.

Intent upon showing a younger generation of male characters, Singleton often frames his stories in genres that accentuate the urban landscape as the hostile territory where black males, in particular, negotiate personal growth. His films provide perspectives on the attitudes of an early hip-hop generation, those young people who, according to cultural critic Bakari Kitwana, were born between 1965 and 1984. For Kitwana, black males of that generation have developed, due to numerous socializing factors, some general attitudes that shape their definitions of manhood: "black male group loyalty" and bonding, a "lack of interest in or understanding of feminism," "the objectification of women," an "intense focus on materialism," sustaining sexist attitudes, and a "disregard" for "the dark side of their heroes."[10] These attributes prompt a particular ethos that results in a hypermasculinity (often read as violence), sexism (often leaning toward misogyny), and a fixation on present creature pleasures at the expense of future goals (often read as living for the moment). Of his films rendered in the contemporary setting, Singleton configures young black manhood around this ethos while highlighting the environmental influences shaping that worldview.

With a collection of films that have been mainstream hits and disappointments, Singleton has consistently scrutinized male behavior in films such as *Poetic Justice* (1993), *Higher Learning* (1999), *Shaft* (2000), and *2 Fast 2 Furious* (2003). In those films, Singleton showed the formidable pressures that confront men and the ways, both successfully and unsuccessfully, that these men rally to deal with those forces. Despite the racial identity of his characters, Singleton's movie masculinity conforms a "toughness" that author James L. Neibaur describes distinctly: "Tough guys are men who don't back down, no matter how intimidating the circumstances may be. They are omnipotent, all-powerful. They are winners in a world of losers."[11] To varying degrees of effectiveness, the director incorporates that mainstream movie masculinity in rendering an intriguing set of black male characters in four films: *Boyz N the Hood* (1991), *Rosewood* (1997), *Baby Boy* (2001), and *Four Brothers* (2005).

With the much-celebrated *Boyz N the Hood*, Singleton earned critical praise, box office success, and the inevitable comparisons to Spike Lee. For example, critic Janet Maslin wraps her comparison within an assessment

of the film: "*Boyz 'n the Hood*, John Singleton's terrifically confident first feature, places Mr. Singleton on a footing with Spike Lee as a chronicler of the frustrations faced by young black men growing up in urban settings. . . . Unlike Mr. Lee's New York stories, which give their neighborhoods the finiteness and theatricality of stage sets, Mr. Singleton examines a more sprawling form of claustrophobia and a more adolescent angst."[12]

Singleton admits that the father figure of Furious Styles (Laurence Fishburne) replicated his own father. This important element of fatherhood functions as the key message in the film, the factor that determines the divergent pathways taken by three childhood friends: Tre (Cuba Gooding Jr.), Ricky (Morris Chesnut), and Doughboy (Ice Cube). Within inner-city Los Angeles, where dead bodies, police sirens, police helicopters, dilapidated buildings, and gang conflict serve as the daily ingredients to their lives, young black men survive successfully through the visibility and presence of a father, the tough man needed to respond to the challenges of the hood and to enforce the codes of conduct for growing boys. Without question, "the film . . . insists on the necessity of a male authority, a father figure, to teach and reinforce responsible behavior in young men."[13] Tre, though closely tied to his homeboys, retains a particular discipline and ambition that result from his sustained relationship with his father, Furious. In their clashes and their playful moments, the bond between Tre and Furious not only creates a nurturing home but also instills within the son the worthiness, drive, and pride necessary to navigate the urban streets. Furious cautions about personal behavior and decision making as he steers Tre through the pitfalls of adolescence. Never an easy day in the hood, "Tre's life is a balancing act of adhering to his father's teachings, hanging out with his friends, and attempting to be intimate with his girlfriend, Brandi (Nia Long)."[14]

Through his diligent nurturing of Tre, Furious models the statement that he shares with the younger Tre: "any fool . . . can make a baby, but only a real man can raise children." The director highlights the uniqueness of Furious and Tre's relationship in the hood while underscoring its positive results. The elevation of the father-son union receives further emphasis in the film as the women, as single parents, lack the skills to disseminate the elusive but recognizable qualities of manhood. Tre's mother, Reva (Angela Bassett), recognizes this deficiency, and even though she is a professional woman and is divorced from Furious, she entreats Furious to take the young Tre under his roof and tutelage. This paradigm of in-home father equals male success adheres to the masculinity mantra often recited by hip-hop performers, including Tupac Shakur, Eminem, Game, and Lil Wayne. These rappers and others through lyrics and interviews proclaim the destructive results of dysfunctional and remote relationships with their fathers.

Melvin Donalson

However, Singleton's emphasis on the father figure governing male wholeness oversimplifies the complexities of manhood and minimizes the forces of the economic and political factor. After all, Ricky's death to gang violence might have happened even if he had a father in the home. The feminist argument could certainly be made that strength, resilience, and motivation that mothers empower to their sons have been just as valuable and essential for maturity and success. To assume that women are incapable of parenting their sons erases the historical evidence to the contrary.

Yet despite the story's endorsement of patriarchy, the film must be credited for indicting American society for ignoring the circumstances that contribute to young black male nihilism but then blaming those same black males for behavior assumed to be inherent to them. Six years after *Boyz N the Hood,* Singleton abandoned the contemporary urban milieu and examined the historical factors that challenged black masculinity. Through the period piece *Rosewood,* the director focuses on older black male protagonists as he returns to the tragic events involving the Florida community of Rosewood and the nearby town of Sumner that took place in 1923.

Into the prospering rural community of Rosewood, a black World War I veteran named Mann (Ving Rhames) appears and decides to buy land and settle in the close-knit black community that extends its hospitality. In particular, Sylvester Carrier (Don Cheadle) welcomes the stranger, as does the young, attractive Scrappie (Elise Neal), who catches Mann's romantic eye. At the same time, in the white township of Sumner a young married white woman attempts to hide an affair with a white lover by claiming that she was beaten and raped by a black man. Mob violence erupts as groups of whites maraud the black community, burning property and lynching blacks.

With the character of Mann, the director inserts the Western-genre model of the lone, quiet stranger who rides a horse into town, bringing his physical skills, courage, and deadliness. Adhering to that concept of movie toughness, Mann—whose allegorical name carries political and cultural importance—serves as the merging of the Western genre type with the so-called New Negro of the early 20th century. With the legacy of slavery, economic hardships, and lynching weighing upon the segregated South, Mann's presence—both physically and spiritually—represents that determined attitude celebrated in artistic expressions of the Harlem Renaissance of the 1920s. Mann's participation in the war denotes his belief in the American system and his willingness to sacrifice his life, and his decision to use his military experience and his leadership skills to help black residents to survive mob violence underscore his commitment to the black community.

Mann takes on a compelling array of crises in *Rosewood*.

Mann embodies the valorous black *man*—as opposed to the racist term "boy"—whose strength, insight, and aggression emerge as ideal masculine traits. Equipped with money, guns, and a self-assurance, Mann battles his white enemies and champions the black community's right to exist. In one sequence as he is being chased by the white mob through the woods on horseback, Mann stops, turns, and single-handedly makes a defiant stand, drawing and firing his two guns and scaring away numerous white men

Melvin Donalson

who cower at his courage. In another scene when Mann is caught, hanged, and left for dead, his physical strength and mastery of his horse allow him to escape death. In a final action sequence of a rushing train, Mann protects the black women and children in his charge, fighting and shooting the white mob attempting to stop the train.

In addition to Mann, the director presents an additional formidable black male figure in Sylvester Carrier, who functions as the intellectual counterpart to Mann's brawn. In short, Sylvester functions as the carrier of black culture in his capacity as a teacher and musician as well as in his relationship to his wife, children, and extended family. Sylvester—also a man, not a "boy"—directly confronts those whites who cross his path, steadily pronouncing his intent to protect his property and family. He is an Afrocentric capitalist who embraces and defends the same aspects of the system as whites do. After the murder of his mother, Sylvester orders his wife and the children into the refuge of the swamps as he and his male cousin defend Sylvester's home and possessions, even though they are outnumbered by a large mob led by the Sheriff. Using a clever plan to escape the mob, Sylvester later joins Mann to formulate a strategy to protect the women and children and to mount a resistance against the mob.

Together Mann and Sylvester represent a black brotherhood that connects on a level of pride and community consciousness. These are black men of the new century who, when faced with the old aspects of oppression, respond individually and in partnership to defy racism in its myriad forms. These are inside men, possessing interior, resilient qualities rooted in their core strength while living by codes of manhood that require a sustained integrity and stern resolve. *Rosewood* serves as Singleton's most accomplished cinematic achievement in regard to his depiction of black masculinity and his effective writing and directing. In a striking contrast, on an opposite end of the manhood spectrum, Jody, the protagonist of *Baby Boy,* is a twenty-year-old "boy," a work in progress who agonizes to find his sense of wholeness.

Traveling back to the hood of Los Angeles in *Baby Boy,* Singleton exposes the deficient personality that results from growing up as a black male in an environment of emotional, intellectual, and economic drought. Jody (Tyrese Gibson) "is at the crossroads in his life, haunted by nightmares of his own demise and unable to take the next step into adulthood."[15] Similar to characters in *Boyz N the Hood,* Jody grows up without a father in the home and has "fathered two children by two different women"; unmotivated, he "spends a lot of time hanging out with his best friend Sweetpea (Omar Gooding), a similarly situated man who is unemployed and spends his idle moments playing video games or cruising the streets."[16]

In the opening sequence the director shows Jody as an embryo within the womb, beneath the sounds of a heartbeat and bubbling amniotic fluids. Jody's voice-over states that a psychiatrist theorized that "because of the system of racism, the black man in this country has been made to think of himself as a baby, a not yet fully formed being who has not realized his full potential." Jody personifies that theoretical premise. Enduring premonitions of his own death, engaging in various sexual trysts, straddling the needs of two children, and dealing with the demands by the women in his life to "be a man," he locks himself within his selfishness, insecurities, and fears. With his only self-proclaimed talent being able to "make beautiful babies," Jody sinks into a routine of juvenile behavior and restless moments. Vacillating between his spoiled treatment when at home with his mother, Juanita (A. J. Johnson), and his romantic treatment when lounging at the home of his "baby mama," Yvette (Taraji P. Henson), Jody avoids decisive actions and responsibilities in his life. When he finally chooses to be an entrepreneur and to sell women's clothing, he hustles merchandise stolen from delivery trucks in the garment district.

Increasing the film's tension, the character Melvin (Ving Rhames) becomes romantically involved with Jody's mother. Melvin, a former gangsta and abuser, acknowledges his previous life and asserts his intentions to establish a positive relationship with Juanita as he maintains a self-owned landscaping business. In one scene as Melvin extends himself to Jody, the former confesses: "I was like you, Jody. Young, dumb, and out of control. I did a dime, man. Ten years straight in San Quentin and Folsom. All over some dumb shit. But you . . . you smarter than I was when I was your age. . . . You ain't no killer like me, and that's good. I was bad. . . . I seen it all, and I've done it all." Melvin, having transcended his gangsta past, reinvents himself and, seeing himself in Jody, attempts in his own manner to encourage Jody. However, Melvin's physical presence and his winning of Juanita's affections only anger Jody, leading to a physical confrontation between the two males.

Echoing the messages from *Boyz N the Hood,* Jody's dilemma results from growing up without a nurturing male presence and being surrounded by a deathly environment that smothers hope. Jody's salvation comes not from religion, education, or a profession but instead from the intervention of an adult black male who, though flawed, shows his concern and attention for Jody's life. With that intercession, in the final sequence under the closing credits, a montage presents Jody, his son, and a pregnant Yvette together as a family.

As a film, *Baby Boy* contains flaws as salient as the ones in its protagonist: awkward pacing, repetitive dialogue, and tedious scenes of profanity-laced

anger and sexuality between Jody and Yvette. However, given the film's ending, Singleton's intentions are admirable, although he forces the audience to reach that finale along a laborious path. Four years later, opting for more visceral action, the film *Four Brothers*, framed within the action genre, unfolds within the urban jungle of inner-city Detroit.

When well-known community activist Evelyn Mercer (Fionnula Flanagan) is gunned down during a convenience store robbery, her adult adopted sons—two white, two African American—come home for her funeral and to find answers regarding her death. Evelyn saved the four troubled boys from a foster home system that failed them: Bobby (Mark Wahlberg), a quick-tempered bruiser; Jack (Garrett Hedlund), a timid fledgling musician; Angel (Tyrese Gibson), an impatient ex-military troublemaker; and Jeremiah (Andre Benjamin), a rational, sensitive spirit. Angel and Jeremiah are the two African American members of this brotherhood, and they possess overtly different personalities.

Angel, like Bobby, is a hothead who confronts the world through a tough no-nonsense veneer. Angel's experiences in the Navy leave him bereft of a purpose in life but unmistakably aggressive and confrontational. Rather than thinking through a situation, Angel acts out, sometimes contradicting what he says. He denies his emotions yet is unable to control them when it comes to his girlfriend Sofi (Sofia Vergara). On the other hand, Jeremiah emerges as the most stable of all the brothers. He has a wife and children, owns a home, and runs a business. Even as he openly confesses that he's "happy to see my brothers," his approach to discovering his mother's killers leans toward methodical efforts within legal parameters. Jeremiah refuses to succumb to his troubled past, but he prefers to utilize his brains and business networking to construct a life for him and his family. Despite his professed love for his brothers, he remains responsible to his family first. At one point when urged by his brothers to join them in following a possible suspect, Jeremiah declines, indicating that he has to take his daughters to gymnastics class. Later when Bobby and Angel accuse Jeremiah of capitalizing on their mother's death through an insurance policy, Jeremiah erupts and declares that he was the only brother who remained in the city and helped to take care of their mother. He resents their lack of understanding of the pressures and responsibilities of staying in the hood and taking care of a family, their mother, and two homes.

As the film presents the bond among the four brothers, it spends time showing the four following the "trail of evidence [that] leads to gang goons, drug scum, rotten cops, crooked politicians, whorish women, Neanderthal contract killers, a whack Detroit gangster in a poufy fur jacket."[17] This African American gangster boss, Victor Sweet (Chiwetel Ejiofor), appears to be

an homage to the 1970s' blaxploitation cycle in his dress and misanthropic attitudes. To the credit of actor Chiwetel Ejiofor, Sweet doesn't descend into the snarling, mumbling image viewed in earlier films, yet he is indeed a type. Devoid of any compassion or much business savvy, Sweet falls victim to his ego long before he meets his demise at the end of the film. The excesses in violence and profane histrionics by Sweet contrast blatantly with the righteous and legitimate behavior expressed by Angel and Jeremiah. Although they didn't have a father in the home, Angel and Jeremiah received a caring and instructive home that helped them reach adulthood and independence, unlike Sweet who, it must be assumed, crawled from a fatherless home within the bowels of the hood.

After *Four Brothers*, Singleton steps away from directing and spends more time producing features, including *Hustle & Flow* (2005), *Black Snake Moan* (2006), and *Illegal Tender* (2007). The sabbatical from helming films appears to have been the result of Hollywood politics. Participating on a panel organized by the Screen Actors Guild in February 2011, Singleton asserted that he was blacklisted by studios because he refused to direct mainstream projects that he felt were demeaning to black people. Rather than acquiescing to corporate demands on his vision, he opted to stand his ground.[18] This insider information is revealing, but it does open up the discussion about the objectionable black images that some critics saw in films that he produced. Singleton returns to his mainstream directing with the 2011 release of *Abduction*, a thriller following a white male protagonist who seeks the truth about his past identity.

When juxtaposing the films of Spike Lee and John Singleton, the recurring focus upon black masculinity emerges as a shared auteurist theme. In doing that, the two directors continued a concern reflected in the works of earlier black directors. The pursuit of significant and complex black male images did not begin with Lee and Singleton, but the legitimacy of that pursuit has been galvanized by the two. Lee and Singleton give visibility to the world of black men often excluded from mainstream viewers. Lee politicizes race and black masculinity, while Singleton renders black images within the cinematic genres proven to be marketable to a popular viewership. Lee prefers a wider canvas of age, class, and sexual orientation, while Singleton leans more toward a city landscape of younger characters.

The black male images fashioned by both directors between the late 1980s and the first decade of the new millennium invite a consideration of the emergence of Barack Obama as president of the United States in 2008. In some conspicuous ways, President Obama reflects those admirable

traits that the two filmmakers sought to depict on-screen. Obama represents the black man who succeeds in the capitalistic system: gaining a law degree from Harvard, becoming a millionaire, and citing billionaires as his friends and supporters. He is intellectual yet takes pride in his athletic skills on the basketball court. Obama describes himself as a religious man who offers supportive, if sometimes guarded, positions regarding gay and lesbian rights. Importantly, he publicly displays affection and respect for black women through his actions and words regarding his wife, daughters, and mother-in-law. Consequently, Obama consolidates numerous black male qualities that both directors affirmed in their cinematic works. In this comparison, the relevance of American cinema as a popular art expression that can inform and reflect significant social, cultural, and political dynamics surfaces in a discernible way. However, even as both directors would appreciate the model of black masculinity that President Obama typifies, he offers but one example of black masculinity.

Displaying both triumphs and weaknesses in their filmmaking, Spike Lee and John Singleton remind audiences that there can be many configurations of black masculinity. In addition to lawyers, politicians, and celebrities, black manhood is reflected in those individuals who are factory workers, educators, and skilled craftsmen, among many professions. Given the variety of talents, professionalism, achievements, and struggles in society, a divergent cinematic representation of black masculinity will remain crucial. For their part in contributing to the discourse and icons of black masculinity, Lee and Singleton deserve credit because without their films, a substantial void would exist in American cinema regarding black male images. The need remains for Lee and Singleton as well as other directors to continue to initiate visual stories that will show black men in an even more progressive manner. As discussed by scholar Mark Anthony Neal, the goal should be to move forward from images of the "strong black male" to the "new black man." The "strong black male," often associated with patriarchy, sexism, and homophobia, merely positions black masculinity in traditional thinking and behavior that has been shown to be problematic; the "new black man," both fluid and complex, embraces personal growth while respecting the difference and dignity of others, regardless of their gender, orientation, and race.[19] Certainly, at this point in their careers Lee and Singleton have provoked reflection and conversation about black masculinity beyond conventional traits. Together, the directors demonstrate that the cinematic artist can also serve as cinematic activist who brings truths that must be assessed on emotional, cultural, and political levels.

NOTES

1. Richard Majors and Janet Mancini Billson, *Cool Pose: The Dilemmas of Black Manhood in America* (New York: Lexington Books, 1992), 1.

2. Edward Guerrero, "Black Men in the Movies: How Does It Feel to Be a Problem (and an Answer)?," in *Traps: African American Men on Gender and Sexuality*, edited by Rudolph P. Byrd and Beverly Guy-Sheftall (Bloomington: Indiana University Press, 2001), 273.

3. Pat Kirkham and Janet Thumin, eds., *Me Jane: Masculinity, Movies and Women* (New York: St. Martin's, 1995), 13.

4. Charlene Regester, "Oscar Micheaux's Multifaceted Portrayals of the African-American Male: The *Good*, the *Bad*, and the *Ugly*," in *Me Jane*, 167.

5. Leon Erich Harris, "The Demystification of Spike Lee," in *Spike Lee Interviews*, edited by Cynthia Fuchs (Jackson: University of Mississippi Press, 2002), 128.

6. Melvin Donalson, *Black Directors in Hollywood* (Austin: University of Texas Press, 2003), 121.

7. Jill Hamilton, "*She Hate Me*," in *Magill's Cinema Annual 2005*, edited by Hillary White (Detroit: Gale, 2005), 328.

8. Kenneth Turan, "Setting Up a Plot—and Us: Changing Pace, *Inside Man* Director Spike Lee Takes the Crime-Film Genre for a Spin and Viewers for a Wild Ride," *Los Angeles Times*, March 24, 2006, http://articles.latimes .com/2006/mar/24/entertainment/et-inside24.

9. Donalson, *Black Directors in Hollywood*, 129–30.

10. Bakari Kitwana, *The Hip Hop Generation: Young Blacks and the Crisis in African American Culture* (New York: BasicCivitas Books, 2002), 101–6.

11. James L. Neibaur, *Tough Guy: The American Movie Macho* (Jefferson, NC: McFarland, 1989), 1.

12. Janet Maslin, "*Boyz 'n the Hood*." in *The New York Times Film Reviews, 1991–1992* (New York: Garland, 1994), 128–29.

13. JoAnn Balingit, "*Boyz 'n the Hood*," in *Magill's Cinema Annual 1992*, edited by Frank N. Magill (Pasadena, CA: Salem, 1992), 56.

14. Donalson, *Black Directors in Hollywood*, 130.

15. Michael Betzold, "*Baby Boy*," in *Magill's Cinema Annual 2002*, edited by Christine Tomassini (Detroit: Gale, 2002), 41.

16. Ibid.

17. Lisa Schwarzbaum, "*Four Brothers*," *Entertainment Weekly*, August 19, 2005, http://www.ew.com/ew/article/0,,1092063,00.html.

18. "The Black Hollywood Experience: Our History . . . Our Future." Panel discussion with Don Cheadle, John Singleton, Taraji P. Henson, and Marla Gibbs. Moderated by Wayne Brady. Sponsored by the Screen Actors Guild National Ethnic Employment Opportunities Committee, February 23, 2011. Held at the Screen Actors Guild, Los Angeles, California.

19. Mark Anthony Neal, *New Black Man* (New York: Routledge, 2005), 1–30.

Claire Sisco King

Legendary Troubles

Trauma, Masculinity, and Race in I Am Legend

On the first anniversary of 9/11, New York City hosted a series of commemorative events that included a variety of speeches delivered by prominent U.S. figures. With the exception of President George W. Bush, who debuted a new speech, Mayor Michael Bloomberg asked speakers to deliver canonical texts from throughout U.S. history instead of original oratories. New York governor George Pataki recited Abraham Lincoln's Gettysburg Address, New Jersey governor Jim McGreevey delivered the preamble and introduction to the Declaration of Independence, and Bloomberg read excerpts from Franklin D. Roosevelt's "Four Freedoms" speech.

While Bloomberg framed his decision to mark the occasion in this way as an attempt to "avoid any possibility of politicizing" the memorialization of 9/11—an impossible task—this choice might also be understood as a defensive gesture, an example of displacement in which consideration of the perceived traumas of 9/11 was shifted onto memories of past events that are easier to bear as part of national history.[1] This act of displacement attempted to cover over the ongoing and unresolved wounds of 9/11. But paradoxically, at an event meant to memorialize a loss, what remained was loss: the absence of that day whose memories have been replaced by others decades, even centuries, old.

I mention this act of repetition and displacement not because it is anomalous but because it represents a thoroughgoing strategy in U.S. public culture to remember and reconstruct 9/11 and its aftermath through a return to prior "experiential frames."[2] For example, Marcia Landy argues that World War II rhetoric about Pearl Harbor has offered a key frame for constructing cultural memory about 9/11. Although rhetoric about the

Vietnam War was noticeably absent in the immediate aftermath of 9/11, it later resurfaced as a critique of the U.S. response to 9/11 and the War on Terror, as exemplified by Senator Edward Kennedy's assertion in April 2004 that "Iraq is George Bush's Vietnam."[3] Post-9/11 Hollywood also performed a return to history, remaking and adapting a number of films from the Vietnam War era as experiential frames for constructing and interpreting post-9/11 American culture. These films include *The Texas Chainsaw Massacre* (2003), *Poseidon* (2006), *The Hills Have Eyes* (2006), and *I Am Legend* (2007), the last of which is the subject of this essay.

I Am Legend is a disaster film about a postapocalyptic future in which a virus, originally developed as a cure for cancer, mutates and either kills most of the world's population or turns them into zombies. Will Smith plays Robert Neville, a military physician who—believing himself to be the plague's sole survivor—struggles to find a cure for the disease and to protect himself from the infected population known as the Dark Seekers. Neville, who lost his wife and child, finds temporary solace when he unexpectedly meets other survivors, Anna and a young boy named Ethan, whom he gives his life to save. *I Am Legend* was the first of several eschatological films in the early 2000s to focus particularly on constructions of masculinity and trauma. Other such films include *The Day the Earth Stood Still* (2008), a science fiction remake of the 1951 film of the same name, in which a scientist must convince an alien not to destroy the earth; *2012* (2009), a disaster film about globally cataclysmic floods caused by the heating of the earth's core and humanity's attempts to avoid extinction; and *Daybreakers* (2009), a futuristic tale that depicts the aftermath of a plague that has turned most humans into vampires who face extinction as their human blood supply dwindles.

In addition to joining a host of contemporary films interested in apocalyptic themes, *I Am Legend* also has a prior lineage of its own. The third film to adapt Richard Matheson's 1954 novel of the same name, *I Am Legend* follows *The Last Man on Earth* (1964), starring Vincent Price, and *The Omega Man* (1971), starring Charlton Heston. *I Am Legend* also references a film not based on Matheson's novel, *The World, the Flesh, and the Devil* (1959), which focuses on an African American man (Harry Belafonte) who finds himself in New York with most of the world's population exterminated by chemical warfare. Of all its antecedents, *I Am Legend* seems especially and most directly tied to its most immediate predecessor, the Vietnam War era's *The Omega Man*. Both *The Omega Man* and *I Am Legend* tell the story of a global epidemic caused by human actions. Both films construct Neville as suffering from characteristic symptoms of post-traumatic stress disorder, and both films end with Neville's self-sacrificial death after he gives his

life to protect and regenerate the world's population. Despite these marked similarities, however, *I Am Legend* does not exactly repeat its forerunner: while *The Omega Man*, like its source texts, takes place on the streets of Los Angeles, *I Am Legend* is set in New York City, and while *The Omega Man* stars a white actor (Heston) as Neville, *I Am Legend* features a black actor (Smith) in the lead role.

As the remake of a remake, *I Am Legend* might be understood as performing a symptomatic act of repetition, compulsively returning to and replaying prior films, which themselves address the subject of trauma. The translations offered by *I Am Legend*—the repetitions with a difference—also suggest rhetorical attempts to reframe and reconstitute more recent history. Translations of both place and race reveal efforts within *I Am Legend* to manage post-9/11 discourse about the nation, its leading men, and its prevailing legends by using the discourse of trauma to recuperate the national-masculine in the face of both anxieties about American vulnerability and critiques of American xenophobia. Operating as a stand-in for the allegedly traumatized nation, Will Smith as Neville fashions his own suffering as the grounds for collective renewal and redemption. In the end, *I Am Legend* posits a fantasy of the nation that is posttrauma and postrace.

MAPPING TRAUMA

I Am Legend never addresses 9/11 overtly, but numerous references within the film animate cultural memories of this event. Chief among these allusions is the film's updated setting. New York City was so important to the film's narrative that *I Am Legend* was shot (in)famously on location in what has been described as one of the most elaborate, expensive, and embattled shoots to take place in the city, reportedly costing more than $300,000 per day and prompting considerable unrest among New Yorkers disrupted by the massive production. As the *New York Post* described, "There is no film in which the city feels so integral to the story, no film that has used its sights and streets to such dramatic effect and, it can't be overlooked, probably no film that has so ticked off residents during its complicated shoot."[4]

I Am Legend, however, does not cite just *any* version of New York City. The New York City depicted in this film is a city in ruins, a city injured and emptied out by unprecedented loss. Of course, *I Am Legend* is by no means the first film to imagine and construct images of New York City's destruction. As Claire Kahane notes, such films as *Armageddon* (1998) and *Independence Day* (1996), the latter of which also stars Will Smith, graphically depict the city's violent devastation in ways that suggest uncanny anticipation of what would transpire on 9/11.[5] In a post-9/11 context, the images of

Will Smith portrays an isolated military scientist in *I Am Legend* struggling to survive the apocalyptic disaster that has destroyed the world around him by arming himself with weapons, coping with his harrowing memories, and seeking the truth behind the cataclysm.

a fallen New York City take on additional registers of political and ideological significance, animating collective fantasy and cultural memory.

Recalling film critic Ty Burr's description of its contemporary *Cloverfield* (2008), *I Am Legend* "plays fast and loose with the iconography of 9/11" and anticipates what Burr will describe as the codification of recognizable post-9/11 iconography in such films as *2012* and *Battle of Los Angeles* (2011).[6] The mise-en-scène frequently features the downtown skyline and is filled with dilapidated, uninhabited buildings and streets overrun

Claire Sisco King

with dust, debris, and abandoned cars. The buildings, marked in red bio-hazard symbols, appear wounded as if lacerated and bleeding themselves. The film also features evacuation scenes in which thousands of New York-ers run for their lives toward bridges to get out of the city. These scenes of a devastated and abandoned New York City likely summon memories of the city in the hours, days, and weeks after 9/11 in which everyday life was radically suspended and the landscape was irrevocably changed.

These links have not been lost on reviewers or fans. To demonstrate, a review for the alternative newspaper *Creative Loafing* reads *I Am Legend* as using an "apocalyptic sci-fi story to purge some post-9/11 anxieties."[7] Simi-larly, a fan post explains that "what used to be a level of destruction only imaginable by CGI technicians is now all too easily conjured up by anyone owning a TV from 9/11 on," allowing *I Am Legend* to "ta[p] into latent 9/11 trauma" with its depictions of loss and often literally explosive violence.[8] As these responses demonstrate, spectators have interpreted this film not only in relation to the historical context of 9/11 but also in relation to the language of trauma, in which 9/11 is constructed as a traumatogenic event wounding the nation, its topography, and its people.

Neville notably designates New York City as "Ground Zero," a phrase that has come to stand for the space where the World Trade Center towers once stood. The term borrows from World War II rhetoric that described Hiroshima after the atomic bomb. Memories of 9/11 are also suggested by frequent references in film dialogue to the date, which indicate that the ma-jority of the film's action takes place during September 4 and 9, 2012, just days before what would be the eleventh anniversary of 9/11. These tempo-ral signifiers thus position *I Am Legend* as offering a fictive before *and* after to 9/11, the memory of which remains displaced (but not erased) within the text.

Of special note with regard to memories of 9/11, *I Am Legend* empha-sizes mediation in the form of televisions and computer screens, which warrants discussion in the context of the important roles that visibility plays in cultural memory of and public discourse about 9/11. The film im-mediately introduces the importance of visuality, opening with a flashback as television reporters speak in voice-over. In the first shot, a television screen fills the frame as a reporter heralds the discovery of a "miracle cure" for cancer: a genetically engineered strain of the measles virus, called Krip-pin virus (KV). This news footage cuts to New York City three years later, after KV has mutated, spread, and ravaged the planet.

The choice to introduce the fatally mistaken predictions about KV's medical promise through the frame of television news references cultural memory of 9/11 as a hypermediated event whose impacts were intensified

by its mediated coverage. The reporter's naive optimism recalls constructions of the nation before 9/11, a nation unaware of an imminent tragedy rhetorically framed as something "no one saw coming." Depictions of infrastructural failures to prevent the spread of the disease and to lend aid following the outbreak further illustrate concern about the nation's blindness to its vulnerabilities.[9] As Neville laments, "Nothing happened the way it was supposed to happen. Nothing worked the way it was supposed to work." Instead, "Everything just fell apart."

This attention to governmental failure to prevent and control the KV outbreak, which was itself the result of human actions and scientific manipulations, unsettles claims of U.S. blamelessness on 9/11. As a military scientist, Neville is professionally connected to the spread of the devastation, and *I Am Legend* thus mirrors *The Omega Man*'s suggestion that humans are to blame for their own suffering. Both films present a different scenario than Matheson's novel and *The Last Man on Earth* present; in those texts, bacteria, not human actions, are to blame. Both *The Omega Man* and *I Am Legend* openly confront the perils of modernist progress, and it is no coincidence that both films were produced in the context of U.S. military aggression that deployed new and devastating technologies. Positioning humans as actively producing apocalyptic devastation and suffering, not as passive or innocent bystanders, each film presents a victim-hero who must right a wrong to which he has contributed. In *I Am Legend*, Neville acknowledges his guilt. For instance, he defaces an image of himself on a *Time* magazine cover, marking a caption that once read "Savior. Soldier. Scientist" with a question mark. This expression of self-doubt anticipates his later confession to another survivor: "God didn't do this, Anna. We did."

Introducing the tragic story of KV through the lens of television reporting also implies a causal relationship between the news media's overstated coverage of KV as a "miracle" and the global tragedy that ensued. This frame critiques the role of television news in shaping public opinion and policy, echoing widespread discourse about the impact of mediated images as traumatizing to spectators and/or damaging to public opinion. As one of the many films on which the U.S. Army Media Relations Division has consulted, *I Am Legend* attends acutely to the political, social, and cultural implications of mediation. It is significant that in *I Am Legend*'s fictional news footage a reporter speaks of KV as a miracle full of promise, while its creator, Dr. Krippin, appears much more tentative and cautious. This sequence implies that television's tendency toward spectacle and sensationalism is as much to blame for the KV disaster as is the virus itself.

Claire Sisco King

Television news continues to feature prominently throughout *I Am Legend* as an organizing element of Neville's lonely existence. In one of his many repetition compulsions, Neville begins each day watching old news broadcasts recorded before the KV outbreak reached its peak. These images reinforce constructions of 9/11 as an event whose horrors have become inextricably tied to its mediated coverage. Depictions of Neville's efforts to find a cure for KV further imply that images themselves operate as a form of violence. As he experiments on kidnapped Dark Seekers as metaphorical lab rats, Neville visually records his work, taping all of his research trials and using computers to stream videos from his lab. On multiple occasions, *I Am Legend* doubly frames Neville on-screen, both within the larger film frame and on the smaller frame of his computer. Frequently these shots feature Neville looking at his own image on the screen before him. As infected subjects repeatedly die on his table, Neville must see constant and sustained evidence of his impotence, revealing him to be both at the mercy of the disease and a participant in its devastation. Polaroid images of dying and deceased Dark Seekers that line the walls of Neville's lab underscore his participation in this violent, visual economy.

Positioning Neville on both sides of the camera, *I Am Legend* figures him as a victim and a complicit witness. As the object of the camera's gaze and the lone survivor of KV, Neville remains exposed: isolated, unprotected, vulnerable, and on display. As the spectator of his own recordings, he is exposed to scenes of violence and devastation, which the film registers as visibly upsetting to him. Unlike prevailing constructions of the typical American citizen-spectator as an innocent and unaware bystander on 9/11, *I Am Legend* implies that Neville is party to his own trauma of spectatorship, for the images that haunt him are of his own creation.

I Am Legend reinforces this commingling of visibility and violence through a recurrent cinematographic device: as Neville hunts (for food, for infected people), point-of-view shots reveal Neville's perspective through the scope on his rifle, its targeting apparatus framing the image. In these point-of-view shots, Neville sees life through the literal lens of violence; as audiences share this viewpoint, *I Am Legend* implies that experiences of spectatorship and violence have become inextricably linked. Hence, *I Am Legend*'s emphasis on visual mediation perhaps suggest unease about the almost instantaneous access that the world had to the events of 9/11 as they were unfolding. As I argue later, however, the narrative emphasis on Neville's visual surveillance of his (ultimately successful) hunt for a cure for KV demonstrates the film's efforts to exert mastery over what is imagined as a traumatic past and to reaffirm traditional masculinist subjectivities.

I Am Legend replays *The Omega Man*'s construction of Neville as a traumatized subject. He exhibits textbook symptoms of psychological trauma, including flashbacks, hallucinations, and a repetition compulsion. Neville appears isolated, fragmented, and at his breaking point. Formally, flashbacks operate as a significant editing device throughout *I Am Legend,* as with *The Omega Man* before it, reinforcing Maureen Turim's understanding of flashbacks as a key trope for representing trauma in Hollywood cinema.[10] These flashbacks depict what transpired in the moments leading up to the city's evacuation, including the death of Neville's wife and child, and specifically indicate that Neville's sense of masculinity has been injured.

Neville's first flashback occurs moments after *I Am Legend* introduces the KV-infected survivors. Neville and the family dog Dam crouch in his bathtub as Dark Seekers screech outside his window. The film cuts to a flashback in which Neville rushes to evacuate his family before the military quarantines the city. Driving his family to the evacuation site but refusing to leave himself, Neville asserts, "I can still fix this. This is Ground Zero. This is my site." The second flashback occurs as Neville visually records his latest findings in his search for a cure for KV, cutting from a close-up of Neville's face on his computer screen to continued scenes of the Neville family's evacuation attempts and ending with a shot of Neville crying and alone. Implying that Neville's attempts to find a cure for KV stem directly from his sense of obligation to his family, this flashback structure ties Neville's heroism to his masculinity and patriarchal directives about his paternal responsibilities. As I argue below, his compulsion to kill the Dark Seekers and cure KV suggests a traumatic response to his failure to live up to these masculinist directives.

The final flashback occurs after Neville deliberately makes himself vulnerable to an attack by the Dark Seekers in the hopes that he would not survive the assault. Following brutal violence that renders him unconscious, Neville remembers his last moments with his family. In the flashback, as U.S. military planes bomb the bridges leading in and out of the city, an out-of-control helicopter careens toward the one evacuating Neville's wife and daughter, Marley. Seconds before impact, the film cuts back to Neville waking up in the present day. Like many 9/11 films, *I Am Legend* refuses to show the midair collision.[11]

Auditory and visual hallucinations further reveal Neville's melancholic attachment to his wife and child. For instance, when Neville first discovers other healthy survivors, Anna and a young boy named Ethan, he imagines them to be his late wife and daughter, who appear momentarily on-screen

before Neville is shocked back into his present-day reality. In one of the final moments of the film, the whispering voice of his young daughter compels Neville to sacrifice himself to save Anna and Ethan. Neville is also prone to speaking to inanimate objects including store mannequins that he has dispersed throughout the city, a device that borrows directly from *The World, the Flesh, and the Devil*. The mannequins never speak, but Neville hallucinates full conversations.

The prominence of family in Neville's flashbacks and hallucinations reveal that his trauma relates not only to the large-scale catastrophe that began at Ground Zero but also to personal loss and to the disruption of his masculine subject position. Doubly displaced from his former life, Neville has lost both his public position of authority as a military scientist and his private position of authority as the patriarch of a nuclear family. Accordingly, his symptoms make clear that much of the damage done to Neville owes to ruptures in his performances of hegemonic masculinity. In the absence of a public sphere in which to act and a private sphere in which to lead, Neville seems uncertain about how to be a man.

Neville also suffers from a repetition compulsion: each day of his lonely existence replays the previous one almost exactly. For instance, he visits the same video store every day to return a video and rent a new one. He is working through the Blockbuster collection alphabetically and declares himself to be "midway through the G's." Interestingly, the film that Neville returns is *The Godfather* (1972), which has been understood as negotiating destabilizations of "the family, the nation, and even the integrity of the individual in the Vietnam era."[12] Confirming the routinized nature of his trip to the store, Neville says to a mannequin in the store, "I'll see you in the morning." Like the watch alarm set consistently to wake him at sunrise and then to alert him to the approach of sunset, these trips to the video store render Neville's days familiar and predictable.

In addition, Neville compulsively broadcasts a radio message every day at noon and waits in the same place, hoping that other survivors will appear. This message, which plays multiple times throughout *I Am Legend*, makes a plaintive promise to Neville's imagined audience: "My name is Robert Neville. I am a survivor living in New York City. I will be at the South Street Seaport every day at midday when the sun is high in the sky. If you are out there, if anyone is out there, I can provide food. I can provide shelter. I can provide security. If there's anybody out there—anybody—please. You are not alone." This message is significant for a number of reasons. First, Neville overtly couples his identity as survivor with his location in New York City, emphasizing memories of the city as a central site for loss and as a place that has suffered. It matters that Neville returns incessantly to the

South Street Seaport, which is located in lower Manhattan's Financial District where the World Trade Center towers once stood. Neville's wife and child died at this site, and it is where Neville returns to attempt suicide. The melancholic Neville remains fixed within his suffering and continues to act out his scene of loss. Accordingly, *I Am Legend* situates downtown Manhattan as the locus of tragedy and the originating point for the traumatic history of its leading man and, by extension, the nation. Just as Neville charts the quadrants of the city, marking spots populated by the Dark Seekers, *I Am Legend* maps New York City, fetishizing its traumatic topography. Although it never shows Ground Zero, this film maintains the primacy of this wound in the U.S. imaginary.

Second, Neville's radio message also reveals the anxiety he feels about his ability to perform traditional masculinity. He is determined (even desperate) to fulfill the patriarchal injunction to be a provider. He insists on his ability to provide food, shelter, and security. As much as Neville insists on his abilities as a provider, however, he also reveals his anxious isolation and fear, ending his message with a forlorn plea for companionship from "anybody." This depiction of Neville constructs trauma as feminizing, having severed him from the social, destroyed his position of patriarchal authority, and crippled his ability to obey the directives of hegemonic masculinity. Hence, Neville offers synecdochic figuration of the allegedly emasculated nation that was unable on 9/11 to protect its citizens from the terrorist attacks.

The figuration of an emasculated nation circulated widely in public discourse about the attacks on 9/11 and, in particular, on the World Trade Center towers. For instance, on September 13, 2001, during ABC's "Special News Report: America under Attack," psychiatrist Alain Poussaint mixed a number of gendered metaphors, likening the attacks on the Twin Towers to a rape, which might leave survivors feeling violated, and describing the "towers as phallic symbols" destroyed by a "symbolic castration."[13] Similarly, on September 18, 2001, political commentator William Saletal described 9/11 as positioning "the United States as the battered wife to the battering husband of Middle Eastern terrorists."[14] This rhetoric not only posits the nation as feminized, or emasculated, but also as traumatized and wounded. Neville's radio message thus reinscribes the claim that fear as it relates to the experience of terror has unmanned the nation, a fear that is allegorized in the film's depiction of the last man on earth. However, as much as *I Am Legend* worries about post-9/11 figurations of the national-masculine, the film also labors to redeem its fallen hero, recuperating legends of national strength, resilience, and masculinity.

Claire Sisco King

While the emphasis on Neville's visibility—his frequent depiction on computer screens—might be understood as expressing anxiety about surveillance and spectatorship in the hypermediated post-9/11 context, the simultaneous emphasis on Neville's vision—his ability to see and to use optical technologies—suggests attempts to manage the politics of visibility and spectatorship. By employing images, cameras, and screens in his search for a cure, Neville enacts visual mastery, asserting a totalizing gaze over post-KV apocalyptic chaos and using mediated technologies as tools of recovery. This technological control realigns what Isabella Freda describes as typical U.S. politics of spectatorship, placing the citizen-subject once again on the "right" side of the camera not as its victim-object but instead as the master of its gaze.[15] This realignment of the politics of spectatorship finds additional reinforcement in the film's use of point-of-view shots in Neville's laboratory. As Neville, with a camera affixed to his glasses, gazes at and captures the image of hostage Dark Seekers, the film also positions spectators to adopt this agentive gaze.

When Neville is not searching for a cure, he hunts Dark Seekers who take shelter in the darkness of abandoned buildings, closely recalling former president George W. Bush's repeated figurations of terrorists as "shadowy" and hiding in "caves and shadows." Taking advantage of the nocturnal creatures' vulnerability to light and their near blindness, Neville stalks the Dark Seekers street by street, echoing Bush's insistence in September 2001 that the United States strive "to hunt down, to find, to smoke out of their holes" those he believed to be responsible for the 9/11 attacks.[16] Like Bush, Neville refuses to turn a blind eye to the threat of the Dark Seekers, and like the lab rats that Neville uses in his research trials, his enemies become the objects of his active investigative gaze. The trope of Neville-as-hunter further performs a restabilization of the politics of spectatorship, positioning the nation's cinematic stand-in as an agentive looker rather than as spectacular prey.

This construction of Neville may be understood as fashioning a fantasy of national remasculinization, a gendered transformation underscored by visual emphasis on Smith's muscular physique and Neville's rigorous exercise routine, including a montage sequence that depicts Neville training on the treadmill and doing pull-ups. If 9/11 has been framed in public discourse as a symbolic castration that unmanned the nation, Neville's vigor and resilience assert his ability to man up in the face of tragedy. His dedication to curing KV and to protecting his site, Ground Zero, perpetuates

traditional associations of masculinity with strength and self-reliance and performs a version of national identity that is unrelenting in its pursuit of security and justice.

This fantasy of unyielding heroism—the insistence on continued struggle no matter how dire the losses or how insurmountable the odds—reinforces former president Bush's stay-the-course rhetoric about the seemingly endless War on Terror. Infiltrating the Dark Seekers' hives, Neville appears to have accepted Bush's insistence, articulated in a speech to the Veterans of Foreign Wars in 2005, that we "go after" our enemies "where they live," a positioning mirrored by resemblances between the film's construction of hidden nocturnal Dark Seekers and Bush's description of terrorists as guided by a "dark vision" and hiding in "shadowy networks."[17]

Although *I Am Legend* expresses ambivalence about Neville's complicity in the KV disaster, the narrative ultimately absolves him of such guilt, praising his subsequent actions as the result of traumatic loss and the source of the world's recovery. *I Am Legend* carefully manages Neville's culpability through two strategies. First, the film counterbalances his violence with examples of his vulnerability and compassion. Second, the film recuperates evidence of both Neville's weakness (or impotence) and his hypermasculine vigilantism through the logic of self-sacrifice, allowing him to undo past losses and atone for transgressions.

Evidence of aggression, hardness, and agency as signifiers of Neville's masculinity coexist with traits more associated with traditional femininity—including gentleness, sensitivity, and emotionality—characterizations supported by Smith's extratextual persona. Throughout the film, Neville's relationship with Sam and memories of his deceased wife and daughter serve as reminders of Neville's softness. Adding to this construction of Neville as an attentive father is the extratextual fact that his daughter is played by Smith's own biological child, a recurrent choice for Smith who also played the on-screen father of his son in *The Pursuit of Happyness* (2006). By registering Neville's woundedness and counterbalancing his resolute pursuit of his enemies with his unflagging love for family, this characterization aligns heroism not with conventionally strong or virile iterations of masculinity but instead with the tragic man. Neville's role may also be read as repairing public narratives about post-9/11 American identity, inviting understanding of the nation not as vindictive and reactive but instead as compassionate and life giving.

In the film's final scenes, it is Neville's paternalistic relationship with his fellow survivors, Anna and Ethan, and his self-sacrificial death that firmly establish him as a warm and loving but also strong and resolved victim-hero. After Dark Seekers have discovered and invaded Neville's home,

Claire Sisco King

which has also become a refuge for Anna and Ethan, Neville adopts the role of protector. By safeguarding his new companions, Neville may rewrite history, atoning for the traumatic loss of his family and his failures as both a public servant and a patriarch. Anna and Ethan in effect become his new family, as signaled by the hallucination in which Neville imagines them to be his late wife and daughter.

As the Dark Seekers rush in, Neville ushers Anna and Ethan into his basement laboratory and hides them in a cement enclosure inside of a shatterproof cell. While Neville's wife and daughter died publicly in the wide-open expanse of the New York City skyline, Neville sequesters his figurative family underground in the confines of his fortified domestic sphere. In crafting a new ending for his family's narrative, Neville has recuperated his patriarchal authority and made, once again, home a safe space. If New York City has been lost, Neville redeems one small corner of his home as a place of refuge in the city, a place that incidentally has also become home to the city's artistic masterpieces, plucked from the walls of museums and hung on Neville's walls for preservation.

Neville enjoins Anna to bring salvation to the rest of the world. Having just discovered that his serum is curing a captive Dark Seeker, Neville realizes that her blood may now transmit immunity to others. He draws her blood and passes on the vile to Anna and Ethan to dispense after his death. With Anna and Ethan safely buried in their cement enclosure and with the remaining Dark Seekers pounding on the shatterproof glass of the cell, Neville (holding a picture of his wife and child) grabs a grenade and pulls the pin, killing himself and the infected population but sparing Anna and Ethan. Compelled to repeat the sacrificial gesture of his cinematic progenitor from *The Omega Man,* Neville gives his own life to beget new ones, and what emerges from his ashes is a new family that owes its life not to the laboring body of a mother but from the broken body of a man.

This act of self-sacrificial regeneration simultaneously confronts and contains the trauma of death, subjecting Neville to its finality but gaining mastery nonetheless. While the devastation wrought by the KV outbreak suggested Neville's (and the nation's) ineptitude and weakness, this final trauma is one that Neville wills for himself. If at first "Everything just fell apart," Neville engineers the final staging of his story. His death marks the beginning of his legend, a fact made explicit in Anna's voice-over narration that closes the film. This exaltation of redemptive death reaffirms the cultural significance of the ultimate sacrifice and the assumption that death (in the trenches or on the battlefield) is the noblest performance of civic duty and that male bodies are a nation's greatest sacrificial offerings.

Illustrating *I Am Legend*'s reliance on the masculinist logic of sacrifice, the film's denouement (like that of *The Omega Man*) differs sharply from the endings of Matheson's novel and *The Last Man on Earth*. These prior texts offer dystopic conclusions, killing the Neville characters tragically, not as an act of salvation. The sacrificial violence of *I Am Legend*'s final scenes also constitutes a revision to the film's original script. In the first version, Neville doesn't die or kill the Dark Seekers but instead encourages peaceful coexistence. In this version, Neville recalls the protagonist in Matheson's novel, realizing that as much as the Dark Seekers have become the monsters of his legend, he has become the monster of theirs, hunting down, kidnapping, and torturing the bodies of their people.

In this original ending, Neville understands that his test subjects are hostages, his experiments forms of torture. The Dark Seekers do not invade his home as animalistic marauders but instead come to rescue the infected subject Neville had taken prisoner. He apologetically returns his captive to her people. Without further violence, the Dark Seekers go home, while Neville, Anna, and Ethan, with the cure for KV in hand, leave to find a rumored survivor's colony. Giving up his masculinist quest for mastery over KV, Neville chooses a path of acceptance. And giving up his imperialist desire to control New York City, no longer his site, he cedes the land to its rightful owners.

This initial ending to *I Am Legend* offers dramatic potential for revising prevailing narratives about U.S. exceptionalism, imperialism, and cowboy politics, inviting self-reflexive attention to the metonymic links that culturally bind heroism and masculinity to physical force and to the violence of the nation-state. This denouement offers empathy and friendship to the Other and builds rather than burns bridges. This ending did not find its way to the big screen, however. Warner Bros. rejected this ending (and its potential subversions and ethical demands) and relegated it to the bonus materials on the DVD as an "Alternate Ending" in favor of an ending that revalorizes sacrificial economies of violence, masculinist heroism, and rejection of the Other.

In the ending of the final cut, Neville maintains his misrecognition of the Other as monster. Refusing to bear witness to his own violence, he obliterates all traces of himself and the traumatic history he helped to create. After Neville detonates the grenade the screen fades to white, visually signaling the film's attempts to clean up or whitewash an untidy past. Killing the Dark Seekers and himself, Neville creates a new Ground Zero, ruins from which a revised legend can be generated and recovery from trauma

　　　　　　　　　　　　　　　　　　　　　　　Claire Sisco King

can be promised. Although *I Am Legend* initially blames Neville for his suffering, its reliance on sacrificial violence undermines this critique, once again positioning the male body as the final solution to traumatic suffering, his martyrdom atoning for and absolving his guilt and that of the nation.

Neville's sacrifice thus acts as both expiation (a purging of guilty parties) and redemption (a cleansing of dirty hands). As he seals off Anna and Ethan and annihilates the remains of KV, *I Am Legend* intimates that traumatic history can indeed be undone and contained, offering a fantasy of moving on that is not based on bearing witness and painful self-examination but instead is equated with leaving behind and closing off. Neville's violence and self-sacrifice ensure that evidence of the traumatic past is destroyed, as with the virus itself.

This cinematic version of closure and recovery from trauma demonstrates Kirby Farrell's assertion that as a trope trauma often becomes an "enabling fiction," used here to justify and legitimate Neville's rejection of the Other and recourse to violence.[18] Constructing KV as a national trauma—compounded by the personal traumas of familial loss—endows Neville with the moral authority needed to justify his violent act of erasure. Following his self-sacrifice, what Neville leaves behind is not a history of disease, infrastructural collapse, governmental complicity, and oppression but rather a new story of recovery, rebirth, and redemption. If the story of KV might be understood as an allegory for American loss on and since 9/11, this narrative structure uses the imagined wounds of the nation as both justification for the violence of the nation-state and evidence that the nation once was and can again be whole, unified, and healthy. And if 9/11, like the KV virus, marked an anomalous interruption to life in America and a disruption of the nation's imagined masculinity, then Neville's successful quest for a cure conflates the possibilities of finding closure and moving on from tragic loss with remasculinization.

As she and Ethan escape, Anna recounts Neville's achievements, her words playing in voice-over as she and Ethan enter a gated survivor's colony after leaving New York City behind. As she enters the gates, Anna praises Neville's "restoration of humanity." The use of voice-over narration resembles survivor testimony and reinforces the film's insistence on closure and moving on. Anna's hopeful words offer the promise of an end to suffering and an "after" following traumatic loss, and the opening and closing of the colony's gates reinforces the film's attempts at closure, with the material evidence of suffering and loss locked safely outside.

Anna's conspicuous references to times and dates further reinforces this notion that trauma can be contained in the past. As she explains, "On September 9th, 2012, at approximately 8:49 p.m. he discovered that cure and at

8:52 he gave his life to defend it." This reference to the temporal specificity of Neville's sacrificial heroism allows the film to compress past, present, and future. Fictively winding back time to those days before September 11, *I Am Legend* attempts to rewrite traumatic history. The film gets close to the temporal signifier of 9/11—almost but not quite touching its memory—in order to erect a new temporal monument: the moment the world was reborn through a wounded man. Anna's rhetoric inverts assertions that 9/11 "changed everything," promising rebuilding and new beginnings.

Anna declares that "We are his legacy. This is his legend. Light up the darkness." The film then closes with Bob Marley's "Redemption Song." The use of Marley's music and the repeated iteration of Marley's phrase "Light up the darkness" link Neville to the reggae icon, whom the narrative constructs as an activist for social change and racial equality. At the same time that the film's ending refuses to confront Neville's (and the nation's) history of violence and oppression, *I Am Legend* openly lays claims to promises of racial equality and harmony. These promises, however, prove to be empty ones. Despite the film's overt discussion of racism, its translations of race and place maintain the privilege of both U.S. national identity and whiteness.

POSTRACE TO THE FINISH

I Am Legend's most significant departure from *The Omega Man* (and from sacrificial films more generally) is its introduction of a black star into the role of sacrificial victim-hero. In this regard, the extratextual significance of Smith's adaptation of Heston's prior role bears noting. At the time *The Omega Man* was released, Heston was associated with the Left. In his first autobiography, he describes himself as being vanguard in his support for civil rights "before it got popular," having marched in 1963 with Martin Luther King Jr.[19] By the time of *I Am Legend*'s release, Heston was well known as an icon of the Right: a former president of the National Rifle Association and a centerpiece of the culture wars, fiercely opposed to affirmative action and identity politics.

If Heston's transformation might be understood as emblematic of the nation's shift from the leftist 1960s, with that era's emphasis on collective action, to the right-wing 1980s and the Reagan-era culture of individualism, then Smith's adoption of Heston's role might be understood as offering at best a national apologia or at worst a disavowal in reaction to critiques of America's histories of racialized violence and xenophobia in the wake of 9/11. Neither racialized violence nor xenophobia is unique to the post-9/11

Claire Sisco King

moment, but critiques of the racial politics of the United States became particularly visible in post-9/11 public discourse about the War on Terror.

To demonstrate, in 2006 just one year prior to the release of *I Am Legend*, A. Sivanandan addressed the participants of the Institute of Race Relations' international conference "Racism, Liberty, and the War on Terror" by arguing that American and British war efforts in the Middle East have "resurrect[ed] a culture of primitive racism (we good, them evil) surrounded by a politics of spurious fear promoted on the back of the real fears of 9/11 and 7/7 and braced by anti-terrorist legislation."[20] Similarly, on the fifth anniversary of 9/11, the website for MSNBC featured a series of articles and testimonials on the subject of race after 9/11 titled "Scorched by the Scourge of Post-9.11 Racism."[21] And in 2006 and 2007, multiple publications directly linked U.S. policies on terrorism to racism, including Steven Salaita's *Anti-Arab Racism in the USA: Where It Comes from and What It Means for Politics* (2006), Mary Bosworth and Jeanne Flavin's *Race, Gender, and Punishment: From Colonialism to the War on Terror* (2007), and Amaey Jamal and Nadine Naber's *Race and Arab Americans before and after 9/11: From Invisible Citizens to Visible Subjects* (2007).

I Am Legend's choice of leading man seems especially significant because, first, Smith also inherited this role from another conservative icon, Arnold Schwarzenegger, who was originally slotted for the remake, and second, Smith is known as a black actor with great popularity and credibility in cultural spaces traditionally defined as white. Adilifu Nama positions Smith as a "seminal figure in American [science fiction] cinema." What gives Smith such currency, argues Nama, is his blend of the "racially nonthreatening posture of Sidney Poitier with the charismatic bravado of Eddie Murphy."[22] Smith's persona makes him an ideal candidate for delicately negotiating tensions with American public culture around the subject of race: a popular and entertaining actor, not known for speaking out politically, Smith can appeal to both black and white audiences without forcing too blunt a confrontation with racial politics.

Citing such films as *Independence Day, Men in Black* (1997) and *I, Robot* (2004), Nama contends that Smith has "reinvigorated the status of blackness in [science fiction] cinema" and unseated a "host of white protagonists who confronted the science fiction metaphors of American cultural crisis."[23] Smith has continued this trend with the science fiction films *Hancock* (2008) and Barry Sonnenfeld's *Men in Black III*, which is slated for release in 2012. Given Smith's striking presence within the science fiction genre and within the series of adaptations of Matheson's novel, Smith's role as Neville might inspire an uplifting and even redemptive narrative of social progress and change, as if his casting constitutes a kind of victory over histories of

racism and inequalities. Interestingly, similar logic reverberated not long after *I Am Legend*'s release during what would eventually become Barack Obama's successful run for the White House.

I Am Legend invites such optimistic understandings of Smith's role in the film through its constructions of Bob Marley, whose album *Legend* plays throughout the film. In fact, Neville repeats the refrain from Marley's "Three Little Birds" ("Don't worry about a thing / 'Cause every little thing is gonna be alright") throughout the film as his survival mantra. Neville describes Marley as having a "virologist's idea that you could cure racism and hate—literally cure it—by injecting music and love into people's lives." This rhetorical stance is significant for a number of reasons.

First, at the level of diegesis, this remark overtly links Marley's identity to Neville the virologist, a link underscored by Neville's decision to name his daughter after the late singer. Although Neville will choose to anni- hilate (rather than accept) the Dark Seekers, the overt associations with Marley invite understanding of Neville's violence not as an act of destruc- tion but instead as an act of salvation. Rather than encouraging reflection on Neville's oppression of and hatred toward the infected population, this reference to Bob Marley positions Dark Seekers as the sources of hate that must be destroyed, marking them, in the rhetoric of George W. Bush, as the "evil-doers." According to such logic, Neville's sacrificial death marks the end of racist hatred rather than another instantiation of it. Despite the film's pledge that Neville offers a hopeful beginning and new ways of see- ing, Neville's vision remains tied to masculinist economies of violence. This new beginning and the end of darkness still derive from violent and tragic loss. Trauma has not been cured or undone; it has simply been displaced.

Second, this reference to Marley and his belief that art can operate like an inoculation against racism operates at an extratextual level as well, po- sitioning both Smith (as artist) and *I Am Legend* (as work of art) as cures to a racist past. *I Am Legend* implies that it might inject hope and love into the lives of its audience as an antidote to racism and xenophobia, but the film offers no critical attention to its participation in the ongoing politics of Othering. In fact, this promise operates as a cover for the film's reinscrip- tion of racist logics. Articulating a postrace fantasy, *I Am Legend* invites understandings of racism as a problem of history that no longer matters or requires attention at the same time that it unwittingly betrays this very claim. The doors on that past, the film implies, have been firmly locked shut—as embodied by Neville's impenetrable cell and the sequestered sur- vivor's colony—and audience members should, quite literally, move on.

This rhetorical strategy echoes remarks made by Republican presiden- tial nominee John McCain during his concession speech to President-elect

Obama. Addressing the historic election of the first African American president, McCain described the nation as having "come a long way from the injustices that once stained our nation's reputation and denied some Americans the full blessing of American citizenship," as if injustices do not continue in the present day and as if all Americans are granted equal rights to citizenship. Referencing the language of trauma, McCain explained that the "memory" of racism "still *had* the power to wound" (emphasis added), that is until now. McCain's use of the past tense implies that these memories no longer carry the power to wound, positing a fictive after or end to the transgenerational traumas of racism. McCain positioned the nation as a "world away from the cruel and frightful bigotry of *that* time" (emphasis added), and to prove this claim he can offer "no better evidence" than the "election of an African American to the presidency of the United States." McCain thus identified Obama's election as a turning point in American history, after which there should be no basis for critique of legacies of national identity or citizenship, asserting, "Let there be no reason now—let there be no reason now for any American to fail to cherish their citizenship in this, the greatest nation on earth."[24] Not only does this rhetoric mirror the move from collective identity to individualism—placing the onus on the individual citizen to live up to his or her rights and privileges—but like the rhetoric of Heston a decade earlier, it also asserts that race should no longer carry rhetorical force as a marker of injustice and that oppression can be understood (and forgotten) as belonging to "that time."

The diegetic links between Neville and Marley as virologists similarly imply that Neville's victory over the Dark Seekers and Smith's triumph as a megastar should be understood as a victory over bigotry and hate and that racism, like the KV virus, should be understood as a thing of "that time" against which survivor's can be inoculated. The "now" inaugurated by *I Am Legend* and McCain's speech, only one year later, is constructed as postrace and posttrauma, a world in which racialized violence and suffering should no longer be said to exist. The proof, as implied by *I Am Legend* and McCain, can be seen in the black male bodies on the screen and in the Oval Office.

And yet despite such promises of hopeful new beginnings and a world in which race no longer matters, *I Am Legend* seems somewhat anxious about Neville's status as a legitimate victim-hero, implying (presumably unwittingly) that Neville's masculine heroism is compromised by his race or, more precisely, by his blood. In *The Omega Man*, Neville's blood becomes the source of new life in postapocalyptic Los Angeles as both the serum that cures those infected by the plague and as a symbolic marker of his self-sacrifice. Although this 1970s-era film might seem progressive in

its depiction of an interracial relationship between Heston and costar Rosalind Cash, Neville is careful to declare that his redemptive blood is "genuine 160-proof old Anglo-Saxon," linking the purity and potency of his blood to his whiteness. Smith's Neville can make no such declarations about his blood, which significantly is *not* the blood that will regenerate the population. Instead of giving his own blood, which boasts immunity to KV, Neville draws blood from his female hostage, the Dark Seeker who has begun to recover and whom he will kill only moments later.

Refusing to offer up Neville's blood as the source of new life, *I Am Legend* maintains fantasies about the purity and naturalness of whiteness such that not one drop of black blood will be used to restore humanity. While the film reinforces the hegemonic privilege assigned to masculinity in U.S. culture, it also asserts that the greatest authority lies in bodies that are both male *and* white. According to such logic, the rite/right of sacrifice belongs to Neville only provisionally. Thus, even as an exception that introduces a black actor into a white role, *I Am Legend* refuses to sever the hegemony of masculinity from whiteness, reinforces the assumption that traumatic heroism is naturally the province of white men, and reinscribes the privileged position of the white male as the nation's noblest and most valuable citizen-victim. *I Am Legend* offers promises of a hopeful new beginning by paradoxically returning to a thrice-told tale, and in the end this film reinscribes old legends about sacrifice, the nation, masculinity, and whiteness.

NOTES

1. Janny Scott, "The Silence of the Historic Present," *New York Times*, August 11, 2002, 29.

2. Isabella Freda, "Survivors in the West Wing: 9/11 and the United States of Emergency," in *Film and Television after 9/11*, edited by Wheeler Winston Dixon (Carbondale: Southern Illinois University Press, 2004), 227.

3. Edward Kennedy, "A Critique of Administration Policy on Health Care, Education, and the Economy." Speech delivered at the Brookings Institute, April 5, 2004, http://www.brookings.edu/events/2004/0405health-care.aspx.

4. Reed Tucker, "Biting the Big Apple—To Make *I Am Legend* Will Smith & Co. Turned Thousands of NYERS into Refugees and Vampires, Shut Down the Brooklyn Bridge and Turned Our Town into the Biggest Movie Lot in History," *New York Post*, December 9, 2007, http://www.nypost.com/p/entertainment/movies/item_SRn4Cp96Jdr2aAoKY0L7VP.

5. Claire Kahane, "Uncanny Sights: The Anticipation of the Abomination," in *Trauma at Home: After 9/11*, edited by Judith Greenberg (Lincoln: University of Nebraska Press, 2003), 107–8.

6. Ty Burr, "Monster Flick Takes Hold Quickly and Doesn't Let Go" [review of *Cloverfield*], *Boston Globe*, January 18, 2008, http://articles.boston.com/2008-01-18/ae/29279195_1_michael-stahl-david-cloverfield-godzilla; Ty Burr, "Armageddagain: *2012* Writes a New Chapter in the Destruction Manual" [review of *2012*], *Boston Globe*, November 13, 2009, http://articles.boston.com/2009–11–13/ae/29256865_1_copper-mine-roland-emmerich-harald-kloser; Ty Burr, "The Sands of Santa Monica: *Los Angeles* Is Viscerally Gripping, If Full of War-Movie Clichés" [review of *Battle of Los Angeles*], *Boston Globe*, March 11, 2011, http://articles.boston.com/2011–03–11/ae/29339603_1_alien-invasion-movie-sergeant.

7. Curt Holman, "*I Am Legend:* Last Man Standing," *Creative Loafing*, December 12, 2007, http://clatl.com/atlanta/i-am-legend-last-man-standing/Content?oid=1271022.

8. *Narrative Junkie*, "Review: *I Am Legend*," January 22, 2008, accessed Nov. 14, 2009, from http://narrativeJunkie.com/2008/01/i-am-legend-html.

9. These narrative devices, along with the iconography of a devastated city that Neville must loot in order to survive, also suggest references to Hurricane Katrina and the devastation in New Orleans. Given that both events have been framed as traumas within American public discourse, their potential overlap in *I Am Legend* is not altogether unsurprising. As Irene Kacandes suggests, "radically different traumas can be experienced as similar by those who have already been traumatized." See Irene Kacandes, "9/11/07 = 1/27/01: The Changed Posttraumatic Self," in *Trauma at Home*, 168.

10. Maureen Turim, *Flashbacks in Film: Memory and History* (New York: Routledge, 1989), 207.

11. For example, in both *United 93* (2006) and *World Trade Center* (2006)—two docudramas about the 9/11 attacks—the camera fades to black seconds before showing the crashing of hijacked planes. It is also interesting to note that the helicopter crash reproduces a plot device from *The Omega Man* although with significant differences. In *The Omega Man,* Neville is on the aircraft that crashes after the pilot becomes symptomatic of the plague, and the result of this crash is Neville's inability to disseminate the vaccine against the spreading illness. However, this film, which was produced at a time when plane crashes didn't carry the specific weight that they do in the post-9/11 imaginary, shows the full impact of the helicopter's fiery crash. *I Am Legend*'s refusal to show the crash demonstrates the work of displacement, in which references that are too specific or too close to 9/11 are frequently tempered or covered over.

12. Nick Browne, "Violence as History in the *Godfather* Films," in *Francis Ford Coppola's Godfather Trilogy,* edited by Nick Browne (Cambridge: Cambridge University Press, 2000), 19. Vera Dika also reads *The Godfather* as operating, in the wake of the Vietnam War, to offer a "satisfying collective fantasy of legitimized violence" in response to perceptions of America as "the perpetrator of

unjust acts." See Vera Dika, "The Representation of Ethnicity in *The Godfather*," in *Francis Ford Coppola's Godfather Trilogy*, 78.

13. Marcia Landy, "'America under Attack': Pearl Harbor, 9/11, and History in the Media," in *Film and Television after 9/11*, 82.

14. Brent Malin, *American Masculinity under Clinton: Popular Media and the Nineties "Crisis of Masculinity"* (New York: Peter Lang, 2005), 162.

15. Freda, "Survivors in the West Wing," 242.

16. George W. Bush, "Remarks by the President upon Arrival," September 16, 2001, speech delivered at the White House, http://georgewbush-whitehouse.archives.gov/news/releases/2001/09/20010916-2.html.

17. George W. Bush, "President Honors Veterans of Foreign Wars at National Convention," August 22, 2005, speech delivered in Salt Lake City, Utah, http://georgewbush-whitehouse.archives.gov/news/releases/2005/08/20050822-1.html.

18. Kirby Farrell, *Post-traumatic Culture: Injury and Interpretation in the Nineties* (Baltimore: Johns Hopkins University Press, 1998), x.

19. Charlton Heston, *In the Arena: An Autobiography* (New York: Simon and Schuster, 1995), 261.

20. A. Sivanandan, "Racism, Liberty, and the War on Terror," *Race Class* 48, no. 4 (2007): 47. The term "7/7" refers to terrorist bombings in the United Kingdom on September 7, 2005.

21. "Scorched by the Scourge of Post-9/11 Racism," MSNBC, http://www.msnbc.msn.com/id/14587965/.

22. Adilifu Nama, *Black Space: Imagining Race in Science Fiction* (Austin: University of Texas Press, 2008), 39.

23. Ibid.

24. John McCain, "Concession Speech," November 4, 2008, speech delivered in Phoenix, Arizona, http://www.nytimes.com/2008/11/04/us/politics/04text-mccain.html.

MARK GALLAGHER

Male Style and Race in the Neoretro Heist Film

Near the end of the first act of the Steven Soderbergh–directed heist film *Ocean's Eleven* (2001), a group of attractive men in designer clothes congregate in a large warehouse, where they operate a drill press, move wood on a conveyer, drive a forklift, and perform other construction and technical work. Viewers know that the men are building a full-scale model of a seemingly impregnable casino vault, a replica they will use to practice their operation and, as revealed later, to record staged video footage of the space. Viewed in another context, the scene resembles nothing so much as a particularly elaborate segment from the popular U.S. television series *Queer Eye for the Straight Guy*, which also featured handsome well-dressed men performing manual labor without breaking a sweat.[1] Also like *Queer Eye for the Straight Guy*, *Ocean's Eleven* includes many scenes of men watching other men perform carefully choreographed operations. The television program arranged romantic dinners and cocktail parties meant to impress loved ones and family, while the film narrates a series of confidence games meant to foil casino owners and security personnel (and at times viewers as well). Many reviewers have noted *Ocean's Eleven*'s preoccupation with sharply dressed men. The film manages its homosocial, and implicitly homoerotic, spectacle through a strong emphasis on the technologies of surveillance. In short, the film sanctions men's gazing at other men by continually asserting their control over the apparatuses of looking and by emphasizing their active performance for the many cameras within the film's diegesis.[2]

With cumulative worldwide grosses of more than $1 billion, the *Ocean's* series can be said to constitute part of popular cinema's zeitgeist in the early 2000s. The films emblematize a particular cultural sensibility, a neoretro

sensibility that takes shape through textual characteristics, engages with generic and cultural codes of past eras, and finds further expression in subsequent popular texts. *Ocean's Eleven* articulates this sensibility particularly through its multiple investments in contemporary formations of masculinity. The film's neoretro attitudes create a space for the multiracial male group, a group defined by style codes and casual as well as highly formalized homosocial interactions. My analysis here concentrates on *Ocean's Eleven*, the most critically successful of the series as well as the most straightforward in terms of narrative arcs, intersecting subplots, and overall integration of an ensemble cast into a single story line. Still, the three films together demonstrate reasonable consistency in their narrative dynamics, characterizations, and overall textual attitudes. In *Ocean's Eleven,* paroled criminal Danny Ocean (George Clooney) assembles a team for an elaborate Las Vegas casino robbery, motivated in part by his desire to reclaim his estranged wife, Tess (Julia Roberts), now romantically involved with the casino's owner, Terry Benedict (Andy Garcia). Ocean and his team achieve both goals, setting up *Ocean's Twelve* (2004), in which Benedict tracks them down and demands repayment. The group relocates to Europe for heists, intrigue, romance, and myriad narrative complications amid Dutch, Italian, and other continental scenery. In a narrative overflowing with characters and plots, *Ocean's Twelve* pits its team against not only Benedict but also aristocratic robber Francois Touleur, known as "the Night Fox" (Vincent Cassel), and introduces the additional con artists and thieves Gaspar LaMarque (Albert Finney) and Isabel Lahiri (Catherine Zeta-Jones), revealed at the film's denouement as father and daughter. Finally, *Ocean's Thirteen* (2007) reassembles the male team to rob and discredit the new casino owned by Willy Bank (Al Pacino), who at the film's outset swindles one of the eleven, Rueben Tishkoff (Elliott Gould), causing his apparent mental breakdown. For this operation, the team enlists Benedict's backing, cons Bank's aide Abigail Sponder (Ellen Barkin), and again fends off the persistent Touleur. All three films showcase male performance, with arch role-playing and subterfuge in abundance. While I focus on this series and its first outing in particular, numerous other contemporary heist films offer close variations on the *Ocean's* films' models of male engagement, as I address in some detail below.

Laying the ground rules for the series, *Ocean's Eleven* crafts an ensemble of playful yet highly professionalized male criminals. Their work involves dressing up, acting up, and going out, usually in each other's company. All three films depict male activity as performative role-playing. *Ocean's Eleven* presents this performance in highly mediated form, usually viewed through the surveillance cameras and monitors that are central to its narrative world. In "Masculinity as Spectacle," Steve Neale ponders the

consequence of situating the male as the object of the camera's gaze. In films where male interactions are central—in Neale's example, the Westerns of Sergio Leone—the viewer's "look is not direct, it is heavily mediated by the looks of the characters involved."[3] Coupled with the emphasis on aggression rather than desire, such films "minimize and displace the eroticism they . . . tend to involve, to disavow any explicitly erotic look at the male body."[4] Yet in *Ocean's Eleven*, this erotic look is strongly present. The male stars—including Clooney, Garcia, Brad Pitt, and Matt Damon— often comport themselves like runway models while other men watch them from different locations. Narratively, these looks verify the execution of parts of the complicated heist. They also serve as mediated views of male performance, with the men's composure, role-playing ability, or sleight of hand under scrutiny. Neale argues that in popular cinema generally, "[w] here women are investigated, men are tested."[5] In *Ocean's Eleven*, men are simultaneously tested—by their compatriots as well as their antagonists— and investigated. In what follows, I interrogate the formal and narrative constituents of this dynamic of mediated looking and performance, particularly as it relies upon and reworks constructions of manhood and of racial and ethnic identity. All three *Ocean's* films construct a large multicultural male group that is both available for viewers' looks and resistant to the debilitating male rivalries endemic in genre films. With their many costume changes and disguises, the films give viewers a male ensemble whose interactions occur largely at the level of personal style.

REMODELING THE HEIST FILM

In *Ocean's Eleven*, eleven career criminals band together to steal the accumulated cash reserves of three Las Vegas casinos from a single, avowedly impregnable vault. Even more implausibly, as the lead criminal manages his team and plans the elaborate theft, he finds time to pursue his estranged wife, who by coincidence has become the romantic partner of the central casino's owner. This familiar enough combination of pop cinema ingredients helps contextualize the film within a particular subgenre, the contemporary caper film, or what can be called the neoretro heist film. It is something of a truism that U.S. popular culture thrives on nostalgic formations. In the film medium, remakes, sequels, and recuperations of distant historical periods are so commonplace as to defy cataloging. Popular cinema's representations of the past often replicate conservative agendas through either narrative strategies or aestheticization. Presumably *Ocean's Eleven*, remaking a featherweight 1960 Rat Pack film, would offer yet another paean to an era defined cinematically through caddishness, irresponsibility, and the

Doing publicity for *Ocean's Eleven*, stars George Clooney and Brad Pitt exhibit a celebrity style parallel to that within the film's world.

venerable battle of the sexes.[6] However, the involvement of Soderbergh—director of such films as the crossover phenomenon *Sex, Lies, and Video-tape* (1989) and the mainstream critical and commercial successes *Erin Brockovich* and *Traffic* (both 2000)—might generate expectations of a more complex and ambitious film.

Ocean's Eleven's textual sensibility follows partly from its reworking of the 1960 caper film of the same title. The newer *Ocean's Eleven* also initiates a cycle of heist film remakes. Films such as *Rififi* (1955), *The Killing* (1956), and *Topkapi* (1964) popularized the ensemble heist film in the 1950s and 1960s. More recently, *The Ladykillers* (2004), *The Italian Job* (2003), *The Good Thief* (2002), and *Welcome to Collinwood* (2002) all adapted existing 1950s and 1960s films. The first two remade British films with the same titles from 1955 and 1969, respectively; the third updated Jean-Pierre Melville's *Bob le Flambeur* (1955); and the last reworked the 1958 Italian caper film *Big Deal on Madonna Street*. Rather than reviving the specific values of past U.S. or European cultures, the newer films all highlight casual semiprofessional relations among large male groups. Young white

American men dominate these groups, but they all include rainbow coalitions of sorts.[7] *Ocean's Eleven* casts African Americans Don Cheadle and Bernie Mac, the young Chinese actor Shaobo Qin, and older Jewish actors Elliott Gould and Carl Reiner. Other neoretro films similarly replace all-white casts with multiracial groups that variably include African Americans, Latino Americans, East and Southeast Asians, and Arabs. Joel and Ethan Coen's *The Ladykillers* provides a criminal group that includes Marlon Wayans as a "hippity-hoppity" thug, Hong Kong Chinese actor Tzi Ma as a Vietnamese general, and Irma P. Hall as the churchgoing black landlady who foils their plans. *The Italian Job* features African American rapper Mos Def and Latino American actor Franky G (born Francisco Gonzalez) in supporting roles. Similarly, *Welcome to Collinwood* (which counts Soderbergh and Clooney among its producers) includes Isaiah Washington and Luis Guzman among its ensemble of low-level criminals. Neil Jordan's *The Good Thief* moves its action slightly south of its Paris-set source film to the French Riviera and mixes East European, Algerian, and white American actors. Although remakes only in the broadest sense, borrowing titles, characters, and kernels of plot from their predecessors, as genre productions all the films emphasize the camaraderie of men engaged in narrowly defined, extralegal enterprises. Generically, the heist film sets its male protagonists apart from the worlds of corporate work and the law, as well as from social institutions such as marriage and family. In *Ocean's Eleven* in particular, aside from a leading man whose romantic pursuits metonymically ensure his teammates' heterosexuality, group members are wholly unencumbered by family or romantic ties. *The Italian Job* does call attention to the undersexed or oversexed inclinations of its supporting characters. Still, even this film locates its men's interactions within the private bordered world of the small group in which each man's specialized skills compensate for his insubstantial or excessive (hetero) sexual abilities.

With heist film remakes blossoming in the early 2000s, we can locate neoretro as a specific pop cultural formation, a part of a generic cycle, and a textual feature of a distinct body of films. The term "neoretro" designates a mode of simultaneous transformation and recuperation. Contemporary heist films foreground in particular neoretro configurations of masculinity, shaped around male group relationships. The neoretro combination updates past sensibilities for contemporary tastes either as a bulwark against perceived losses (i.e., a response to patriarchy's manufactured crises of masculinity) or as an accoutrement to refined social roles (a revival of old masculinities for a postfeminist age, for example). In his work on "new retro" cinema, Philip Drake identifies the retro film as one of multiple film subgenres capable of activating the past. Retro cinema, he argues, fuses

past and present iconographies, accentuates "pastness" as a stylistic feature, and exploits that pastness to market films and ancillary products such as soundtracks.[8] *Ocean's Eleven* cohesively embodies each aspect of the retro sensibility that Drake describes. The film updates Rat Pack iconography through an ingratiating model of on-screen playfulness that extratextual discourses link to stars' offscreen behavior but that lacks the racial tokenism and misogynistic undercurrent that characterize the early 1960s' Rat Pack films. Like some retro films, the neoretro *Ocean's Eleven* continually measures its distance from the past—through arch antinaturalist performance and narrative emphasis on contemporary security technology—producing a sensibility forward-looking enough to sustain two more films. The neo-retro sensibility extends to films such as *The Italian Job*, which fuses retro elements such as a first-act European heist overseen by 1970s star Donald Sutherland with newer high-tech and hip-hop elements. The sensibility also undergirds the rejuvenated James Bond franchise, with the latest iteration of *Casino Royale* (2006) offering a retrosexual Bond, Daniel Craig's sculpted abs, shaved chest, and gay-friendly fashion sense countering (or complementing) the narrative's old-school patriarchal-spy elements, such as a genital-torture scene adapted wholesale from Ian Fleming's 1953 novel. The further Bond outing *Quantum of Solace* (2008) largely abandons any neoretro pretense in favor of the playboy adventuring and loose topicality characteristic of Bond films since the 1980s. However, other contemporary heist films as diverse as *Criminal* (2004; also a Soderbergh/Clooney production and a remake), *Inside Man* (2006), and *The Taking of Pelham 1 2 3* (2009) also manifest aspects of neoretro sensibilities, marking their distance from the past while valorizing particular modes of male communication, camaraderie, and conflict.

The generic heist film uses a crime plot as a backdrop for semi-intimate relations among male professionals. Correspondingly, reception discourse frames the 2001 *Ocean's Eleven* as a vehicle for male group interactions. Major U.S. critics found the newer film relatively insubstantial, either blandly or deliciously superficial. Words such as "suaveness," "flair," and "polish" recur throughout reviews, as does the suggestion that the film is less about the complex heist that drives its narrative than about the easy, familiar interactions among its male principals.[9] Such camaraderie has found its way into other contemporary heist films, films that negotiate the terms of their homosocial milieus in heterogeneous ways. Writer-director David Mamet's *Heist* (2001), for example, features a series of male double-crosses but also centrally emphasizes the relationship between middle-aged criminals played by Gene Hackman and Delroy Lindo. Despite this thematic emphasis on the interracial friendship, narratively *Heist* defines

male interactions principally in terms of competition and subterfuge. As the film progresses, deception and treachery far supersede professional bonds or apparent friendships. Mamet's characters express their masculinity through a combination of craftiness and deadly violence.

The U.S. remake of *The Italian Job* also turns on professional treachery but situates the joking relationships of its male cohorts alongside their professional activities. In the film a devious criminal (Edward Norton) betrays his fellow thieves, stealing the group's purloined gold and murdering their venerable leader (Donald Sutherland). This act galvanizes the remaining men, led by the young Charlie Croker (Mark Wahlberg), into collective action. As they plan their revenge, the group members engage in ongoing games of sexual one-upmanship. Beyond demonstrating their heterosexuality, the stylized fraternity-boy antics of Lyle (Seth Green) and Handsome Rob (Jason Statham) shift the film's energies away from a familiar heist film discourse of steely professionalism. Related to this rehabilitation of the generic heist film team, *The Italian Job* grants agency to men of different races, with instrumental roles for Mos Def (playing an explosives expert, just as Sammy Davis Jr. and Don Cheadle do in the versions of *Ocean's Eleven*) and Franky G, the latter of whom achieves an iconographic weight disproportionate to his small role in the film. Franky G's character receives a number of lingering camera shots, emphasizing his heavily muscled arms and also granting him an empathetic presence, perhaps evidencing African American director F. Gary Gray's investment in men of color. (The original *Italian Job,* by comparison, presents its criminal group as a band mostly of amiable, connotatively working-class buffoons, all white men.)

Given *Ocean's Eleven* Rat Pack origins, one might expect the film to nostalgize the era of its predecessor or retread conservative positions about male bonding. As with other neoretro remakes, though, its male groups and interactions are ultimately irreducible to such simple schemata. On one level, the cool relations among members of criminal groups in the neoretro heist film work conservatively, reaffirming sanctioned boundaries of male homosocial interactions. These relationships also function progressively, positing an original configuration of male interaction inclusive of racially and ethnically marginal figures. Proto–*Queer Eye for the Straight Guy* iconography aside, the *Ocean's* films make little allowance for homosexuality, which could be seen to fundamentally transform the overall group dynamic. The sequels do make room for Roman Nagel, an accomplice of the group played by Eddie Izzard as a fastidious English dandy. References to his interest in women, though, provide ripostes to the connotative gayness of his clothing and mannerisms (in *Ocean's Thirteen,* for example, he wears loafers without socks and fusses over a tea selection). *Ocean's Thirteen*

The publicity images for *Ocean's Thirteen* circulate the view of easy male camaraderie promoted across the series.

also admits a pun on his name and that of a former schoolmate, Greco, that plays on the polymorphous sexuality of British boarding schools, but only after Roman mentions women as one of many "distractions" in his life. Overall, the *Ocean's* films define their male group not by mutual antagonism, sexual anxiety, and mistrust but instead by communalism and recognition of specialized abilities. With this group, the films shun the ruthless individualism and fatalism prevalent across thriller and crime film modes. Fraternal conflicts instead turn on strategy decisions and on codes of male style. These codes, often expressed through clothing and comportment, make the group dynamics legible to viewers and facilitate the men's autonomy within and ultimate victories over inegalitarian institutions. In *Ocean's Eleven*, for example, tycoon Terry Benedict and his casino's operations signify big business, class condescension, and affectlessness.

The neoretro sensibility can also involve creative responses to contemporary challenges. In *Ocean's Eleven*, circulation within the casino and the theft of its money depend on control of surveillance technologies. Heist films regularly stage crimes as penetration-and-withdrawal operations that require circumvention of security technology. They often rely on lack of

Mark Gallagher

detection through sound: alarms must be disconnected, or strict silences must be observed (as in *Mission: Impossible* [1996] or its precursor, *Rififi*). In *Ocean's Eleven,* male professionals manage adversarial technology rather than combating it. Visuality and mediation gain primacy. Antagonists' vision is not obstructed but instead is deceived, and the films' viewers and antagonists together witness simulation, artifice, and masquerade. The resourceful criminal group combats its deep-pocketed adversary and a formidable surveillance apparatus through deception, in particular repeated episodes of implausible comic role-playing. Clothing and body language stand in for psychological and physical intensity, foregrounding layers of male performance. For example, in one scene Ocean and his second-in-command Rusty Ryan (Pitt) stage an argument for the benefit of one of their teammates. At another point Ocean receives an apparent beating in a camera-free room, but his assailant fakes the blows, exaggerating them through sound. Ocean's wrinkled clothes subsequently attest to his manhandling. Later at the culmination of the heist, the participants use sound to simulate a machine-gun battle. The film presents sound information as frequently misleading, with visual evidence proving only marginally more reliable. Overall, the men's collective control of audiovisual technologies and their simulation of a range of generic male pursuits both define their professional method and enable their fundamentally friendly interactions. The highlighting of such traits as flair and suaveness in reviews of the film suggests the broad appeal of this mode of male engagement at the outset of the twenty-first century.

STYLE WARS

Across the *Ocean's* series, the privileging of surface-level male style partly mutes considerations of class, and high class position is not the sole guarantor of winning style within the films. Instead, frequent impersonations and costume changes suggest the fluidity of class codes. *Ocean's Eleven* features superrich antagonist Terry Benedict (notably a character not drawing explicitly on Garcia's Cuban heritage) pitted against men from nearly every other socioeconomic stratum.[10] Benedict owns the thoroughly inauthentic Bellagio hotel and casino, an Italian-themed resort in the Nevada desert but one that does include visible international wealth (prosperous-looking Italian, French, and Japanese men sit at its casino tables) and authentic high culture (in historical reality, the Bellagio attracted press attention with the 1998 opening of its Gallery of Fine Art, which offers rotating exhibits of museum artwork). Aligned against Benedict are prison parolee Danny Ocean, Florida retiree Saul Bloom (Reiner), Atlantic City blackjack dealer

Frank Catton (Mac), wealthy racketeer Tishkoff, and other professional criminals of indistinct economic backgrounds. Danny Ocean, Frank, and Rusty dress in *GQ*-style nightclub wear. Tishkoff's outfits run to flamboyant excess: garish patterns and apparent acres of satin and silk. Bloom first appears in polyester casuals but exchanges this wardrobe for an expensive steel-gray suit to masquerade as an imperious East European businessman. Matt Damon's Linus Caldwell favors khakis and ballcap (supporting the film's coding of him as a "kid," a young newcomer), then branches out with a nondescript suit for his role in the heist. At the film's resolution he wears a more fashionable version of his preppy attire: a striped T-shirt and a casual jacket, a neobeatnik look that signals his membership in the style-conscious group. The group's technology expert, Livingston Dell (Eddie Jemison), wears badly matched sweaters and buttoned-to-the-top shirts. Of all the men he is the only one who sweats, a trait that defines his style as only haphazardly maintained. The acrobat Yen (Qin) wears a high-collared embroidered coat and later a form-fitting unitard. Explosives specialist Basher Tarr (Cheadle) sports a range of Euro-style clubwear. Finally, the Mormon Malloy brothers (Casey Affleck and Scott Caan) move through a series of disguises, impersonating southwestern rubes, casino employees, hotel-catering staff, and bodyguards.[11] Later in the series, the men's style codes evolve in accord with their surroundings. With much of its story set in sunny Italian locations, *Ocean's Twelve* puts Danny and Rusty in bright whites repeatedly, and even Linus appears in a modish cream-colored suit. These outfits put the men in sartorial competition with Cassel's Night Fox, who also favors an expensive Mediterranean-casual wardrobe. Finally, in *Ocean's Thirteen,* Danny and Rusty explicitly make over Linus in preparation for his role as a seducer, giving him a dark suit, cropped hair, and a Cyrano-esque artificial nose. Here too, former villain Benedict is stylistically rehabilitated thanks to his less antagonistic role and to the much gaudier moneyed-magnate style of new villain Willy Bank.

In *Ocean's Eleven,* sartorial shifts function narratively to advance the heist plot and thematically to make the film's conflict a war of male styles. Victory does not simply go to the best-dressed person; the mogul Benedict, flanked by his extravagantly garbed companion Tess, would win that category. Instead the film esteems the men who manage their styles most successfully, with understatement or controlled excess. The crime film generically turns on questions of specialized male skills, and *Ocean's Eleven* literalizes this thematic emphasis, favoring men who perform well in front of cameras, those within the film and those of the production itself. The film's narrative celebrates autonomy amid surveillance: as part of the heist plot, Ocean makes himself visible at the Bellagio casino from which he's

been barred. Contrastingly, Benedict prohibits Tess from kissing him as they admire an artwork, noting that "in my hotels, there's always somebody watching." Late in the film, a similar camera captures Benedict declaring his preference for money over Tess, and this recording, transmitted to a television in Tess's suite, ensures his romantic defeat. Scenes such as these exemplify the film's strategy of negotiating relationships through camera surveillance. When pressed, Benedict acts like a scheming businessman, but most of the other male characters and the lone woman Tess act like photogenic movie stars, comfortable in front of many cameras. Within the film, class and race privilege still matter, but so does one's ability to appear at ease in a performative setting.

Ocean's Eleven also anticipates the surveilling tendency that comes to define its cultural moment. Watching and being watched, particularly men watching men, are crucial to both the film's plot and its mise-en-scène.[12] Disguises, impersonation, diversions, and above all falsely staged images of secure areas thwart the casino's oppressive surveillance, represented via repeated shots of an "eye in the sky" room of video monitors that display security-camera footage. The men accept and navigate this surveillance apparatus. Indeed, they also arrange their own set of monitors in a Bellagio hotel suite. The film thus narrates their access to vision, with their gazes at surveillance-video feeds repeatedly contrasted with the misinterpreted or false footage transmitted to the "eye in the sky" room. In the film's third act, Benedict enters this room and studies the false footage himself, but he fails to detect the deception in time to prevent it. Again the dynamics that Neale identifies as key to cinema's attention to women and men—investigation and testing—both operate here in relation to men. Ocean and his men investigate the casino (via their own monitors) and allow themselves to be investigated (by hiding in plain sight). Meanwhile, Benedict tests the team unsuccessfully (arranging for Ocean's beating and setting other snares) and fails tests himself (in particular by revealing the limits of his affection for Tess).

The film acknowledges the perils of visibility—the team must circumvent the many surveillance cameras that could detect their crime—but transforms them into benefits. Popular cinema typically gives viewers sustained visual access to a film's principals, and Ocean's Eleven makes stars' playing for the camera essential to its plot. The film renders star performances, and the accompanying performances of characters, as assertions of power, control, and agency.[13] In its narrative construction too, the film works to maintain all the characters' screen presences. In their DVD commentary, Soderbergh and screenwriter Ted Griffin note that they tried to construct the film so that each of the eleven would make an appearance at least every ten minutes in screen time.[14] The film still maintains a hierarchy

based on stardom and white patriarchy: Ocean clearly leads, with Rusty as a near equal, and supporting actors' relative star power largely determines their centrality. At the same time, the film defines the group as an extralegal, utopian entity, somewhat removed from traditional social hierarchies. This group fragments and recomposes itself seamlessly to commit a crime that, the film implies, harms only the very wealthy. This implicit promise of relative equality suits the film's structural goal of maintaining the characters' screen presence. The narrative premise that the men regularly parade themselves in view of surveillance cameras suits this goal too, and in doing so feeds into arguments about male visibility and display.

SEEING AND SPACE

A heavily patrolled space packed with would-be lawbreakers, the casino in *Ocean's Eleven*—and indeed the real-world corollary of such a space—functions according to the regulatory spatial logic that philosopher Michel Foucault defines in *Discipline and Punish*. Foucault describes a seventeenth-century regulatory mechanism for quarantining plague outbreaks, an "enclosed, segmented space, observed at every point, in which the individuals are inserted in a fixed place, in which the slightest movements are supervised, in which all events are recorded, . . . in which power is exercised without division, according to a continuous hierarchical figure, in which each individual is constantly located [and] examined."[15] Foucault extends his survey to an analysis of Jeremy Bentham's panopticon prison model in which inmates are perpetually on display, always subject to an authoritative, carceral gaze. The cells serve as sites for performance and display: "they are like so many cages, so many small theatres, in which each actor is alone, perfectly individualized and constantly visible. . . . Visibility is a trap."[16] In *Ocean's Eleven*, though, visibility entraps only the surveilling powers. The presence of a competing surveillance mechanism—the gang's rigged "eye in the suite"—is crucial to this process. Significantly too, the group's apparent acquiescence to surveillance engineers their success. Again, the situation recalls Foucault's descriptions of surveilling power: "He who is subjected to a field of visibility, and who knows it, assumes responsibility for the constraints of power; he makes them play spontaneously upon himself; he inscribes in himself the power relation in which he simultaneously plays both roles; he becomes the principle of his own subjection."[17] Yet since *Ocean's Eleven* stages a series of performances, it expands the notion of playing both roles. The film does not simply render a conflict between the powerful and the powerless but instead shows a series of struggles for control, some illusory or

misleading. Throughout the film, power circulates among many individuals and groups.

Even as *Ocean's Eleven* superficially champions criminal enterprise, a sensibility compatible with the Las Vegas mythology of unregulated vice and libertarian economic freedoms, it strategically validates the gambling industry's corporate superstructure. Overall, the film's crime does not upset the economic system but instead only redistributes wealth. (In the film's sequels, huge sums of money continue to change hands, with some eventually diverted to charity as a comic punch line at the end of *Ocean's Thirteen*.) The Las Vegas milieu necessarily emphasizes the legal if unproductive exchange of money through gambling, a system that stimulates the economy not through production but instead through service employment and through the massive outlays of the casino infrastructure. Panoptic surveillance is instrumental to this economic model as well. As Foucault argues, "The Panopticon . . . has a role of amplification; although it arranges power, although it is intended to make it more economic and more effective, it does so not for power itself . . . ; its aim is to strengthen the social forces—to increase production, to develop the economy."[18] The criminal group's countersurveillance also refers to this by-product of power. Just as their scheme requires a substantial financial outlay, their crime causes no social disruption, only the dissolution of the unsatisfying romance between Tess and Terry Benedict. Aside from a comic flashback showing three past robbery attempts that are violently put to rest, the film features no unstaged physical violence, that is, violence represented as real within the diegesis. Even the explosive device used during the heist produces only an electromagnetic pulse that temporarily blacks out the city. The actual Bellagio's cooperation with the production suggests the degree to which the film endorses the Las Vegas mystique of luxury, sophistication, and omnipresent wealth.

PERFORMING RACE

The neoretro sensibility of *Ocean's Eleven* allows men to renew their dominance of the film frame but only by adopting modified codes of style, performance, and fraternization. The film imagines a world in which self-conscious performance underwrites positive race relations and the transfer of wealth from the very privileged to men of other class positions. Ocean and his team use public performance as a form of subterfuge. This performance fuses classical gentlemanliness, contemporary metrosexual dress and grooming, a professionalism that crosses historical periods, and a leavening of arrested-adolescent antics. For Mac's character, onetime casino

employee Frank Catton, a double-consciousness performance of aggrieved blackness contributes as well to control of a contested space. After joining Ocean's team, Catton moves from being a low-level service-industry worker to playing one, planting himself as a dealer in Benedict's Bellagio as part of the heist plan. (Later, in *Ocean's Thirteen*, he infiltrates Bank's casino by posing as a salesman of novelty slot machines.) In *Ocean's Eleven*, the team exploits Catton's subordinate status through a staged racial showdown. In Benedict's presence and in disguise as a barely competent state employee, Damon's Linus Caldwell refers to Frank as "colored," producing a commotion during which Linus steals a passkey from Benedict. The film's one racially motivated conflict is thus performed and artificial, with the men using a camouflage of racism to achieve their shared goal. While the racial antagonism is staged, viewers may recognize Frank's outrage as an authentic response, a realist performance akin to Mac's own standup comedy and television persona. In contrast, Rusty's arch caricatures of a federal agent and a local doctor in other scenes do not mobilize tropes of social inequity.

At the same time as *Ocean's Eleven* supports the conservative fantasy of vast wealth on conspicuous display, it challenges a conservative (or any prosocial) agenda by lionizing a criminal group. This mixed-race, mixed-ethnicity, mixed-age, extralegal male ensemble represents an original and vaguely utopian grouping. Still, the film does gesture toward conventional configurations of power. The sixty-something Jewish Reuben Tishkoff represents property and finance: of all the men, only his home appears, and he funds and presides over the operation without actively participating in it. Moreover, in *Ocean's Thirteen*, Tishkoff's bilking at the hands of the more diabolical mogul Bank mobilizes his old friends to restore his financial welfare (along with his mental health, imperiled by Bank's treachery). Tishkoff's friends rally to his aid, thus aiming to reinstate a more traditional Vegas entrepreneur. This restorative project also leaves out women entirely: "it's not their fight," Danny asserts with regard to Tess and Isabel, both of whom enjoy more central roles in the con games of *Ocean's Twelve*. Also across the series, the Afro-British Basher Tarr is less than fully integrated, marked as an outsider by his exaggerated accent and his slang discourse though visually joining the group at regular intervals in keeping with the film's circulation project. Similarly, Qin's nearly silent role as Yen makes it easy for viewers to regard him as an inscrutable Oriental, although the films make sport of this typage as well. While most of Yen's rare lines of dialogue are delivered in untranslated Mandarin, in *Ocean's Eleven* he speaks one line in English—"Where the fuck you been?"—to comic effect, showing the film's minimal if knowing commitment to cross-cultural dialogue.

While *Ocean's Eleven* methodically narrates performed conflicts involving men of different races, it conspicuously withholds the spectacular representation of one race-based combat significant to the crime plot. The heist coincides with a boxing match between black British Canadian Lennox Lewis and white Kazakhstani Vladimir Klitschko. While the film shows both men entering the arena and the boxing ring, they receive relatively little visual attention, and once they strip down to bare-chested fight attire, they appear only in fleeting glimpses. In one shot the camera passes across Lewis's body in the frame's foreground to focus on Tess and Terry seated at ringside. Another shot, from near Tess and Terry's vantage point, displays the men only on a video monitor and does not tilt up to the unmediated view. This brief sequence—the most elaborate by far staged for the film, requiring more than two thousand extras—specifically diverts the viewer's gaze from the spectacle of racial-ethnic-international physical conflict. The boxing match itself supplies a paradigmatically exploitative situation in that men's staged physical suffering profits the service industry. (Describing the heist plan to the team, Ocean notes the much-elevated gambling revenues on nights with marquee boxing matches, thus indicating this economic relationship in passing.) The film prefers fleeting or mediated views of the showcase bout, suggesting its lack of investment in this popular forum for male conflict. In contrast to films at the more action-packed end of the heist film spectrum—films such as *The A-Team* and *The Losers* (both 2010)—*Ocean's Eleven* fixes its attention not on partly naked, heavily muscled subalterns but instead on the wealthy businessman Benedict, his attractive consort, and the men who seek to undo him. The film swiftly extinguishes the fight view altogether, as Basher's rigged device causes the blackout just after the fight begins. When the blackout ends the fight appears to resume, but the film returns to its central story line and leaves the match behind.

Basher's instrumentality in the citywide blackout highlights the struggle for control of vision and vision technologies as well as the centrality of race in this conflict. The criminal gang's countersurveillance ostensibly thwarts the vision of Benedict's virtually all-white team of security personnel. Yet significantly, the gang's own surveillance is principally white on white. In most of the shots showing both gazers and agents, white men principally survey, and thus authorize, the actions of other white men. During the heist, sweaty techno-geek Livingston remains positioned at the video monitors while other men periodically appear behind him to witness the work of their comrades. The occasional departures from this white-on-white pattern are notable. In one brief scene, both Bernie Mac's Frank and Don Cheadle's Basher stand above and behind Livingston, making them

coauthors of a group gaze directed at the images of the other white men, Clooney's, Pitt's, and Damon's characters in particular. This configuration, with African American men as the purveyors of the gaze rather than its object, realigns the power of the many cameras within the film and that of the film camera itself. Generally, only black-dominated cinema foregrounds the gaze of black men. For example, in private eye films such as *Shaft* (1971), the protagonist's restless gazing propels the narrative, and in the 1990s' in-the-hood film *Menace II Society* (1993), black criminals replay a security videotape of a lethal convenience store robbery. In more recent films of *Ocean's Eleven*'s vintage, the powerful gaze of the black heavy— Keith David's wealthy drug lord in *Requiem for a Dream* (2000) or Michael Clarke Duncan's villainous Kingpin in *Daredevil* (2003)—represents a specific threat to white femininity or to the legitimate social structure. U.S. cinema, from black or white filmmakers, regularly offers the black gaze as a threatening one, aligning it with criminality or with sexual desire for vulnerable white women. In contrast, *Ocean's Eleven* affirms the legitimacy of the black male gaze in mainstream cinema while using that gaze to amplify the savoir faire of the film's white principals.

Heterosexuality, Technology, and the Male Group

Ocean's Eleven articulates multiracial, multiethnic male style through a series of complex negotiations. Amid these maneuvers, the film introduces questions of male sexuality. *Ocean's Eleven* repeatedly shows men watching other men in highly mediated fashion: on video monitors as the men perform a series of masquerades, including those of paramedics, SWAT team members, and a Nevada Gaming Commission agent. The levels of mediation limit the potentially homoerotic spectacle of the performances, as the male group's gaze finds its object only through relays of technology. The relays preclude physical contact and complicate but by no means prohibit acts of voyeurism. In one scene, the film comically acknowledges the homoeroticism of this visual dynamic. As Danny and Linus, in snug black T-shirts and tight synthetic vests, prepare to gather the Bellagio vault's money, the film cuts to a shot of other men staring at the monitor, and the elderly Saul remarks, "That is the sexiest thing I have ever seen." He refers to the money, but the shot of the two stars is presumably the sexier sight for many viewers. Despite his earlier impersonation of an expensively dressed and floridly accented European player, the Florida retiree Saul is iconographically the last candidate for homosexuality among the group, so his pronouncement offers a joke to viewers without substantively questioning the group members' collective sexuality. The film explicitly asserts only

two team members' heterosexuality. Danny Ocean's goal of reunion with Tess underwrites the heist plot and drives the film. More ambiguously, at the film's coda Tess says to Danny that "we need to find a girl for Rusty." Her statement calls attention to the homoeroticism of this final scene in which Danny, Rusty, and Tess drive off in a car, with Tess relegated to the back seat.

Beyond representing curious gender configurations, films from Hollywood and elsewhere that feature mostly male ensembles routinely ask what it means to be a man in a group or team. Such films show men balancing individualism and teamwork, pursuing personal goals (of work, pleasure, or romance) alongside group goals (which can involve all three as well). With their interest in cosmopolitan heterosexuality, neoretro heist films often show individual pursuits—particularly romantic interest in women—as initially threatening but ultimately beneficial to male groups. In *Ocean's Eleven*, Danny Ocean's pursuit of Tess ultimately complements his team's heist plan. Later, in *Ocean's Twelve*, Tess contributes to the group's successful role-playing, as does Rusty's paramour Isabel, a Europol agent whom the film also presents initially as a complication to the heist activity. Similarly, the films include subplots of occasional solo activity (e.g., secretive phone calls) that suggest selfish motives, but such activity invariably turns out to have been instrumental to the group's success as well. For the most part, the *Ocean's* films work to limit viewers' but not team members' full knowledge of group plans. In films such as the updated *Italian Job* and *Casino Royale*, though, key characters betray their comrades or loved ones but in ways unsurprising to savvy genre-film viewers. While these and many other heist films routinely say "use your instincts, act in your own self-interest, and trust no one," the *Ocean's* series says instead "work for the team, and look good doing it."

Like many of their neoretro descendants, the *Ocean's* films define their semipublic spaces as sites for heterosexual men to interact, work, and perform, occasionally with female company. *Ocean's Eleven* in particular uses its locations for multiple showcases and tests of homosocial masculinity. The film repeatedly delivers the runway-model spectacle of handsome, carefully attired men striding down well-lit corridors and across casino floors. The overarching remarriage plot mitigates this spectacle's homoeroticism, although that plot is itself a test of masculinity, pitting Ocean against Benedict. Consistent with popular representations generally, the spectacle favors white men. In contrast, Cheadle's role includes scenes of him emerging from a sewer caked in mud and, later, sitting alone in a hotel room. (*Ocean's Thirteen*, meanwhile, repeatedly shows him laboring over a large underground drill.) For his key contribution to the first film's heist,

he appears alone in a long shot in an empty parking lot. In his roles as blackjack dealers, Mac is similarly static, standing behind a card table in a casino-issued outfit. He does wear a stylish brightly colored suit for a scene in which he literally strong-arms a car dealer, but here too Mac remains virtually motionless. Black men provide the foundations for the heist, leaving their white partners free to range about with movie-star panache. The very presence of African Americans (and to a much lesser extent of the Chinese Yen) signifies the hip multiculturalism of the otherwise white group, allowing the film to parcel out physical command of space to actors Clooney, Pitt, Damon, and Reiner.[19] As the Bellagio's owner, Benedict also commands physical space, but the film marks this authority as illegitimate, based on tightly wound severity rather than carefully but casually managed style. Ocean's clothes, including the tuxedo he often wears, are modishly rumpled, and Rusty favors inelegantly wide collars and wears a sport coat and tie only in his deliberately clichéd disguises. Benedict's style is more inflexible, his gait purposeful rather than relaxed, and he is ultimately undone by the too-candid performance, captured on his hotel's security cameras, in which he reveals his largely mercenary interest in Tess. His loss of command spurs Tess's departure from the casino, filmed in a long tracking shot; prior to this scene, she appears only within the Bellagio interior.

The *Ocean's* series evokes not only casino cultures' various style options—from slot machine–jockey comfort wear to nouveau-riche flash to high-rolling luxury—but also a Sharper Image milieu of arcane male gadgetry. The sequels continue to emphasize surveillance technologies and mediated looking, with computer screens, miniature cameras, and even rifle scopes isolating views of people and places. *Ocean's Twelve*, in dialogue with European heist films of the 1960s and 1970s, also shows physical tools used to overcome high-tech security: Ocean's group uses a tabletop model of the so-called Galleria d'Arte di Roma in their heist planning, and the Night Fox eludes a laser alarm array with a polished gymnastics routine. *Ocean's Thirteen* resumes the series' love affair with casino gadgetry, requiring the team, among other challenges, to circumvent a security system that not only sees and hears patrons but also scans them biometrically for signs of suspicious behavior. Both sequels give viewers many shots of screens within screens, often depicting further male role-playing. At the end of *Ocean's Thirteen*, for example, a television in an airport waiting area shows Benedict explaining to Oprah Winfrey his avowed interest in charitable giving, and the scene then shows Danny, Rusty, and Linus watching his performance as they prepare to depart. Across the series, men bond implicitly while watching video together, just as they do through their serial engagement with digital, analog, mechanical, and manual technologies.

Mark Gallagher

Black and East Asian men use some of these technologies, but as for neo-retro heist films more broadly, white men enjoy the most sustained access to and mastery of contemporary technology.

IT'S A (WHITE) MAN'S WORLD

The climactic events of *Ocean's Eleven* depend on performance and masquerade and, in particular, on malleable white masculinity. To extricate themselves from the casino vault they penetrate, some of the men don the black jumpsuits and face masks of SWAT commandos, temporarily hiding their features. Meanwhile, other group members, including the black men Frank and Basher, remain in a hotel suite watching the staged action on a video monitor. Here the film partly contests the convention of representation in which white men savor the limelight while nonwhites are subjected to a punitive, emasculating gaze. Instead, black men watch from a safe distance. However disguised, white men are central to the film, upholding a racial hierarchy more retro than neo. Despite periodic incursions from black and Asian men, white men dominate visual and narrative space. They can be chameleonlike in their shifts of identity (as are Rusty and Linus as well as Casey Affleck and Scott Caan's clownish Malloy brothers) or fully on display (as is Danny, who plants himself at a casino bar before his role in the heist and later allows himself to be arrested). In all, they bear out Richard Dyer's observation that white men—despite their apparent racial invisibility and their definition in relation to other races rather than through essential characteristics—remain "at the centre of global representation."[20] Across the *Ocean's* franchise, flexibility of personal style guarantees this centrality, as white men are able to mobilize a range of charismatic personas irrespective of social class while evading the grasp of authoritarian institutions.

Neoretro heist films such as the *Ocean's* series speak to Hollywood and other cinemas' narrative, formal, and generic investments in the pleasures and power dynamics of men looking at other men. Technologies of looking and recording throw gendered style codes and racialized social interactions into relief. At their most enlightened, such films offer opportunities for advantageous male performance as well as for positive group relations. These films can show us men ruthlessly besting their competitors or betraying their allies, but they can also represent enriching male work, play, and friendship. We can conclude with attention to two disparate moments in *Ocean's Eleven* that exemplify the series' treatment of male looking and race-based style. The first is Danny Ocean's release from prison, which actually occurs twice, both at the beginning and end of the

film. Both times he wears a tuxedo, indicating a festive situation preceding his internment. The film also takes a casual view of incarceration by not showing the prison itself. The opening scene depicts Danny speaking before his parole board, but the camera remains in a medium-long shot on him, never cutting to his questioners. Thus, *Ocean's Eleven* maintains the genre film fantasy that repeated prison terms need not encroach measurably on a man's personal style.

White men in the *Ocean's* series respond to social control by dressing up and putting on a show. The films' black men, laboring in popular representation under the legacy of minstrelsy, negotiate social control in different ways. *Ocean's Eleven*'s other notable synthesis of style, race, and the look occurs midway through the film, accompanying the public spectacle of the destruction of the fictional Xanadu Hotel. While Danny and Rusty stand in a crowd witnessing the demolition, Basher views it from a hotel room. Given his role as the team's explosives expert, professional curiosity could motivate his viewing. Sitting on a couch in an undershirt, he watches the event on television, although one shot shows the hotel fully visible through the window behind him. Aside from its visual irony, the brief scene suggests that this black character prefers the mediated spectacle to the unmediated view; this preference joins him thematically with his surveillance-conscious white teammates. Moreover, the scene hints at the possibilities of black use of media technology, particularly as a means to upset power. The demolition causes a temporary power surge, inspiring Basher's plan to stage the citywide blackout that serves as a diversion for the heist. The viewing of the demolition marks his literal turning away from destruction, as he instead pursues an undamaging use of technology. This insight occurs in an exceedingly casual setting, with Basher lounging on the couch half-dressed and thus embodying a male style distinct from the upper-class leisure style favored by the white stars.

The racial and style politics of the *Ocean's* series must be contextualized alongside the narrative and generic parameters of the films, which insist on the antic, self-conscious nature of male performance. At the same time, the series occupies a cultural milieu in which race matters a great deal and a context of film representation whereby fictional characters' activities are routinely presented and received in strongly racial terms. While not all neoretro heist films offer similar dynamics of interracial male engagement, the scenarios that the *Ocean's* series imagines for male group activity offer models for critical approaches to other representations in popular cinema and popular culture. Progressively and conservatively, the *Ocean's* films merge their inflections of style into a coherent rendering of uncompetitive male solidarity. These films ultimately withhold substantive critiques

284 *Mark Gallagher*

of inegalitarian social institutions and belief systems. Nevertheless, they demonstrate that popular cinema's configurations of masculinity need not depend on violence, suffering, misogyny, or racial scapegoating.

NOTES

Thanks to Elaine Roth, Karen Eng, and Claudia Springer for valuable comments on drafts of this essay and on the films that it investigates.

1. *Ocean's Eleven* opened in the United States in December 2001. The television series *Queer Eye for the Straight Guy* debuted on the Bravo cable channel in July 2003.

2. Steven Cohan, *Masked Men: Masculinity and the Movies in the Fifties* (Bloomington: Indiana University Press, 1997), notes the centrality of performance and masquerade, at the level of star image and within film narratives, in films such as *Picnic* (1955), *The Man in the Gray Flannel Suit* (1956), and *North by Northwest* (1959). The original *Ocean's Eleven* follows this trend, with Frank Sinatra, Dean Martin, Sammy Davis, and other Rat Packers playing characters virtually identical to their offscreen show-business personas and performing occasional musical numbers within the film. Later, in his essay "Queer Eye for the Straight Guise: Camp, Postfeminism, and the Fab Five's Makeovers of Masculinity," in *Interrogating Postfeminism: Gender and the Politics of Popular Culture*, edited by Yvonne Tasker and Diane Negra, 176–200 (Durham, NC: Duke University Press, 2007), Cohan investigates the metrosexual ideal toward which *Queer Eye for the Straight Guy*'s interactions of straight and gay men invite viewers to aspire.

3. Steve Neale, "Masculinity as Spectacle: Reflections on Men and Mainstream Cinema," in *Screening the Male: Exploring Masculinities in Hollywood Cinema*, edited by Steven Cohan and Ina Rae Hark (London: Routledge, 1993), 18.

4. Ibid.

5. Ibid., 19.

6. Representative examples of the period include Rock Hudson–Doris Day films such as *Pillow Talk* (1959) and *Lover Come Back* (1961), Frank Tashlin's late 1950s' comedies such as *Artists and Models* (1955) and *Will Success Spoil Rock Hunter?* (1957), Elvis Presley musicals, and other Rat Pack films such as *Sergeants 3* (1962), *Robin and the 7 Hoods* (1964), and *Marriage on the Rocks* (1965).

7. As in many studio films, strategic casting of men of different ages, races, and ethnicities helps attract disparate audiences. Whatever the motivation, contemporary heist films grant black or elderly actors roles with more agency and depth than do token roles in 1970s' ensemble films such as *Earthquake* or *The Towering Inferno* (both 1974).

8. Philip Drake, "'Mortgaged to Music': New Retro Movies in 1990s Hollywood Cinema," in *Memory and Popular Film*, edited by Paul Grainge (Manchester, UK: Manchester University Press, 2003), 187.

9. *Salon*'s Stephanie Zacharek calls the film "sharply creased and polished" ("*Ocean's Eleven*" [review], Salon.com, December 7, 2001, http://www.salon .com/entertainment/movies/2001/12/07/oceans_11/index.html). The *New York Times*' Elvis Mitchell describes it as "an elating blaze of flair and pride" and argues that its chief interest is "manicured, superbly outfitted masculinity" ("For the New Rat Pack, It's a Ring-a-Ding Thing," *New York Times*, December 7, 2001, http://movies.nytimes.com/movie/review?res=9F03E5D8123CF934A35751 C1A9679C8B63). Roger Ebert, in the *Chicago Sun-Times*, calls it "not a movie about suspense but about suavity" and describes Andy Garcia's character as "groomed, polished and tailored" ("*Ocean's Eleven*" [review], *Chicago Sun-Times*, December 7, 2001, http://rogerebert.suntimes.com/apps/pbcs.dll/article ?AID=/20011207/REVIEWS/112070302/1023). Similarly, in the *Village Voice*, J. Hoberman describes George Clooney's character as a "suave mastermind" ("Role Players and End Games," *Village Voice*, December 4, 2001, http://www .villagevoice.com/2001-12-04/film/role-players-and-end-games/).

10. Benedict is loosely modeled on casino mogul Steve Wynn, onetime owner of the Bellagio and many other casino-resorts.

11. Relatedly, in a making-of documentary on the film's DVD release, costume designer Jeffrey Kurland broadly outlines the intended style signifiers of the main characters' outfits.

12. By making video surveillance so central to the film's plot, *Ocean's Eleven* calls attention to the process of staging film scenes as well. As noted above, characters within the film periodically act like movie stars, and Brad Pitt's brief caricatures of a tough-talking cop and a frenzied doctor satirize tired genre film conventions. Similarly, many elements of the heist are staged specifically so that casino security personnel can view them on closed-circuit video. Reviewing the David Mamet film *Heist*, the *New York Times*' A. O. Scott remarks that "one of the reasons filmmakers are perpetually drawn to heist pictures is that an elaborately planned, extravagantly risky criminal caper can serve as a metaphor for filmmaking itself" ("Forget the Girl and Gold; Look for the Chemistry," *New York Times*, November 9, 2001, http://movies .nytimes.com/movie/review?res=9C00E5DB1F39F93AA35752C1A9679 C8B63). Following this logic, the elaborate surface-level intrigue of *Ocean's Eleven*'s plot mirrors Soderbergh and his crew's own experiences managing a massively budgeted star-driven studio film.

13. In her review of the film on the PopMatters website, Cynthia Fuchs suggests that the chief appeal of the 1960 *Ocean's Eleven* is that it "is about your access, your feeling that you're seeing Frank and Sammy and Dean hang out, improvise, horse around (however this access is contrived)." As Fuchs observes, the 2001 version of the film depends on a similar type of access: "your watching their good time is what's important" ("*Ocean's Eleven*," PopMatters, December 6, 2011, http://www.popmatters.com/pm/review/oceans-eleven). The remake also promises access to the veiled operations of the casino, fabricating a world of nearly airtight security, industrial corridors, and sleek elevators—iconography

of the spy thriller or high-tech caper film—within the colorful but familiar space of Las Vegas casinos.

14. Commentary track, *Ocean's Eleven* DVD (Warner Home Video, 2002).

15. Michel Foucault, *Discipline and Punish: The Birth of the Prison*, translated by Alan Sheridan (New York: Vintage, 1979), 197.

16. Ibid., 200.

17. Ibid., 202–3.

18. Ibid., 208.

19. Claudia Springer's essay "Playing It Cool in *The Matrix*," in *The Matrix Trilogy: Cyberpunk Reloaded*, edited by Stacy Gillis, 89–100 (London: Wallflower, 2005), identifies a similar pattern of black cool underwriting white male agency in the hugely popular *Matrix* films.

20. Richard Dyer, *White* (London: Routledge, 1997), 39. For more on the simultaneous invisibility and power of racial whiteness, see in particular chapter 1, "The Matter of Whiteness."

Gina Marchetti

Flexible Masculinities and the *Rush Hour* Franchise

The Asian Body, the American Male, and Global Hollywood

Although some performers may detest roles or despise projects pursued for a pecuniary end, few actors dare admit that they do not like a film in production or in current release. Jackie Chan stands as a firm exception to that rule. After decades pursuing the American Dream of star standing in Hollywood, Chan cannot admit to liking any of the three *Rush Hour* films he made with costar Chris Tucker (1998, 2001, 2007), all directed by Brett Ratner, and does not seem to be any happier with Rob Minkoff's *The Forbidden Kingdom* (2008), which pairs Chan for the first time with Jet Li.[1] With regard to *Rush Hour 3*, Chan remarks on his blog that "Nothing particularly exciting stood out that made this movie special for me . . . I spent four months making this film and I still don't fully understand the humor."[2] In fact, he did not care for the first *Rush Hour* either: "When we finished filming, I felt very disappointed because it was a movie I didn't appreciate and I did not like the action scenes involved. I felt the style of action was too Americanized and I didn't understand the American humor."[3] Although the third installment did not deliver the same profit as the first two films, all three *Rush Hour* releases have been reasonably successful. A very rare star indeed distances himself from his successes, claims to feel alienated from them as foreign ("too Americanized"), and admits to not understanding them fully.

Imagining a slightly different scenario, it is not easy to picture other immigrant action stars, such as Arnold Schwarzenegger, Jean-Claude Van Damme, or even Jet Li or Chow Yun-Fat, making similar remarks. A self-deprecating blog with a critical edge that goes against the box office does not really suit the image of the male action hero on or off the screen in Asia or in Hollywood. In fact, this flies in the face of the model male action

performer as a man of few words (fewer critical comments), a proud demeanor (no self-doubt), implicit wisdom (always understanding), and with a quiet mastery of every situation (in America or anywhere on the planet). However, for Jackie Chan, it marks an offscreen continuation of an on-screen swarm of contradictions involving his race, ethnicity, and masculinity within the context of the postmodern Hollywood-produced global action feature. From one perspective, Chan fashions a new type of masculinity within global Hollywood; however, as Chan experiences the situation, his identity seems too flexible, and he feels himself slipping away. He becomes the object of jokes that he cannot grasp and the agent of kicks, punches, and flips that make no sense to him as a martial arts performer.

However, *Rush Hour* is not exclusively a Jackie Chan star vehicle, and Chan must share the screen with African American comedian Chris Tucker as well as with a supporting cast of damsels in distress and villainous rogues. As an icon of masculinity (more specifically, nonwhite, non-Western, non-American maleness), Chan functions within the Hollywood blockbuster as a site of ambivalent desires, frustrations, and fears for the global audience. His masculinity must always be situated within this commercial context with an eye to satisfying domestic viewers, crossing national borders, overcoming class divisions, and recognizing gender differences from a Hollywood perspective. However, Chan himself remains impervious to *Rush Hour*'s appeal. Although the packaging takes on the trappings of the Chan star persona in Asia, the end product does not sit well with the star and remains outside his comprehension as "too Americanized."

Within the context of the action film, this notion of America remains inextricably linked to the imagination of gendered bodies and definitions of masculinity and femininity. By looking at Chan's contested masculinity within this context, a better understanding emerges as to what constitutes American masculinity on-screen, how race factors in, and how the tensions surrounding the male body within the Hollywood action genre have changed since September 11, 2001. As Chan's experience of being in *Rush Hour* conflicts with box office facts, questions of how different forms of masculinity and ethnicity operate within the global action film surface. Chan walks the line between being an envied flexible citizen of a brave new globalized world and evaporating into nothing as alienated, deracinated, expatriated, and emasculated.[4] His coming out against *Rush Hour* as the series marked ten years after the change of sovereignty of Hong Kong in 1997 and changing attitudes toward China and America since 9/11 adds another layer to the way in which Chan's performance as a man, as an Asian man, as a Chinese man, and as a Hong Kong man must be factored in to any analysis of masculinity in the series.

Asian martial arts star Jackie Chan and African American comedian Chris Tucker share the screen in *Rush Hour*.

RUSH HOUR AND AMERICAN MASCULINITY

Although America looms large in all three *Rush Hour* films, it plays an ambivalent role in the series, and the depiction of American masculinity in relation to Chinese masculinity remains malleable. In the first *Rush Hour,* the main contest boils down to corrupt British colonials in league with Hong Kong triads in a battle against the emerging power of the People's Republic of China. Under the aegis of the Federal Bureau of Investigation (FBI) and the Los Angeles Police Department (LAPD), America, through James Carter (Chris Tucker), functions mainly as the world's cop, a role that the nation has fashioned for itself and has been duly criticized for assuming. In *Rush Hour 2,* a corrupt Hong Kong cop joins forces with the triads and a shady Las Vegas businessman on a transnational deal countered by U.S. law enforcement. In this case America, in addition to patrolling the world, must also police itself and the excesses of capitalism embodied by Las Vegas. However, Hong Kong, although physically present in the first part of the film, gradually becomes less important to the plot. Wendy Gan observes that "Hong Kong, despite its presence in *Rush Hour 2,* thus tends to become marginalized in the film's imagining of global relations as U.S.-centric."[5]

Rush Hour 3 moves farther away from America as the battle turns to corrupt Europeans with Asian underworld connections in a fracas with

a motley group of avengers (Hong Kong Chinese, African American, and French) who have little official standing internationally. However, with this move physically away from the United States, America becomes more hotly contested terrain within the global imagination. There appears to be a clear shift from *Rush Hour 2* to *Rush Hour 3* in this respect, and given the topical clues peppered throughout the third film, this change seems to be linked to perceptions of America and American masculinity after September 11, 2001. Torture for information, sadism connected to homosexual humiliation, and European criticism of America's so-called outlaw mentality become important themes in *Rush Hour 3*.

There is also quite a lot of post-9/11 Orientalist humor in *Rush Hour 3*. For example, Carter finds himself demoted to traffic cop at the beginning of the film because he mistakenly jailed a group of Iranian scientists as "terrorists." He defends himself with the quip "Because they cure cancer in rats? That doesn't mean they won't blow shit up." If the first *Rush Hour* drew on the still-sensitive issue of the LAPD's beating of Rodney King on video in 1991 and the civil unrest occasioned the following year by the acquittal of the white policemen involved, then *Rush Hour 3* moves, post-9/11, to the issue of racial profiling, the USA Patriot Act, and questions about the suspension of habeas corpus. Post-9/11, topical allusions to American Orientalism in popular culture abound, and *Rush Hour 3* provides only a single example.

With Edward Said's notion of the Orient as the West's "underground self" in mind, looking at Jackie Chan as a projection of Hollywood fantasies makes sense.[6] Chan may bristle at racism, Western xenophobia, and American chauvinism. However, he should not claim to not understand them. In fact, he appears to be more than a bit disingenuous with this point on his blog. He has always been aware of his African American fans and his global appeal beyond Asia to Hispanics, nonwhite minorities in Europe, and others outside the Euro-American mainstream.[7] References to figures such as Michael Jackson and other aspects of African American and Hispanic culture pop up in many of Chan's Asian features, and he has indicated a certain understanding of racism and ethnic antagonism in many of his films. Moreover, he has drawn on American entertainers such as Buster Keaton and Harold Lloyd for inspiration for his stunts, and it is not so easy to label a particular action style as purely Asian or American within a genre that feeds on Japanese, European, Hollywood, and Chinese film traditions.

With an eye on Hollywood early in his Hong Kong film career, Chan often spoke of his work in relation to American film.[8] However, he now feels a need to walk away from this malleable hybrid mimicry, disavow his complicity with its construction, and, as he grows older, attempt to craft a new identity

distinct from his role as Inspector Lee in the *Rush Hour* series. Even in Hollywood productions such as *The Karate Kid* (2010), Chan embraces the role of Beijing-based martial arts master rather than take up the role of Asian immigrant inaugurated by Pat Morita in the 1984 version. In fact, on a trip to India, Chan even urged Asian filmmakers to unite against Hollywood's global screen hegemony: "Asians should unite against American cinema. . . . Why do we need to ape their culture?"[9] Changing geopolitical circumstances may help to explain why, and these political transformations remain inextricably bound to notions of gender in the cinema.

THE MASCULINE MASQUERADE IN ACTION

Chris Holmlund, in her essay titled "Masculinity as Multiple Masquerade: The 'Mature' Stallone and the Stallone Clone" on the male star buddy film, underscores the role that performance plays in any embodiment of gender on-screen.[10] The masculine masquerade takes on elements of colonial mimicry, racial passing, homosexual panic, fetishism, and spectacular violence. In portraying Inspector Lee, Chan therefore must perform a number of different and often conflicting male roles from a wide range of cultural and aesthetic traditions. He must fit into the parameters set for the action hero within what Melvin Donalson has called the "interracial buddy film."[11] Chan deals with the racial tensions attached to the pairing as well as the homophobic jockeying for power within a homosocial relationship between men, which may be seen as somehow queer. Beyond this, Chan also needs to reconcile Hollywood's traditional representations of Asians and Asian Americans (from Charlie Chan to Bruce Lee) with the star persona that he laboriously constructed for his Asian fans.

Many scholars have noted that Jackie Chan's performance of masculinity differs from other male stars in Asia as well as in Hollywood. As a comic, Chan does not adhere to the same screen rules followed by comparable action heroes. For example, he occasionally performs in drag or partially naked, takes jokes about his sexual inadequacies in stride, and deals with situations involving queer characters with unflappable goodwill. He takes on female and male adversaries in combat and never seems to treat female martial artists as any less able than male opponents. In a fight against Hu Li (Zhang Ziyi) in *Rush Hour 2*, for example, Chan/Lee shows he is a match in every way for his female opponent by demonstrating his remarkable agility. Clearly, Chan was particularly proud of his ability to slide through a slit in a teller's window in a Las Vegas casino, since he put clips of the failed attempts in the outtakes featured during the ending credits. Arnold Schwarzenegger or Sylvester Stallone could never dream of getting their bulky

Gina Marchetti

frames through such a tight spot. In addition to this physical "feminine" flexibility, Kam Louie sees Chan's emotional sensitivity and vulnerability as comparable to "any New Age Guy."[12] Mark Gallagher, Kwai-Cheung Lo, and others perceive a gender-bending component to Chan's performance of masculinity that takes him outside of the macho realm inhabited by most male action stars.[13] As Kwai-Cheung Lo observes, Chan appears to inhabit a "space" associated with the feminine in the *Rush Hour* series: "Although Chan's image is by no means effeminized, as many Asian men were in earlier Hollywood films, his ethnicity has already been framed in a passive feminized space."[14]

However, Chan does not combat Hollywood's traditional portrayal of Asian men as either impotent eunuchs or rapacious villains with a hypermasculine Asian chauvinism. Playing off what David Eng has termed "racial castration," Chan carves a niche for himself as "flexible": neither too masculine nor too effeminate, Chinese but open to American ways, physically strong but vulnerable, a clown with manners befitting a Confucian gentleman.[15] In his work on Jackie Chan, Steve Fore has pointed out the power of the scene in *Rumble in the Bronx* (1995) in which Chan interrupts a brawl to give a lecture on social harmony, ending with an invitation to his street gang opponents to sit down and have a cup of tea.[16] In a similar scene in *Rush Hour 2*, Chan/Lee interrupts a triad fight taking place on bamboo scaffolding on the side of a Hong Kong apartment block. After using laundry to tie up the triads, he apologizes to the old "Uncle" in the flat and to his wife for disrupting their dinner. Good manners and Confucian respect for the elderly contribute to the rhythm of the action, and Chinese culture becomes part of the fabric of the *Rush Hour* series through Jackie Chan's cultivation of a particular masculine persona.

Chan was trained in Peking Opera from an early age, and his martial talents and physical features thus make him a natural for *wu chou* roles. Although these clowns with martial arts skills and acrobatic prowess play supporting parts in Peking Opera, this character type became a staple of the kung fu comedy with which Chan has been identified in Hong Kong cinema. Even in the *Rush Hour* series, close-ups of Chan's features (including his prominent nose) in a droll grimace conjure up images of the *chou*, with the white patch highlighting the nose as the comic centerpiece of the face. The image of masculinity projected by the clown remains flexible. He may be lowly, but he is often witty. He may be an ordinary fighter who can be exceptionally agile and tough. Although the character may be a commoner, the *chou* performer occasionally outshines those in principal parts.

In the *Rush Hour* series, Jackie Chan as Inspector Lee certainly brings the potential of the *chou* to disrupt hierarchical notions of masculinity to

the screen. He does not step in as the Confucian scholar or Chinese warrior in command. Rather, he enters as a clown, part of the carnivalesque element in the film. However, the line between subversive humor that may explode macho bravura and comic humiliation that solidifies notions of the Asian as somehow unmanly remains thin. Chan may feel less a part of a project to refashion screen masculinity outside the white Western patriarchal norm and more the object of racist deprecation and a tool used to construct an apparently multicultural and multiracial American masculinity as a mask that covers the exercise of American domination on and off the film screen. As Slavoj Žižek warns, the subversive power of the carnivalesque may not be all that it seems: "I violently disagree with this carnivalesque vision of liberation. Carnival is a very ambiguous term, more often than not used by reactionaries. My God, if you need a carnival, today's capitalism is a carnival. A KKK lynching is a carnival."[17] While Žižek may be too dismissive of Mikhail Bakhtin's enormous contribution to understanding the operation of humor to critique the power dynamics operating within social hierarchies, Žižek's point about the ambiguous use and potential abuse of humor may help to explain Chan's *Rush Hour* malaise.[18]

Chan's body has been appropriated as part of a carnival that may have little to do with his own interests as a star or as a performer. Flexible, hybrid, malleable, and mercurial, the carnivalesque body may challenge masculine norms in ways that Chan finds disturbing or may solidify an image of masculinity that excludes him through laughter. Either way, *Rush Hour* has not liberated him, and he finds the humor obscure and the action mired in a specifically American sensibility.

Brotherhood in the Asian and African Diasporas

Gary Okihiro has talked about "yellow" as being between black and white in American culture, and the *Rush Hour* series carefully positions its characters in a world deeply divided by race.[19] Because of these very real divisions and the narrative importance of crafting a fantasy in which an ethnic Chinese man from Hong Kong can form a brotherly bond with an African American from Los Angeles, the series must struggle to create a common ground for these characters. Going back to the series' roots in blaxploitation and Hong Kong martial arts films, *Rush Hour* manages to recognize this history while drawing in a more mainstream American audience. In *Rush Hour 2*, for example, Lee meets one of Carter's African American contacts, Kenny (Don Cheadle), who operates a Chinese restaurant with his Chinese wife as a front for a gambling operation in the predominantly black Crenshaw area of Los Angeles. When Kenny and Lee start to grapple, they

recognize that they share knowledge of Tiger Claw kung fu and begin to chat in Cantonese.[20] Shared interest in martial arts has been an important part of ethnic Chinese and African American connections for decades, and the lead that Kenny gives Lee takes him to Zing (Ernie Reyes Jr.), another blast from this martial arts past. Reyes and his father both performed in *Berry Gordy's The Last Dragon* (1985), a film about an African American practitioner of Chinese kung fu. Fans within the American kung fu community know African American martial arts aficionados who do in fact speak Cantonese. While many may laugh in disbelief at a Chinese-speaking black man, the film pays homage to this niche audience that knows otherwise.

While the myth of the American multicultural melting pot works to a degree and bonds can form around shared popular culture (e.g., American music, Chinese martial arts, Hong Kong kung fu films), *Rush Hour* creates its most fundamental link between its protagonists through their masculinity. The two share a common heterosexual appreciation for the opposite sex (embodied by Hispanic and Afro-European actresses in the series to avoid the conundrum of supposedly racially inappropriate partners). Also, they have very similar family histories. Their fathers were police officers killed in the line of duty. However, confirming racist assumptions about Asian triads and African American gangs, both also have strong family ties to the criminal underworld. Carter's cousin runs a gambling den and has many close family members on the opposite side of the law. Lee's father's partner (an avuncular figure in Lee's life), Ricky Tan (John Lone), and his sworn brother Kenji (Hiroyuki Sanada), a yakuza with whom Lee spent his childhood in a mainland Chinese orphanage, become Lee's major adversaries in the series. In fact, both Ricky and Kenji taunt Lee with the intimacy of their relationships and the implicit Confucian obligations of their ties. Ricky compares Lee to his "weak" father, and Kenji criticizes Lee for his lack of brotherly loyalty. In *Rush Hour 3* in particular, Kenji puts Lee's "Asian values" in doubt, and Lee must choose between Kenji and Carter as "brothers" worthy of his loyalty. Therefore, to prove their own legitimacy, Lee and Carter must bond together against these intimate associations with Asian and African American criminality.

Because of the ideological potency of putting nonwhites at the service of policing the American multiethnic body politic, interracial buddy films are fairly common in Hollywood history. Although the teaming of an Asian and an African American as buddies may be rare, it is not unprecedented. For example, *Mulan* (1998), released the same year as the first *Rush Hour*, features African American comedian Eddie Murphy as the voice of the little red dragon Mushu, the female warrior Mulan's sidekick, and Murphy uses streetwise banter associated with the black stand-up tradition similar

to Tucker's in *Rush Hour*.[21] Following the popularity of *Rush Hour,* Sammo Hung (Jackie Chan's schoolmate from opera school) also paired up with African American comedian Arsenio Hall on the television series *Martial Law* (1998–2000), about a Chinese cop stationed in Los Angeles. Takeshi Kitano's *Brother* (2000), a Japanese action film, also pairs an Asian and an African American together in Los Angeles.

Kwai-Cheung Lo has compared Inspector Lee to Hollywood's Charlie Chan.[22] In fact, Charlie Chan was paired with African American sidekicks in the series, such as Stepin Fetchit as Snowshoes in *Charlie Chan in Egypt* (1935). However, Jackie Chan's Lee and Tucker's Carter really resemble two other characters from the Charlie Chan series more closely: African American chauffeur Birmingham Brown (Mantan Moreland) and Chan's Number Two Son (played by Victor Sen Yung or Benson Fong). In their comic repartee, Birmingham Brown and Number Two Son embodied racial types that highlighted cultural misunderstandings through humor. Although the *Rush Hour* series may start out with Jackie Chan as a rather orthodox cop in Hong Kong, Lee, through his friendship with Carter, quickly becomes acclimated to America by loosening his collar, grooving to Edwin Starr's "War," and enjoying his romp in Hollywood.

As in the Charlie Chan series, the relationship between the African American and ethnic Chinese characters revolves around cultural miscommunication, comic verbal exchanges, and slapstick humor within the context of a police mystery that allows for action sequences. While Charlie Chan was never known for his brawn, Jackie Chan beefs up the action and highlights the physical spectacle. However, as the upright and sometimes uptight cop, Lee, a filial son and determined crime fighter, resembles both Charlie Chan and his Number Two Son. As a stock type, the Chinese detective embodies the contradictions associated with Asian masculinity in Hollywood: brainy but unable to speak proper English, tied to the Old World while his children represent a comically Americanized facade, apparently asexual but the patriarch of a sizable family, a patriotic American rendered forever foreign, exotic, mysterious, and inscrutable by his race.[23] Lee fits easily within this Hollywood mold, crafted decades before, and Jackie Chan must struggle to break with convention to establish a different approach to Asian masculinity in Hollywood film.

Although the comically fearful Birmingham Brown may not resemble the plucky Carter as closely, both characters do fit within Hollywood molds for African American men. The voluble, crafty, overconfident trickster figure of the minstrel tradition has always had a place in Hollywood, and Carter, from his arrogant womanizing to his willingness to play the dozens with Lee, deviates little from established conventions.[24] African American

humor has long relied on balancing self-deprecation with jabs at other races (white and otherwise), and Carter serves as both the source and the butt of many of the jokes involving race, particularly those related to his sexuality. In the dialogue and through musical citations ("Another Part of Me" in the first *Rush Hour* and "Don't Stop 'Til You Get Enough" in *Rush Hour 2*), Michael Jackson (and his associations with plastic surgery and accusations of child molestation) haunts Carter with an alternative version of African American sexuality used for comic effect but also included to place Carter's masculinity within a wider popular cultural context.[25]

Although quite cocky, Carter seldom seems able to use his charm to get the girl. In *Rush Hour*, Carter's treatment of his partner Tania Johnson (Elizabeth Pena) would likely get him brought up on charges of sexual harassment if it occurred outside of Hollywood fiction. *Rush Hour 2* places Carter in a bordello with a nod to a similar scene in *Enter the Dragon* (1973) in which African American martial artist Jim Kelly finds himself unable to choose a single girl from the Asian beauties on display. However, Carter cannot satisfy his "big appetite," and it is coitus interruptus when a brawl takes his mind off sex. In *Rush Hour 2* and *Rush Hour 3*, Carter also faces the challenge of female masculinity in the form of tough triad women (Zhang Ziyi as Hu Li), female yakuza (Youki Kudoh as Jasmine), and a bald love interest whom he fears may be a transvestite (Noémie Lenoir as Genevieve). Even the little girl Soo-Yung (Julia Hsu in *Rush Hour* and a more grown-up Zhang Jingchu in *Rush Hour 3*) is a trained martial artist as well as damsel in distress. Although all the films have plenty of beautifully coiffed and attired call girls, chorus girls, and party girls to provide the backdrop for the display of masculinity, the series complicates the male spectacle by allowing female characters to infringe on male territory through martial artistry, gender ambiguity, or sexual independence.

Although Carter may seem somewhat oversexed while Lee appears to be undersexed, both buddies have trouble with the women in their lives. In *Rush Hour 2*, they briefly compete for undercover drug agent Isabella Molina (played by Puerto Rican actress Roselyn Sanchez), and Lee appears to succeed with her. His being cute "like Snoopy" translates into a brief kiss at the end of the film. However, as *Rush Hour 3* makes crystal clear, Carter managed to destroy their budding romance by putting the poor woman in the hospital. In fact, as in many buddy films, the bond between the men comes at the cost of relationships with women. In *Rush Hour 2*, the not-so-latent misogyny covers homosexual panic in Carter's standoff against Hu Li.[26] As they square off, Carter says, "I'm going to pretend you're a man—a very beautiful man, with a perfect body, who I'd like to take to the movies." In the middle of the fight, Carter grabs Hu Li from the rear and comments

on how good she smells; Hu Li responds by kicking him in the face. After he vanquishes her, Carter addresses her unconscious body: "We could have had something special, but you're one crazy-ass bitch."

Carter and Lee's homosocial bond puts the threat of homosexuality into play, as it does in virtually all Hollywood buddy movies. In *Rush Hour 3*, one of the female characters remarks, "You know what I hate about cops? Even when they're with a woman they can't stop thinking about getting their man." The fear of homosexuality limits the homoerotic dimension of the intensity of these male relationships. As in most action films, Lee and Carter navigate a course in which they can display their bodies and showcase their physical prowess while still maintaining an illusion of het-eronormative maleness. Because both are comic characters, this is some-times quite a challenge. Threatened by women, questioned by white male authorities, and demeaned by African American and Asian crooks, Lee and Carter cling to each other, imaginatively forming a whole out of the broken parts of multicultural, multiracial American masculinity. Coming from an action tradition rooted in blaxploitation and Hong Kong kung fu, the *Rush Hour* series continues to depict African American and Asian bodies as em-blems of violent physicality, sexuality, and strength to appeal to audiences living with the emasculating impact of racism and colonialism. *Rush Hour* brings that vision of masculinity under threat to a wider audience, using comedy to dilute the challenge that films of an earlier era posed to the white Euro-American bourgeois norm.

However, *Rush Hour* does maintain the villain associated with the blax-ploitation/kung fu tradition. In *Rush Hour 2*, when at a loss for a lead in the case, Carter says, "Follow the rich white man," which adheres to the blaxploitation/kung fu generic plotline. *Rush Hour* carefully constructs Lee and Carter's male identities by contrasting their masculinity with the gender norms associated with the white male Euro-American capitalist. Even though African American crooks and Asian thugs people the series and Ricky Tan is really the true villain of *Rush Hour 2*, the image of the rich white man remains the ultimate sign of genuine evil in the series, with greed and lust for power as his trademark faults.

In *Rush Hour*, Thomas Griffin (Tom Wilkinson), alias Jun Tao, covers his underworld triad connections with the respectable facade of a Hong Kong colonial administrator. However, in both his legitimate and illegal activities, he remains suspect as a wealthy British official who profited from colonialism. Although Ricky Tan (a corrupt former Hong Kong cop) is Asian, he cannot achieve his criminal ends without the help of his rich white partner, Steven Reign (Alan King), a Las Vegas kingpin.[27] The root of Asian triad/yakuza evil in *Rush Hour 3* is none other than European

Throughout the *Rush Hour* franchise, the body of Jackie Chan hangs quite anxiously—and literally—on Hollywood.

ambassador Reynard (Max von Sydow).[28] The influence of these rich white men is overly determined by their accumulated wealth, political power, and masculine authority. Although Carter and Lee directly or indirectly bring these men to justice, neither ever enjoys anything approaching the power and position of these villains. Ambassador Han (Tzi Ma), who appears in the first *Rush Hour* and in *Rush Hour 3,* also wields little actual power as a representative of the Chinese government in the West.

While Griffin and Reynard are Europeans and all three villains are tainted by their associations with the Asian underworld, they still manage to embody a particular image of the American Dream of wealth, individuality, and male power (albeit the dark side of that myth). The films reserve places for the remainder of the white male authority figures within the ranks of the FBI, the LAPD, and French police as mischievous, implicitly racist, incompetent, and in dire need of reform but ultimately benevolent. Lee and Carter's efforts serve to keep this authority intact and, as nonwhite heroes and buddies have done for decades in Hollywood, use their bodies to shore up the legitimacy of white authority.

In the African American–Asian buddy film, the white presence keeps its distance, but its existence remains palpable. Similarly, even though Jackie Chan should have control of his performance, given his star standing and reputation for astonishing stunts and compelling screen fights, and Chris Tucker, as a stand-up comedian, would be expected to improvise a sizable portion of his own material, Brett Ratner, as the director, has the ultimate authority to insist on an Americanized end product. Although absent like the offscreen white authority figures who reveal themselves as villains late in the plot, Ratner has mastery of the screen, and Jackie Chan clearly resents what he cannot understand and what he sees as attempts to Americanize his physical performance.

Learning from Las Vegas: Simulating Masculinity, Postmodernism, and the Wheel of Fortune

Although he is not likely to win any awards at Cannes, Ratner's postmodern approach does share certain stylistic characteristics with the films of more acclaimed American directors such as Quentin Tarantino. *Rush Hour 2* begins with a reference to one of Tarantino's favorite films, *Chungking Express* (1994), directed by Wong Kar-Wai, with its opening sequence set in Hong Kong. Hu Li (Zhang Ziyi) appears in raincoat, blond wig, and sunglasses similar to the attire of the unnamed drug runner (Brigitte Lin) in the Hong Kong New Wave classic, who resembles Hollywood stars such as Marilyn Monroe.[29] In *Rush Hour 3*, a Mexican standoff between Lee and Kenji makes an allusion to another Tarantino favorite, John Woo, and his Hong Kong "heroic bloodshed" films. The film also includes a triad ritual that resembles Johnnie To's gangster feature *Election* (2005). Allusions to the classic Hollywood buddy film with an African American partner known for comedy as well as action, of course, forms the foundation for the *Rush Hour* series.[30]

Using a self-consciously postmodern approach, Ratner reassembles material from blaxploitation films, classic Hollywood comedies, Hong

Kong action movies, Japanese yakuza films, the European New Wave, and global art cinema. As a result, the *Rush Hour* franchise becomes slippery and quickly turns from comedy to drama, from slapstick humor to serious action, at the blink of an eye. It cannot be pinned down ideologically. With a postmodern disregard for Hollywood convention, the series manages to undercut any apparent statement it may or may not be making about race, ethnicity, or masculinity simply by switching codes and bending the generic rules. An apparently serious statement about brotherhood dissolves into an exaggerated display of racially inflected invective that then may become a potentially subversive assault on racist misconceptions or dismissed as a quotation from a classic comedy.

Because of the reliance on postmodern pastiche in *Rush Hour 2,* concluding the film in Las Vegas seems quite appropriate. As Robert Venturi and Jean Baudrillard point out, America, as the bastion of postmodern, postindustrial consumer culture and the simulated image environment, has become Las Vegas for the world.[31] Ricky Tan inadvertently describes the American economy of the simulated image when he remarks, "Imagine a business where people hand you money and you hand back absolutely nothing—that's a real American Dream." As the image of Carter in a snakeskin suit winning at craps while misquoting Martin Luther King Jr. indicates, Las Vegas represents America as pure image, a chance at appearing to be a millionaire without any substance to the claim.

If Los Angeles serves as the home for American screen fantasies in the "dream factory" of Hollywood, Las Vegas gives those dreams three simulated dimensions and links them to games of chance.[32] With legal prostitution and drive-through wedding chapels, Las Vegas very openly puts sex on sale, often exaggerating gender, hypersexualizing commodities, and putting a price tag on the body. When Carter and Lee arrive in Las Vegas, they immediately go shopping for a new wardrobe; the clothes make the men. However, in addition to getting some new clothes, they also face a challenge to their heterosexuality in the form of a Versace salesman (Jeremy Piven). A caricature of an effeminate gay man, the clerk assumes that Lee and Carter form a couple, who may want to dress alike, and plans to make them the "belles of the ball" by clothing them in dead animals. The salesman openly flirts with Carter and admires Lee's choice of a partner with "fire." Prefiguring *Queer Eye for the Straight Guy,* Lee and Carter leave the shop apparently quite pleased with the clerk's choices.[33]

Although clearly played for humor at the expense of the gay community, this scene points to an aspect of Las Vegas, contemporary Hollywood films, and the *Rush Hour* series that cannot be ignored in any discussion of contemporary American masculinity. Lee and Carter craft their masculinity

from a wardrobe of choices, taking into account a range of sexual orientations, ethnic differences, and cultural peculiarities, in order to present a male spectacle suitable for a global postmodern consumer market. Feminism (in the form of Zhang Ziyi's woman warrior), postfeminism (Roselyn Sanchez's confident double agent who uses her sexuality to do her job), and gay liberation (embodied by the salesclerk) remind Lee and Carter that a queer eye may be watching them. In the postmodern age, masculinity becomes a visual spectacle, a construct, a product of consumer capitalism. Although they may try to create an illusion of playing it straight, they inevitably play with constructions of masculinity stitched together like their outfits. However, their masculine masquerade seems outdated, a nostalgic evocation of when men were men and women were glad of it. Lee and Carter's performance of masculinity harkens back to older forms of African American *Superfly* machismo, Charlie Chan inscrutability, and kung fu heroics. Because of this, within postmodern pastiche, the residue of sexism and homophobia continues to haunt this reconstituted masculinity while, at the same time, denying it.

In fact, the *Rush Hour* series, as noted by the way the films liberally draw on classic B-movies, blaxploitation, and Hong Kong kung fu traditions, can be considered "nostalgic" in Fredric Jameson's postmodern sense of the term.[34] Although some of the humor comes from topical allusions to the LAPD, Nelson Mandela, and Michael Jackson, the films also draw on classic slapstick stunts and old-fashioned vaudeville acts. *Rush Hour 2* and *Rush Hour 3,* for example, both repeat versions of the famous Bud Abbott and Lou Costello routine, "Who's on First?" In *Rush Hour 2,* "who" becomes "you"/Detective Yu, and in *Rush Hour 3,* "who" becomes "you"/"Yu" and "me"/"Mi." Direct quotations from Hong Kong martial arts classics abound, including a fight with a giant martial artist similar to Bruce Lee's face-off with Kareem Abdul-Jabbar in *Game of Death* (1978) in *Rush Hour 3.*

As a result, Lee and Carter's embodiment of black and Asian masculinities also seems nostalgic. Whether played for humor or not, these male images lack substance and operate as pastiche. Carter may call Lee "Third World ugly," but the righteous anticolonial Third World anger at the heart of the revivified male hero of blaxploitation or Hong Kong kung fu has evaporated. In *Rush Hour 3* after the two have a brief falling out, Carter watches *Indiana Jones and the Temple of Doom* (1984) in a Parisian café. As a prime example of postmodern nostalgia, the film, set in Old Shanghai, conjures up mass-produced images and styles associated with the past rather than any actual historical incidents. The scene on-screen features Indiana (Harrison Ford) and his young Asian sidekick, Short Round (Ke Huy Quan), whose name was filched from Sam Fuller's Korean War–era *Steel*

Helmet (1951).[35] Carter presumably sees himself as the American hero, with Lee as the infantilized Chinese sidekick.

His imaginative identification with a retro white American masculinity does not parallel Lee's own sentiments reflected in his choice to watch a documentary on male bonding in Africa. Two tribal Africans kiss each other's hands in a gesture of equality and friendship, and Lee presumably imagines himself as black with Carter as his equal. These two very different notions of masculinity and brotherhood—inflected by race, nation, and gender—haunt the depiction of Lee and Carter in the series. Lee serves as the non-American childlike helper, while Carter becomes his comic black elder brother, a vision of the excesses of American masculinity without the power of white authority.

THE VIEW FROM FRANCE:
CONSTRUCTING A POST-9/11 AMERICAN MASCULINITY

Another characteristic of the postmodern film involves the violation of the dividing line between high art and popular entertainment. While including Zhang Ziyi, associated with Zhang Yimou and China's Fifth Generation, and John Lone, who has worked with European art film luminaries such as Bernardo Bertolucci, may point in that direction in *Rush Hour 2*, *Rush Hour 3* brings the European art cinema front and center in a way that goes beyond the obvious Paris locations.

In a scene that parallels Lee and Carter's arrival in Las Vegas, the duo first encounters Detective Revi (Roman Polanski) when they arrive in Paris. Placing Roman Polanski in his current hometown of Paris brings up a wealth of associations involving his roots in the East European New Wave, his impact on Hollywood cinema, and his unquestioned status as a major auteur within global cinema. In this uncredited cameo, the casting of Polanski alludes to another cameo he did in a film he also directed, *Chinatown* (1974). In that film, Polanski plays a sadistic thug who cuts the nose of the nosy detective Jake Gittes (Jack Nicholson). The film uses the Los Angeles Chinese community as a backdrop, and Ratner plays with his own Hollywood Chinese connections with this casting choice.

In *Rush Hour 3*, Polanski plays Revi as a sadistic French cop who handcuffs Lee and Carter, hangs them from the ceiling, and spanks them with phone books. He puts on surgical gloves and relishes doing a complete search of every cavity in their bodies. After a session with Revi, Lee and Carter waddle away with their masculine pride sorely shaken by the ordeal. Being probed up the rectum by a renowned European director—with no love lost for a country in which he is a fugitive from the law—provides

a backdrop for the construction of Chan and Tucker as emblems of an American-inflected masculinity distinct from the Old World or the modern European Union. *Rush Hour* and its male protagonists draw in the European art film as pastiche and draw a line between American and European cinema by juxtaposing different models of masculinity.

However, homoerotic sadomasochistic gestures also conjure up images of torture associated with the American military presence in Abu Ghraib, made notorious by the release of photos featuring abused prisoners in 2004. Turning the tables on American masculinity and having Lee and Carter endure the brunt of the pain and humiliation takes Revi's probing to yet another level. Given former French president Jacques Chirac's opposition to the invasion of Iraq in 2003, Revi's sadism seems to say that the French may be opposed to war but are still willing to exercise their power through torture. For Americans, Revi may satisfy a secret desire to see Polanski and, by extension, France and continental Europe as guilty of sadism and sexual misconduct, an exemplar of perverse masculinity.

Casting another stalwart of European art cinema, Max von Sydow, as the villain, adds to the point by asserting Hollywood's power to draw an actor of von Sydow's stature into the realm of American popular entertainment. Associating the villain with the International Criminal Court and the European Union only adds to the xenophobic fantasy in which multicultural America vanquishes the criminal excesses of Europe's dark collaboration with Asian capitalism. African American and English-speaking Chinese diasporic buddies eliminate European threats in the narrative, and *Rush Hour 3* proclaims American action as commercially superior. Hollywood rules world screens.

Europe's debt to Hollywood movies becomes even more salient in the musical review featuring Serge Gainsbourg's 1968 rendition of "Bonnie and Clyde" with Brigitte Bardot. The recording appeared a year after Arthur Penn's *Bonnie and Clyde* (1967), a film noted for the influence of the French New Wave on its cinematic style, and Gainsbourg and Bardot dress up in the clothing made popular by Warren Beatty and Faye Dunaway on the cover of the album.[36] As Faye Dunaway's pose with a cigar and a pistol highlighted, gender play in *Bonnie and Clyde* became one of the defining features of the film's stylistic success. Of course, many of the pioneering works of the French New Wave (e.g., Godard's *Breathless* [1960] and Truffaut's *Shoot the Piano Player* [1960]) owe a debt to American crime films as well. Olivier Assayas added Hong Kong into the mix in *Irma Vep* (1996) by marrying the legacy of the French New Wave (represented by Truffaut's protégé Jean-Pierre Léaud) to the Hong Kong action film (represented by Jackie Chan's former leading lady Maggie Cheung)

and concluding it all with Luna's cover version of Gainsbourg's "Bonnie and Clyde."

All of these allusions take on added significance as Noémie Lenoir/ Genevieve takes the stage dressed as a hybrid amalgamation of Bonnie and Clyde (man's tailored coat with women's lingerie and beret). Given the queer associations going back to outlaw Clyde Barrow's homosexuality and the ramifications of that fact as the Depression-era couple went through their many incarnations in the global popular imagination, the performance of Lenoir/Genevieve, a Francophone woman of European and African descent, further complicates the matter of masculinity in *Rush Hour 3*. Of uncertain loyalties, indeterminate race, and questionable gender, Genevieve provides a complicated love interest for Carter in the film. His ability to overcome this challenge and win her over to the American way runs parallel to the film's ability to overcome all challenges to Hollywood's global supremacy.

Rush Hour 3 cites and transcends European cinema, which had alluded to and surpassed Hollywood in the 1960s. The film does this by quoting from a song that references American cinema and had been used by a French filmmaker making a film with a Hong Kong performer associated with Jackie Chan. If *Irma Vep* is at least partially about the crisis in European film, *Rush Hour 3* takes advantage of that crisis by incorporating Hong Kong in a more commercial way through Jackie Chan. As "Bonnie and Clyde" clearly indicates, this jockeying for screen dominance finds its visual expression in the masculine masquerade. Bald, tattooed, and in semi-drag, Genevieve, like Revi, indicates that there may be something wrong with Europe linked to its flippant disregard for normative (read: American) notions of gender.

If any of this postmodern irony remains beyond the reach of *Rush Hour 3*'s audience, French taxi driver George (Yvan Attal, a film director and actor who happens to be married to Serge Gainsbourg's daughter) makes the connection to masculinity and American hegemony perfectly clear. When Lee and Carter enter George's cab, the anti-American driver refuses to accept their business. Referring to Carter, he says, "I don't drive his kind—Americans. They're the most violent people on earth—always killing people, always starting wars. Americans make me sick." His diatribe devolves from American foreign policy to African American sports figures: "You're pathetic—always pushing around the little guy. You lost in Vietnam; you lost in Iraq; you can't even beat the Europeans at basketball. The Dream Team is dead." George, of course, refers to the 1992 Olympic basketball team from the United States led by African American star players such as Michael Jordan, Patrick Ewing, and Magic Johnson (who just the year before announced that

he was HIV-positive), which won the gold medal at the games in Barcelona. In recent years, the American team has not done as well against its European competition. With *Rush Hour 3* appearing as Beijing revved up for the 2008 Olympics, the presence of an ethnic Chinese man on Carter's "team" took on additional significance, particularly since Houston's Yao Ming went on to play quite well for the People's Republic of China at the Beijing Olympics.

Questions of America's place in the world and the multiethnic, multiracial composition of that American presence as a competitive threat find a comic voice in George's angry remarks. However, the gravity of those comments lessens as he switches from war to sports and eventually to entertainment with a reference to another African American performer, Halle Berry. America's geopolitical presence, through this linguistic displacement, becomes less violent, less white, and less male. Carter, however, comically confirms George's opinions by putting a gun to the cabdriver's head and forcing him to say "I love America" and to make an attempt at singing "The Star-Spangled Banner."

Throughout this assault on the unarmed Frenchman, Lee fades into the background. As he had in an earlier scene in which Carter took the lead in the interrogation of a Francophone Asian gangster with the help of Sister Agnes (Dana Ivey), a French-speaking nun, Lee seems ill at ease in the presence of Carter's aggression. Unfortunately, although George can say "The French are neutral. This is not my fight," Lee does not have the same option. Because of his ethnic connection to the Asian gangs as "sworn brother" to one of the mobsters, Lee cannot extricate himself from what should be the story of an American in Paris on Avenue Franklin Delano Roosevelt.

Several car chases later, however, George experiences an epiphany and converts to American manhood. He says to Carter, "The guns, the shooting, now I understand what it means to be an American. . . . Let me be your driver, let me kill someone tonight." Lee, the embodiment of an alternative to American masculinity, remains silent; George has no burning desire to learn kung fu. Clearly flattered as well as flabbergasted, Carter does not seem to discourage George when he tells him that "you'll never be an American." Later, Carter's American masculinity gets another boost in the bedroom scene with Genevieve. Aroused, she says, "I've never been with an American man before." To shore up any suspicions about his heterosexuality, Carter responds, "Neither have I."

Drawing perhaps on Jackie Chan's established star image, Lee's masculinity does not suffer from the homosexual panic attached to Carter. The series associates Carter with popular personalities such as Michael Jackson, and Carter mentions films such as *The Crying Game* (1992) and *Brokeback Mountain* (2005), placing his own heterosexuality and normative

masculinity in doubt. George also suffers from homosexual panic linked to the sexist depiction of his spouse. Noticing a change in her husband's behavior, George's wife (Julie Depardieu, Gerard Depardieu's daughter), asks him if he's gay. A henpecked victim of French feminism, George must listen to his wife and be home for dinner. He laments, "I will never know what it feels like to be an American—what it feels like to kill for no reason." Although comically expressed, the link between American masculine violence and implicit misogyny remains strong.

Rush Hour 3 ends with a celebration of male bonding and America's welcome presence as the policemen of the world. George does get to shoot the villain, and Lee and Carter solidify their bond by punching Revi, who just manages to get in a final blow to Carter's male ego by first kissing him on both cheeks. The French have been won over and knocked out. With Max von Sydow, Roman Polanski, and their European art-house ways out of the picture, *Rush Hour 3* has also symbolically made world screens safe for Hollywood. As the peace song "War" comes up on the soundtrack, the irony of the meeting of American and Asian manhood on the battleground of the European Union surfaces. Throughout the series, Lee and Carter have made their peace through war.

JACKIE CHAN: GLOBAL BRAND VERSUS AMERICA'S ASIAN SIDEKICK

Jackie Chan should feel at peace with his masculinity, since he has negotiated a minefield of Hollywood misconceptions, American prejudices, and global suspicions of U.S. imperialism. As Kenneth Chan astutely points out in his essay "Mimicry as Failure: Jackie Chan in Hollywood," Chan has mastered a performance that constantly slides between mainstream American and other notions of masculinity:

> In reconfiguring his macho-comic image and inserting himself into Hollywood genre-specific settings and character types, he performs a humorous mimicry that can be both subversive and self-mocking, the ambiguity of which lies [in] its appeal, particularly to U.S. audiences. It is also in the processes of a (post)colonial mimicry that the hint of an anti-imperialist critique can serve to connect Chan to his global audiences, a critique that unfortunately does not quite push the radical envelope far enough but instead resorts to locating Chan in a political comfort zone that reinforces his universal cosmopolitan appeal, that is, a politically correct Jackie Chan for everyone.[37]

However, times change, and the *Rush Hour* series, particularly after 9/11, does not feel politically correct to Chan. Although Inspector Lee may be at peace with his African American brother Carter, Jackie Chan continues to feel uncomfortable and embattled. Given the dynamics of the global film market, it may be dangerous for Chan to appear to be too Americanized. He is a brand name, and this has implications for his performance of a particular masculine role outside of the Hollywood mold.[38] While he made his name internationally on the authenticity of his stunts, his aging body and ethnically compromised roles in Hollywood put a strain on his transnational star stature in Asia. Postmodernism may have drained heterosexual norms and patriarchal postures of their absolute authority; however, the marketplace remains, and Chan must rely on images of his body, on representations of his particular performance of masculinity, and on the appearance of his acrobatic prowess to make a living. Hollywood may be at peace with Jackie Chan, but Chan may still need to fight to keep his star as flexible as possible and hitched to his own construction of a male hero less dependent on American connections.

Notes

A portion of the research for this essay came from the Seed Funding Program for Basic Research, University of Hong Kong. I am particularly grateful to Leon Hunt of Brunel University for chatting with me about the reception of *Rush Hour 3* in England. Portions of this essay appear in a different form in Gina Marchetti, *The Chinese Diaspora on American Screens: Race, Sex, and Contemporary Cinema* (Philadelphia: Temple University Press, 2012). Information on film credits comes from the Internet Movie Database, www.imdb.com.

1. Chan has less to say in a critical vein about his pairing with Owen Wilson in *Shanghai Noon* (2000) and *Shanghai Knights* (2003). *The Tuxedo* (2002), *The Medallion* (2003), and *Around the World in Eighty Days* (2004) appear to be completely off his radar.

2. "Jackie Chan Admits He Is Not a Fan of 'Rush Hour' Films," Foxnews .com, September 30, 2007, http://www.foxnews.com/story/0,2933,298648,00 .html.

3. Ibid.

4. Aihwa Ong, *Flexible Citizenship: The Cultural Logics of Transnationality* (Durham, NC: Duke University Press, 1999).

5. Wendy Gan, "The Hong Kong Local on Film: Re-Imagining the Global," *Jump Cut,* no. 49 (2007), http://www.ejumpcut.org/archive/jc49.2007/wendy-gan/text.html.

6. Edward W. Said, *Orientalism* (New York: Vintage, 1979), 3.

7. See my essay "Jackie Chan and the Black Connection," in *Keyframes: Popular Cinema and Cultural Studies,* edited by Matthew Tinkcom and Amy Villarejo, 137–58 (London: Routledge, 2001). Because I discuss *Rush Hour* in that essay, the focus here shifts to *Rush Hour 2* and *Rush Hour 3. Rush Hour 2* had its premiere shortly before 9/11, and *Rush Hour 3* came out at the height of America's involvement in the War on Terror in Afghanistan and Iraq in 2007.

8. See Jackie Chan, *I Am Jackie Chan: My Life in Action,* with Jeff Yang (New York: Ballantine, 1999).

9. Interview with the *Times of India,* www.asian-nation.org/headlines/2005/11/jackie-chan-avoid-hollywood-movies/.

10. Chris Holmlund, "Masculinity as Multiple Masquerade: The 'Mature' Stallone and the Stallone Clone," in *Screening the Male: Exploring Masculinities in Hollywood Cinema,* edited by Steven Cohan and Ina Rae Hark, 213–29 (London: Routledge, 1993). For a consideration of gender and race in the action genre, see Yvonne Tasker, *Spectacular Bodies: Gender, Genre and the Action Cinema* (London: Routledge, 1993).

11. Melvin Donalson, *Masculinity in the Interracial Buddy Film* (Jefferson, NC: McFarland, 2006).

12. Kam Louie, *Theorising Chinese Masculinity: Society and Gender in China* (Cambridge: Cambridge University Press, 2002), 150.

13. Quite a lot has been written about Jackie Chan's star image, and much of it bears directly or indirectly on his performance of masculinity. For thoughtful considerations of his star image in Hong Kong cinema, see Lisa Odham Stokes and Michael Hoover, *City on Fire: Hong Kong Cinema* (New York: Verso, 1999); Stephen Teo, *Hong Kong Cinema: The Extra Dimensions* (London: British Film Institute, 1997); David Bordwell, *Planet Hong Kong: Popular Cinema and the Art of Entertainment* (Cambridge, MA: Harvard University Press, 2000); and Leon Hunt, *Kung Fu Cult Masters: From Bruce Lee to Crouching Tiger* (London: Wallflower, 2003). For more on Jackie Chan's body movements, see Aaron Anderson, "Action in Motion: Kinesthesia in Martial Arts Films," *Jump Cut,* no. 42 (1998): 1–11, 83; and Aaron Anderson, "Violent Dances in Martial Arts Films," *Jump Cut,* no. 44 (2001), http://www.ejumpcut.org/archive/jc44.2001/aarona/andersontextonly.html. For more specifically on Chan's transnational flexibility, see Ramie Tateishi, "Jackie Chan and the Reinvention of Tradition," *Asian Cinema* 10, no. 1 (1998): 78–84; and Kenneth Chan, "Mimicry as Failure: Jackie Chan in Hollywood," *Asian Cinema* 15, no. 2 (2004): 84–97. For an analysis of masculinity in relation to Chan's star persona, see Mark Gallagher, "Masculinity in Translation: Jackie Chan's Transcultural Star Text," *Velvet Light Trap* 39 (1997): 23–41; Gayle Wald, "Same Difference: Reading Racial Masculinity in Recent Hong Kong/Hollywood Hybrids," paper presented at the Society for Cinema Studies Conference, Chicago, March 10, 2000; Yvonne Tasker, "Fists of Fury: Discourses of Race and Masculinity in the Martial Arts Cinema," in *Race and the Subject of Masculinities,* edited by Harry Stecopoulos and Michael Uebel, 315–36 (Durham, NC: Duke University Press, 1997); and Kwai-Cheung

Lo, "Muscles and Subjectivity: A Short History of the Masculine Body in Hong Kong Popular Culture," *Camera Obscura* 39 (1996): 104–25. For information on Jackie Chan's appeal to his female fans in Hong Kong, see Day Wong, "Women's Reception of Mainstream Hong Kong Cinema," in *Masculinities and Hong Kong Cinema,* edited by Laikwan Pang and Day Wong, 239–60 (Hong Kong: Hong Kong University Press, 2005).

14. Kwai-Cheung Lo, *Chinese Face/Off: The Transnational Popular Culture of Hong Kong* (Urbana: University of Illinois Press, 2005), 139.

15. David L. Eng, *Racial Castration: Managing Masculinity in Asian America* (Durham, NC: Duke University Press, 2001).

16. Steve Fore, "Jackie Chan and the Cultural Dynamics of Global Entertainment," in *Transnational Chinese Cinemas: Identity, Nationhood, Gender,* edited by Sheldon Hsiao-peng Lu, 239–64 (Honolulu: University of Hawaii Press, 1997). See also Steve Fore, "Life Imitates Entertainment: Home and Dislocation in the Films of Jackie Chan," in *At Full Speed: Hong Kong Cinema in a Borderless World,* edited by Esther C. M. Lau, 115–42 (Minneapolis: University of Minnesota Press, 2001).

17. Interview with Slavoj Žižek, "Divine Violence and Liberated Territories: *Soft Targets* Talks with Slavoj Žižek," *Soft Targets,* March 14, 2007, www .softtargetsjournal.com/web/zizek.php.

18. Mikhail Bakhtin, *Rabelais and His World,* translated by Helene Iswolsky (Bloomington: Indiana University Press, 1984).

19. Gary Okihiro, *Margins and Mainstreams: Asians in American History and Culture* (Seattle: University of Washington Press, 1994), 31–63.

20. Fu Jow Pai is actually a southern Chinese kung fu system practiced in the United States, and there are many fine African American practitioners of this style. For more on Fu Jow Pai in America, see "Fu Jow Pai's Tiger Walk," www.plumpub.com/info/knotebook/boxfujowpai.htm, and "About Fu-Jow Pai," http://www.fujowpai.com/about.shtml.

21. Murphy also has a close relationship with an Asian "little Buddha" in *The Golden Child* (1986). Furthermore, in several scenes Chris Tucker obliquely refers to *Mulan* by peppering his speech with references to "mu shu." For more on the racial dynamics of *Mulan,* see Sheng-Mei Ma, *The Deathly Embrace: Orientalism and Asian American Identity* (Minneapolis: University of Minnesota Press, 2000), 126–44.

22. Kwai-Cheung Lo, "Double Negations: Hong Kong Cultural Identity in Hollywood's Transnational Representations," *Cultural Studies* 15, no. 3/4 (2001): 464–85.

23. Jachinson Chan, *Chinese American Masculinities: From Fu Manchu to Bruce Lee* (New York: Routledge, 2001).

24. Dozens is the African American version of flyting, a contest of insults.

25. For more on *Rush Hour* and the minstrel tradition, see Laleen Jayamanne, "Let's Miscegenate: Jackie Chan and His African-American Connection," in *Hong Kong Connections: Transnational Imagination in Action Cinema,*

edited by Meaghan Morris, Siu Leung Li, and Stephen Chan Ching-kiu, 151–62 (Durham, NC: Duke University Press, 2005).

26. In an interview in the *Advocate,* Ratner claims that the scene in which Carter experiences homosexual panic is based on his own personal experience: "My first blow job was from a man, but I didn't know it was a man. That's where that comes from. It's based on personal experience. It happens to a lot of people. . . . I'm not homophobic or uptight about it. That happens to a lot of heterosexuals." Paul Pratt, "Q and A: Brett Ratner," Advocate.com, August 3, 2007, http://www.advocate.com/Arts_and_Entertainment/Comedy/Brett_Ratner_knows_gay_sex/. Furthermore, Hu Li means "fox" in Chinese and for the bilingual viewer may conjure up treacherous but beautiful fox spirits as well as the "foxy" ladies of African American soul.

27. Although Alan King (now deceased) was best known as a comedian, he played it straight in *Rush Hour 2.* Instead, the Jewish Catskill humor that King helped to popularize ends up coming out of Tucker's mouth as he asks for a Kosher meal on flights in *Rush Hour 2* and *Rush Hour 3.* For more on the interface between black and Jewish entertainment in America, see Michael Rogin, *Blackface, White Noise: Jewish Immigrants in the Hollywood Melting Pot* (Berkeley: University of California Press, 1996).

28. "Renard" is French for "fox," and Reynard the Fox is a fabled trickster in France. However, Max von Sydow may not be as "foxy" as Zhang Ziyi's Hu Li. It is interesting that Reynard is associated with the International Criminal Court in The Hague (called the World Criminal Court in *Rush Hour 3*), since both the United States and China have taken issue with its authority.

29. See my book *From Tian'anmen to Times Square: Transnational China and the Chinese Diaspora on Global Screens, 1989–1997* (Philadelphia: Temple University Press, 2006), 31–62.

30. In a book on the series, Ratner's love for *Beverly Hills Cop* (1984) and *48 Hours* is mentioned. See Brett Ratner, *Rush Hour 1, 2, 3: Lights, Camera, Action!* (New York: Newmarket, 2007).

31. Robert Venturi, Denise Scott Brown, and Steven Izenour, *Learning from Las Vegas: The Forgotten Symbolism of Architectural Form* (Cambridge, MA: MIT Press, 1972); Jean Baudrillard, *America,* translated by Chris Turner (London: Verso, 1988).

32. Hortense Powdermaker, *Hollywood: The Dream Factory* (Boston: Little, Brown, 1950).

33. This television series first aired in 2003.

34. Fredric Jameson, "Postmodernism and Consumer Society," in *The Anti-Aesthetic: Essays on Postmodern Culture,* edited by Hal Foster, 111–25 (Port Townsend, WA: Bay Press, 1983).

35. In *Steel Helmet,* the Asian child, Short Round, is played by William Chun.

36. Faye Dunaway also starred in Polanski's *Chinatown.*

37. Kenneth Chan, "Mimicry as Failure: Jackie Chan in Hollywood," *Asian Cinema* 15, no. 2 (2004): 85–86.

38. For more on Jackie Chan and "brand Hong Kong," see Stephanie Hemelryk Donald and John Gammak, "Competing Regions: The Chromatics of the Urban Fix," in *Hong Kong Film, Hollywood and the New Global Cinema: No Film Is an Island*, edited by Gina Marchetti and Tan See Kam, 193–205 (London: Routledge, 2007). For more on Chan and Hong Kong tourism, see Laikwan Pang, "Jackie Chan, Tourism, and the Performing Agency," in *Hong Kong Film, Hollywood and the New Global Cinema*, 206–18.

Appendix

U.S. Films since 1990 Addressing Masculinity

This filmography is composed of relevant titles from the past two decades that may foster further research on masculinity in movies. The list is not meant to be exhaustive, and because there are so many U.S. films about male protagonists and issues, I established a limited set of criteria for inclusion: (1) films mentioned in the essays in this volume; (2) feature films about masculinity that earned at least $200 million at the domestic box office, arguably indicating popular success; (3) feature films that were nominated for Academy Awards in male acting categories, arguably indicating critical success. I encourage other scholars to expand upon what we have studied here.

1990

Awakenings

Dances with Wolves

Dick Tracy

Ghost

The Godfather Part III

Goodfellas

Kindergarten Cop

Longtime Companion

Mo' Better Blues

Reversal of Fortune

Bugsy

Cape Fear

City Slickers

The Fisher King

JFK

Jungle Fever

The Prince of Tides

Rush

The Silence of the Lambs

Terminator 2: Judgment Day

Thelma and Louise

1991

Backdraft

Barton Fink

Boyz N the Hood

1992

Chaplin

A Few Good Men

Glengarry Glen Ross

Light Sleeper

Malcolm X

Mr. Saturday Night

Point Break

Scent of a Woman

Thunderheart

Unforgiven

1993

Demolition Man

The Fugitive

In the Line of Fire

Menace II Society

Mrs. Doubtfire

Philadelphia

Poetic Justice

Schindler's List

What's Eating Gilbert Grape

What's Love Got to Do with It

1994

Blown Away

Bullets Over Broadway

Crooklyn

Disclosure

Ed Wood

Forrest Gump

Nobody's Fool

Pulp Fiction

Quiz Show

The Shawshank Redemption

1995

Apollo 13

Billy Madison

Clockers

Copycat

Dead Man Walking

Leaving Las Vegas

Mr. Holland's Opus

Nixon

Rumble in the Bronx

Tommy Boy

12 Monkeys

The Usual Suspects

Virtuosity

1996

Black Sheep

Bulletproof

Fargo

Get on the Bus

Ghosts of Mississippi

Girl 6

Happy Gilmore

Independence Day

Jerry Maguire

Mission: Impossible

The People vs. Larry Flint

Primal Fear

Scream

Sling Blade

Swingers

Twister

1997

Amistad

The Apostle

As Good as It Gets

Boogie Nights

Good Will Hunting

In & Out

Jackie Brown

L.A. Confidential

Men in Black

My Best Friend's Wedding

Rosewood

Titanic

Ulee's Gold

Uncle Sam

Wag the Dog

1998

Affliction

American History X

Armageddon

A Civil Action

He Got Game

Out of Sight

Rush Hour

Rushmore

Saving Private Ryan

A Simple Plan

There's Something about Mary

The Truman Show

The Waterboy

The Wedding Singer

1999

American Beauty

Any Given Sunday

Austin Powers: The Spy Who Shagged Me

Big Daddy

Bringing Out the Dead

The Cider House Rules

The Corruptor

Dick

Fight Club

The Green Mile

Higher Learning

The Hurricane

The Insider

Magnolia

The Sixth Sense

Sweet and Lowdown

Star Wars Episode I: The Phantom Menace

The Straight Story

The Talented Mr. Ripley

2000

Bamboozled

Cast Away

The Cell

The Contender

Dude, Where's My Car?

Erin Brockovich

Gladiator

High Fidelity

Little Nicky

Meet the Parents

Mission: Impossible II

The Perfect Storm

Pollock

Requiem for a Dream

Shadow of the Vampire

Shaft

Shanghai Noon

Traffic

Unbreakable

2001

Ali

Baby Boy

A Beautiful Mind

The Deep End

The Fast and the Furious

Hannibal

I Am Sam

In the Bedroom

The Mexican

The Mummy Returns

Ocean's Eleven

The Royal Tenenbaums

Rush Hour 2

Saving Silverman

Shallow Hal

Training Day

2002

About Schmidt

Adaptation

Austin Powers in Goldmember

Catch Me If You Can

Chicago

Eight Crazy Nights

FeardotCom

Gangs of New York

The Good Thief

The Hours

Insomnia

Mr. Deeds

My Big Fat Greek Wedding

One Hour Photo

Panic Room

Phone Booth

Punch-Drunk Love

The Quiet American

Red Dragon

Road to Perdition

Signs

Spider-Man

Star Wars Episode II: Attack of the Clones

The Tuxedo

Welcome to Collinwood

2003

Anger Management

Bruce Almighty

Cold Mountain

The Cooler

Daredevil

House of Sand and Fog

In America

The Italian Job

The Last Samurai

Lost in Translation

The Matrix Reloaded

The Medallion

Mystic River

Old School

Pirates of the Caribbean: The Curse of the Black Pearl

Shanghai Knights

21 Grams

2 Fast 2 Furious

X2

2004

Anchorman: The Legend of Ron Burgundy

Around the World in Eighty Days

The Aviator

Collateral

Closer

Criminal

50 First Dates

Finding Neverland

Hotel Rwanda

I, Robot

The Ladykillers

The Life Aquatic with Steve Zissou

Meet the Fockers

Million Dollar Baby

Ocean's Twelve

Ray

Saw

She Hate Me

Sideways

Spanglish

Spider-Man 2

2005

Batman Begins

Brokeback Mountain

Capote

Cinderella Man

Crash

The 40-Year-Old Virgin

Four Brothers

Good Night, and Good Luck

A History of Violence

Hustle & Flow

King Kong

The Longest Yard

Sin City

Star Wars Episode III: Revenge of the Sith

Syriana

Walk the Line

War of the Worlds

Wedding Crashers

2006

Black Snake Moan

Blood Diamond

The Break-Up

Casino Royale

Click

The Departed

Dreamgirls

Failure to Launch

Half Nelson

Inside Man

Little Children

Little Miss Sunshine

Night at the Museum

Pirates of the Caribbean: Dead Man's Chest

The Pursuit of Happyness

Superman Returns

Talladega Nights: The Ballad of Ricky Bobby

300

X-Men: The Last Stand

You, Me and Dupree

2007

American Gangster

The Assassination of Jesse James by the Coward Robert Ford

Blades of Glory

The Bourne Ultimatum

Charlie Wilson's War

The Darjeeling Limited

The DaVinci Code

Hannibal Rising

I Am Legend

Illegal Tender

I Now Pronounce You Chuck and Larry

Into the Wild

Knocked Up

Michael Clayton

National Treasure: Book of Secrets

No Country for Old Men

Ocean's Thirteen

Pirates of the Caribbean: At World's End

Reign Over Me

Rush Hour 3

Spider-Man 3

Superbad

Sweeney Todd: The Demon Barber of Fleet Street

There Will Be Blood

Transformers

You Don't Mess with the Zohan

2008

Bedtime Stories

The Curious Case of Benjamin Button

The Dark Knight

Doubt

The Forbidden Kingdom

Forgetting Sarah Marshall

Frost/Nixon

Hancock

Indiana Jones and the Kingdom of the Crystal Skull

Iron Man

Milk

Miracle at St. Anna

Pineapple Express

Quantum of Solace

Revolutionary Road

Role Models

Semi-Pro

Step Brothers

Street Kings

Tropic Thunder

Untraceable

The Visitor

W

The Wrestler

2009

Avatar

The Blind Side

Crazy Heart

The Fantastic Mr. Fox

Funny People

The Hangover

The Hurt Locker

I Love You, Man

Inglourious Basterds

Invictus

The Lovely Bones

The Messenger

Observe and Report

The Road

Sherlock Holmes

A Single Man

Star Trek

The Taking of Pelham 1 2 3

Transformers: Revenge of the Fallen

Up in the Air

Watchmen

Whiteout

Zombieland

2010

The A-Team

Despicable Me

Eclipse

The Fighter

Grown Ups

Harry Potter and the Deathly Hallows: Part 1

Inception

Iron Man 2

The Karate Kid

The Kids Are All Right

Little Fockers

The Losers

127 Hours

The Other Guys

Shrek Forever After

The Social Network

The Special Relationship

The Town

True Grit

The Twilight Saga: Eclipse

Winter's Bone

2011

The Artist

Beginners

The Descendants

Drive

Extremely Loud & Incredibly Close

Fast Five

The Girl with the Dragon Tattoo

The Hangover Part II

Harry Potter and the Deathly Hallows: Part 2

Hugo

Mission: Impossible—Ghost Protocol

Moneyball

My Week with Marilyn

Pirates of the Caribbean: On Stranger Tides

Rise of the Planet of the Apes

Tinker Tailor Soldier Spy

Tintin

Transformers: Dark of the Moon

Warrior

X-Men: First Class

2012

The Hunger Games

Dr. Seuss' The Lorax

BIBLIOGRAPHY

Anderson, Aaron. "Action in Motion: Kinesthesia in Martial Arts Films." *Jump Cut*, no. 42 (1998): 1–11, 83.

———. "Violent Dances in Martial Arts Films." *Jump Cut*, no. 44 (2001), http://www.ejumpcut.org/archive/jc44.2001/aarona/andersontextonly.html.

Anderson, Mark Cronlund. *Cowboy Imperialism and the Hollywood Film*. New York: Peter Lang, 2007.

Anger, Kenneth. *Hollywood Babylon*. Phoenix, AZ: Associated Professional Services, 1965.

Arbuthnot, Lucie, and Gail Seneca. "Pre-Text and Text in *Gentlemen Prefer Blondes*." In *Issues in Feminist Film Criticism*, edited by Patricia Erens, 112–25. Bloomington: Indiana University Press, 1990.

Aronson, Amy, and Michael Kimmel. "The Saviors and the Saved: Masculine Redemption in Contemporary Films." In *Masculinity: Bodies, Movies, Culture*, edited by Peter Lehman, 297–317. New York: Routledge, 2001.

Ashcraft, Karen Lee, and Lisa A. Flores. "'Slaves with White Collars': Persistent Performances of Masculinity in Crisis." *Text and Performance Quarterly* 23, no. 1 (2003): 1–29.

Atkinson, Michael. "The Way We Laughed." *Village Voice*, July 3–9, 2002, http://www.villagevoice.com/film/0227,atkinson,36156,20.html.

Babington, Bruce, and Peter William Evans. *Affairs to Remember: The Hollywood Comedy of the Sexes*. Manchester, UK: Manchester University Press, 1989.

Babuscio, Jack. "The Cinema of Camp (*aka* Camp and the Gay Sensibility)." In *Camp: Queer Aesthetics and the Performing Subject; A Reader*, edited by Fabio Cleto, 117–35. Edinburgh, UK: Edinburgh University Press, 1999.

Baker, Aaron. *Contesting Identities: Sports in American Film*. Urbana: University of Illinois Press, 2003.

Baker, Brian. *Masculinity in Fiction and Film: Representing Men in Popular Genres, 1945–2000.* London: Continuum, 2006.

Balingit, JoAnn. "*Boyz 'n the Hood.*" In *Magill's Cinema Annual 1992,* edited by Frank N. Magill, 55–59. Pasadena, CA: Salem Press, 1992.

Barthes, Roland. *Mythologies.* New York: Macmillan, 1972.

Baudrillard, Jean. *America.* Translated by Chris Turner. London: Verso, 1988.

Benshoff, Harry M. "*Milk* and Gay Political History." *Jump Cut: A Review of Contemporary Media,* no. 51 (Spring 2009), http://www.ejumpcut.org/archive/jc51.2009/Milk/index.html.

Benshoff, Harry M., and Sean Griffin. *Queer Images: A History of Gay and Lesbian Film in America.* New York: Rowman and Littlefield, 2006.

Benyon, John. *Masculinities and Culture.* Buckingham, UK: Open University Press, 2002.

Betzold, Michael. "*Baby Boy.*" In *Magill's Cinema Annual 2002,* edited by Christine Tomassini, 41–43. Detroit: Gale, 2002.

Biel, Steven. *American Gothic: A Life of America's Most Famous Painting.* New York: Norton, 2005.

Bingham, Dennis. *Acting Male: Masculinities in the Films of James Stewart, Jack Nicholson, and Clint Eastwood.* New Brunswick, NJ: Rutgers University Press, 1994.

———. *Whose Lives Are They Anyway? The Biopic as Contemporary Film Genre.* Piscataway, NJ: Rutgers University Press, 2010.

Black, Dustin Lance. *Milk: The Shooting Script.* New York: Newmarket, 2008.

Bly, Robert. *Iron John: A Book about Men.* Brisbane, Queensland: Element, 1991.

Bordwell, David. *Planet Hong Kong: Popular Cinema and the Art of Entertainment.* Cambridge, MA: Harvard University Press, 2000.

Bradshaw, Peter. "*Observe and Report.*" *Guardian,* April 24, 2009, http://www.guardian.co.uk/film/2009/apr/23/observe-and-report-film-review.

Brady, Wayne, moderator. "The Black Hollywood Experience: Our History . . . Our Future." Panel discussion with Don Cheadle, John Singleton, Taraji P. Henson, and Marla Gibbs. Sponsored by the Screen Actors Guild National Ethnic Employment Opportunities Committee, Los Angeles, California, February 23, 2011.

Breivold, Scott, ed. *Howard Hawks: Interviews.* Jackson: University Press of Mississippi, 2006.

Brody, Jennifer DeVere. "The Returns of *Cleopatra Jones.*" *Signs* 25 (1999): 91–121.

Browne, Nick. "Violence as History in the *Godfather* Films." In *Francis Ford Coppola's Godfather Trilogy,* edited by Nick Browne, 1–22. Cambridge: Cambridge University Press, 2000.

Bruzzi, Stella. *Bringing Up Daddy: Fatherhood and Masculinity in Post-War Hollywood.* London: British Film Institute, 2005.

Bunch, Sonny. "Sean Penn Overacts as Gay Leader in *Milk.*" *Washington Times,* November 26, 2008, http://www.washingtontimes.com/news/2008/nov/26/milk-man/.

Burr, Ty. "Armageddagain: '2011' Writes a New Chapter in the Destruction Manual." *Boston Globe,* November 13, 2009, http://articles.boston.com/2009-11-13/ae/29256865_1_copper-mine-roland-emmerich-harald-kloser.

———. "Monster Flick Takes Hold Quickly and Doesn't Let Go." *Boston Globe,* January 18, 2008, http://articles.boston.com/2008-01-18/ae/29279195_1_michael-stahl-david-cloverfield-godzilla.

———. "The Sands of Santa Monica: 'Los Angeles' Is Viscerally Gripping, If Full of War-Movie Clichés." *Boston Globe,* March 11, 2011, http://articles.boston.com/2011-03-11/ae/29339603_1_alien-invasion-movie-sergeant.

Bush, George W. "President Honors Veterans of Foreign Wars at National Convention." Speech delivered in Salt Lake City, Utah, August 22, 2005, http://georgewbush-whitehouse.archives.gov/news/releases/2005/08/20050822-1.html.

———. "Remarks by the President upon Arrival." Speech delivered at the White House, September 16, 2001, http://georgewbush-whitehouse.archives.gov/news/releases/2001/09/20010916-2.html.

Butler, Judith. *Bodies That Matter: On the Discursive Limits of "Sex."* London: Routledge, 1993.

———. "Critically Queer." *GLQ: A Journal of Lesbian and Gay Studies* 1, no. 1 (1993): 5–27.

———. "Performative Acts and Gender Constitution: An Essay in Phenomenology and Feminist Theory." *Theatre Journal* 40, no. 4 (1988): 519–31.

———. *The Psychic Life of Power: Theories in Subjection.* Stanford, CA: Stanford University Press, 1997.

Canby, Vincent. "*Alice,* Young Widow Finds Herself." *New York Times,* January 30, 1975, C-3.

Carnicke, Sharon Marie. "Lee Strasberg's Paradox of the Actor." In *Screen Acting,* edited by Alan Lovell and Peter Krämer, 75–87. London: Routledge, 1999.

Cavell, Stanley. *Pursuits of Happiness: The Hollywood Comedy of Remarriage.* Cambridge, MA: Harvard University Press, 1981.

Chan, Jachinson. *Chinese American Masculinities: From Fu Manchu to Bruce Lee.* New York: Routledge, 2001.

Chan, Jackie, with Jeff Yang. *I Am Jackie Chan: My Life in Action.* New York: Ballantine, 1999.

Chan, Kenneth. "Mimicry as Failure: Jackie Chan in Hollywood." *Asian Cinema* 15, no. 2 (2004): 84–97.

Chodorow, Nancy. *The Reproduction of Mothering: Psychoanalysis and the Sociology of Gender.* Berkeley: University of California Press, 1978.

Chopra-Gant, Mike. "Absent Fathers and 'Moms,' Delinquent Daughters and Mummy's Boys: Envisioning the Postwar Family in Hitchcock's *Notorious.*" *Comparative American Studies* 3, no. 3 (2005): 361–75.

———. *Hollywood Genres and Postwar America: Masculinity, Family and Nation in Popular Movies and Film Noir.* New York: Palgrave Macmillan, 2006.

———. "Representing the Postwar Family: The Figure of the 'Absent Father' in Early Postwar Hollywood Films." In *Screen Methods: Comparative Readings in Film Studies,* edited by J. Furby and K. Randell, 136–57. London: Wallflower, 2006.

Clare, Anthony. *On Men: Masculinity in Crisis.* London: Chatto and Windus, 2000.

Clark-Flory, Tracy. "The Twisted World of 'Ex-girlfriend Porn.'" Salon.com, February 28, 2011, http://www.salon.com/life/feature/2011/02/28/exgirlfriend_porn/index.html.

Cohan, Steven. *Masked Men: Masculinity and the Movies in the Fifties.* Bloomington: Indiana University Press, 1997.

———. "Queer Eye for the Straight Guise: Camp, Postfeminism, and the Fab Five's Makeovers of Masculinity." In *Interrogating Postfeminism: Gender and the Politics of Popular Culture,* edited by Yvonne Tasker and Diane Negra, 176–200. Durham, NC: Duke University Press, 2007.

Cohan, Steven, and Ina Rae Hark, eds. *Screening the Male: Exploring Masculinities in Hollywood Cinema.* New York: Routledge, 1993.

Connell, R. W. *Masculinities.* Berkeley: University of California Press, 1995.

Connelly, Joe. *Bringing Out the Dead.* New York: Vintage, 1998.

Corkin, Stanley. *Cowboys as Cold Warriors: The Western and U.S. History.* Philadelphia: Temple University Press, 2004.

Corneau, Guy. *Absent Fathers, Lost Sons.* Boston: Shambhala, 1993.

Custen, George F. *Bio/Pics: How Hollywood Constructed Public History.* Piscataway, NJ: Rutgers University Press, 1992.

Dalton, David, and Ron Cayen. *James Dean: American Icon.* New York: St. Martin's, 1984.

Davies, Jude, and Carol R. Smith. *Gender, Ethnicity and Sexuality in Contemporary American Film.* Edinburgh, UK: Keele University Press, 1997.

Debord, Guy. *The Society of the Spectacle.* New York: Zone Books, 1994.

Deleyto, Celestino. "Between Friends: Love and Friendship in Contemporary Hollywood Romantic Comedy." *Screen* 44, no. 2 (2003): 167–82.

Denby, David. "A Fine Romance." *New Yorker,* July 23, 2007, http://www .newyorker.com/reporting/2007/07/23/070723fa_fact_denby?currentPage=1.

Dika, Vera. "The Representation of Ethnicity in *The Godfather.*" In *Francis Ford Coppola's Godfather Trilogy,* edited by Nick Browne, 76–108. Cambridge: Cambridge University Press, 2000.

Dixon, W. W. *Straight: Constructions of Heterosexuality in the Cinema.* New York: SUNY Press, 2003.

Dole, Carol. "The Gun and the Badge: Hollywood and the Female Lawman." In *Reel Knockouts: Violent Women in the Movies,* edited by M. McCaughey and Neal King, 76–97. Austin: University of Texas Press, 2001.

Donald, Stephanie Hemelryk, and John Gammak. "Competing Regions: The Chromatics of the Urban Fix." In *Hong Kong Film, Hollywood and the New Global Cinema: No Film Is an Island,* edited by Gina Marchetti and Tan See Kam, 193–205. London: Routledge, 2007.

Donalson, Melvin. *Black Directors in Hollywood.* Austin: University of Texas Press, 2003.

———. *Hip Hop in American Cinema.* New York: Peter Lang, 2007.

———. *Masculinity in the Interracial Buddy Film.* Jefferson, NC: McFarland, 2006.

Doty, Alexander. *Flaming Classics: Queering the Film Canon.* New York: Routledge, 2000.

Drake, Philip. "'Mortgaged to Music': New Retro Movies in 1990s Hollywood Cinema." In *Memory and Popular Film,* edited by Paul Grainge, 170–86. Manchester, UK: Manchester University Press, 2003.

Dyer, Richard. *The Culture of Queers.* London: Routledge, 2002.

———. "*A Star Is Born* and the Construction of Authenticity." In *Stardom: Industry of Desire,* edited by Christine Gledhill, 136–44. London: Routledge, 1991.

———. *Stars.* London: British Film Institute, 1979.

———. *Stars.* 2nd ed. London: British Film Institute, 1998.

———. *White.* London: Routledge, 1997.

Ebert, Roger. "*Ocean's Eleven.*" *Chicago Sun-Times,* December 7, 2001, http://rogerebert.suntimes.com/apps/pbcs.dll/article?AID=/20011207/ reviews/112070302/1023.

Edwards, Tim. *Cultures of Masculinity.* London: Routledge, 2006.

Eitzen, Dirk. "The Emotional Basis of Film Comedy." In *Passionate Views: Film, Cognition, and Emotion,* edited by Carl Plantinga and Greg M. Smith, 84–101. Baltimore: Johns Hopkins University Press, 1999.

Elsaesser, Thomas. "The Pathos of Failure: American Films in the 1970s; Notes on the Unmotivated Hero." In *The Last Great American Picture Show: New Hollywood Cinema in the 1970s,* edited by Thomas Elsaesser, Alexander

Horwath, and Noel King, 279–92. Amsterdam: Amsterdam University Press, 2004.

Emerson, Ralph Waldo. *Essays and Lectures.* New York: Library of America, 1983.

Eng, David. *Racial Castration: Managing Masculinity in Asian America.* Durham, NC: Duke University Press, 2001.

Faludi, Susan. *Stiffed: The Betrayal of the American Man.* London: Vintage, 2000.

Farber, Stephen. "Has Martin Scorsese Gone Hollywood?" *New York Times,* March 30, 1975, C-1.

Farrell, Kirby. *Post-traumatic Culture: Injury and Interpretation in the Nineties.* Baltimore: Johns Hopkins University Press, 1998.

Fisher, Lucy. "Can Macho, Non-Metro Actors Play Gay?" *ABC News,* December 3, 2008, http://abcnews.go.com/Entertainment/Movies/story?id=6378749&page=1.

Fore, Steve. "Jackie Chan and the Cultural Dynamics of Global Entertainment." In *Transnational Chinese Cinemas: Identity, Nationhood, Gender,* edited by Sheldon Hsiao-peng Lu, 239–64. Honolulu: University of Hawaii Press, 1997.

———. "Life Imitates Entertainment: Home and Dislocation in the Films of Jackie Chan." In *At Full Speed: Hong Kong Cinema in a Borderless World,* edited by Esther C. M. Lau, 115–42. Minneapolis: University of Minnesota Press, 2001.

Foucault, Michel. *Discipline and Punish: The Birth of the Prison.* Translated by Alan Sheridan. New York: Vintage, 1979.

———. *The History of Sexuality.* 3 vols. New York: Vintage, 1988.

Freda, Isabella. "Survivors in *The West Wing:* 9/11 and the United States of Emergency." In *Film and Television after 9/11,* edited by Wheeler Winston Dixon, 226–46. Carbondale: Southern Illinois University Press, 2004.

Freud, Sigmund. *Beyond the Pleasure Principle.* Translated and edited by James Strachey. New York: Norton, 1961.

———. "Mourning and Melancholia." In *The Standard Edition of the Complete Psychological Works of Sigmund Freud, Vol. XIV (1914–1916),* translated and edited by James Strachey, 48–80. London: Hogarth and the Institute of Psychoanalysis, 1957.

Fuchs, Cynthia. "The Buddy Politic." In *Screening the Male: Exploring Masculinities in Hollywood Cinema,* edited by Steven Cohan and Ina Rae Hark, 194–210. New York: Routledge, 1993.

———. "*Ocean's Eleven.*" PopMatters, December 6, 2011, http://www.popmatters.com/pm/review/oceans-eleven.

Gallagher, Mark. *Action Figures: Men, Action Films, and Contemporary Adventure Narratives.* New York: Palgrave Macmillan, 2006.

——. "Masculinity in Translation: Jackie Chan's Transcultural Star Text." *Velvet Light Trap* 39 (1997): 23–41.

Gan, Wendy. "The Hong Kong Local on Film: Re-Imagining the Global." *Jump Cut*, no. 49 (2007), http://www.ejumpcut.org/archive/jc49.2007/wendygan/text.html.

Gates, Philippa. *Detecting Men: Masculinity and the Hollywood Detective Film.* Albany: SUNY Press, 2006.

Gehring, Wes. "Screwball Comedy." In *Schirmer Encyclopedia of Film*, Vol. 4, edited by Barry Keith Grant, 1217–33. Detroit: Thomson Gale, 2007.

Gerstner, David. *Manly Arts: Masculinity and Nation in Early American Cinema.* Durham, NC: Duke University Press, 2006.

Giroux, Henry. "Private Satisfactions and Public Disorders: *Fight Club,* Patriarchy, and the Politics of Masculine Violence." *JAC: A Journal of Composition Theory*, 21, no. 1 (2001): 1–31.

Giroux, Henry, and Imre Szeman. "IKEA Boy and the Politics of Male Bonding: *Fight Club.*" *New Art Examiner* (December 2000–January 2001): 32–37.

Goffman, Erving. *The Presentation of Self in Everyday Life.* London: Penguin, 1959.

Greven, David. *Manhood in Hollywood from Bush to Bush.* Austin: University of Texas Press, 2009.

Grossman, Julie. *Rethinking the Femme Fatale in Film Noir: Ready for Her Close-Up.* New York: Palgrave Macmillan, 2009.

Grossvogel, David. *Vishnu in Hollywood: The Changing Image of the American Male.* Lanham, MD: Scarecrow, 2000.

Grundmann, Roy. "Auteur de Force: Michael Haneke's 'Cinema of Glaciation.'" *Cineaste* 31, no. 2 (2006): 6–14.

Guerrero, Edward. "Black Men in the Movies: How Does It Feel to Be a Problem (and an Answer)?" In *Traps: African American Men on Gender and Sexuality*, edited by Rudolph P. Byrd and Beverly Guy-Sheftall, 270–80. Bloomington: Indiana University Press, 2001.

Hamilton, Jill. "*She Hate Me.*" In *Magill's Cinema Annual 2005*, edited by Hillary White, 617–22. Detroit: Gale, 2005.

Harper, P. B. *Private Affairs: Critical Ventures in the Culture of Social Relations.* New York: New York University Press, 1999.

Harris, Leon Erich. "The Demystification of Spike Lee." In *Spike Lee Interviews*, edited by Cynthia Fuchs, 127–38. Jackson: University Press of Mississippi, 2002.

Heston, Charlton. *In the Arena: An Autobiography.* New York: Simon and Schuster, 1995.

Hoberman, J. "Blazing Saddles." *Village Voice,* November 30–December 6, 2005, C48.

———. "Role Players and End Games." *Village Voice,* December 4, 2001, http://www.villagevoice.com/2001-12-04/film/role-players-and-end-games/.

Holmlund, Chris. "Masculinity as Multiple Masquerade: The 'Mature' Stallone and the Stallone Clone." In *Screening the Male: Exploring Masculinities in Hollywood Cinema,* edited by Steven Cohan and Ina Rae Hark, 213–29. London: Routledge, 1993.

Horton, Andrew, ed. *Comedy/Cinema/Theory.* Berkeley: University of California Press, 1991.

Howe, Irving. "The Nature of Jewish Laughter." In *Jewish Wry: Essays on Jewish Humor,* edited by Sarah Blacher Cohen, 154–67. Detroit: Wayne State University Press, 1987.

Hunt, Leon. *Kung Fu Cult Masters: From Bruce Lee to Crouching Tiger.* London: Wallflower, 2003.

Hymowitz, Kay. *Manning Up: How the Rise of Women Has Turned Men into Boys.* New York: Basic Books, 2011.

James, David. "Is There a Class in this Text? The Repression of Class in Film and Cultural Studies." In *A Companion to Film Theory,* edited by Toby Miller and Robert Stam, 182–201. Oxford: Blackwell, 2004.

Jameson, Frederic. "Class and Allegory in Contemporary Mass Culture." In *Signatures of the Visible,* 35–54. New York: Routledge, 1992.

———. "Postmodernism and Consumer Society." In *The Anti-Aesthetic: Essays on Postmodern Culture,* edited by Hal Foster, 111–25. Port Townsend, WA: Bay Press, 1983.

Jayamanne, Laleen. "Let's Miscegenate: Jackie Chan and His African-American Connection." In *Hong Kong Connections: Transnational Imagination in Action Cinema,* edited by Meaghan Morris, Siu Leung Li, and Stephen Chan Ching-kiu, 151–62. Durham, NC: Duke University Press, 2005.

Jeffords, Susan. *Hard Bodies: Hollywood Masculinity in the Reagan Era.* New Brunswick, NJ: Rutgers University Press, 1994.

Jenkins, Henry. "'The Laughingstock of the City': Performance Anxiety, Male Dread and *Unfaithfully Yours.*" In *Classical Hollywood Comedy,* edited by Kristine Brunovska Karnick and Henry Jenkins, 238–64. New York: Routledge, 1995.

Jones, Kent. "Family Romance." *Film Comment* 37, no. 6 (2001): 37–44.

Kacandes, Irene. "9/11/07 = 1/27/01: The Changed Posttraumatic Self." In *Trauma at Home: After 9/11,* edited by Judith Greenberg, 168–86. Lincoln: University of Nebraska Press, 2003.

Kahane, Claire. "Uncanny Sights: The Anticipation of the Abomination." In *Trauma at Home: After 9/11,* edited by Judith Greenberg, 107–16. Lincoln: University of Nebraska Press, 2003.

Kaplan, E. Ann. *Women in Film Noir.* London: British Film Institute, 1998.

Kauffmann, Stanley. "On Films—Promises, Promises." *New Republic,* December 31, 2004, 68–71.

Kennedy, Edward. "A Critique of Administration Policy on Health Care, Education, and the Economy." Speech delivered at the Brookings Institute, April 5, 2004, http://www.brookings.edu/events/2004/0405health-care.aspx.

Kimmel, Michael. *Manhood in America: A Cultural History.* New York: Free Press, 1996.

King, Barry. "Articulating Stardom." *Screen* 26, no. 5 (1985): 27–51.

King, Neal. *Heroes in Hard Times: Cop Action Movies in the U.S.* Philadelphia: Temple University Press, 1999.

Kirchick, James. "A Friend to Gays and Antigay Dictators Alike." *Advocate,* December 9, 2008, http://www.advocate.com/Arts_and_Entertainment/ Film/A_Friend_to_Gays_and_Dictators_Alike/.

Kirkham, Pat, and Janet Thumim. *Me Jane: Masculinity, Movies, and Women.* New York: St. Martin's, 1995.

———. *You Tarzan: Masculinity, Movies, and Men.* New York: St. Martin's, 1993.

Kitses, Jim. "All That Brokeback Allows." *Film Quarterly* 60, no. 3 (2007): 25–32.

Kitwana, Bakari. *The Hip Hop Generation: Young Blacks and the Crisis in African American Culture.* New York: Basic Civitas Books, 2002.

Klein, Kathleen. *The Woman Detective: Gender and Genre.* Urbana: University of Illinois Press, 1995.

Kolker, Robert. *A Cinema of Loneliness: Penn, Stone, Kubrick, Scorsese, Spielberg, Altman.* New York: Oxford University Press, 2011.

Krutnik, Frank. "Conforming Passions? Contemporary Romantic Comedy." In *Genre and Contemporary Hollywood,* edited by Steve Neale, 167–86. London: British Film Institute, 2002.

———. "The Faint Aroma of Performing Seals: The 'Nervous' Romance and the Comedy of the Sexes." *Velvet Light Trap* 26 (1990): 57–72.

Lahr, John. "Citizen Penn: The Many Missions of Sean Penn." *New Yorker* 82, no. 7 (2006): 59–63.

Landy, Marcia. "'America under Attack': Pearl Harbor, 9/11, and History in the Media." In *Film and Television after 9/11,* edited by Wheeler Winston Dixon, 79–100. Carbondale: Southern Illinois University Press, 2004.

LaSalle, Mick. *Dangerous Men: Pre-code Hollywood and the Birth of the Modern Man.* New York: St. Martin's, 2002.

Lauzen, Martha. "The Celluloid Ceiling: Behind-the-Scenes Employment of Women on the Top 250 Films of 2010." Women in Film, 2011. http://www.wif.org/images/repository/pdf/other/2011-celluloid-ceiling-exec-summ.pdf.

Le Cain, Maximilian. "Storytime: *The Royal Tenenbaums*." *Senses of Cinema* 20 (2002), http://www.sensesofcinema.com/2002/feature-articles/tenenbaums/.

Lee, Terry. "Virtual Violence in *Fight Club:* This Is What Transformation of Masculine Ego *Feels* Like." *Journal of American and Comparative Cultures* 25, no. 3 (2002): 17–33.

Lehman, Peter. *Running Scared: Masculinity and the Representation of the Male Body.* Philadelphia: Temple University Press, 1993.

———, ed. *Masculinity: Bodies, Movies, Culture.* New York: Routledge, 2001.

Lo, Kwai-Cheung. *Chinese Face/Off: The Transnational Popular Culture of Hong Kong.* Urbana: University of Illinois Press, 2005.

———. "Double Negations: Hong Kong Cultural Identity in Hollywood's Transnational Representations." *Cultural Studies* 15, no. 3/4 (2001): 464–85.

———. "Muscles and Subjectivity: A Short History of the Masculine Body in Hong Kong Popular Culture." *Camera Obscura* 39 (1996): 104–25.

Louie, Kam. *Theorising Chinese Masculinity: Society and Gender in China.* Cambridge: Cambridge University Press, 2002.

Ma, Sheng-Mei. *The Deathly Embrace: Orientalism and Asian American Identity.* Minneapolis: University of Minnesota Press, 2000.

MacInnes, John. *The End of Masculinity: The Confusion of Sexual Genesis and Sexual Difference in Modern Society.* Buckingham, UK: Open University Press, 1998.

Majors, Richard, and Janet Mancini Billson. *Cool Pose: The Dilemmas of Black Manhood in America.* New York: Lexington Books, 1992.

Malin, Brenton. *American Masculinity under Clinton: Popular Media and the Nineties "Crisis of Masculinity."* New York: Peter Lang, 2005.

Malone, Michael. *Heroes of Eros: Male Sexuality in the Movies.* New York: Dutton, 1979.

Marchetti, Gina. *The Chinese Diaspora on American Screens: Race, Sex, and Contemporary Cinema.* Philadelphia: Temple University Press, 2012.

———. *From Tian'anmen to Times Square: Transnational China and the Chinese Diaspora on Global Screens, 1989–1997.* Philadelphia: Temple University Press, 2006.

———. "Jackie Chan and the Black Connection." In *Keyframes: Popular Cinema and Cultural Studies,* edited by Matthew Tinkcom and Amy Villarejo, 137–58. London: Routledge, 2001.

Maslin, Janet. "*Boyz 'n the Hood.*" In *The New York Times Film Reviews, 1991–1992,* 128–29. New York: Garland, 1994.

Mazierska, Ewa. *Masculinities in Polish, Czech and Slovak Cinema: Black Peters and Men of Marble.* New York: Berghan, 2008.

McBride, Joseph. *Hawks on Hawks.* Berkeley: University of California Press, 1982.

McCain, John. "Concession Speech." Speech delivered in Phoenix, Arizona November 4, 2008, http://www.nytimes.com/2008/11/04/us/politics/04text-mccain.html.

Mellen, Joan. *Big Bad Wolves: Masculinity in the American Film.* New York: Pantheon, 1977.

Mendelson, Scott. *"Milk." Huffington Post,* December 24, 2008, http://www.huffingtonpost.com/scott-mendelson/review-milk-2008_b_153377.html.

Meyer, Moe, ed. *The Politics and Poetics of Camp.* London: Routledge, 1994.

Mitchell, Elvis. "For the New Rat Pack, It's a Ring-a-Ding Thing." *New York Times,* December 7, 2001, http://movies.nytimes.com/movie/review?res=9F03E5D8123CF934A35751C1A9679C8B63.

Mizejewski, Linda. *Hardboiled & High Heeled: The Woman Detective in Popular Culture.* New York: Routledge, 2004.

Modleski, Tania. *Feminism without Women: Culture and Criticism in a "Post-feminist" Age.* New York and London: Routledge, 1991.

———. *Loving with a Vengeance: Mass-Produced Fantasies for Women.* London and New York: Routledge, 1990.

Morag, Raya. *Defeated Masculinity: Post-traumatic Cinema in the Aftermath of War.* New York: Peter Lang, 2009.

Nama, Adilifu. *Black Space: Imagining Race in Science Fiction.* Austin: University of Texas Press, 2008.

Neal, Mark Anthony. *New Black Man.* New York: Routledge, 2005.

Neale, Steve. "The Big Romance or Something Wild? Romantic Comedy Today." *Screen* 33, no. 3 (1992): 284–99.

———. "Masculinity as Spectacle: Reflections on Men and Mainstream Cinema." In *Screening the Male: Exploring Masculinities in Hollywood Cinema,* edited by Steven Cohan and Ina Rae Hark, 1–18. London: Routledge, 1993.

Neibaur, James. *Tough Guy: The American Movie Macho.* Jefferson, NC: McFarland, 1989.

Nowell-Smith, Geoffrey. "Minnelli and Melodrama." In *Home Is Where the Heart Is: Studies in Melodrama and the Woman's Film,* edited by Christine Gledhill, 70–75. London: British Film Institute, 1987.

Okihiro, Gary. *Margins and Mainstreams: Asians in American History and Culture.* Seattle: University of Washington Press, 1994.

Ong, Aihwa. *Flexible Citizenship: The Cultural Logics of Transnationality.* Durham, NC: Duke University Press, 1999.

Ossana, Diana. *Brokeback Mountain: Story to Screenplay.* New York: Scribners, 2005.

Oxford Dictionary of Contemporary English. 3rd ed. Edited by Catherine Soanes. New York: Oxford University Press, 2001.

Palahniuk, Chuck. *Fight Club.* London: Vintage, 2003.

Pang, Laikwan. "Jackie Chan, Tourism, and the Performing Agency." In *Hong Kong Film, Hollywood and the New Global Cinema: No Film Is an Island,* edited by Gina Marchetti and Tan See Kam, 206–18. London: Routledge, 2007.

Parker, Kathleen. *Save the Males: Why Men Matter, Why Women Should Care.* New York: Random House, 2010.

Patterson, Eric. "From *Brokeback* to *Milk:* Progress in Hollywood's Representation of Sexual and Gender Minorities." *Rowmanblog,* March 19, 2009, http://rowmanblog.typepad.com/rowman/2009/03/from-brokeback-to-milk-progress-in-hollywoods-representation-of-sexual-and-gender-minorities.html.

Paul, William. "The Impossibility of Romance: Hollywood Comedy, 1978–1999." In *Genre and Contemporary Hollywood,* edited by Steve Neale, 117–29. London: British Film Institute, 2002.

Peberdy, Donna. *Masculinity and Film Performance: Male Angst in Contemporary American Cinema.* Basingstoke, UK: Palgrave Macmillan, 2011.

Penley, Constance, and Sharon Willis, eds. *Male Trouble.* Minneapolis: University of Minnesota Press, 1993.

Penn, Sean. "Conversations with Chavez and Castro." *Nation,* November 25, 2008, 11.

———. "Mountain of Snakes." *Huffington Post,* November 30, 2008, http://www.huffingtonpost.com/sean-penn/mountain-of-snakes_b_146765.html.

———. "An Open Letter to the President . . . Four and a Half Years Later." *Huffington Post,* March 24, 2008, http://www.huffingtonpost.com/sean-penn/an-open-letter-to-the-pre_2_b_44172.html.

———. "Sean Penn in Iran," *San Francisco Chronicle,* August 22, 2005, http://www.sfgate.com/cgi-bin/article.cgi?f=/c/a/2005/08/22/DDGJUEAF041.DTL.

Perglut, Don. "Jewish Comedy, Adam Sandler Style." Don Perglut's Blog, March 29, 2009, http://donperlgut.wordpress.com/personalities/jewish-comedy-adam-sandler-style/.

Pleck, Joseph. "The Theory of Male Sex-Role Identity: Its Rise and Fall, 1936 to the Present." In *The Making of Masculinities: The New Men's Studies,* edited by H. Brod, 21–38. New York: Routledge, 1987.

Pomerance, Murray. "The Man-Boys of Steven Spielberg." In *Where the Boys Are: Cinemas of Masculinity and Youth,* edited by Murray Pomerance

and Frances Gateward, 133–54. Detroit: Wayne State University Press, 2005.

Pomerantz, Dorothy, and Dan Bigman, eds. "The World's Most Powerful Celebrities." Forbes.com, May 18, 2011, http://www.forbes.com/wealth/celebrities/list.

Powdermaker, Hortense. *Hollywood: The Dream Factory.* Boston: Little, Brown, 1950.

Powrie, Phil, Ann Davies, and Bruce Babington. *The Trouble with Men: Masculinities in European and Hollywood Cinema.* London: Wallflower, 2004.

Pratt, Paul. "Q and A: Brett Ratner." Advocate.com, August 3, 2007, http://www.advocate.com/Arts_and_Entertainment/Comedy/Brett_Ratner_knows_gay_sex/.

Radway, Janice. *Reading the Romance: Women, Patriarchy and Popular Literature.* Chapel Hill: University of Carolina Press, 1984.

Rafter, Nicole Hahn. *Shots in the Mirror: Crime Films and Society.* 2nd ed. New York: Oxford University Press, 2006.

Ratner, Brett. *Rush Hour 1, 2, 3: Lights, Camera, Action!* New York: Newmarket, 2007.

Ray, Robert B. *A Certain Tendency of the Hollywood Cinema, 1930–1980.* Princeton, NJ: Princeton University Press, 1985.

Regester, Charlene. "Oscar Micheaux's Multifaceted Portrayals of the African-American Male: The *Good,* the *Bad,* and the *Ugly.*" In *Me Jane: Masculinity, Movies and Women,* edited by Pat Kirkham and Janet Thumin, 166–83. New York: St. Martin's, 1995.

Rehling, Nicola. *Extra-ordinary Men: White Heterosexual Masculinity in Contemporary Popular Cinema.* Lanham, MD: Lexington, 2009.

Rich, Adrienne. "Compulsory Heterosexuality and Lesbian Existence." In *The Lesbian and Gay Studies Reader,* edited by Henry Abelove, Michele Aina Barale, and David M. Halperin, 227–54. New York: Routledge, 1993.

Robinson, Paul. *The Freudian Left.* Ithaca, NY: Cornell University Press, 1969.

Rogin, Michael. *Blackface, White Noise: Jewish Immigrants in the Hollywood Melting Pot.* Berkeley: University of California Press, 1996.

Rosen, Marjorie. "Isn't It about Time to Bring on the Girls?" *New York Times,* December 15, 1974, 169.

Rubin, Gayle. "The Traffic in Women: Notes on the 'Political Economy' of Sex." In *The Second Wave: A Reader in Feminist Theory,* edited by Linda Nicholson, 27–62. New York: Routledge, 1997.

Rubinfeld, Mark. *Bound to Bond: Gender, Genre, and the Hollywood Romantic Comedy.* Westport, CT: Praeger, 2001.

Russo, Vito. *The Celluloid Closet.* New York: Harper and Row, 1981.

Ryan, Michael, and Douglas Kellner. *Camera Politica: The Politics and Ideology of Contemporary Hollywood Film.* Bloomington: Indiana University Press, 1988.

Saad, Lydia. "Four Moral Issues Sharply Divide Americans." Gallup.com, May 26, 2010, http://www.gallup.com/poll/137357/Four-Moral-Issues-Sharply-Divide-Americans.aspx.

———. "Tolerance for Gay Rights at High-Water Mark." Gallup.com, May 29, 2007, http://www.gallup.com/poll/27694/Tolerance-Gay-Rights-HighWater-Mark.aspx.

San Filippo, Maria. *The B Word: Bisexuality in Contemporary Film and Television.* Bloomington: Indiana University Press, forthcoming in 2013.

Sangster, Jim. *Scorsese.* London: Virgin Books, 2002.

Schrader, Paul. *Transcendental Style in Film: Ozu, Bresson, Dreyer.* Berkeley: University of California Press, 1972.

Schwarzbaum, Lisa. *"Four Brothers." Entertainment Weekly,* August 19, 2005, http://www.ew.com/ew/article/0,,1092063,00.html.

Scott, A. O. "Forget the Girl and Gold; Look for the Chemistry." *New York Times,* November 9, 2001, http://movies.nytimes.com/movie/review?res=9C00E5DB1F39F93AA35752C1A9679C8B63.

Scott, Janny. "The Silence of the Historic Present." *New York Times,* August 11, 2002, 29.

Sedgwick, Eve Kosofsky. *Between Men: English Literature and Male Homosocial Desire.* New York: Columbia University Press, 1985.

Seidman, Steve. *Comedian Comedy: A Tradition in Hollywood Film.* Ann Arbor, MI: UMI Research, 1979.

Shapiro, Bruce G. *Reinventing Drama: Acting, Iconicity, Performance.* Santa Barbara, CA: Greenwood, 1999.

Silverman, Kaja. *Male Subjectivity at the Margins.* New York: Routledge, 1992.

Sivanandan, A. "Racism, Liberty, and the War on Terror." *Race Class* 48, no. 4 (2007): 45–50.

Sklar, Robert. *City Boys: Cagney, Bogart, Garfield.* Princeton, NJ: Princeton University Press, 1992.

Slotkin, Richard. *The Fatal Environment: The Myth and Frontier in the Age of Industrialization, 1800–1890.* Norman: University of Oklahoma Press, 1998.

———. *Gunfighter Nation: Myth of the Frontier in Twentieth-Century America.* Norman: University of Oklahoma Press, 1998.

———. *Regeneration through Violence: The Mythology of the American Frontier, 1600–1860.* Norman: University of Oklahoma Press, 2000.

Sontag, Susan. "Notes on 'Camp.'" In *Camp: Queer Aesthetics and the Performing Subject; A Reader,* edited by Fabio Cleto, 53–65. Edinburgh, UK: Edinburgh University Press, 1999.

Sparks, Richard. "Masculinity and Heroism in the Hollywood 'Blockbuster': The Culture Industry and Contemporary Images of Crime and Law Enforcement." *British Journal of Criminology* 36, no. 3 (1996): 348–60.

Spoto, Donald. *Camerado: Hollywood and the American Man.* New York: New American Library, 1978.

Springer, Claudia. "Playing It Cool in *The Matrix.*" In *The Matrix Trilogy: Cyberpunk Reloaded,* edited by Stacy Gillis, 89–100. London: Wallflower, 2005.

Statistical Abstract of the United States 2011. Prepared by the chief of the Bureau of Statistics, Treasury Department. Washington, DC: U.S. U.S. Government Printing Office, 2012.

Stokes, Lisa Odham, and Michael Hoover. *City on Fire: Hong Kong Cinema.* New York: Verso, 1999.

Studlar, Gaylyn. *This Mad Masquerade: Stardom and Masculinity in the Jazz Age.* New York: Columbia University Press, 1996.

Sullivan, Nikki. *A Critical Introduction to Queer Theory.* Edinburgh, UK: Edinburgh University Press, 2003.

Tasker, Yvonne. "Fists of Fury: Discourses of Race and Masculinity in the Martial Arts Cinema." In *Race and the Subject of Masculinities,* edited by Harry Stecopoulos and Michael Uebel, 315–36. Durham, NC: Duke University Press, 1997.

———. *Spectacular Bodies: Gender, Genre, and the Action Cinema.* New York: Routledge, 1993.

Tateishi, Ramie. "Jackie Chan and the Reinvention of Tradition." *Asian Cinema* 10, no. 1 (1998): 78–84.

Taylor, Aaron. "Thinking through Acting: Performative Indices and Philosophical Assertions." In *Acting and Performance in Moving Image Culture: Bodies, Screens, Renderings,* Vol. 9, edited by Joerg Sternagel, Deborah Levitt, and Dieter Mersch, 17–35. Bielefeld: Transcript Verlag, 2012.

Teo, Stephen. *Hong Kong Cinema: The Extra Dimensions.* London: British Film Institute, 1997.

Thomson, David. *A Biographical Dictionary of Film.* 5th ed. New York: Knopf, 2010.

Traister, Bryce. "American Viagra: The Rise of American Masculinity Studies." *American Quarterly* 52, no. 2 (2000): 274–304.

Trice, Ashton, and Samuel Holland. *Heroes, Antiheroes and Dolts: Masculinity in American Popular Films, 1921–1999.* Jefferson, NC: McFarland, 2001.

Tripp, C. A. *The Intimate World of Abraham Lincoln*, edited by Lewis Gannett. New York: Simon and Schuster, 2005.

Troyer, John, and Chani Marchiselli. "Slack, Slacker, Slackest: Homosocial Bonding Practices in Contemporary Dude Cinema." In *Where the Boys Are: Cinemas of Masculinity and Youth*, edited by Murray Pomerance and Frances Gateward, 264–78. Detroit: Wayne State University Press, 2005.

Tucker, Reed. "Biting the Big Apple—To Make *I Am Legend*, Will Smith & Co. Turned Thousands of NYERS into Refugees and Vampires, Shut Down the Brooklyn Bridge and Turned Our Town into the Biggest Movie Lot in History." *New York Post*, December 9, 2007, http://www.nypost.com/p/entertainment/movies/item_SRn4Cp96Jdr2aAoKY0L7VP.

Tudor, Deborah. *Hollywood's Vision of Team Sports: Heroes, Race, and Gender.* New York: Garland, 1997.

Turan, Kenneth. "Setting Up a Plot—and Us: Changing Pace, *Inside Man* Director Spike Lee Takes the Crime-Film Genre for a Spin and Viewers for a Wild Ride." *Los Angeles Times*, March 24, 2006, http://articles.latimes.com/2006/mar/24/entertainment/et-inside24.

Turim, Maureen. *Flashbacks in Film: Memory and History.* New York: Routledge, 1989.

Turner, Ralph Lamar, and Robert J. Higgs. *The Cowboy Way: The Western Leader in Film, 1945–1995.* Westport, CT: Greenwood, 1999.

Vary, Adam B. "The *Brokeback Mountain* Effect." *Advocate*, no. 957 (February 28, 2006): 36–41.

Venturi, Robert, Denise Scott Brown, and Steven Izenour. *Learning from Las Vegas: The Forgotten Symbolism of Architectural Form.* Cambridge, MA: MIT Press, 1972.

Wager, Jans. *Dames in the Driver's Seat: Rereading Film Noir.* Austin: University of Texas Press, 2005.

Wald, Gayle. "Same Difference: Reading Racial Masculinity in Recent Hong Kong/Hollywood Hybrids." Paper presented at the Society for Cinema Studies Conference, Chicago, March 10, 2000.

Wartenberg, Thomas. *Unlikely Couples: Movie Romance as Social Criticism.* Boulder, CO: Westview, 1998.

Weddle, David. *"If They Move, Kill 'Em": The Life and Times of Sam Peckinpah.* New York: Grove, 1994.

West, Candace, and Don Zimmerman. "Doing Gender." *Gender & Society* 1, no. 2: (1987): 125–51.

Westerfelhaus, Robert, and Robert A. Brookey. "At the Unlikely Confluence of Conservative Religion and Popular Culture: *Fight Club* as Heteronormative Ritual." *Text and Performance Quarterly* 24, no. 3/4 (2004): 302–26.

Williams, Linda. "Film Bodies: Gender, Genre, and Excess." In *Film Genre Reader III*, edited by Barry Keith Grant, 141–60. Austin: University of Texas Press, 2003.

Williams, Randy. *Sports Cinema: 100 Movies; The Best of Hollywood's Athletic Heroes, Losers, Myths, and Misfits.* Pompton Plains, NJ: Limelight, 2006.

Williams, Tony. *Larry Cohen: The Radical Allegories of an Independent Filmmaker.* Jefferson, NC: McFarland, 1996.

Wills, Garry. *John Wayne's America.* New York: Simon and Schuster, 1997.

Wong, Day. "Women's Reception of Mainstream Hong Kong Cinema." In *Masculinities and Hong Kong Cinema,* edited by Laikwan Pang and Day Wong, 239–60. Hong Kong: Hong Kong University Press, 2005.

Wood, Robin. *Hollywood from Vietnam to Reagan . . . and Beyond.* New York: Columbia University Press, 2003.

———. *Rio Bravo.* London: British Film Institute, 2005.

Wyatt, Justin. "Identity, Queerness and Homosocial Bonding: The Case of *Swingers.*" In *Masculinity: Bodies, Movie, Culture,* edited by Peter Lehman, 51–66. New York: Routledge, 2001.

Zacharek, Stephanie. "*Ocean's Eleven.*" Salon.com, December 7, 2001, http://www.salon.com/entertainment/movies/2001/12/07/oceans_11/index.html.

Žižek, Slavoj. "Divine Violence and Liberated Territories: *Soft Targets* Talks with Slavoj Žižek." *Soft Targets,* March 14, 2007, www.softtargetsjournal.com/web/zizek.php.

———. *Looking Awry: An Introduction to Jacques Lacan through Popular Culture.* Cambridge, MA: MIT Press, 1992.

Contributors

Caetlin Benson-Allott is an assistant professor of English at Georgetown University, where she teaches courses on U.S. film history, new media theory, the horror genre, and gender and technology studies. Her research has appeared in *South Atlantic Quarterly,* the *Journal of Visual Culture, Jump Cut,* the *Quarterly Review of Film and Video, In Media Res,* and in *Film Quarterly,* to which she contributes a regular column, "Platforming," on intersections of motion picture technology and spectatorship. She is the author of *Regarding Video: Motion Pictures, Spectatorship, and the Aesthetics of Home Entertainment* (University of California Press, forthcoming).

Mike Chopra-Gant is a reader in media, culture, and communications at London Metropolitan University and is the author of *Hollywood Genres and Postwar America: Masculinity, Family and Nation in Popular Movies and Film Noir* (I. B. Tauris, 2006), *Cinema and History: Constructing the Past in the Movies* (Wallflower, 2008), and *The Waltons: Nostalgia, Myth and Seventies America* (I. B. Tauris, 2012).

Melvin Donalson is a professor of English at California State University–Los Angeles. He edited the text *Cornerstones: An Anthology of African American Literature* (1996) and has written three critical books on American cinema: *Black Directors in Hollywood* (University of Texas Press, 2003), *Masculinity in the Interracial Buddy Film* (McFarland, 2006), and *Hip Hop in American Cinema* (Peter Lang, 2007). He also wrote, produced, and directed two narrative short films: *A Room Without Doors,* which was broadcast as a finalist on Showtime's Black Filmmakers Showcase in 1999, and *Performance* (2008), which was screened at twelve film festivals. He maintains a website at www.meldonalson.com.

Mark Gallagher is a lecturer in film and television studies at the University of Nottingham. He is the author of *Another Steven Soderbergh Experience: Authorship and Contemporary Hollywood* (University of Texas Press, forthcoming) and *Action Figures: Men, Action Films, and Contemporary Adventure Narratives* (Palgrave Macmillan, 2006). His work on U.S. and global film and television has appeared in numerous anthologies and journals, including *Feminist Media Studies,* the *Quarterly Review of Film and Video,* the *Journal of Popular Film and Television,* the *Journal of Film and Video,* and *Velvet Light Trap.*

David Greven is an associate professor and chair of the Department of Literatures in English at Connecticut College. He is the author of *Representations of Femininity in American Genre Cinema* (Palgrave Macmillan, 2011), *Manhood in Hollywood from Bush to Bush* (University of Texas Press, 2010), *Gender and Sexuality in Star Trek* (McFarland, 2010), and *Men Beyond Desire* (Palgrave Macmillan, 2005). His most recent book, *Psycho-Sexual: Hitchcock and the Films of the 1970s,* will be published by the University of Texas Press in 2013. Greven is currently working on books about Hawthorne and Freud, same-sex desire in antebellum American literature, and postmillennial Hollywood masculinity.

Claire Sisco King is an assistant professor in the Department of Communication Studies at Vanderbilt University, where she also teaches in the film studies program. Her research interests include gender, sexuality, and trauma. Her work on masculinity in the cinema has been published in such journals as *Text and Performance Quarterly,* the *Quarterly Journal of Speech, Communication and Critical Cultural Studies,* and *Critical Studies in Media Communication.* She is also the author of *Washed in Blood: Male Sacrifice, Trauma, and the Cinema* (Rutgers University Press, 2011), which explores the relationship between trauma discourse and sacrificial rituals in popular American cinema by examining disaster films in which the leading male protagonist dies to redeem himself and save others.

Neal King is an associate professor of interdisciplinary studies at Virginia Tech. He has written two books on film violence, *Heroes in Hard Times: Cop Action Movies in the U.S.* (Temple University Press, 1999) and *The Passion of the Christ* (Palgrave, 2011), and coedited another, *Reel Knockouts: Violent Women in the Movies* (University of Texas Press, 2001). His articles have been published in the *Journal of Film and Video, Gender & Society,* and *Postmodern Culture* as well as in numerous books. He also produced the rape-education video *Mean Women* (2007).

Gina Marchetti teaches in the Department of Comparative Literature, School of Humanities, at the University of Hong Kong. Her books include *Romance and the "Yellow Peril": Race, Sex and Discursive Strategies in Hollywood Fiction* (University of California, 1993); *Andrew Lau and Alan Mak's Infernal Affairs: The Trilogy* (Hong Kong: Hong Kong University Press, 2007); and *From Tian'anmen to Times Square: Transnational China and the Chinese Diaspora on Global Screens* (Philadelphia: Temple University Press, 2006). She has also coedited several volumes, most recently, *Hong Kong Screenscapes: From the New Wave to the Digital Frontier,* with Esther M. K. Cheung and Tan See-Kam (Hong Kong University Press, 2011).

R. Barton Palmer is Calhoun Lemon Professor of Literature at Clemson University, where he also directs the film studies program. Palmer is the author, editor, or general editor of more than forty-five books on various literary and cinematic subjects. He recently authored (with Robert Bray) *Hollywood's Tennessee: The Williams Films and Postwar America* (University of Texas Press, 1999) and *To Kill a Mockingbird: The Relationship between the Text and the Film* (Methuen, 2008). He has also coedited with Linda Bradley and Steven Jay Schneider *Traditions in World Cinema* (Rutgers University Press, 2006); with Murray Pomerance *"A Little Solitaire": John Frankenheimer and American Film* (Rutgers, 2011) and *Larger Than Life: Movie Stars of the 1950s* (Rutgers, 2010); with Steven Sanders *The Philosophy of Steven Soderbergh* (University of Kentucky Press, 2010); and, most recently, with David Boyd *Hitchcock at the Source: The Auteur as Adapter* (SUNY Press, 2011). Palmer, with Linda Bradley, is the founding and general editor of the Traditions in World Cinema series from Edinburgh University Press.

Donna Peberdy is a senior lecturer in film and television studies at Southampton Solent University in the United Kingdom. Her research and publications focus on masculinity, sexuality, and acting and performance in American cinema. She has written articles and chapters on acting and performance in film noir (*The Blackwell Companion to Film Noir,* edited by Helen Hanson and Andrew Spicer), speech affectations and masculinity (*Film Dialogue,* edited by Jeff Jaeckle), Michael Douglas and contemporary male stardom (*Pretty People: Movie Stars of the 1990s,* edited by Anna Everett), acting and performance in the films of Wes Anderson (*New Review of Film and Television*), Tom Cruise and bipolar masculinity (*Men & Masculinities*), and the voice in film and theater (*Screening the Past*). She is the author of *Masculinity and Film Performance: Male Angst in Contemporary American Cinema* (Palgrave MacMillan, 2011) and is currently

coediting a collection of essays on the representation of sexual taboo in film titled *Tainted Love: Screening Sexual Perversities* (I. B. Tauris).

Chris Robé is an associate professor of film and media studies in the School of Communication and Media Studies at Florida Atlantic University. His research explores the ways in which historic and contemporary social movements utilize film and new media in collectively organizing around social justice issues. He has published in journals such as *Cinema Journal, Framework,* and *Jump Cut.* He is the author of *Thunder Over Hollywood: Cinema, Modernism, and the Emergence of U.S. Left Film Theory and Criticism* (University of Texas Press, 2010). He is currently working on a theoretically inflected history concerning digital media activism from 1970 to the present.

Maria San Filippo teaches cinema and media studies and gender and sexuality studies at Harvard College, MIT, and Wellesley College, where she was the 2008–2010 Mellon Postdoctoral Fellow in Cinema and Media Studies. Her book *The B Word: Bisexuality in Contemporary Film and Television* is forthcoming in 2013 from Indiana University Press, and her articles and reviews have appeared in *CineAction, Cineaste, Film History, In Media Res,* the *Journal of Bisexuality,* the *Quarterly Review of Film and Video,* and *Senses of Cinema* as well as in the anthology *Global Art Cinema* (Oxford University Press, 2010). Her research focuses on intersections between screen media and contemporary cultural politics, especially in regard to representing and negotiating alternative sexualities.

Christopher Sharrett is a professor of communication and film studies at Seton Hall University. He is the author of *The Rifleman* (Wayne State University Press, 2005), the editor of *Crisis Cinema: The Apocalyptic Idea in Postmodern Narrative Film* (Maisonneuve, 1993) and *Mythologies of Violence in Postmodern Media* (Wayne State University Press, 1999), and the coeditor of *Planks of Reason: Essays on the Horror Film* (Scarecrow, 1984). His work has appeared in *Cineaste, Cinema Journal, Framework,* the *Journal of Popular Film and Television, Film International, Kino Eye, Senses of Cinema,* and other publications, including numerous anthologies.

Timothy Shary has been a professor at the University of Massachusetts, Clark University, and the University of Oklahoma. He is the author of *Generation Multiplex: The Image of Youth in Contemporary American Cinema* (University of Texas Press, 2002) and *Teen Movies: American Youth on Screen* (Wallflower, 2005) and the coeditor with Alexandra Seibel of *Youth*

Culture in Global Cinema (University of Texas Press, 2007). His research on the representational politics of age and gender has been published in many anthologies, and his essays and reviews have also appeared in journals such as *Men and Masculinities, Film Quarterly, Sight and Sound,* the *Journal of Film and Video, Film Criticism,* the *Journal of Popular Film and Television, Wide Angle,* and the *Journal of Popular Culture.*

Aaron Taylor is an associate professor in the Department of New Media at the University of Lethbridge. He is the editor of *Theorizing Film Acting* (Routledge, 2012), and his most recent publications on film performance can be found in the *Quarterly Review of Film and Video* (2012), *Acting and Performance in Moving Image Culture* (2012), *Stages of Reality: Theatricality in Cinema* (2011), and the *Journal of Film and Video* (2007). His study of *It's a Wonderful Life* is forthcoming in the Cultographies series from Wallflower Press.

Index

apocalypse films, 244–48

Arbuckle, Roscoe "Fatty," 203, 213

Arbuthnot, Lucie, 185

Armageddon (1998), 245

Aronson, Amy, 128

Artists and Models (1955), 285n6

Ashcraft, Karen Lee, 85

Assayas, Olivier: *Irma Vep*, 304, 305

Atkinson, Michael, 19–20

Attal, Yvan, 305

The A-Team (2010), 279

authority: of cinematic fathers, 101; markers of, 2; white male, 300

Babuscio, Jack, 57–58

Baby Boy (2001), 233; black masculinity in, 237–39

Backdraft (1991), 141

Baker, Brian: *Masculinity in Fiction*, 8

Bakhtin, Mikhail, 293

Bale, Christian, 145

Bamboozled (2000), 225

Bardot, Brigitte, 304

Barrymore, Drew, 22

Barthes, Roland: *Mythologies*, 157

Bassett, Angela, 234

Battle of Los Angeles (2011), 246

Baudrillard, Jean, 301

Beatty, Warren, 27, 304

Bedtime Stories (2008), 23, 46

Begnini, Roberto, 22

Belafonte, Harry, 244

Belushi, John, 203

Benjamin, Andre, 239

Benshoff, Harry, 56

Benson-Allott, Caetlin, 12

Bentham, Jeremy: Panopticon of, 276

Berry, Halle, 306

Berry Gordy's the Last Dragon (1985), 295

beta male comedies, 151–58; double protagonists of, 152, 162n5; masculinity crisis in, 151, 152; *Observe and Report*, 152–58

Beverly Hills Cop (1984), 311n30

Big Daddy (1999), 23, 28

Big Deal on Madonna Street (1958), 268

Billson, Janet Mancini, 223

Billy Madison (1995), 19, 21, 24, *24*, 49n8; anger in, 10; songs in, 43

Bingham, Dennis, 183; *Acting Male*, 6

bisexuality, 12; in *Gentlemen Prefer Blondes*, 184–85, 186; as mediating factor, 193; in *Wedding Crashers*, 192, 195–96

Black, Dustin Lance, 59

Black Snake Moan (2006), 240

Blanchett, Cate, 110

blaxploitation films, 67, 224; costumes of, 71–72; female power in, 69; influence on *Rush Hour* trilogy, 294, 298, 300; Singleton's homage to, 240

Bloomberg, Michael, 243

Blown Away (1994), 72

Bly, Robert, 99

Bob le Flambeur (1955), 268

bodies: ambiguously gendered, 201; cultural intelligibility of, 201, 205, 216n3; marginalization through heterosexuality, 201; orientation to physical world, 216; pleasurable, 208; representational contact with, 202, 212

bodies, fat, 200–216; abject, 212–13; boundaries on, 215; in *Capote*, 200; cultural intelligibility of, 205; female, 201; hedonistic, 203, 205; Hoffman's representation of, 12, 200–216; and homosexuality, 206; infantilization of, 213; invisibility of, 205, 212; marginalization of, 206; and masculinity, 203; and normativity, 211, 213; non-phallocentric, 212, 216; stereotypes of, 201–2, 218n16; of villains, 214–15

bodies, male: in cinema, 140; erotic contemplation of, 152–53; homosocial, 184; in media, 8; powerful, 206; sacrificial offerings of, 255; symbolic structures of, 216

Body Double (1984), 154

Bogart, Humphrey, 215

Bonds, De'Aundre, 227
Bonham Carter, Helena, 87
Bonnie and Clyde (1967), 304–5
Boogie Nights, *209*, *212*;
 bodily signification in, 213;
 heteronormativity in, 213; Hoffman
 in, 206–13, 218n20, 218n24; porn
 industry in, 206
Boyle, Lara Flynn, 202
Boys Don't Cry (1999), 55
Boyz N the Hood (1991), 232; black
 masculinity in, 233–35; fatherhood
 in, 234–35; hip hop in, 234
Bradshaw, Peter, 154
Braugher, Andre, 228
Breaking Bad (television series), 152
Breathless (1960), 304
Bresson, Robert, 126
Bridesmaids (2011), 46
Bringing Out the Dead (1999), 11,
 123–41, *138;* alienation in, 127;
 community in, 127; gender in, 128,
 129; healing in, 127; homage to
 Bresson, 126; male characters of,
 138–39; narrative climax of, 125;
 paradox of masculinity in, 127;
 patriarchy in, 129; postindustrial
 life in, 141; service industry work in,
 136–39; transcendental experience
 in, 123, 124; transformative love in,
 128; working class in, 129, 136, 141
Bringing Up Baby (1938), 39
British Invasion (1960s), 114
Brokeback Mountain (2005), 11–12,
 55, 165–80, *168*, *178*, 197n2, 306;
 American Gothic in, 178–79;
 authenticity markers in, 56;
 community in, 174–76, 177;
 domesticity in, 176–77; genital sex in,
 170, 172; heroism in, 172, 173, 174;
 heterosexual marriage in, 175–77,
 179; iconography of, 172; labor in,
 176–77; landscape of, 171–73, 179;
 patriarchy in, 177, 179; production
 of, 56; representational space of, 56;
 score of, 172; sexual identity in, 181;

violence in, 177–78; Western myth
 and, 167, 171
bromances, 46, 181–97; marriage
 equality in, 196–97; white
 masculinity in, 183. *See also* buddy
 films
Brookey, Robert A., 86, 90–91
Brooklyn's Finest (2009), 72; climax of,
 73–74; corruption in, 73; hero of, *69*
Brooks, James L., 25
Bruzzi, Stella: *Bringing Up Daddy*, 7, 118;
 on cinematic fathers, 101
Bryant, Anita, 58
Buck and the Preacher (1969), 224
buddy films, 12, 40–41, 161n6, 198n11;
 African American-Asian, 300;
 female, 184; heteromasculinity in,
 196; homoeroticism in, 182–83;
 interracial, 67–68, 80, 292, 295–
 96; male bonding in, 72; overt
 homosexuals in, 187–88; postclassical
 incarnation of, 182–83; psychosexual
 displays in, 183–84; Western, 167. *See
 also* bromances
Bulletproof (1996), 41
Burr, Ty, 246
Burstyn, Ellen: in *Alice Doesn't Live Here
 Anymore*, 131, 133, 135–36
Bush, Billy Green, 132
Bush, George W.: 9/11 commemoration,
 243; terrorist rhetoric of, 253, 254,
 260
Butch Cassidy and the Sundance Kid
 (1969), 182
Butler, Judith, 56, 63n5; *Bodies That
 Matter*, 54; on gender, 101, 200–201;
 on social power, 106
Byrd, Thomas Jefferson, 227

Caan, Scott, 274, 283
Cage, Nicholas, 123, *138*
California Split (1974), 182
Callahan, "Dirty" Harry (film character),
 69
Cameron, James: *Terminator 2*, 144
camp, 57–58

Canby, Vincent, 132
Candy, John, 203
Cape Fear (1962), 144
capitalism: class issues in, 130; in *Fight Club*, 85, 86, 87, 91, 95, 97, 98–99; masculinity and, 95, 98
Capote (2005), 201; male bodies in, 200
Capote, Truman: *In Cold Blood*, 200
Carnie, Dave, 197n1
the carnivalesque, subversive power of, 294
Carrell, Steve, 152
Casino Royale (2006): betrayal in, 281; retro elements of, 270
Cassel, Seymour, 114
Cassel, Vincent, 266
Casseus, Gabriel, 228
Castro, Raúl, 62
Cavell, Stanley, 21, 40, 197n1; on comedies of remarriage, 190
The Cell (2000), 72
Chan, Jackie, 13; agility of, 292–93; Americanization of, 300; in *Around the World in Eighty Days*, 308n1; as Asian sidekick, 307–8; Asian stardom of, 308; bodily movements of, 309n13; *chou* characteristics of, 293–94; ethnicity of, 289; female fans of, 310n13; global appeal of, 291–92, 307–8; Hong Kong films of, 291, 309n13, 312n38; and Hong Kong tourism, 312n38; in *The Karate Kid*, 292; in *The Medallion*, 308n1; Peking Opera training, 293; performance of masculinity, 288–308, 309n13; on *Rush Hour*, 288, 289; in *Rush Hour* series, 288–308, *290, 299*; in *Shanghai* series, 308n1; sources for persona, 291; star image of, 309n13; transnational flexibility of, 309n13; in *The Tuxedo*, 308n1
Chan, Kenneth, 307
Charlie Chan in Egypt (1935), 296
Chávez, Hugo, 62
Cheadle, Don: in *Ocean's Eleven*, 269, 271, 274, 279; in *Ocean's Thirteen*,

281; in *Reign Over me*, 31, 37; in *Rosewood*, 235; in *Rush Hour 2*, 294
Chesnutt, Morris, 234
Cheung, Maggie, 304
China, American attitude toward, 289
Chinatown (1974), 303
Chirac, Jacques, 304
Chodorow, Nancy, 103
Chopra-Grant, Mike, 10; *Hollywood Genres and Postwar America*, 8
Chun, William, 311n35
Chungking Express (1994), 300
Cimarron (1931), 174
cinema, American: androcentric themes of, 33; anti-homosexual, 55; Asians in, 292, 293, 296, 300; biographical, 60–61; black male stars of, 3–4; black masculinity in, 223–41, 296; body genres, 161n4; class in, 131; compulsory heterosexuality in, 201; eschatological, 244–48; ethnic issues in, 9, 289; fitness culture of, 201; gender disparity in, 4; global audience of, 289, 292, 302, 303, 307; "hard body," 140; low-budget, 67; male domination of, 4–5; male ensembles in, 281, 285n7; masculinity crisis in, 101; masquerade in, 285n2, 292–94; minstrel tradition in, 296, 310n25; New Wave, 182; Oedipus myth in, 94–95, 126, 148; patriarchy in, 128, 145, 148–49; performance of social roles in, 54; post-Vietnam, 6, 129; power genres of, 152; psychopaths in, 90–91; race in, 3–4, 9, 289; sociocultural influences of, 241; transcendental, 123, 126; women's roles in, 4–5, 34, 43, 66–80, 135, 225, 297–98; working-class males in, 139–40, 141. *See also specific genres of cinema*
cinema, European: crisis in, 305; and *Rush Hour 3*, 303–8
Clark, Spencer Treat, 140
class: academic study of, 129–30; in *Alice Doesn't Live Here Anymore*,

131, 133; in American cinema, 131; in Anderson's films, 113–15, 118; artistic representation of, 131; in *Bringing Out the Dead*, 129, 131; in cinematic masculinity, 11; in cultural studies, 130; in film studies, 130; and gender, 118, 129, 131; in *The Life Aquatic*, 117–18; lived experience of, 131, 141; politics of, 134; and wage labor, 176. *See also* working class

culture (*continued*)
melting pot myth in, 295; 9/11 in, 247–48; nostalgia in, 267; post-9/11, 244; second-wave feminism in, 128; sexism in, 189; sexual violence in, 74–79; shifts in, 258; Texan, 173; therapy in, 95; transformative love in, 128; work in, 134–35
The Curious Case of Benjamin Button (2008), 90
Custen, George, 61

Dalton, David, 180n8
Damon, Matt: in *Ocean's Eleven,* 267, 274, 278, 280
Dangerfield, Rodney, 161n7
Daniels, Erin, 145
Daredevil (2003), 280
The Darjeeling Limited (2007), 119n4, 120n16; racism in, 120n24
Davies, Jude, 55
Davis, Ossie, 224, 228
Davis, Sammy, Jr., 271
Davison, Bruce, 5
Daybreakers (2009), 244
The Day the Earth Stood Still (2008), 244
Dean, James, 170–71, 180n8
death, sacrificial, 254–55, 257, 258, 260
Debord, Guy, 98
The Deep End (2001), 146–47
Deleyto, Celestino, 35
Demolition Man (1993): climax of, 75–76; female sidekick of, 82n32; hero of, *71;* sodomite allusions in, 74, 75–76, 77
Denby, David, 33
De Niro, Robert, 22; in *Cape Fear,* 148; on Sean Penn, 53; in *Taxi Driver,* 123, 145, *147*
De Palma, Brian, 155; suspense comedies of, 154
Depardieu, Julie, 307
desire, criminalization of, 215
Dexter (television series), 152
Diaz, Cameron, 191
Dika, Vera, 263n12

directors: black male, 224; gay, 55
Dirty Harry (1971), 67
disability studies, in queer theory, 216n3
divorce rate, increase in, 2
Dobkin, David: *Wedding Crashers,* 12, 33, 152, 181–97
Dole, Carol, 70
Donalson, Melvin, 12, 16n20, 70, 292
Do the Right Thing (1989), 225
Doty, Alexander, 185, 186, 194, 198n13
Doubt (2008), 217n5
Douglas, Michael, 150
dozens (insult contest), 296, 310n24
Drake, Philip, 269–70
Dream Team (basketball team, 1992), 305–6
Dressed to Kill (1981), 154
du Bont, Jan: *Twister,* 201, 203–6
Dude, Where's My Car? (2000), 183
Dunaway, Faye: in *Bonnie and Clyde,* 304; in *Chinatown,* 311n36
Duncan, Michael Clark, 280
Dutton, Charles S., 228
Dyer, Richard, 32, 54, 55, 62, 283; *The Culture of Queers,* 56

Eastwood, Clint, 166
Easy Rider (1969), 182
Ebert, Roger, 286n9
Edwards, Tim, 25
Eight Crazy Nights (2002), 23, 50n12; anger in, 26; songs in, 43
Ejiofor, Chewitel: in *Four Brothers,* 239–40; in *Inside Man,* 231
El Dorado (1966), 168
Election (2005), 300
Ellis, Bret Easton: *American Psycho,* 144–45
Elsaesser, Thomas, 182
The Enforcer (1976), 77, 79
Eng, David, 293
Enter the Dragon (1973), 297
Erin Brockovich (2000), 268
ethnicity, in American cinema, 9, 289
Ewing, Patrick, 305
exceptionalism, American, 256

Friedan, Betty, 133; *The Feminine Mystique*, 132, 135
friendship, male, 35. *See also* homosociality
Fright Night (1985), 154
Fringe (television series), 159
Fuchs, Cynthia, 183–84, 286n13
Fu Jow Pai (kung fu), 310n20
Fuller, Sam: *Steel Helmet*, 302–3
Funny People (2009), 46–49, 153; Sandler in, *48*; structural motifs of, 47

G, Franky, 269, 271
Gainsbourg, Serge: "Bonnie and Clyde," 304, 305
Gallagher, Mark, 13, 293; *Action Figures*, 8
The Game (1997), 150
Game of Death (1978), 302
Gan, Wendy, 290
Gandhi, 92, 93
gangsters, cinematic, 6
Garcia, Andy, 266, 273, 286n9
Garofalo, Janeane, 47
Gates, Philippa, 66, 69, 70, 81n29; *Detecting Men*, 8
gay culture: in straight media, 40–41. *See also* homosexuality
gay rights, 3
gay texts, surreptitious, 198n20
gaze: agentive, 253; carceral, 276; emasculating, 283; technologies of, 283
gaze, cinematic: black males', 280, 283; male objects of, 267
Gehring, Wes, 43
gender: in action films, 289; in American culture, 3–4; in *Bringing Out the Dead*, 128, 129; cinematic stereotypes of, 8; class and, 118, 129, 131; compulsory system of, 216n2; cultural construction of, 200; and cultural intelligibility, 201; in film studies, 122; issues for men, 3–4; lived experience of, 131; performance of, 54, 101, 123, 292; politics of, 134, 140; role in identity, 128; as social

construct, 54; twenty-first century binaries of, 190–91
gender identity, Butler on, 200–201
gender relations: in *Alice Doesn't Live Here Anymore*, 132–34; effect of World War II on, 88
genre films: hybridity in, 154–55, 157; psycho figures in, 144
Gentlemen Prefer Blondes (1953): bisexuality in, 184–85, 186; double wedding in, 194–95
Gere, Richard, 126
Gerstner, David: *Manly Arts*, 7
Gertz, Jami, 204
Getchell, Robert, 131
Get On the Bus (1996), 225, 232; activism in, 228; black masculinity in, 227–29; father-son relationships in, 227, 229; homophobia in, 228; male responsibility in, 228–29
Ghostbusters (1985), 154
Giant (1956), 170–71; challenge to Western myth, 171
Gibson, Tyrese: in *Baby Boy*, 237; in *Four Brothers*, 239
Gilman, Sander, 202
Girl 6 (1996), 225
Giroux, Henry, 85
Glover, Danny, 115
Godard, Jean-Luc: *Breathless*, 304
The Godfather (1972), 251, 263n12
God Told Me To (1977), 149
Goffman, Erving, 55–56
Goldblum, Jeff, 113
Gooding, Cuba, Jr., 234
Gooding, Omar, 237
Goodman, John, 138
The Good Thief (2002), 268, 269
Gordon's War (1973), 224
The Graduate (1967), 104, 194
Granger, Farley, 159
Grant, Barry Keith: *Shadows of Doubt*, 8
Gray, F. Gary, 271
The Great Train Robbery (1903), 165
Green, David Gordon: *Pineapple Express*, 152

Green, Seth, 271

Greenstreet, Sydney, 203

Greer, Germaine: *The Female Eunuch*, 132

Greven, David, 11; *Manhood in Hollywood from Bush to Bush*, 7

Griffin, Ted, 275

Grossvogel, David: *Vishnu in Hollywood*, 7

Grown Ups (2010), 19, 27, 35, 46, 47

Grundmann, Roy, 180n11

Guerrero, Ed, 224

Guzman, Luis, 269

Gyllenhaal, Jake, 55, 167

Hackman, Gene: in *Heist*, 270; in *The Royal Tenenbaums*, 103

Hall, Arsenio, 296

Hamburg, John: *I Love You, Man*, 152

Hammer, Mike (fictional character), 69

Hancock (2008), 259

The Hangover (2009), 46, 152

Hanks, Tom, 55, 59

Hannibal Lecter films, 68; transformations to, 161

Happiness (1998), Hoffman in, 202–3, 217n5

Happy Gilmore (1996), 21–22, 27; anger in, 26

Happy Madison (production company), 51n27

Hardcore (1979), 126

Hark, Ina Rae, 122, 127

Harlem Renaissance, 235

Harper, Hill, 228

Harrelson, Woody, 229

Harris, Leonard, 155

Harron, Mary, 145

Hart, William S., 166

Hathaway, Anne, 167

Hawks, Howard, 198n12; Westerns of, 168–69

Hedlund, Garrett, 239

He Got Game (1998), 225

Heigl, Katherine, 153

Heist (2001), 270–71, 286n12

heist films: crime plots of, 270; ensemble, 268, 285n7; as metaphor for filmmaking, 286n12; technology in, 272–73

heist films, neoretro, 267–73; action in, 279; male gaze in, 283; male groups in, 281, 283; masculinity crisis in, 269; multiracial cast of, 269. *See also* *Ocean's* series

Hemingway, Ernest, 92

Henson, Taraji P., 238

Herman, Pee-Wee, 32

heroism: in *Brokeback Mountain*, 172, 173, 174; in cop cinema, 68–69, 73, 77; in *I Am Legend*, 254, 261; masculinist, 10, 256. *See also* Western heroes

Heston, Charles: in *The Omega Man*, 244, 258, 262; political views of, 258

heteromasculinity: in buddy films, 196; in *Wedding Crashers*, 188

heteronormativity, 11, 216n2; in *Boogie Nights*, 213; phallocentrism of, 212, 216; in *Twister*, 203, 205–6; in *Wedding Crashers*, 185, 193. *See also* heterosexuality, compulsory

heterosexuality: performativity of, 54; postmodern, 308; in *Rush Hour* trilogy, 295; security issues in, 102

heterosexuality, compulsory, 91; in cinema, 201; male embodiment outside, 216. *See also* heteronormativity

Higher Learning (1999), 233

Hill, Jody: *Observe and Report*, 11, 152–58

The Hills Have Eyes (2006), 244

Hitchcock, Alfred: *Psycho*, 160; *Strangers on a Train*, 159–60

Hoberman, J., 182

Hoffman, Philip Seymour: acting successes of, 213; in *Along Came Polly*, 213; in *Boogie Nights*, 206–13, 218nn20,24; in *Capote*, 200, 201; in *Doubt*, 217n5; fat characters of, 12, 200–216; in *Flawless*, 217n5;

Hoffman, Philip Seymour (*continued*)
in *Happiness*, 202–3, 217n5; in
Mission Impossible III, 201, 213–15,
219n35; Oscar of, 200; in *Owning
Mahowny*, 213, 217n5; physical
performances of, 200, 202–3, 206,
208, 215–16; *polysarkia* of, 202; in
Red Dragon, 202; in *25th Hour*, 213,
217n5; in *Twister*, 201, 203–6, 217n5;
use of gesture, 202, 207–9, 218n20;
weight adjustments by, 213
Holland, Samuel: *Heroes, Antiheroes,
and Dolts*, 6–7
Holmes, Katie, 149
Holmlund, Christ, 292
homophobia: in *Get On the Bus*, 228;
in *The Life Aquatic*, 113, 117–18;
violent, 3
homosexuality: of Cold War era, 159;
de-eroticization of, 183; fat bodies
and, 206; normalizing model of, 182;
performance of, 53–54, 56–57, 58,
62; public attitudes toward, 14n2. *See
also* identity, queer
homosexuality, cinematic, 4; authenticity
in, 53–54, 56, 59; in buddy films,
187–88; in cop cinema, 70; cultural
codes for, 56; in *Milk*, 62–63;
performance of, 53–55, 62–63; in *A
Single Man*, 57; star images in, 56;
stereotypes of, 55, 56; straight actors'
portrayal of, 55, 56; in *Suddenly, Last
Summer*, 161n12
homosexuals, in the military, 2
homosociality, cinematic, 35; interracial,
292; of male bodies, 184; in *Ocean's
Eleven*, 265, 270, 281; in *Rush Hour*
trilogy, 298
Hong Kong: change of sovereignty, 289;
martial arts films of, 294, 302
Hope, Bob, 22
Hopkins, Anthony, 144
horror, hybridity with other genres, 152,
154, 161n4
Hud (1962), 173
Hudson, Rick, 171

Hung, Sammo, 296
Hunt, Helen, 204
Hurricane Katrina, 263n9
Hustle & Flow (2005), 240
Huston, Anjelica: in *The Darjeeling
Limited*, 120n16; in *Lonesome Dove*,
170; in *The Royal Tenenbaums*, 103
Hymowitz, Kay: *Manning Up*, 151
hypermasculinity: in American culture,
173; of hip-hop generation, 233

I Am Legend (2007), 12–13, 243–62,
246; agentive gaze in, 253; alternative
endings of, 256–57; antecedents
of, 244–45; Bob Marley in, 260;
date of action, 247, 257–58;
flashbacks in, 250; Ground Zero
in, 247, 256; helicopter crash in,
250, 263n11; heroism in, 254, 261;
human responsibility in, 248, 254;
masculinist subjectivities of, 249,
250, 251, 252; masculinity in, 253–54;
mediated images in, 249; New York
City in, 245, 251–52, 255; 9/11
references in, 245, 247–50; and *The
Omega Man*, 245, 249, 250, 258, 261–
62; Other in, 256; patriarchy in, 250,
251, 252, 255; point-of-view shots
in, 249, 253; post-9/11 discourse in,
245; post-traumatic stress disorder
in, 244, 250; racism in, 258, 260, 262;
redemption in, 245, 261–62; reviews
of, 245, 247; sacrificial death in,
254–55, 257, 258, 260; spectatorship
in, 249; survivor testimony in, 257;
television reporting in, 247, 248–49
Ice Cube, 234
identity: gender, 128; normative, 1;
politics of, 130–31, 258; post-9/11, 254
identity, masculine: in *Fight Club*,
85, 93–99; instability in, 101;
masochistic, 161n5; mature, 89,
90–91, 99; narcissistic, 161n5; race
and, 9, 12–13
identity, queer: in Hoffman's films, 12
identity, sexual, 181; constructedness of, 58

women's goals during, 191–92. *See also* same-sex marriage

Marriage on the Rocks (1965), 285n6

marriage rate, decrease in, 2

martial arts films, of Hong Kong, 294, 302

Martial Law (television series), 296

masculinity: aggression in, 26; and American hegemony, 305; during Clinton era, 7; cultural constructions of, 123; demographic changes effecting, 2; depraved, 143; domestication of, 33; entitled, 102, 103, 111, 118–19; fat and, 203; gay, 41; and grieving, 106; hegemonic, 262; Hemingwayesque, 188; heroic, 10, 256; historical events effecting, 2; historiography of, 101; idealized, 91–93, 99; versus manhood, 102, 119n6; marketing of, 27; as masquerade, 212, 294, 305; in mass culture, 167; in media, 1; multiracial, 294; nonwhite, 303; paradox of, 127; paternalistic, 92–93; performance of, 102, 119n6, 266; and physical force, 256; postmodern, 302; post-9/11, 252, 291, 303–8; primal, 98, 99; race and, 9, 12–13; during Reagan era, 6; regressive, 151; rejection of femininity, 103; retro, 303; rites of passage in, 90–91; as social condition, 21; transition from childhood, 90–91; virtues of, 26. *See also* men, American

masculinity, black: in American cinema, 223–41, 296; formulaic narratives of, 224; in Lee's films, 224–32; in *Mo' Better Blues*, 225–27; mutifacetedness of, 241; politicization of, 240; in *She Hate Me*, 229–30; in Singleton's films, 224, 232–40

masculinity, cinematic, 1, 3–13; in action films, 289; arrested adolescence in, 24, 31, 32; Asian, 293, 296; in beta male comedies, 152; castration themes in, 122; Chan's performance of, 288–308, 309n13; Chinese versus

American, 290; class issues in, 11; conformity in, 22; conservativism in, 10; content analysis of, 66; in cop cinema, 66–80; corporeal imagery of, 8; domination in, 122; European, 304; film theory on, 122; friendship in, 35; hedonistic, 33; heroic, 10, 66, 71, 80; hierarchical notions of, 293–94; homosocial cameraderie of, 35; hyperbolic, 69, 70, 152, 166; lack in, 122; in *The Life Aquatic*, 103; maturation in, 10; neoretro, 269; nonwhite, 294; performance of, 9, 10; race in, 289; in *Rush Hour* trilogy, 288–308; Sandler's, 20, 21; scholarship on, 5–8; in Scorsese's films, 146; of silent era, 8; socialization in, 10; spiritual issues in, 11; unification in, 10; unrealistic images of, 5–6; violence in, 10–11; work ethic in, 28, 33

masculinity crisis, 7–8, 9; in beta male comedies, 151; consumerism in, 27, 86; cultural shifts affecting, 26; effect of economy on, 28–29; fathers' role in, 88; in *Fight Club*, 85, 86, 95, 99; in Lee's films, 225; in Sandler's performances, 24, 25, 29, 40, 49; in U.S. cinema, 101

Maslin, Janet, 233–34

masochism, phallic standard of, 212

masquerade: in American cinema, 285n2, 292–94, 305; masculinity as, 212, 292–94

masturbation, social debates concerning, 2

Matheson, Richard: *I Am Legend*, 244, 256, 259

Matrix series, 287n19

Mature, Victor, 144

Maxwell, Roberta, 179

McAdams, Rachel, 185

McBride, Joseph, 198n12

McCain, John: concession speech of, 260–61

McConaughey, Matthew, 27, 33

McGreevey, Jim, 243
McMurtry, Larry: *Horseman, Pass By,*
 173; *Lonesome Dove,* 169–70
McRobbie, Peter, 179
Mean Streets (1973), 131
mediation: of information, 247, 248–49;
 in *Ocean's Eleven,* 273, 284
Meet the Parents (2000), 192
Me Jane (Kirkham and Thumin), 6
melancholia: of cinematic fathers,
 105–11; in *The Life Aquatic,* 111–13;
 and mourning, 106; in *The Royal
 Tenenbaums,* 110
Mellen, Joan: *Big Bad Wolves,* 5–6
Melville, Jean Pierre: *Bob le Flambeur,*
 268
memorialization, repetition in, 243, 245
men, African American: cinematic
 images of, 12; definition of manhood,
 223; demeaning portrayals of, 225;
 experience of patriarchy, 223; of
 hip-hop generation, 233; kung fu
 practitioners, 295; in Lee's films, 225;
 obstacles facing, 223; participation
 in society, 224; relationship
 with Chinese, 295, 296; societal
 participation by, 224; understanding
 of feminism, 233
men, American: college-educated, 2;
 cultural shifts concerning, 2–3;
 feminization of, 7, 27, 41–42, 86, 95;
 gender issues for, 3–4; infantilized,
 90, 95, 99; in postfeminist age,
 161n3; working class, 125. *See also*
 masculinity
men, Asian: in American cinema, 293,
 296
Menace II Society (1993), 280
Men in Black (1997), 259
The Mexican (2001), 33
Meyer, Moe, 58
Michaels, George: "Freedom," 41
Midnight Cowboy (1969), 182
military, homosexuals in, 2
Milk (2008), 10, 52–54; authenticity
 markers in, 56; as biopic, 59;

heterosexual performance in, 61,
 62–63; human rights issues in, 62;
 production of, 56; public/private
 personas in, 58–59; representational
 space of, 56; reviews of, 59
Milk, Harvey, 10, 53; gay identity of,
 57, 58; "last testament" of, 58–59;
 personality of, 59–60; relationship
 with Scott Smith, 59
Million Dollar Baby, 4, 9
Million Man March (1995), 227, 229
mimesis, versus impersonation, 64n31
Ming, Yao, 306
Minkoff, Rob: *The Forbidden Kingdom,*
 288
Miracle at St. Anna (2008), 232
Miss Congeniality (2000), 72; sexual
 vulnerability in, 77
Mission Impossible (1996), 273
Mission Impossible III (2006): Hoffman
 in, 201, 213–15, 219n35; MacGuffin
 of, 215, 219n35
Mitchell, Radha, 149
Mitchum, Robert, 144, 147
Mo' Better Blues (1990), 12, 225, *226,*
 232; black masculinity in, 225–27;
 gender issues in, 225
Modleski, Tania: *Feminism without
 Women,* 101
monogamy, compulsory, 197n3
monosexuality, 197n3; compulsory, 181
Monroe, Marilyn, 185
Monsoon Wedding (2001), 146
Monster (2003), 55
Moore, Julianne, 210
Morag, Raya: *Defeated Masculinity,* 8
Moreland, Mantan, 296
Morita, Pat, 292
Mos Def, 271
Mosher, Jerry, 202
Mostel, Zero, 203
Motion Picture Association of America,
 rating system of, 68, 81n9
Mottola, Greg: *Superbad,* 152
mourning: in *Rushmore,* 107–9; social
 power over, 106; for Vietnam, 108–9

One Hour Photo (2002): Oedipus myth in, 148; pedophilia in, 147, 148; psycho figure in, 145–46, 147–49

Ophuls, Max, 146

Orientalism, American, 291

Ossana, Diana, 169

Other: in Anderson's films, 113; deviant, 144; empathy with, 256; fat, 201; in *Observe and Report*, 157; politics of, 260; racial, 168

Out of Sight (1998), 77

Owen, Clive, 231

Owning Mahowny (2003), 213, 217n5

Palahniuk, Chuck, 88–89

Pallana, Kumar, 104

Palmer, R. Barton, 11

Panic Room (2002), 90

Panopticon, Bentham's, 276

Parker, Kathleen: *Save the Males,* 151

Parks, Gordon, 224

Pataki, George, 243

*Pat Garrett and Billy the Ki*d (1974), 169

patriarchy, 9, 10; in American cinema, 128, 145, 148–49; in Anderson's films, 101–2; black male experience of, 223; in *Bringing Out the Dead*, 129; in *Brokeback Mountain*, 177, 179; homosociality and, 35; in *I Am Legend,* 250, 251, 252, 255; in marriage, 192; masculine subjectivity in, 122; in *Ocean's Eleven*, 276; psycho figures and, 145, 148–49; self-perception in, 40; symbolic order of, 143; women's bodies under, 227

Patterson, Eric, 58

Paxton, Bill, 203

Peberdy, Donna, 10; *Masculinity and Film Performance,* 8

Peck, Gregory, 144

Peckinpah, Sam, 180n6; Westerns of, 169

Peking Opera, 293

Pena, Elizabeth, 297

Peña, Michael, 156

Penn, Robin Wright, 140

Penn, Sean: activism of, 10, 53, 61–62; in *The Game,* 150; in *Milk,* 10, 52–54, 56, 57, 59, *60,* 62; offscreen persona of, 53–54, 61–62; Oscar acceptance speech, 52, 62; Oscar nominations of, 61

The Perfect Storm, 136, 141

performance: authenticity of, 55–56; of gender, 54, 101, 123, 292; gesture and, 202; of homosexuality, 56–57, 58, 62; of masculinity, 9, 10, 102, 266; in *Ocean's* series, 284; and performativity, 54, 57, 63n5; of politics, 57; politics of, 53–54; of race, 277–80; and sexuality, 54, 56; social codes of, 56

performance, cinematic: authenticity in, 61; camp, 57–58; gendered, 66–80; of homosexuality, 53–57; of social roles, 54

performative indices, 49n5; Sandler's, 20–21, 29, 31, 32, 36, 37, 40, 46

performativity: of heterosexuality, 54; performance and, 54, 57, 63n5

Persian Gulf War, disabilities following, 2

Peter Pan syndrome, 184, 194

phallocentrism, of heteronormativity, 212, 216

Philadelphia (1993), 55; authenticity markers in, 56; fictional aspects of, 59; representational space of, 56

Philips, Todd: *The Hangover,* 46, 152

Phone Booth: conservative values of, 161; psycho figure of, 149

Pickpocket (1959), 126, 127

Pillow Talk (1959), 285n6

Pineapple Express (2008), 152, 153

Pitt, Brad, 33; in *Fight Club*, 86, 150; in *Ocean's Eleven*, 267, *268,* 273, 280

Piven, Jeremy, 277

Pleck, Joseph, 88

Plummer, Christopher, 231

Poetic Justice (1993), 233

Point Break (1992), 10; corruption in, 78; male bonding in, 78

Poitier, Sidney, 224, 259

Reiner, Carl, 269, 273
remarriage: comedy of, 186, 190, 196, 197n1; in *Ocean's Eleven*, 281; in *Twister*, 204
Requiem for a Dream (2000), 280
Reyes, Ernie, Jr., 295
Reynolds, Burt, 206
Rhames, Ving: in *Baby Boy*, 238; in *Rosewood*, 235
Rich, Adrienne, 197n3
Ride the High Country, 173
Rififi (1955), 268, 273
Rio Bravo (1959), gay subtext of, 168
The Road (2011), 101
Robé, Chris, 11
Roberts, Julia, 266
Robin and the 7 Hoods (1964), 285n6
rock music, in Sandler's films, 36
Rocky franchise, 140
Rogen, Seth, 161n7; in *Funny People*, 153; in *Observe and Report*, 152–54, 155; persona of, 153
Rogers, Kasey, 160
Role Models (2008), 152
role-playing, 58. *See also* performance
romance narratives, generic structure of, 96, 100n14
romantic comedy: versus comedian comedy, 39; nervous, 39; women characters of, 43
Roosevelt, Franklin D.: "Four Freedoms" speech, 243
Rosewood (1997), 12, 233, *236;* black masculinity in, 235–37; community consciousness in, 237; violence in, 235–36
The Royal Tenenbaums (2001), *110;* absent father in, 109, 110, 119; alienation in, 104–5; critics on, 107; fathers in, 101, 103, 118; loss in, 109–10; melancholia in, 110; racism in, 113, 118
Rubin, Gayle, 192
Rubinfeld, Mark: *Bound to Bond*, 8
Rudin, Scott, 123
Rumble in the Bronx (1995), 293

Rush Hour (1998): gender norms in, 298; musical citations in, 297
Rush Hour 2 (2001): America in, 290; global relations in, 290; Jewish humor in, 311n30; Las Vegas in, 290, 292; misogyny in, 297; musical citations in, 297; postmodern pastiche in, 301; style in, 277
Rush Hour 3 (2007): America in, 290–91; depiction of anti-Americanism, 305–6; European art cinema and, 303–8; heterosexuality in, 306; Jewish humor in, 311n30; male bonding in, 307; masculine masquerade in, 305; Orientalist humor in, 291; post-9/11 issues in, 291; xenophobia in, 304
Rush Hour trilogy (1998–2007), 13; Americanization in, 296, 300; blaxploitation influence on, 294, 298, 300; code switching in, 301; comedy in, 293–94, 301, 302; cultural origins of, 294, 298, 300–301, 302; disruptions to masculinity, 293–94; drama in, 301; heterosexuality, 295; hierarchical masculinity in, 293–94; homosexuality in, 297, 306, 311n26; homosociality in, 298; masculinity in, 288–308; nostalgia in, 302; postmodern culture in, 302; race in, 294, 295; Tarantino's influence on, 300; topical allusions in, 302; villains of, 298–300; white male authority in, 300; women characters of, 297–98, 302
Rushmore (1998), *104, 115;* alienation in, 104; class resentment in, 113–15; father in, 101, 102–3, 109; mourning in, 107–9; soundtrack of, 104, 114–15; sublimation in, 115
Russell, Jane, 185
Russo, Vito: *The Celluloid Closet*, 55
Ryan, Michael, 182

sacrifice: in *I Am Legend*, 254–55, 257, 258, 260; of male bodies, 255; masculinist logic of, 256

Salaita, Steven: *Anti-Arab Racism in the USA*, 259
Saletal, William, 252
same-sex marriage, 182; bans against, 52; legalization of, 3
Sanada, Hiroyuki, 295
Sandler, Adam: in *Anger Management*, 149–50; in *Billy Madison*, 19, 24, *24*; collaborators of, 46–47; critics' condemnation of, 19–20, 21; depictions of masculinity, 20, 21; evaluative attitudes toward, 19–20; filmography of, 47; in *Funny People, 48*, 153; in *I Now Pronounce You Chuck and Larry*, 182; and Jewish comic traditions, 25, 50nn11–12; performance style of, 22–23, 32; performative indices of, 20–21, 29, 31, 32, 36, 37, 40, 46; physical qualities of, 23–24, 49n8; popularity of, 10, 19, 21, 27; production company of, 51n27; in *Reign Over Me, 38*; romantic comedies of, 37, 39–40, 42–44; *Rotten Tomatoes* rating, 46, 51n39; song-and-dance numbers of, 43–44; in *Spanglish, 30*; sports-related roles of, 26–27; star persona of, 20, 39, 44; on "Worst Dressed" list, 28
Sandler persona, 21–24; *amour fou* in, 21, 37, 39–44; anger in, 10, 20, 22, 25–26, 29, 31, 42, 44; antiromantic nature of, 37; anxiety in, 23, 24, 25–26; arrested adolescence in, 10, 20, 24, 31–37; conformity in, 21, 22; conservatism of, 46; family men, 28–29, 34–35; in *Funny People*, 47; and gay masculinity, 41; and health culture, 27; hostility in, 26, 37; marketing of, 34; masculinity crisis in, 24, 25, 29, 40, 49; mentor figures of, 34; phallic order and, 34; physicality of, 34; responses to, 20; schlemiels, 25, 44; September 11 and, 36; women characters and, 34; and work culture, 28

San Filippo, Maria, 12
Santaolalla, Gustavo, 172
Saturday Night Live, 21, 47, 183
Saw films, 145
Scarecrow (1973), 182
schlemiel (comic figure), 49n11; Sandler's use of, 25, 44
Schrader, Paul: auteurist agenda of, 123, 126; on Bresson, 126; *Taxi Driver* screenplay, 145–46, 155–56; *Transcendental Style in Film*, 141n9
Schultz, Michael, 224
Schumacher, Joel, 149
Schwartzman, Jason: in *The Darjeeling Limited*, 121n24; in *Rushmore*, 107
Schwarzenegger, Arnold, 259, 292; in *Kindergarten Cop*, 140; in *Terminator 2*, 144
Scorcese, Martin: auteurist agenda of, 126; cultural issues in, 129; depiction of class, 129; depiction of masculinity, 146; heterosexual ideals in, 155; homage to Bresson, 126. Films: *Alice Doesn't Live Here Anymore*, 131–34; *Bringing Out the Dead*, 11, 123–41; *Mean Streets*, 131; *Taxi Driver*, 123
Scott, A. O., 286n12
Scott, Randolph, 166, 173
Screening the Male (Cohan and Hark), 6
Screen theory, 130
screenwriters, gay, 55
screwball comedies, 39; of remarriage, 40
The Searchers (1956), 169, 172, 174
Seneca, Gail, 185
September 11 attacks, 3, 249; action films following, 289; in American culture, 247–48; American identity following, 254; documentary dramas on, 263n11; emasculated nation imagery of, 252; gendered metaphors of, 252; governmental failures concerning, 248; hypermediation of, 253; in *I Am Legend*, 245, 247–50; masculinity following, 252, 291, 303–8; mediated coverage of, 247–48;

Turim, Maureen, 250
Twain, Mark: *Huckleberry Finn,* 120n11
25th Hour (2002), 213, 217n5
2012 (2009), 13, 244, 246
The Twilight Saga: Eclipse, 4
The Twilight Zone, 145
Twister (1996): fat sexuality in, 203–4; heteronormativity in, 203, 205–6; Hoffman in, 201, 203–6, 217n5; remarriage in, 204

Unbreakable (2000), 139–41; male physicality in, 139–40; working class in, 140
Uncle Sam (1997), 160–61
United 93 (2006), 263n11
Untraceable (2008), 10, 73; climax of, 74
Ustinov, Peter, 203

Van Peebles, Melvin, 224, 230
Van Sant, Gus: *Milk,* 10, 52–54, 56
Vartan, Michael, 145
Vaughan, Vince: in *Wedding Crashers,* 181, 186–87, 194–95
vengeance: in cop cinema, 70, 79; curative powers of, 120n22; in *The Life Aquatic,* 111–13
Venturi, Robert, 301
Vergara, Sofia, 239
Vietnam: mourning for, 108–9; rhetoric about, 243–44
villains: fat, 214–15, 218n34; of *Rush Hour* trilogy, 298–300
violence: foundational, 177; legitimized, 263n12; racialized, 258; spectatorship of, 249
violence, male, 167; in *Brokeback Mountain,* 177–78; cinematic, 10–11; regeneration through, 111–13; ritualized, 26; in television drama, 159
The Virginian (1929), 166
Virtuosity (1995), 79
visibility: in *Ocean's Eleven,* 273, 275–76, 279, 280; politics of, 253
von Sydow, Max: in *Rush Hour 2,* 299, 304, 311n30

W (2008), 60
Wahlberg, Mark, 206; in *Four Brothers,* 239; in *The Italian Job,* 271
Wain, David: *Role Models,* 152
Walken, Christopher, 187
Walker, Robert, 159
Walking Tall (1973), 67
A Warm December (1973), 224
War on Terror, public discourse on, 259
Wartenberg, Tom, 42
Washington, Denzel: in *Inside Man,* 231; in *Mo' Better Blues,* 225, 226
Washington, Isaiah, 269
Washington, Kerry, 229
The Waterboy (1998), 23; anger in, 10, 26
Watermelon Man (1970), 224
Watson, Elwood: *Pimps, Wimps, Studs, Thugs and Gentlemen,* 7
Wayans, Damon, 41, 269
Wayne, John, 166
wealth, men's, 2
Wedding Crashers (2005), 12, 152, 181–97, *190, 195, 196;* audio commentary of, 186–87, 194–95; bisexuality in, 192, 195–96; in buddy film tradition, 185–86; church and state imagery in, 192; emotional allegiance in, 190; extratextual space in, 187; figurative transvestism on, 189; hedonism in, 33; heteromasculinity in, 188; heteronormativity in, 185, 193; marriage in, 190–93; metaphorical matrimony in, 184; power in, 192; queer sensitivity of, 187–88; reverse stereotypes in, 190; same-sex relationships in, 185; sexual crises in, 184; sexual identity in, 181; wedding montage of, 183–84
The Wedding Singer (1998), 22, 27, 39; songs in, 44
Weintraub, Sandy, 131
Welcome to Collinwood (2002), 268, 269
West, American: fantasy landscape of, 171; popular representations of, 167
West, Candace, 66
Westerfelhaus, Robert, 86, 90–91

Western heroes, 6, 15n17; in
 Brokeback Mountain, 172, 173,
 174; in community rituals, 174–76;
 emotional instability among, 170;
 flawed, 173; gender codes of, 167;
 heterosexual domesticity of, 176;
 insecurity among, 166; relationship
 to landscape, 171; repressed selves
 of, 165, 167; self-control of, 166;
 sexuality of, 166; strong silent type,
 165–67, 170. *See also* heroism
Westerns: buddy scenes in, 167;
 civilizing process in, 165; domestic
 heterosexuality of, 169; frontier
 killers in, 166; gay subtext of, 168–69;
 iconography of, 172, 173; madonna/
 whore construct in, 168; male bonds
 in, 167–70; sexual dynamics of, 169
Weston, Celia, 157
When the Levees Broke (2006), 232
whiteness: fantasies of, 262; power of,
 287n20
Whiteout (2009), gender contrasts in,
 78
whites, American: apprehensiveness
 of, 3
The Who, *Quadrophenia,* 36
Widmark, Richard, 144
The Wild Bunch (1969), 169
Wilkinson, Tom, 298
Williams, Cynda, 226
Williams, Dar, 1
Williams, Michelle, 175
Williams, Robin, 145
Williams, Tony, 149
Willie Dynamite (1973), 224
Willis, Bruce, 82n33, 140
Wills, Frank, 229
Wills, Gary, 166
Will Success Spoil Rock Hunter? (1975),
 285n6
Wilson, Luke, 105
Wilson, Owen: in *The Darjeeling
 Limited,* 120n16; in *The Life Aquatic,*
 105, 110; in *Shanghai* series, 308n1;

in *Starsky and Hutch,* 199n27; in
 Wedding Crashers, 181, 186–87
Wolfe, Collette, 155
women: cinematic depiction of, 4–5;
 college-educated, 2; in cop films, 66–80
Women in Film (advocacy group), 4
women's liberation movement, 132. *See
 also* feminism
Woo, John, 300
Wood, Grant: *American Gothic,* 178–79,
 180n12
Wood, Robin, 168, 188; on buddy
 movies, 184, 185, 198n11; on
 surreptitious gay texts, 187, 198n20
work: in *Bringing Out the Dead,* 136–39;
 meaningful, 134–35, 136–37; in *Taxi
 Driver,* 129, 137
working class: in *Alice Doesn't Live
 Here Anymore,* 132, 133, 134, 136; *in*
 American cinema, 139–40, 141; in
 Bringing Out the Dead, 129, 136, 141;
 cinematic depiction of, 125; loss of
 opportunity for, 133; in *Unbreakable,*
 140
workplace, feminization of, 41
The World, the Flesh, and the Devil
 (1959), 13, 244, 251
World Trade Center (2006), 263n11
World War II: effect on gender relations,
 88; rhetoric of, 243
Wynn, Steve, 286n10

xenophobia: post-9/11, 258; in *Rush
 Hour 3,* 304

You, Me and Dupree (2006), 35
You Don't Mess with the Zohan (2007),
 25, 27, 50n12
You Tarzan (Kirkham and Thumin), 6
Yung, Victor Sen, 296

Zacharek, Stephanie, 286n9
Zimmerman, Don, 66
Ziyi, Zhang, 292, 297, 300, 311n30
Žižek, Slavoj, 143, 294

their own. Either way, it is a sample based on having a dramatic and emotionally compelling story. As the fine print says, their results are not typical!

Unfortunately, our minds are wired to believe this type of evidence. We place more weight on dramatic, personal stories.

A scientific study of the weight loss supplement

Now, imagine we conduct a scientific experiment using a more substantial, random sample that represents the broader population. We'll also include a treatment and control group for comparison. We must go beyond a few compelling stories and get the bigger picture that scientific studies can provide.

In this graph, triangles again represent supplement takers, and circles represent those who didn't take the supplement. These results are not as impressive as the anecdotal graph. Why? Together, random sampling and the control group create an unbiased picture with a broader context.

Notice how some who took the supplement lost the weight shown in the TV ad, but many more lost much less weight. Those people didn't come forward with their less exciting stories! Furthermore, participants in the control group did not take the supplement, but they fit the same weight loss pattern as those who did. Collectively, taking the supplement didn't produce more substantial weight loss than the control group.

Because our supplement study uses a random sample that represents the population, rather than a self-selected sample, we have reason to believe we can apply these results outside the sample.

Anecdotal stories are not necessarily fictional. Instead, they don't represent typical results, account for other factors, and have no control group. In fact, the people in the anecdotal graph are also in the random sample graph. Imagine the anecdotal people first participated in the study and then appeared in the TV ad. Their accounts are accurate. However, after they self-select to appear in the ad and there is no control group, their stories provide a false impression of the supplement's effectiveness.

A key lesson throughout this book is that how you collect your data determines what, if anything, you can learn from them.

How Statistics Beats Anecdotal Evidence

In statistics, there are two basic methods for determining whether a dietary supplement causes weight loss: observational studies and randomized controlled trials (RCTs).

In an observational study, scientists measure all pertinent variables in a representative sample and then generate a statistical model that describes the role of each variable. For each subject, you measure variables such as basal metabolic rate, exercise, diet, health, etc., and the consumption of dietary supplements. After you factor in the role of all other relevant variables, you can determine whether the

supplement correlates with weight loss. Anecdotal evidence provides none of this critical, contextual information.

Randomized controlled trials (RCTs) is the other method. RCTs are the gold standard because they allow you to draw causal conclusions about the treatment effect. After all, we want to determine whether the supplement causes weight loss. RCTs assign subjects to treatment and control groups randomly. This process helps ensure that the groups are comparable when treatment begins. Consequently, treatment effects are the most likely cause for differences between groups at the end of the study.

Don't worry. We'll cover all of this information about experiments in much greater detail starting in chapter 7. For now, understand that using data to identify causal relationships (the supplement causes the weight loss) and being able to generalize the results beyond the original sample requires the researchers to use various data collecting procedures and experimental designs.

Making decisions based on anecdotal evidence might not always be harmful. For example, if you ask a friend for a restaurant recommendation, the risk is low, especially if you know his/her tastes. However, if you're making important decisions about things like finances, healthcare, and fitness, don't base them on anecdotal evidence. Look at scientific data and expert analysis even though they're not as flashy as emotionally charged stories presented by relatable people!

If you find yourself being won over by anecdotal evidence, remind yourself that the results are not typical!

Organization of this Book

Unless you are involved with data analysis, you're probably more familiar with the graphical and numeric results that someone else produced. However, the field of statistics covers much more than that,

including a wide variety of processes and methodologies for producing trustworthy results.

Consequently, I've split this book into two major parts.

The first portion covers the essential tools of the trade, including data types, summarizing the data, and identifying relationships between variables. I'll describe the types of data and how to present them graphically. Learn how summary statistics represent an entire dataset and describe where an observation falls within it. These statistics include measures of central tendency, measures of variability, percentiles, and correlation. Then, we'll move onto probability distributions. Probability distributions help you understand the distribution of values and calculate probabilities. We'll pay extra attention to the crucial Normal Distribution.

Collectively, this knowledge allows you to understand the basics of the different types of data, how to summarize a dataset, identify relationships between different types of variables, and use probabilities to know how the values are distributed. These skills will allow you to summarize a dataset and explain relationships between variables to others.

The second portion covers the practices and procedures for inferential statistics and using statistics in the scientific process. Inferential statistics allow you to use a relatively small sample to learn about an entire population. However, making this leap from a sample to the population requires additional procedures and methodologies. I'll also cover how the field of statistics fits in with the scientific method along with the essentials of designing experiments to answer questions.

Data Types, Graphs, and Finding Relationships

In the field of statistics, data are vital. Data are the information that you collect to learn, draw conclusions, and test hypotheses. After all, statistics is the science of learning from data. However, there are different types of variables, and they record various kinds of information. Crucially, the type of information determines what you can learn from it, and, importantly, what you cannot learn from it. Consequently, you must understand the different types of data.

The term "data" carries strong preconceived notions with it. It almost becomes something separate from reality. Throughout this book, I want you to think about data as information that you are gathering for an inquiry. Data are evidence you can use to answer questions. For example:

- Do flu shots prevent the flu?
- Does exercise improve your health?
- Does a gasoline additive improve gas mileage?

When you assess any of these questions, there's a wide array of characteristics that you can record. For example, in a study that uses human subjects, you can log numerical measurements such as height and weight. However, you can also assign categories, such as gender, marital status, and health issues. You can record counts, such as the number of children. Or, use binary data to record whether a person has the flu or not.

For some characteristics, you can record them in multiple ways. For instance, you can measure a subject's body fat percentage, or you can indicate whether they are medically obese or not.

In this chapter, you'll learn about the different types of variables, what you can learn from them, and how to graph the values using intuitive examples. We'll start with individual variables. Then, I'll show how to use graphs to look for relationships between pairs of different types of variables. For now, we'll only use graphs to gain insights about our data. In chapter 3, we'll start calculating numeric summary statistics.

A relationship between a pair of variables indicates the value of one variable depends on the value of another variable. In other words, if you know the value of one variable, you can predict the value of the other variable more accurately.

Different fields and analysts use several taxonomies for classifying data. For each type of data, I'll provide several synonyms to cover the various classification schemes. Additionally, I'll include small snippets of the data sheet so you can see how the data can appear in your software.

Quantitative versus Qualitative Data

The distinction between quantitative and qualitative data is the most fundamental way to divide types of data. Is the characteristic something you can objectively measure with numbers or not?

Quantitative: The information is recorded as numbers and represents an objective measurement or a count. Temperature, weight, and a count of transactions are all quantitative data. Analysts also refer to this type as numerical data.

Qualitative: The information represents characteristics that you do not measure with numbers. Instead, observations fall within a countable number of groups. This type of variable can capture information that isn't easily measured and can be subjective. Taste, eye color, architectural style, and marital status are all types of qualitative variables.

Within these two broad divisions, there are various subtypes.

Continuous and Discrete Data

When you can represent the information you're gathering with numbers, you are collecting quantitative data. This class encompasses two categories.

Continuous data

Continuous variables can take on any numeric value, and the scale can be meaningfully divided into smaller increments, including fractional and decimal values. There are an infinite number of possible values between any two values. And differences between any two values are always meaningful. Typically, you measure continuous variables on a scale. For example, when you measure height, weight, and temperature, you have continuous data.

Statisticians divide continuous data into two types that you measure using the following scales:

Interval scales: On interval scales, the *interval*, or distance, between any two points is meaningful. For example, the 20-degree difference between 10 and 30 Celsius is equivalent to the difference between 50 and 70 degrees. However, these scales don't have a zero measurement

that indicates the lack of the characteristic. For example, Celsius has a zero measure, but it does not mean there is no temperature.

Due to this lack of a true zero, measurement ratios are not valid on interval scales. Thirty degrees Celsius is not three times the temperature as 10 degrees Celsius. You can add and subtract values on an interval scale, but you cannot multiply or divide them.

Ratio scales: On ratio scales, intervals are still meaningful. Additionally, these scales have a zero measurement that represents a lack of the property. For example, zero kilograms indicates a lack of weight. Consequently, measurements *ratios* are valid for these scales. 30 kg is three times the weight of 10 kg. You can add, subtract, multiply, and divide values on a ratio scale.

With continuous variables, you can assess properties such as the mean, median, distribution, range, and standard deviation. For example, the mean height in the U.S. is 5 feet 9 inches for men and 5 feet 4 inches for women. The next chapter covers these summary statistics.

Histograms: Distributions

%Fat
23.9
28.8
32.4
25.8
22.5

Histograms are an excellent way to graph continuous variables because they show the distribution of values. Understanding the distribution allows you to determine which values are more and less common amongst other properties.